Drawing Academy

BARRON'S

Original title of the book in Spanish:
Academia de Dibujo
© 2008 Parramón Ediciones, S.A.—World Rights
Published by Parramón Ediciones, S.A., Barcelona, Spain.

Texts: Gabriel Martín
Exercises: Marta Bru, Carlant, Almudena Carreño,
Mercedes Gaspar, Gabriel Martín, Esther Olivé de Puig,
Esther Rodríguez and Óscar Sanchís
Photography: Studio Nos & Soto

Translated from the Spanish by Michael Brunelle
and Beatriz Cortabarria (Parts 1 and 4); Marcela Estibill
(Part 2); and Eric A. Byer, M.A. (Part 3).

All inquiries should be addressed to:
Barron's Educational Series, Inc.
250 Wireless Boulevard
Hauppauge, New York 11788
www.barronseduc.com

ISBN-13: 978-0-7641-6183-4
ISBN-10: 0-7641-6183-0

Library of Congress Control Number: 2008924881

Printed in China
9 8 7 6 5 4 3 2 1

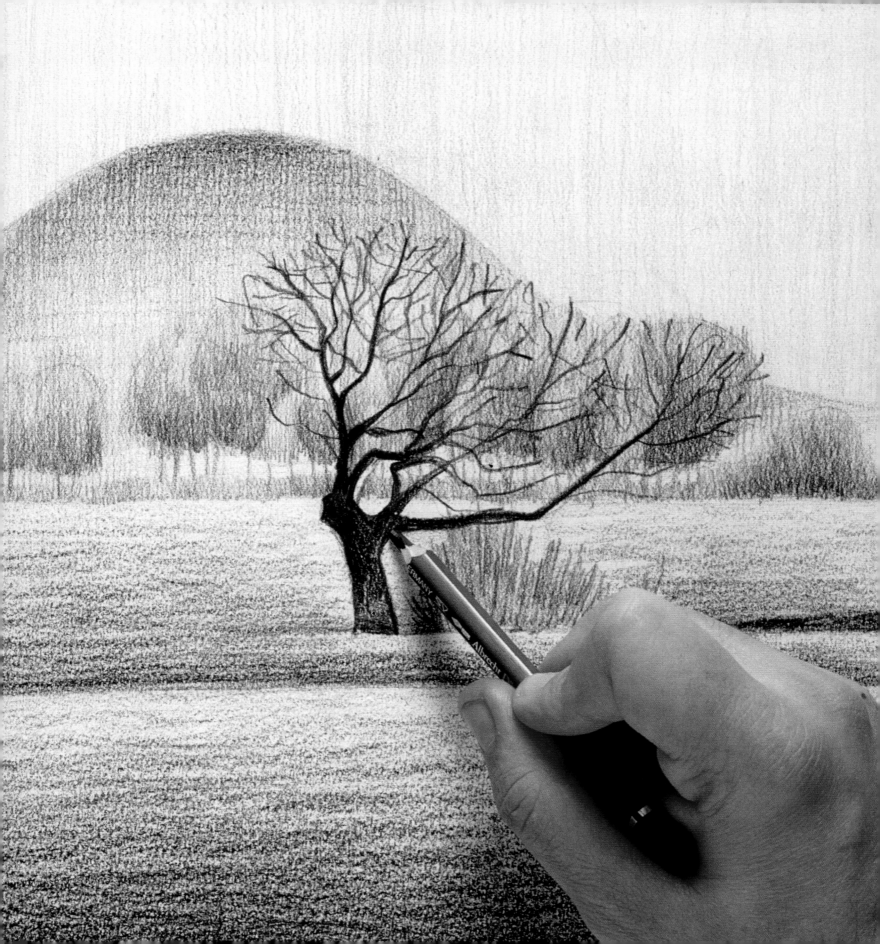

CONTENTS

1. The Basics of Drawing

2. Line and Shading in Drawing

CONTENTS

3. Light and Shadow in Drawing

4. Perspective Drawing

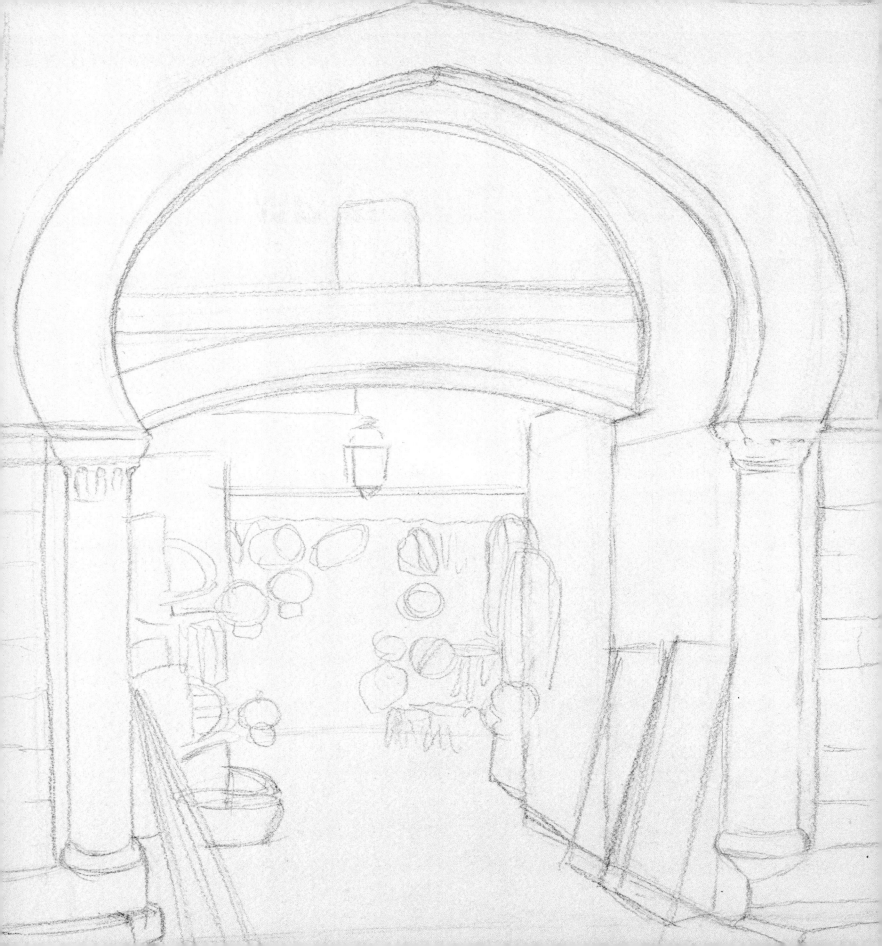

Drawing has humble origins, and in its simplest form can be reduced to a pencil scribbling on paper. In this manner, we have all drawn at some time, even if it was absent-mindedly making doodles. Therefore, to start out we should not see drawing as an ability of others, but as ours, an impulse that we are able to generate and that helps us to freely and uninhibitedly express our instincts, whether premeditated or irreverently or unconsciously, almost without trying, like what happens when we doodle on paper while talking on the telephone. But drawing is not only a way to release tension, a prescription for boredom when we are required to attend a sleep-inducing conference or a therapeutic practice; it is much more.

Drawing is a marvelous language with a great ability for surprise; some lines, a few brushstrokes, are enough to evoke life, feeling, and beauty. And this magic, immediacy, and freshness become the basis for all artistic creation. It is the genesis of all works of art, the basis and common denominator of the plastic arts. Without preliminary sketches painters could not paint, sculptors could not sculpt, no designer could design, and no architect could build.

Drawing lets us explore the world, analyze and fix our vision of things on a piece of paper. Therefore, drawing, above any manual and technical ability, involves learning to see and understand our surroundings. Doodling may be a talent that we would call innate, but learning to control lines so that our drawings take on meaning is not. Learning to draw is a process and a discipline that requires enthusiasm and will from the beginner, the desire to experiment with different media, and perseverance trying again when things do not turn out well. This book was created for those beginning this apprenticeship and for those with the desire to master the art. It combines the main methods and techniques of teaching drawing, which are shown in a clear and complete manner, like a full-scale course in an art academy.

The basic problems that the new draftsmen face are those related to the construction of the representation of the scene in the drawing: generated by the shift from three-dimensional vision to the two-dimensional plane of the support, and the conflicts that arise between vision/perception and representation/concept. Our investigations as artists are based on these questions: How

was this done? In what order was the drawing organized? How was the intensity of the line achieved, and the transparency, and the support?

This manual answers these and many other questions. It looks at the material problems of the drawing and the techniques that reorganize the meaning of the image, offering an explanatory view of the different processes, techniques, and resources with

the goal of understanding the layout, the modeling, the shading, and the effects of depth and perspective, in other words, the principles that guide academic teaching today. Included is a wide program of intentions, clarifying examples, advice that anticipates any problem that may arise, and step-by-step exercises where we will learn from the hands of professional artists. All this is oriented to visualizing ways of understanding the problems of drawing and the possible

solutions that will help us understand the structure of graphic thinking.

The book is organized in four sections: basic drawing, which introduces form and its representation; line and shading, a good way of controlling line and contrast; light and shadow, which is about the effects of modeling and the sense of volume; and finally perspective, which explains the different ways of creating depth in the drawing.

Learning to draw is like learning to cook. Once we know the main ingredients of a dish and the order of preparation, we have the basics for creating several variations. In drawing, the ingredients are limited to a few required graphic operations that when later combined in different ways allow us to create a wide range of surprising representations, ultimately having the resources for drawing any model and multiplying our possibilities of representation.

1.
The Basics
of Drawing

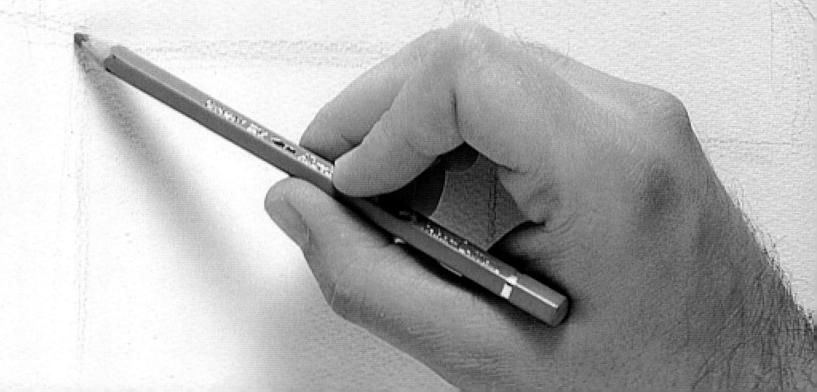

GETTING TO KNOW THE MATERIALS. The first step in the development of your drawing abilities is to familiarize yourself and to become confident with the great variety of drawing media. You will discover that each medium has its own particular characteristics. Getting acquainted with them will help you become proficient and create certain effects.

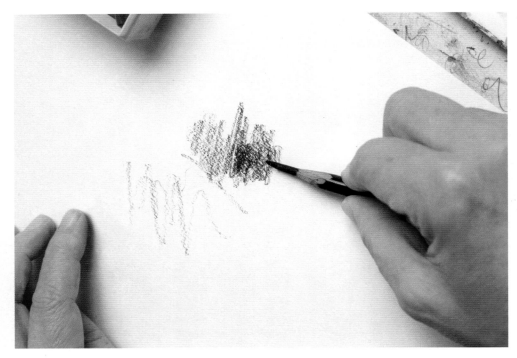

THE GRAPHITE PENCIL.

The graphite pencil is the most common and widely used drawing medium. It is available in many grades of hardness, ranging from very soft or extra soft to very hard or extra hard. Both are equally effective for simple line work and for showing detail, tone, and texture. Pencils respond instantly to the pressure applied to them.

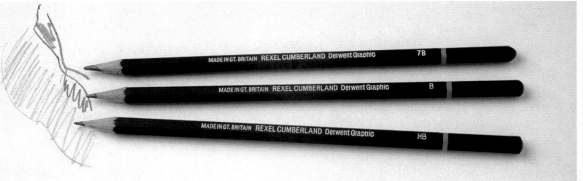

HARD AND SOFT PENCILS.

The line created with a hard pencil is light gray, and does not become darker no matter how many layers are applied to the paper. The tip does not glide smoothly when shading. A soft pencil's lead is thicker than that of a hard one. The line created with a soft pencil is oily and soft; and unlike a hard one, a soft pencil glides easily on the paper when shading.

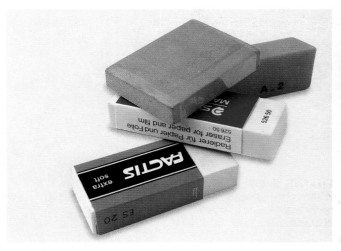

ERASERS.

The eraser is a very important drawing tool because it is not only used to eliminate lines, but is also used for drawing. It is often used during the first phase of the drawing for blocking in and for drawing the basic lines, but is also used during the last phase to create highlights.

VINE CHARCOAL.
The charcoal stick is a carbonized vine. It can be either thick or thin. When rubbed against paper it leaves a matte gray mark that is not very dark. It is used on large-format drawings. It is very useful for shading effects, gradations, and diffusions. When you need more detailed or defined lines, it is possible to combine charcoal sticks with compressed charcoal pencils.

CHALK.
Chalk shares some of its properties with charcoal in that it is easy to handle and has a similar granulated texture. However, the quality of its line is somewhat greasier and therefore more stable. Brown and sienna chalks impart solidity to forms, black is deep and rich in nuances, and white is ideal for creating highlights. There is also a reddish variety of chalk, called sanguine, which provides great warmth to the drawing.

FIXATIVE SPRAY.
A secondary, yet equally necessary material is spray fixative, which protects drawings done with charcoal or chalk.

CHOOSING THE SUPPORT. This factor is as important as the drawing medium itself. The final result of the work, including the intensity of the line as well as the quality of the finish, will vary considerably depending on whether the paper is smooth or textured, heavy or light.

A PAPER FOR EACH DRAWING MEDIUM.
Each medium requires a specific paper. For graphite pencils, we recommend using fine-textured or smooth papers, which allow rich gradations and easy blending. Fine and smooth papers are also good for drawing with oily pencils, crayons, or colored pencils. If you want to draw with charcoal or chalk, it is best to use a medium-grain paper because it retains the pigment particles better and offers greater abrasion. Heavy-grain papers are best reserved for large-format work done with chalk or charcoal. They give the drawing a very granulated texture as well as an energetic and expressive shading. Do not be afraid to draw on watercolor papers, which have very distinctive textures. They add a charming effect to the drawing and are very durable.

FRONT AND BACK.
Drawing paper has a front and a back. Either side can be used for drawing, although for most drawings the front side, which is less smooth, is used. To confirm this, simply hold the paper near a light. Fold one corner over and notice the difference in texture between sides.

A RIGID SUPPORT.
When drawing, the paper cannot be placed against just any surface. It must be attached to a hard and smooth surface that has no texture which can affect the purity of the lines and colored areas. If you work on a surface that has lines, cracks, texture, or holes, they will leave unwanted marks on the drawing. MDF or plywood boards are best because they have flat, smooth surfaces. Ideally, the board should be larger than the paper attached to it.

SECURING THE PAPER.
The paper can be secured to a piece of hard cardboard or a wood surface with masking tape, thumbtacks, or clips. This way, the paper will not wrinkle or fly away easily with the wind when working outdoors.

A VARIETY OF PAPERS.
Keep samples of a variety of papers. This way, you will be able to test any medium on them before you begin to draw.

Controlling the Form

The shape of an object used as a model is determined by its outline. The features that stand out define its identity. They are the starting point of the sketch or the diagram that gives it form. This does not mean that the object is a strict representation of its outline, because its form is always linked to the design of the internal framework, imaginary lines, and other underlying structures. In the same way that you must practice to teach your hand to draw, you must also train your eye to see those underlying schemas that help you identify the distinctive features of each form. This is why the artist is encouraged to understand before acting, to observe the structure of what he or she sees before beginning to draw, to recognize an innate framework upon which the definitive form of the model could be based.

DIFFERENT WAYS OF BLOCKING IN. For the beginner, controlling the model's form can present some challenges, especially when its shape is symmetrical. Controlling the form is not only a matter of manual dexterity; there is also a method for blocking in symmetrical objects correctly. During the first phase of the learning process, it is important to establish the axes of symmetry and to reduce each shape to a few simple structural sketches that will be easy to memorize and correct if you make a mistake. Let us look at some examples.

1.

AXES OF SYMMETRY. The axes of symmetry are established by drawing a very simple grid that divides the rectangle according to its halves and diagonals. This geometric division helps articulate the surface of the work in accordance with the object that needs to be reproduced. These grid lines are guidelines that help you draw the outline of an object with harmony and proportion. Get accustomed to drawing axes of symmetry before you begin any drawing and you will notice the difference.

2.

GEOMETRIC STRUCTURE. The shape of an object can also be resolved by synthesizing the model using the geometric forms that are contained in it. If you select the correct forms, you will be able to draw a symmetrical object quite accurately, with few mistakes.

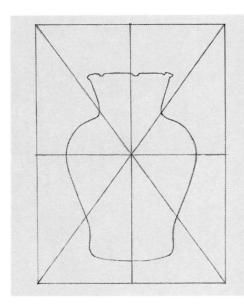

The axes of symmetry make it possible to make a good, well-balanced composition and to draw a symmetrical object with the same outline on each side.

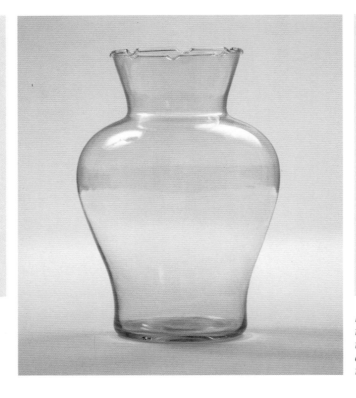

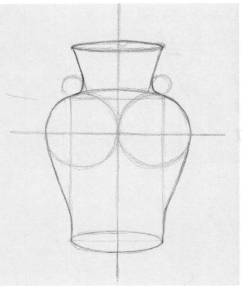

Draw the horizontal and vertical axes of symmetry, followed by a rectangle. Place an inverted trapezoid over it, along with two identical circumferences, one on each side. Draw the final outline based on these shapes.

Forget the ruler, the compass, and the square when you draw; every line should be drawn freehand. This way, even when the lines are not completely even, you will become more proficient at it.

3.

SYSTEM OF COORDINATES. Another interesting method for blocking in an object's form is based on controlling the measurement of each one of its parts. To do this, first draw horizontal and vertical lines to define the height and width of the object, identifying each point by its coordinates. Once the measurements have been established, simply draw the outline of the object through the points indicated.

4.

MODULES OR BOXES. Any model, no matter how irregular or complicated it may be, can be bounded by a flat box or geometric shape. This is the technique of blocking in using modules: when an object is drawn, its shape is encased by a square module that should be as high and wide as the model. If you need to be more precise, several square boxes can be combined.

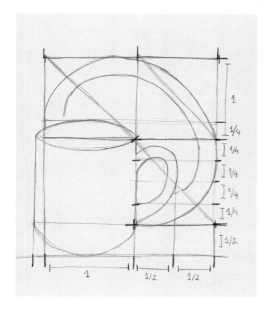

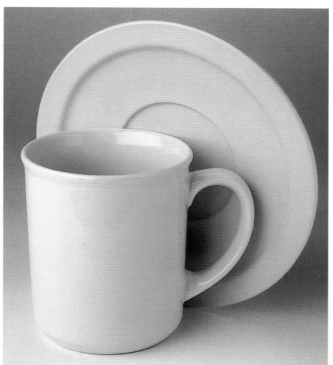

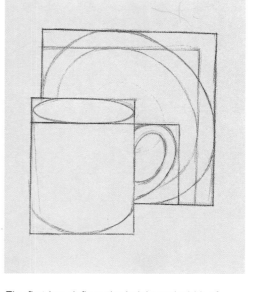

The most important thing is to measure the height and width of each area. From that point you can begin indicating coordinates on these lines, making sure that they take into account the object's size variations. Once the measurements have been established, the outline can be drawn.

The first box defines the height and width of the cup, and the second one, that of the plate. They can be complemented by other boxes that provide additional information about the model.

Blocking in using graph paper is not common among beginners. Normally, it should only be used when copying a photograph or a print that is to be reproduced in a size larger than that of the original. The squares facilitate blocking the model.

5.

BLOCKING IN SYMMETRICAL OBJECTS. The exercises that follow show the most common method for structuring and blocking in a symmetrical model. At first this may look easy to do: you simply draw one side, then repeat the process on the other side as closely as possible. This task may be more challenging than it appears because it requires great attention and control of the line.

THE SCHEMATIC APPROACH. This consists of blocking in the outline of an object with polygonal lines, drawing a general view of it. This is done by drawing the contour with sketchy strokes, using a series of straight, short lines that gradually define the profile.

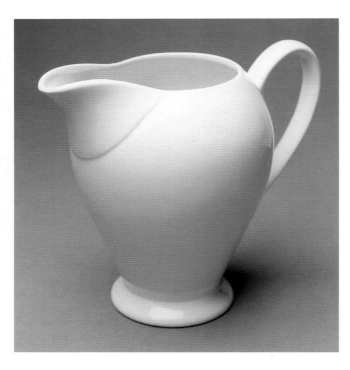

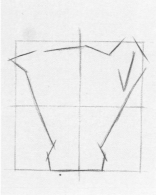

The first lines are a series of straight and short strokes that establish a sketchy outline of the object. This is a visual approximation that will require adjustments and corrections.

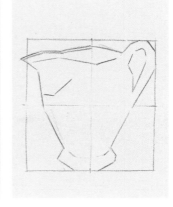

The lines are erased and redrawn, correcting the basic shapes to perfect the drawing.

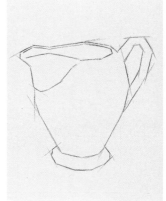

In the end, the straight lines are replaced by rounded lines that are softer and less angular. You must erase the previous step, and to redraw the object with rounded lines, following the traces of the pencil lines.

A square box is always very helpful when drawing an object. By marking each side you will get very useful reference points that can be used to sketch the outline of the model.

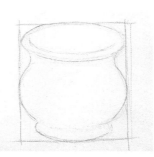

Professional artists develop a sketch of the model using quick, accurate, and loose marks, although much practice is needed to arrive at this point.

6.

THREE-DIMENSIONAL FORMS. If you analyze the shape of any object you will notice that nearly every object can be fitted inside a geometric shape. Beginning with three-dimensional geometric shapes will make it easier to draw the structure of the model and to represent its volume. To aid in blocking in the objects, the geometric shape creates a transparent, imaginary volumetric background, as if it was a box whose sides make contact with each side of the object being drawn.

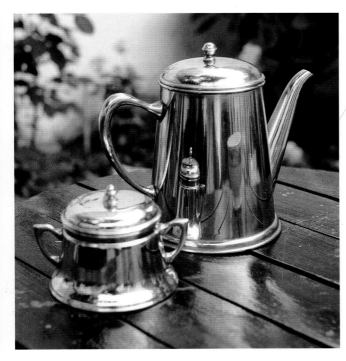

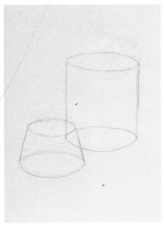
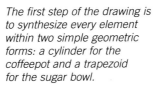

The first step of the drawing is to synthesize every element within two simple geometric forms: a cylinder for the coffeepot and a trapezoid for the sugar bowl.

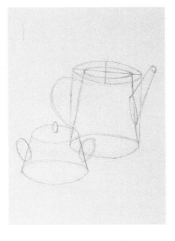

Based on these geometric structures, we begin to draw each form, paying special attention to the contours of the objects. This way, the coffeepot's cylinder becomes a trapezoid. We use ellipses to establish the placement of the handles.

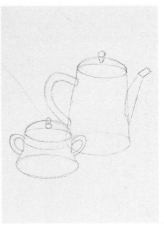

The lids are drawn using half of a sphere. The handles are already in place, as well as the spout of the coffeepot, which was drawn with straight lines. When everything is sketched, the initial geometric box is erased.

If a shape appears in foreshortening, it can be drawn gradually or with transverse sections that will look attached.

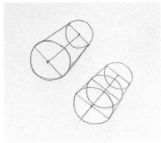

Imagining the objects as if they were transparent is a good tool for understanding their internal structure, creating a clean drawing, and controlling the angles and proportions of the representation.

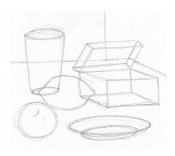

CONTROLLING THE LINE. Becoming proficient at drawing fluid lines, knowing how to hold the pencil correctly, being aware of the variety of lines, and training the hand to perform various motions are essential for successfully defining the outline of any drawing.

SOLIDIFYING THE LINE. When the drawing's outline has been completely defined, it is reinforced with a more liberal and firm hand. To do this, it is very important to sketch the preliminary lines very softly so they can be easily corrected.

The tentative line is one of the first ones that an amateur artist should learn. It consists of drawing several lines, one over the other, to sketch the form of the model. This line is standard in the first stages of a drawing.

Inexperienced artists tend to draw with inconsistent lines that lack continuity, a practice that should be avoided.

When drawing, you need to be able to control the line. You should aim to draw with decisive, direct, and uniform strokes.

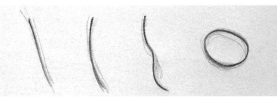

Line control in a drawing is the result of successive tentative marks that leave an imprint on the paper after each stroke. Precision in the form is developed as firmer and darker lines are superimposed over the others.

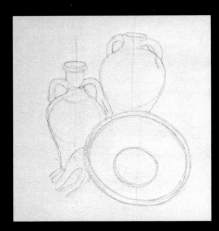
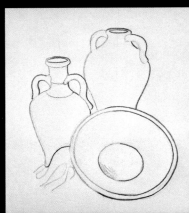

The preliminary layout is composed of quick, loose lines that are drawn by the artist as an approximation. This method allows several lines to be drawn one over the other to describe the outlines of the objects.

As the drawing progresses, tentative lines should be avoided. The drawing should become firmer and more defined and the forms should become more precise.

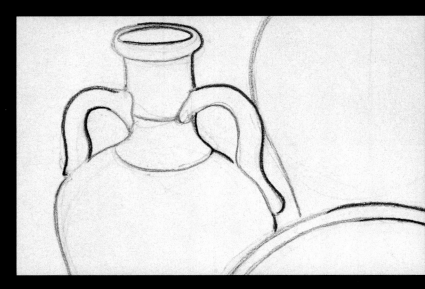

Finally, reinforce the drawing with new, heavier lines that make it stand out against the background. Lighter lines are reserved for the highlights and for the model's interior details, creating a three-dimensional effect.

CONTROLLING THE LINE. Once the basic structure of the objects has been established, you can begin to outline the form, paying more attention to the stroke. The secret of a professional drawing resides in the movement of the hand in conjunction with the forearm; they often move as a single unit.

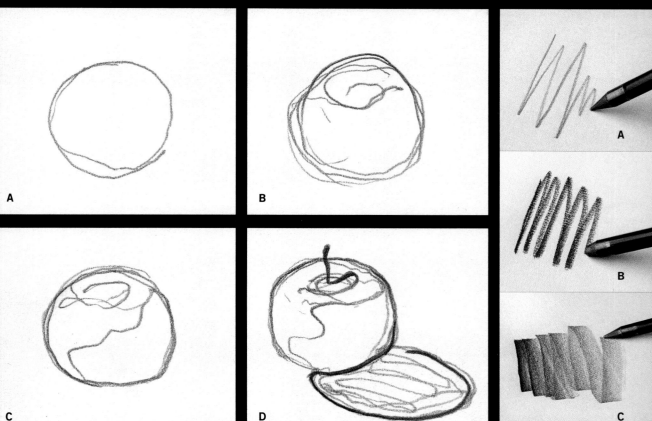

ANGLE OF THE POINT. *The shape of the point and the angle at which the drawing tool is held are important for controlling the quality of the line. The results vary depending on whether the point is sharpened (A), worn (B), or held at a low angle (C).*

OUTLINES AND INSIDE SHAPES. *These sequential drawings show you how to control the line to draw an apple. First, the object is blocked in with a circle (A). Second, new lines are superimposed on the previous ones to finish rounding off the outline and to sketch the inside forms (B). The outline is reinforced with thicker lines (C). At last, the form is completed by adding new, heavier lines and projecting the shadow (D).*

DRAWING ELLIPSES. *Shown here are the most common mistakes made by beginners, who tend to draw the ellipses too short and either too sharp or too rounded, like a sausage. These errors should be avoided.*

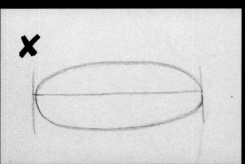

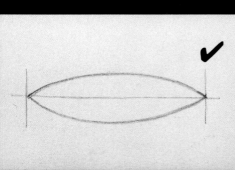

DRAWING ELLIPSES. *Many objects are drawn based on circles seen in perspective. Therefore, learning to draw ellipses is one of the requirements for being an artist. As the circle gradually becomes an ellipse, its four parts will decrease in height until they become rectangles. This exercise is ideal for drawing glasses, vases, and plates.*

GEOMETRIC APPROACH. You can use several approaches to the model when you begin to plan a drawing; one of them is to interpret the forms with geometric figures that help you control the proportions.

7.1

BUILDING WITH FIGURES. Blocking in should be the most elaborate and intense phase of the process. The entire structure of the drawing depends on it. Blocking in allows you to make sure that it is balanced, that the proportions are correct, and that there are no mistakes in the lines that require greater precision. In this exercise, we will use geometric shapes as if they are pieces in a puzzle.

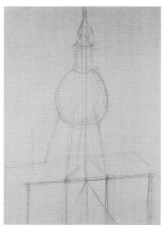

The base of the tower is represented by a rectangular shape. The lower section of the bell tower presents a pyramid-like form topped off by a huge egg. The cone-shaped top of the bell tower is superimposed upon it.

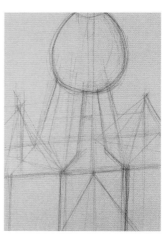

When drawing structures as if they were transparent, you can use horizontal and vertical lines, in addition to axes, to help with the process of comparing reference points with diagonals and tangents.

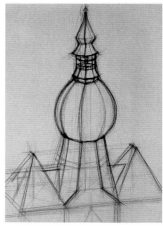

This drawing, completely defined by structural lines, reveals the different geometric shapes that constitute the building's shell. When the artist is completely satisfied with the drawing, the lines are darkened with firmer and more decisive strokes.

Cézanne proclaimed that "In nature, everything is modeled after three fundamental shapes: the sphere, the cone, and the cylinder. One must learn to paint these three very simple figures, and from there you can do anything you want."

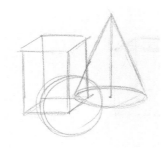

To block in the geometric shapes, we recommend starting the drawing with a pencil that produces light lines, such as an HB, then working with softer pencils as the drawing progresses.

7.2

CONSOLIDATING THE DRAWING AND SHADING. After several geometric shapes have been superimposed to achieve the model's structure, they are connected with lines to define the outside shape. The phase is completed with light shading that provides a sense of volume to the grouping.

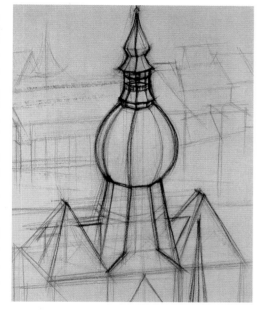

You have drawn the model as if the geometric shapes were transparent, made of glass. Now, redraw the outlines trying to envision the forms as opaque bodies. Only the visible outlines are taken into account; erase the initial structural lines to avoid confusion.

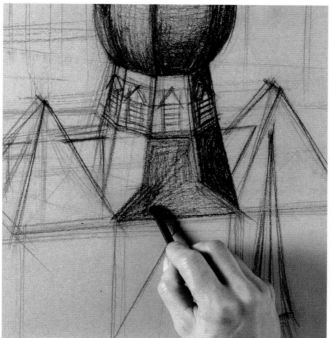

Emphasize the shaded areas to give the geometric shapes a greater feeling of volume. The shaded parts are lightly drawn with the side of a chalk stick.

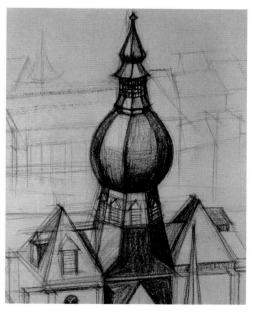

Darken the right side of the bell tower. This tone, very close to black, establishes the main contrast between light and dark, helping to emphasize the tower's profile against the background. It also becomes the point of reference for the darkest tone in the drawing.

To draw an apparently complex object, first draw a rectangular box to contain it; next, based on this, develop the form.

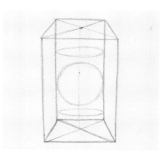

When blocking in objects inside geometric shapes, do not forget to draw the axis of symmetry, a perpendicular line that divides the figure in two and acts as a reference point.

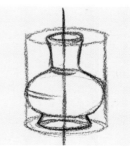

27

7.3

GEOMETRY, HIGHLIGHTS, AND VOLUME EFFECTS. The last stage consists of shading and modeling the forms. The dark shading and the white chalk highlights will eventually cover any underlying or structural lines that are still visible.

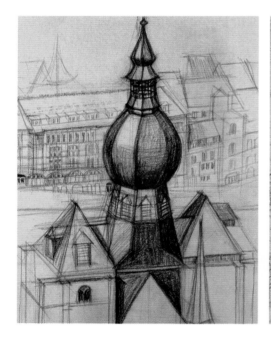

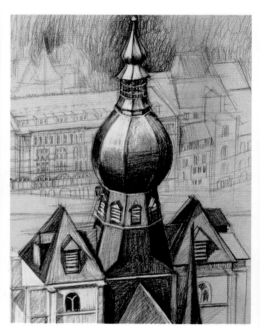

Create the background by sketching the façades of the buildings. The background should be dynamic, without too many details. Draw it without pressing too hard on the chalk; some areas can even be left out.

Emphasize the areas of light with white chalk. Dfferentiation among the various sides of the tower bell is achieved with contrasting tones. This effect is created where two sides that have different amounts of light meet; this way each plane is defined according to its position relative to the source of light.

Finish drawing the building with a variety of light and dark tones. To give your drawing more contrast, add lighter whites and draw new dark areas, superimposing these tones on the previous ones. This causes the foreground to stand out against the light gray background.

Chalk produces much better results when it is used on colored backgrounds.

The final phase of the drawing consists of completing the lower part of the building, which is created by combining light lines made with white chalk and shaded areas drawn with black chalk. A very soft new gray layer is applied to the background. It is important to draw the background in a more sketchy manner so you do not take away importance from the foreground. Drawing by Esther Olivé de Puig.

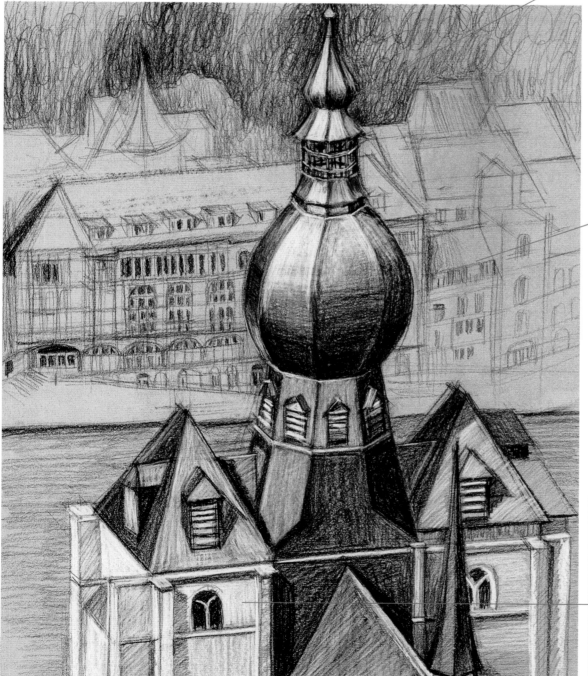

When an object in the foreground is superimposed against a gray background, you can darken it around the outlines to emphasize its profile even more through the effect of contrast.

The buildings in the background are drawn to look like sketches. No white chalk lines are used here because the color of the paper provides the intermediate tones.

To differentiate among the various planes that receive similar amounts of light, the artist can resort to the use of lines drawn in different directions. While the walls have vertical lines, the shadows of the pilasters are drawn with diagonals.

INTERIOR LINES. All objects have interior lines that help block in the drawing or resolve its form much more easily.

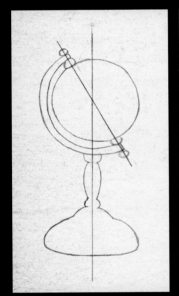

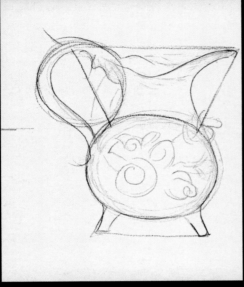

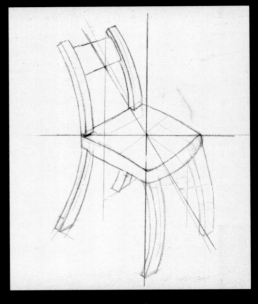

Many times, a straight diagonal line is sufficient to help you understand the configuration of the object that you are drawing.

When the object's shapes are more complex, you can combine straight lines with simple geometric shapes that help define its outline.

Diagonal lines can also be combined with the axes of symmetry. Here, crossed lines help construct a chair proportionally.

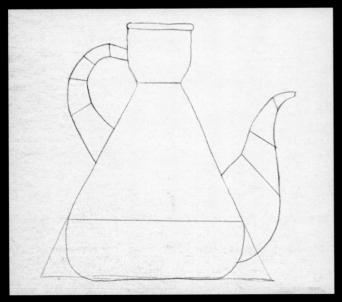

There are some interior lines that, when incorporated into a drawing, can help you better understand how to draw more complex areas, such as the handle and the spout of this oil cruet.

PROPORTION. For every model, it is possible to draw imaginary lines that correspond to its orientation or distance. These lines help with blocking in and with measurement of the proportions. This analytical work is very useful to do before you finalize the drawing.

A CORRECT OUTLINE. Encasing an object inside a box and within the axes of symmetry will help you draw its outline correctly and symmetrically.

FROM BLOCKING IN TO DRAWING. When you are faced with a complex subject, you can approach it in four well-defined phases that will help you come up with a proportionate solution.

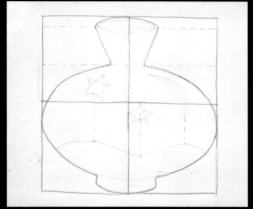

To draw the outline of an object, in this case a vase, copy the left side of the vase as shown in the two boxes on the right, using each box as a guide for blocking in the form.

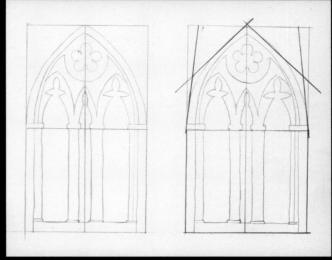

First, draw a box with the model inside. Then, locate the axes of symmetry, which will help you balance both sides of the drawing.

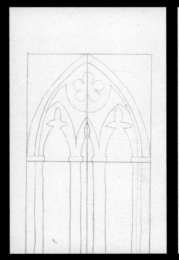

With new lines, study the model's outline in relationship to the initial box, controlling the correct angle of the Gothic arch.

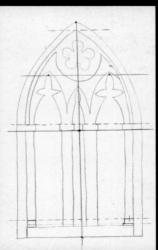

Drawing straight horizontal lines to establish new interior measurements will help you draw the decorative design.

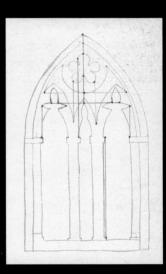

To draw the ornamental elements, it is necessary to study the placement of key points along a line and to make sure that the proportions are correct.

ESTABLISHING MEASUREMENTS. We have shown that reducing the main forms to simple geometric shapes and straight converging lines helps to establish the model's measurements. This permits accurate study of its proportions and the subsequent detailed representation of each of its parts.

8.1

FORMS, LINES, AND DIAGRAMS. Any subject can be accurately represented through the correct construction of lines and simple forms. Begin the process by drawing a few very simple geometric lines that establish the basic proportions of the different objects.

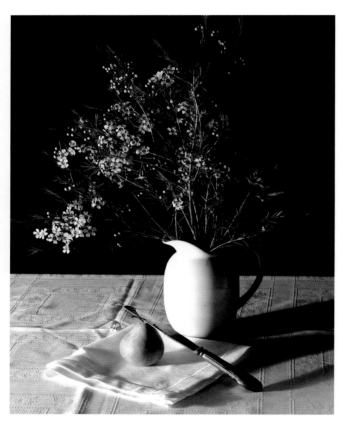

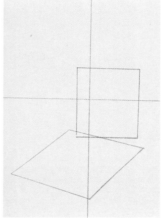

To understand the model's forms, begin with very simple diagrams drawn with a few lines. Two straight lines, one horizontal and another vertical that cross at the center point, are sufficient to define axes of symmetry. The shapes of the vase and the napkin are synthesized from a square and a rhomboid.

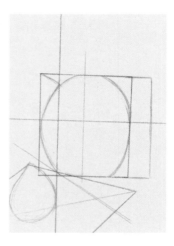

The vase is drawn based on a rectangle. If you measure it, you will realize that the space occupied by the handle is approximately one-fifth the width of the pitcher. A rectangle is drawn to its left to indicate this space. The pear extends a little beyond the middle of the pitcher.

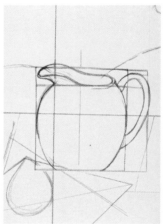

To draw the top part of the pitcher you can use almost the same measurement as you used for the handle. A rectangle drawn horizontally contains the opening of the pitcher. A couple of diagonal lines indicate the placement of the knife and the fold in the tablecloth. Now, begin to sketch the space that will be occupied by the bouquet of flowers.

When you attempt a more complex form, begin by making a good diagram; this will give you an advantage when you begin to draw your subject.

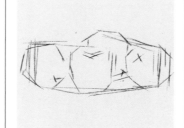

In this phase the work is done with a very sharp pencil. To avoid constant sharpening, rub the pencil against the paper at an angle.

8.2

DRAWING THE WHOLE. The main forms of the model, drawn with a 2B pencil, are based on a very simple diagram. The goal of this stage is for the beginner to understand the importance of working the "whole," (the overall drawing) and paying attention to the shading and details.

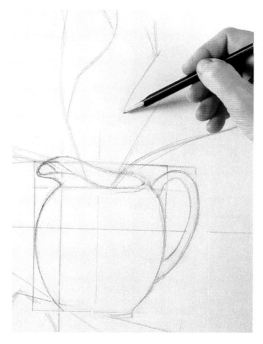

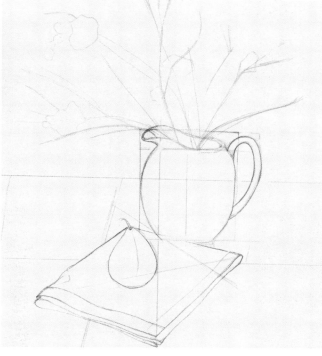

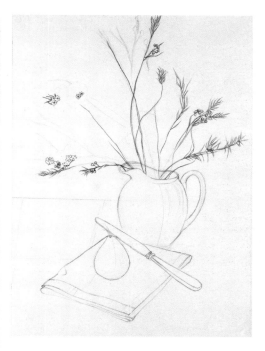

Notice this simple approach to the outlines of the objects and the bouquet's main branches,. New lines are superimposed on the previous ones to provide a first look at the whole. Draw these lines very cleanly to avoid confusion later.

A solid preliminary sketch reinforces the drawing, which becomes surer as you define more parts. This way, it is much easier to indicate the definitive lines of the pitcher, the napkin, and the pear over the preliminary diagram. The stems of the bouquet are also sketched out in this phase.

Redefine the structure of the bouquet by darkening the lines. Use the diagonal edge of the napkin to define the placement of the knife. Once the compositional and structural lines are no longer needed, you can easily remove them with an eraser.

Some professional artists superimpose several lines on the same outline when they draw. A final revision will tell you which version will be the definitive one; highlight it with a heavier and more intense line.

33

8.3

DEFINING THE PARTS. Now is the time to add the details. Draw them with precision, paying attention to each one of the model's parts: the reflections on the metal, the shaded areas, the foliage, the bouquet's flowers, and the folds of the tablecloth. In this phase, lines are intensified and shaded areas take a more important role in the drawing.

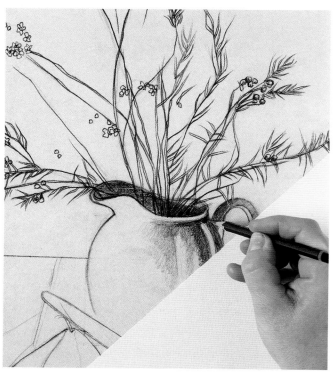

From this point on you should use a 4B graphite pencil. Draw the flowers and the leaves in more detail and apply the first areas of shading. Use a sheet of paper as protection to prevent the drawing surface from becoming smudged as you rub your hand on it.

As you progress, draw darker lines each time to de-emphasize the earlier lines that served as guides. Continue the gray shading of the pitcher on the knife and the pear to give them a sense of volume. Apply the shading very lightly so no lines are apparent.

Cover the drawing's background with light shading. Do not press too hard on the paper because the idea is to eliminate these lines by rubbing lightly with a blending stick. Draw the shadows projected on the table with evenly applied gray shading; draw the outlines with a very light line.

Learn to draw volume with a graphite pencil, barely applying pressure on the pencil. This enables you to create very soft modeling without visible lines.

It is also important to practice creating gradations with graphite. This skill will be handy when you paint the model's background.

When you get to this point, you may consider the drawing to be complete; the most important areas of the still life are finished. All that is left is to darken the background, which is between and behind the flowers. For consistency, the projected shadows must be darkened with new shading and the folds of the cloth that covers the table must be better defined. Drawing by Almudena Carreño.

In this final stage, complete the background with very soft shading. Work with a pencil whose point is flat and worn so the graphite can be rubbed and extended over the paper evenly.

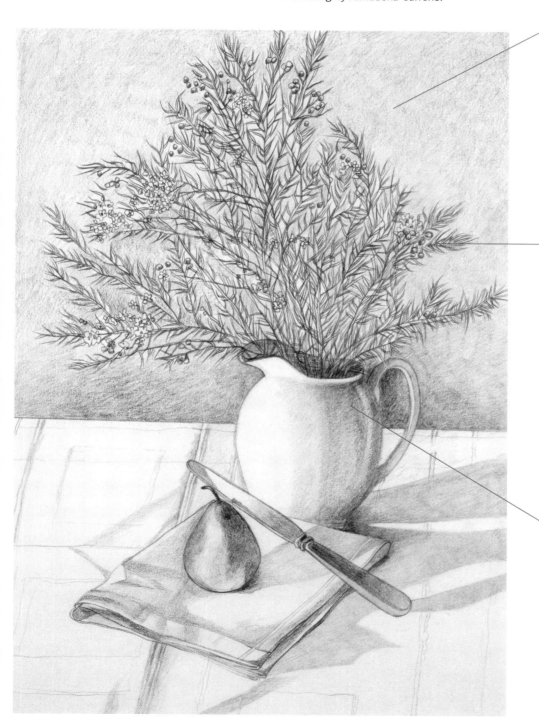

Notice how the details evolve through the process of drawing: The darker the background that surrounds the bouquet, the darker the lines will be that define the leaves and the flowers.

The gradated areas convey a feeling of volume to the objects. Here, a soft gradation defines the pitcher's roundness and its soft and shiny texture.

CHOOSING INTERESTING COMPOSITIONS. Often, you will come across discordant elements that distract you from the main subject and that do not add anything interesting to the drawing. One way to find new, interesting approaches is to use a frame, which you can make yourself using two pieces of mat board, each cut in the shape of an L.

This view of a group of houses has a composition that is excessively monotonous, too static, and without interest.

A vertical layout emphasizes the shapes of the buildings much more, even when some of the façades are cut out.

Although this is a centered and balanced composition, the position of the frame provides greater interest than the original layout, emphasizing the vertical effect of the buildings.

Another way to add interest is to choose a horizontal layout that is based on the upper part of the drawing.

COMPOSITION. Any composition is in some way a selective representation of a theme. Each image is a unique observation and conveys a personal point of view. Drawing sketches offers different ways for selecting a layout and lets you try out different possibilities. Shown below are the most common ones.

EXCLUDING CERTAIN PARTS OF THE DRAWING. There is no rule that dictates the inclusion of an element in a drawing just because it's there. If for compositional or other reasons you need to cut off part of the model or eliminate some elements, you should not hesitate to do so.

Here the artist has chosen a composition that includes only the small church and excludes all the other elements.

In this new composition, part of the small church has been cut off to include the cypress trees on the right.

BALANCING OUT EMPTY SPACES.
Nontraditional artists often use compositions that are off center and out of balance. They play off the area occupied by the model against an empty space that acts as a counterbalance. The resulting spatial tension adds great interest.

A new composition directs the viewer's attention toward the ground, creating a dialogue between the empty space of the ground and the architectural features of the church's facade.

Sometimes, as you draw a subject, you may realize that you are only interested in part of it. If this happens, you must select a new composition and improvise the rest. From this point you can

This vertical format places the model at the bottom of the composition, while the top area is left empty, covered with only a simple gradation.

When drawing, you do not necessarily have to accept the model as you see it. The most important thing is to study it and emphasize some aspects of the subject, minimize others, and eliminate those that are altogether irrelevant.

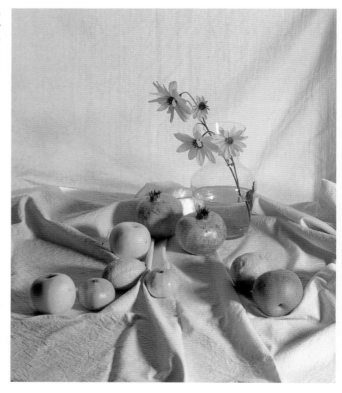

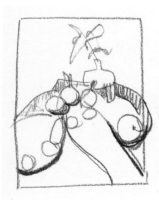

When you analyze the drawing you may notice that the pieces of fruit are all in a line. In this sketch the layout crops the subject, resulting in this composition. The fruit is placed along a curved line, forming arabesques.

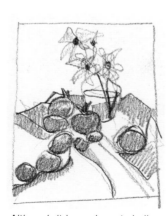

Although it has a layout similar to that of the previous one, this sketch focuses on an analysis of light and shadow, marking the darkest areas with gray shading.

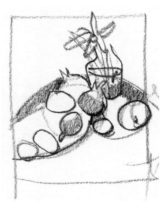

This sketch is yet another study of compositional elements. To create variations, the artist simply shaded several pieces of fruit and reinforced the tablecloth's folds with shaded areas. However, the shading is too fragmented and dispersed.

After a final study, it looks like this is going to be the definitive layout. The fruit is placed along the two compositional curves. The pitcher with the flowers breaks up the symmetry because it is located somewhat to the right, and the bottom part is drawn as an empty space.

ANALYZING COMPOSITION AND LAYOUT. In essence, a drawing's composition and layout make reference to the artist's attitude toward the model—to the way he or she sees the subject, chooses its most interesting parts, and organizes and combines all the elements that form part of the work. Therefore, it is a good idea to make many preliminary studies to experiment with the formal disposition of the model.

From the previous sketches, the artist arrived at a synthesis of the model interpreted with basic lines, respecting the order of the objects placed on the table while slightly modifying their distribution and size.

A DIFFERENT LAYOUT. There are some traditional compositional layouts that should not be disregarded, but it is also very interesting to interpret some fragments of a scene from a personal perspective. This is the approach of the following exercise. This layout, instead of concentrating on the view from the balcony, which would be the conventional approach, focuses instead on the effects that the light creates on the room's floor. The interior is drawn with sanguine chalk, which is applied the same way as charcoal, but it adheres to the paper better.

9.1

THE INTERIOR SPACE. The choice of layout, the absence of furniture, and the perspective view of the floor tiles make it easy to represent this interior scene with a simple perspective sketch.

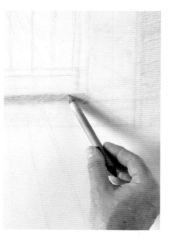

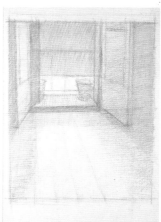

The first step in drawing an interior is to draw a sketch in perspective. After you have placed the horizontal line very close to the top margin of the drawing, draw the perspective lines, which allow you to draw the floor tiles. Then draw the frame of the balcony and the doors.

Cover the back wall and the doors with light shading. The pressure applied with the sanguine, whether in stick or pencil form, should be minimal. Avoid hatching to make blending easier later. You will do this by rubbing lightly with a blending stick.

In its early stages the drawing should have even, homogeneous tones. The lines should be very light, barely standing out against the shading. Here, only the lighted areas are left uncovered: the doors, the panes of glass, the bottom part of the composition, and the floor.

It is possible to draw with the blending stick when it is very full of sanguine. In some cases, it is employed as a useful drawing tool that creates very soft shading.

Create the preliminary drawing and the initial shading by drawing softly with the tip of the pencil or the sanguine chalk. The tool should barely touch the surface of the paper when shading so your marks will be very light.

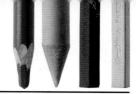

9.2

SHADING AND MODELING. The technique of modeling with sanguine is based mainly on tonal gradation and blending. It is important to pay attention to light and reflections, because they differentiate the planes and spaces of the interior.

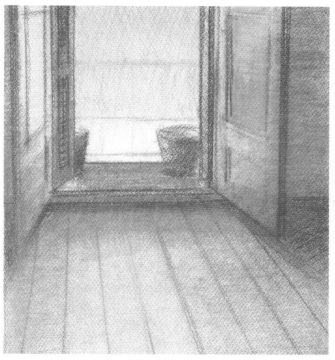

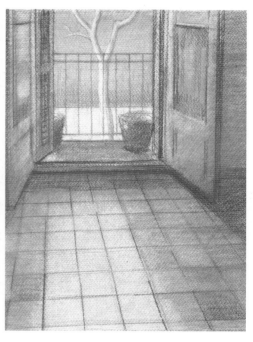

Darken the previous shading slowly and progressively, leaving the most illuminated areas blank. Then, to integrate the light areas with the shaded ones, rub the entire surface of the paper with the side of the blending stick to remove the boundaries between areas of light and shadow and cover any spots of the paper that may have been left uncovered.

When the first values are completely developed, begin to plan the intermediate tones, work the gradated areas of the floor, and darken the outlines of the doors. Work on the background wall, where the shadows need to be intensified with the sanguine stick.

Draw the lines of the balcony, the railing, and the doorframe and darken the lines of the floor tiles. With a sanguine pencil, draw the tree in the background, which stands out thanks to the shading around it. The modeling does not look heavy, but instead is light and atmospheric, a result of the tone of sanguine.

To create diffused shading, first apply shading with sanguine. Then, rub this shaded area with the blending stick to make it denser and more diffuse.

9.3

DRAWING THE ORNAMENTAL ELEMENTS. Once the tonal values have been resolved, the final phase consists of clarifying the details, including the ornamental elements of the railing and the pattern of the floor tiles.

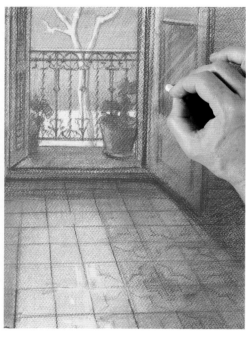

Emphasize contrasts by shading and outlining the dark areas with a sanguine pencil. Touch up the tree's outline and finish the flowerpots on the balcony, which are silhouetted against the light, with very dense shading and hatching. Rest your hand on a sheet of paper to avoid getting the drawing dirty when you rub your hand against it.

With the tip of the chalk stick, draw the ornamental motifs of the floor tile. It is not necessary to completely draw the tiles; it is sufficient to outline a few of them with sketched lines, applying very light pressure. In this case, it is more interesting to suggest the remaining tiles than to draw them in detail.

Use the white chalk to create the most important highlights to the doorframe and the windowpanes. They will stand out dramatically because you have covered the entire surface of the paper with light sanguine color during the drawing process. Using the tip of the chalk produces more intense highlights.

Detail the ornamental motifs of the iron railing with the tip of the sanguine stick. It is important to pay attention to the model in order to replicate its forms correctly.

Do not touch up the drawing or work the details too much. A quick drawing that leaves some areas unfinished gives the work a freshness that is lost when the drawing is too finished.

Darken the outlines that you wish to emphasize. This treatment only works when it is very carefully placed and does not extend indiscriminately over the entire drawing.

The success of sanguine resides in the warmth and softness that it brings to the drawing. Additionally, it is a medium that is easy to control and creates rich tonal gradations. A very convincing drawing of an interior theme that is based on the contrast of light and shadow can be achieved by alternating three or four values. Drawing by Carlant.

A few parallel lines are enough to describe the texture of the glass. Work done with white chalk has to be very well thought out; if too many highlights are applied they will lack relevance.

The effect of light coming from the street is created through contrast. This makes the lighter tones, when placed next to darker ones, appear much lighter.

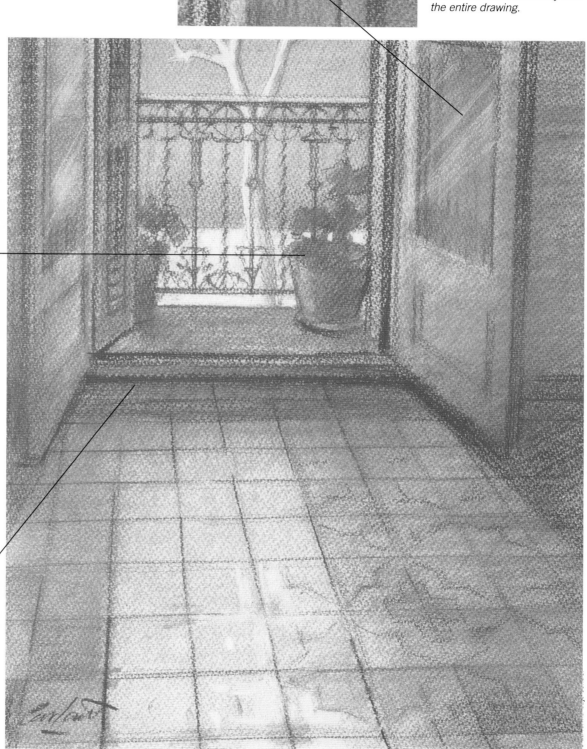

THE GEOMETRIC APPROACH. When you draw an object from a model, sometimes you have to simulate the depth that the eye sees by using intuitive perspective or some geometric method. You should become familiar with the graphic language used to geometrically represent three-dimensional forms in different projection systems, and their application in sketches and freehand perspective drawings.

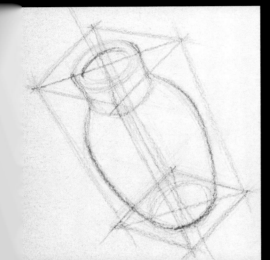

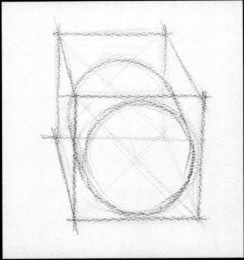

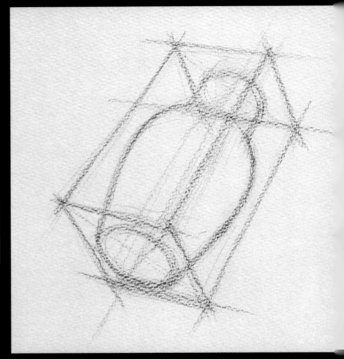

If you have difficulty drawing a tilted object with obvious perspective or foreshortening effects, it is best to draw it in a box. By using this box as a guide, you can draw the object from any angle.

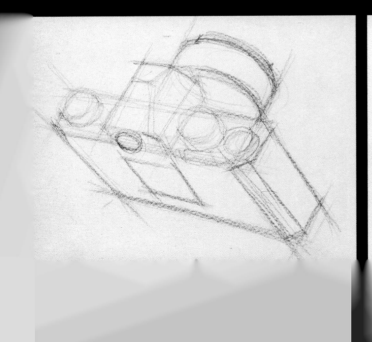

This imaginary box defines and synthesizes the three-dimensional effect of the object. Changing the point of view and rotating the box will allow you to draw the object without ever losing the perspective effect.

FORESHORTENING. This is the influence of the perspective effect on an object that extends directly toward the viewer. It creates a very evident contrast in scale between the object's closest and farthest parts. It can be seen in the way of representing an object so that it is arranged perpendicular and angled in respect to the viewer.

OVERSCALED PARTS. The art of foreshortening consists of representing an object from a point of view so that its dimensions are modified by the perspective. Such effects require the artist to enlarge forms nearest the viewer to accentuate the effect of perspective on the model.

Foreshortening alters the proportional relationships of an object. The part of a foreshortened sweater that is closest to you will be overscaled; in this case the sleeve, altered by perspective, looks larger than the rest of the sweater.

The same thing happens to a tree that has a branch that visually advances toward the viewer. Knowing this, you should enlarge the branch in relation to the rest of the tree.

In drawings of the human figure it is typical to encounter foreshortening in some parts of the body. Usually a leg or an arm will look too large or deformed, giving the impression that it is moving toward the viewer.

In shading this Cubist model you can use flat shading or create tonal gradations to make small volumetric fragments that impart a spectacular effect to the composition.

To fragment the image, it is important to destroy the continuity of the object's outlines, for example, by making cuts or by rearranging its parts as if they were autonomous and could move by themselves.

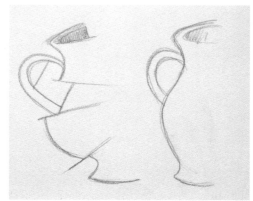

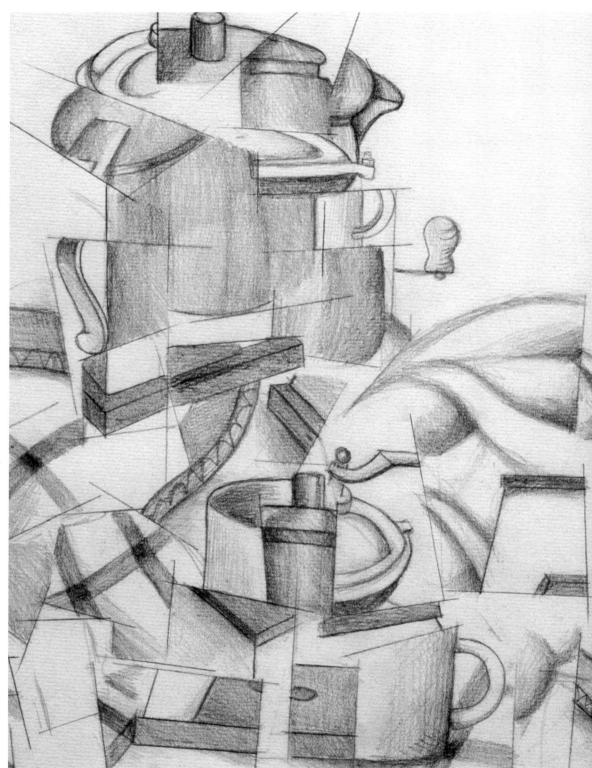

SIMULTANEOUS POINTS OF VIEW. The eye is not static; it is constantly in motion and moves unconsciously from one part of the scene to another to focus on a small area with each movement. Therefore, in drawing it is important to "see around the object" in order to better understand the model. This idea caused Picasso to simultaneously incorporate several points of view of a model in one drawing. This is how Cubism was born.

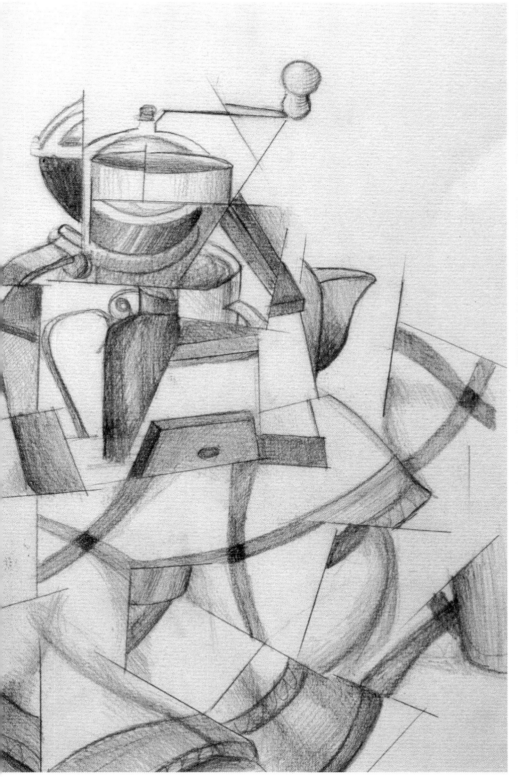

Cubism is based on the incorporation of several overlapping points of view of the same model. To understand how this works, draw the same quadrangular form from two different viewpoints. Then, overlay the two drawings.

Fuse the two geometric forms, altering some of their shapes.

Shade them in any way you wish. The result is a Cubist form.

Cubism creates a fragmented and dynamic view of the subject, like a puzzle in which each piece takes on a life of its own.

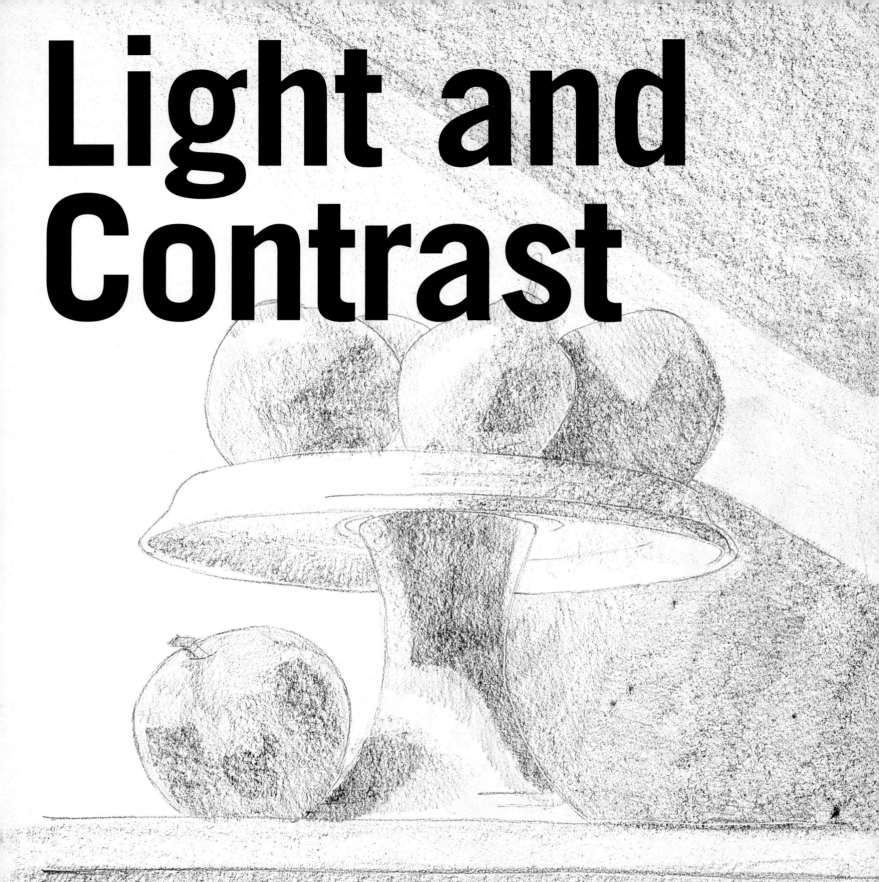

Light and Contrast

The line is the clearest and most descriptive element in a drawing. Everything can be defined with the utmost precision using lines, and it is no surprise that architects, engineers, topographers, and other professionals who plan, design, and represent aspects of reality always work with lines. But there is one thing that a line cannot define, at least completely: light. To represent light and its opposite, shadow, something more than line is required: shading, tones, and contrasts between the light parts and the dark parts.

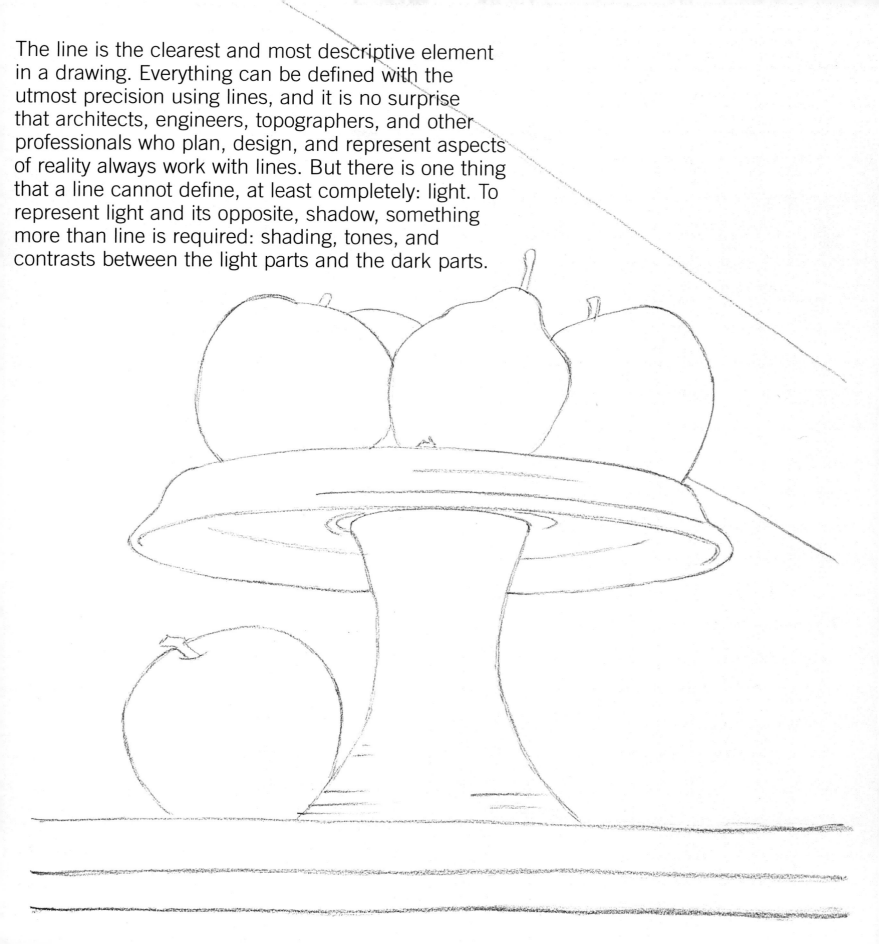

DRAWING SHADOWS. You are going to draw an urban subject, starting by structuring its shadows with vine charcoal. In this exercise you will make a detailed study of light and tonal values. It is very important to lay the drawing out perfectly before beginning its definitive resolution. The reflections and lightest areas must be reserved; that is, from the beginning the paper must be left white and untouched where the brightly lit areas are.

10.1

OUTLINING THE ZONES. The basic sketch of the model is easy to make; first, draw the subject with the point of the charcoal to create an approximate form. Then, color the shaded wall of the building with the flat side of the stick. After lightly blending with your hand, you have finished the layout of the subject.

Make the framework of the drawing using the point of the charcoal. With just a few lightly drawn lines, indicate the outline of the building. This stage of the drawing requires special attention, since all later steps will be based on the results of this one.

Cover the wall with shading using the side of the charcoal stick. Apply even pressure without making lines on the paper; remember that sometimes vine charcoal has a grain that does not make a mark but will scratch.

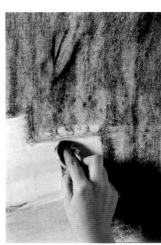

If the tone you obtain by softly rubbing the charcoal like this is still light, you can apply successive layers, rubbing it each time until you achieve the desired tone. Next, mark the outlines of the illuminated façades with a kneaded eraser to create more contrast.

This is the best way to hold the charcoal stick when making your line sketch.

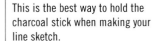

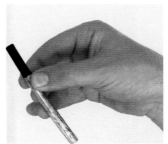

Your fingertips should be covered with charcoal dust. This way, when you begin blending you will not remove the powder already deposited on the paper, but will spread it on the paper as desired.

10.2

MODELING WITH THE HAND. When the paper is covered with pigment it can be modeled with your fingers, which are able to easily pick up the charcoal dust. This technique makes it possible to use your hands to reduce or grade tones at any time.

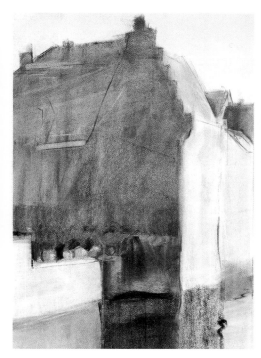

Once the façade is shaded, wipe it lightly with your hand to make the shading more even and eliminate any traces of lines. The area of the illuminated roof also looks shaded and blended, but with a much lighter gray.

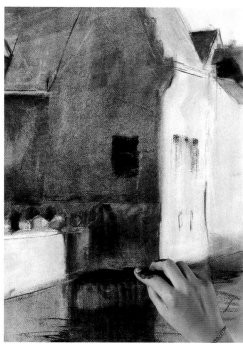

In a charcoal work, there are always fine outlines, thin, light, linear marks on the roof or contrasting spaces at the base of the building that indicate reflections on the surface of the water. These lines are made with a stick of vine charcoal with a sharp point.

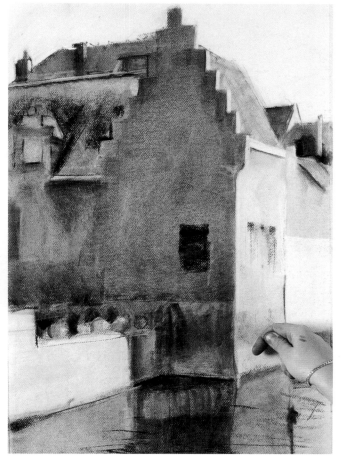

Now, blend the shading on the illuminated façade, barely rubbing with the side of your finger. Wipe your fingers very lightly over the charcoal powder on the paper to spread it without removing it.

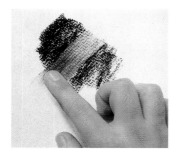

If you apply a lot of pressure with your finger on the drawing surface, you will wipe away the charcoal dust. You can avoid this danger by working very lightly.

10.3

DETAILS AND ERASING. At this stage, the cotton rag and the kneaded eraser become very important. These tools, which can do so many things, are perfect complements for charcoal drawing.

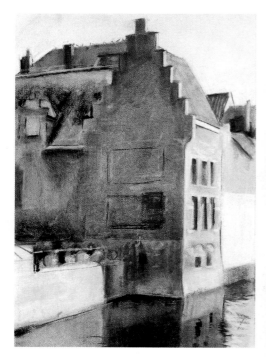

Draw the darkest shadows of the windows and the reflection projected on the water with the point of the vine charcoal. Then draw new lines on the shaded area to mark the locations of some of the windows. Apply these lines lightly.

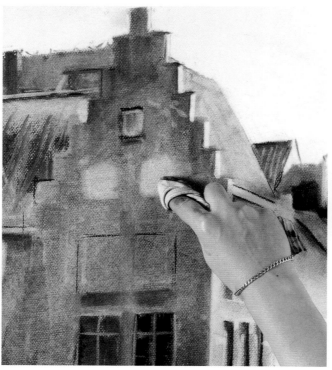

Lighten the upper windows of the façade. Vine charcoal is very unstable and easy to erase. Just rub the areas that you wish to correct with a clean rag so that the charcoal dust is removed.

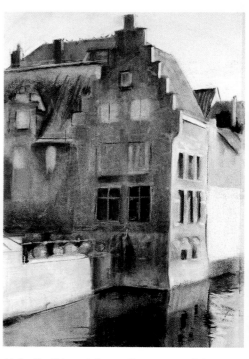

Make the thinnest lines with a corner of the eraser. All that is left to do is to draw an occasional line with a stick of compressed charcoal to sharpen the forms of the windows and the roof.

It is easier to remove charcoal powder with a cotton rag if it is not overworked; if it is, no matter how hard you rub you will not be able to remove the layer of pigment.

A blending stick can be used on small areas that are too small to rub with a finger.

The final result is a work containing the basic characteristics of a charcoal drawing: meticulous blending with the hands and a cotton rag to model the volumes, dark tones made with repeated applications of charcoal, and highlights made with the eraser. Drawn by Mercedes Gaspar.

It is not necessary to completely draw the windows when drawing building façades; they can simply be indicated. Often a suggestion is more interesting than a detailed drawing.

Use an eraser for small spaces, making outlines, highlighting, and drawing light areas.

The reflections of a body in water are always vertical, with zigzag outlines and darker tones than the actual object.

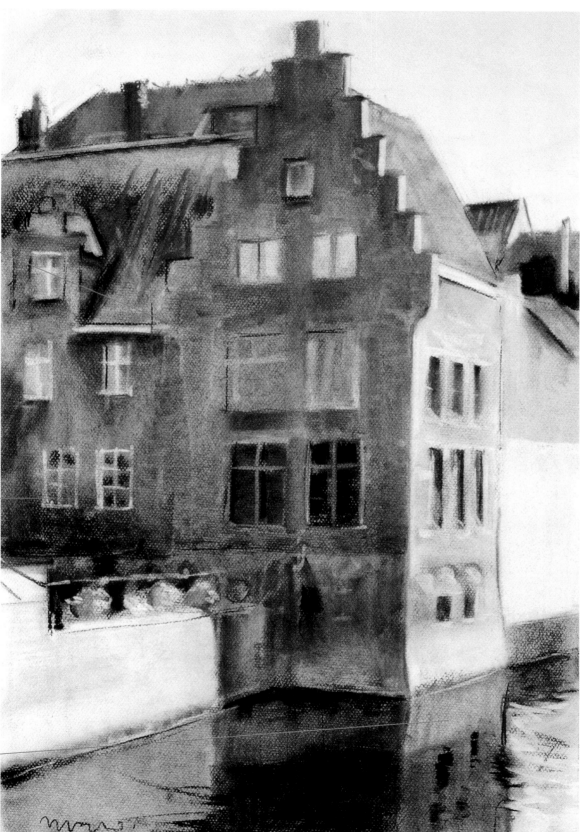

BLOCK SHADING. This exercise is a good way to learn the technique of shading. By juxtaposing areas with different flat tones you can represent changes in light and volume in a simple and direct way.

11.1

PREPARATION. Choose some simple elements; for example, a fruit stand with an assortment of fruit. It is important to combine objects of different colors to see how color can be translated into a range of grays. Once you have arranged the objects on a shelf with a neutral background, adjust the direction of the light and decide on the framing of the subject.

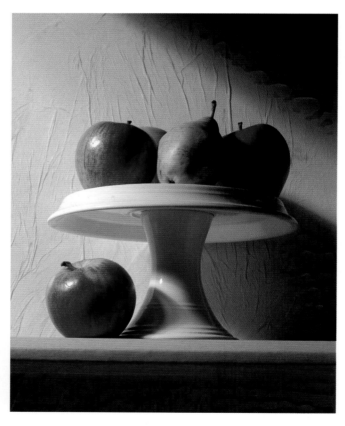

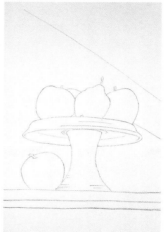

Lay out the sketch with lines before doing the shading.

The first step is to clearly differentiate the illuminated areas from the shaded ones. Use the side of a stick of black chalk to create the shading.

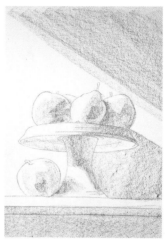

Add a second value, pressing harder on the paper with the side of the chalk stick. This allows you to differentiate two gray tones.

When one gray tone is laid over a previous one it darkens the original gray and reduces the visible texture of the paper.

It is a good idea to rub your chalk sticks on a separate piece of paper first; if you do not do this, your strokes may be streaky and broken and negatively affect the final drawing. The shading should always be uniform.

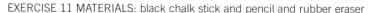

11.2

INCREASING CONTRAST. Strong tonal contrasts define the forms and focus attention on them. Contrasts are created where two differently illuminated areas come into contact; this makes it possible to differentiate the planes based on their position relative to the light source.

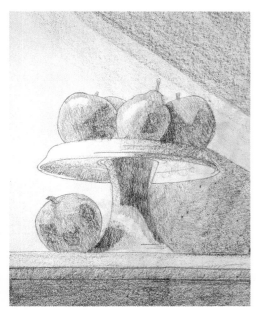

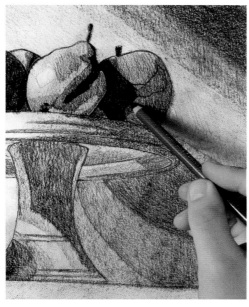

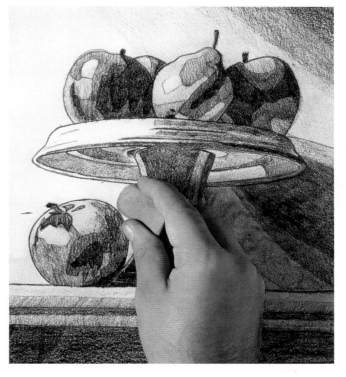

If you apply a third value to the previous drawing, progressively increasing the pressure on the side of the chalk stick, you will create a drawing in which the shadows look very synthesized. Although the contrast still is not enough, it is already possible to notice a clear volumetric effect.

Now use a sharpened soft chalk pencil to shade the darkest areas with nearly pure black. This creates a contrast with the range of intermediate tones that you previously applied. Remember that the shaded areas should be clearly separated from each other.

The less light that shines on different areas of the still life, the darker they will be. You can increase the contrast where you think it is needed by lightening the illuminated parts with a rubber eraser.

When you draw the medium tones and the darker shadows, it is good not to press too hard on the paper. This protects the grain, which many artists feel is attractive.

The success of a well-drawn outline often resides in covering the background that surrounds the model with dark shading. The objective is to emphasize the shapes through tonal contrast.

THE VALUE SCALE. Making gray scales with different techniques is a method many beginners use to master a wide range of values. The more shading a subject has, the greater the distance between the black and the white; that is, it will contain a larger number of different values.

It is a good idea to practice wide tonal ranges to guarantee the quality of shading in your drawings.

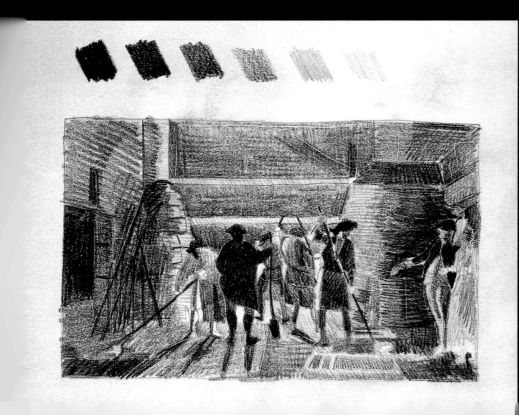

The original painting Visit to the Foundry, *by Léonard Defrance (Valón Art Museum, Liège, Belgium), has been reduced to a monochrome study consisting of six values.*

VALUES. Up until now we have used various terms, such as gradation, intensity, and tone, when referring to light and shadow. All these words make reference to the same visible reality: the different appearance of light and shadows in a drawing, with some areas seeming lighter and others darker. From now on, to avoid confusion, we will use a single concept value. A shaded drawing is composed of different values and each one of them represents a degree of light or shadow.

To illustrate the previous explanation it is a good idea to make some abstract compositions, based on sketches, that only take into consideration the areas of middle tone and shadows. Your approach should be very geometric and without any details. Let's look at some examples.

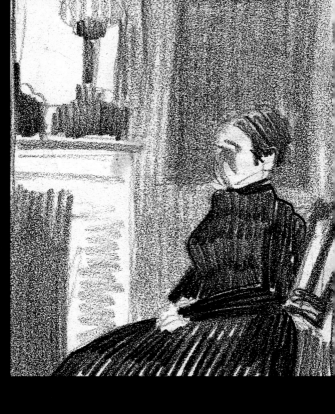

An ideal exercise consists of drawing different chiaroscuro values of the forms that surround the model without using any lines. The tone or shading should simply follow the outline of the body.

Here is a series of values made with graphite and sanguine. Among these samples are several intensities of tone that will help you evaluate the hardness and quality of the media. When making a drawing it is a good idea to alternate among leads of different hardnesses.

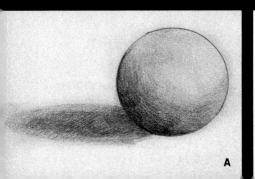

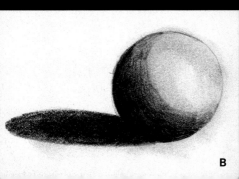

A **B**

Once you are clear about the concept of value you can attempt simple exercises like this one, which consists of creating the effect of relief on a sphere by adding shading. The first step is to make the sphere gray and project the shadow with light and flat shading. In the second step, darken the shadows that indicate the outline of a crescent on the sphere and an ellipse on the projected shadow.

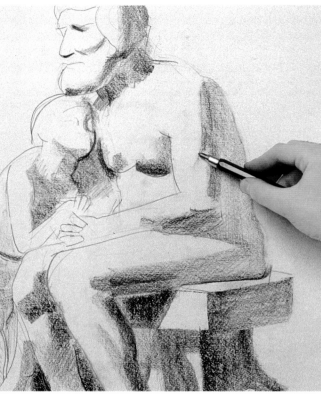

Tones, like many other aspects of a drawing, have a greater effect if they are simplified. Think in terms of three main values: dark, medium, and light.

You should make the first lines of shading with a pencil or graphite lead. Use parallel lines set at a 45-degree angle; the distance between them will determine the darkness of the tone.

With the side of the lead, darken the initial shadows more and emphasize the most important ones.

It is possible to alternate among various media in the same drawing to achieve different gradations of gray. Sticks always make very uniform, but less dark, values.

THE TONAL RANGE OF A DRAWING. When drawing from life, you must ascertain the source and direction of the light as well as the extension and distribution of the shadows and the key general tone of the subject.

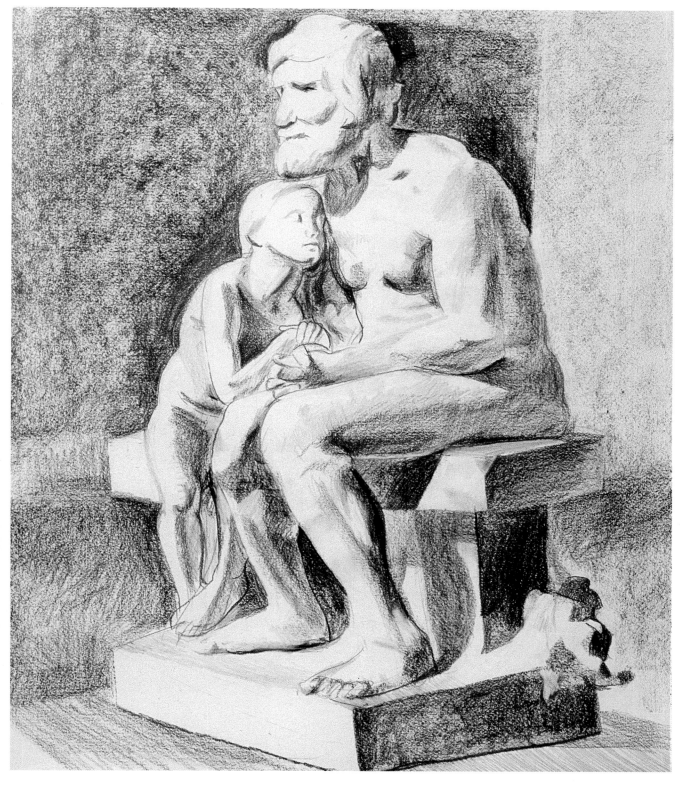

The tone is based on variations of light and darkness in the drawing, and suggests the three-dimensionality of the model. With most media, variations in tone are achieved by changing the pressure applied to the paper.

GRADATIONS. In the following exercise, you are going to practice gradating. You will draw a subject using only gradations, without resorting to flat shading, since all shadows will consist of decreasing tones. The base of the gradated stroke will be drawn with lines that begin with a dark tone and gradually become lighter until they disappear into the white of the paper. You will use a pair of blue oil-base pencils, one light and the other dark, to do this exercise.

12.1

A VERY LIGHT LINE. As always, the first stage consists of sketching the subject with light lines that set up the composition and become the basis of the drawing. The result must be a very clean and linear drawing that will act as a guide and that can be easily shaded and gradated.

We draw the model with the light blue pencil, using simplified geometric forms. You should hold the pencil in the middle to obtain a light, fluid line. In this first step you will only draw the most basic lines. These form the infrastructure of the buildings and the planes that comprise the mountains in the background.

Redraw all the lines with the darker pencil. This ensures the correction of the initial sketch with new, darker lines that will be visible during the entire development of the drawing. As you draw, adjust the form to match the model and add architectural details.

When sketching with oil-base pencils, it is a good idea not to press too hard, since they are very hard to erase in case of an error.

12.2

GRADING THE MOUNTAINS. Apply the first gradations to the mountains to convey the effect of distance. Begin with darker gradations at the lowest part, making them flatter and more unfocused as they move away from the foreground.

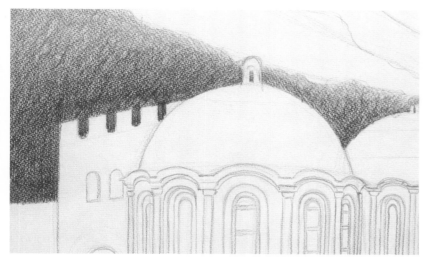

The two most distant planes are the lightest and least defined. For this you must use the light pencil again, making two new gradations with the same technique as you used for the previous plane. On the last mountain, make the lines looser so they spill into the sky to break up the edge of the mountain and integrate it into the atmosphere.

Start by grading the shape of the mountain closest to the viewer. First, draw the outline of the building with a uniform, dark blue tone. Grade up to the upper outline of the mountain, so that the lightest shading is at this edge.

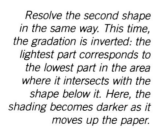

Resolve the second shape in the same way. This time, the gradation is inverted: the lightest part corresponds to the lowest part in the area where it intersects with the shape below it. Here, the shading becomes darker as it moves up the paper.

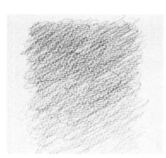

The gradations of the mountains in the foreground show a succession of short, overlaid lines going in the same direction.

61

12.3

ARCHITECTURAL GRADATION. As you move on to the foreground the gradation is more precise, since it must combine with more definite lines and architectural details. Here, gradations help explain the architecture by emphasizing each one of its details without sacrificing the volumetric effect.

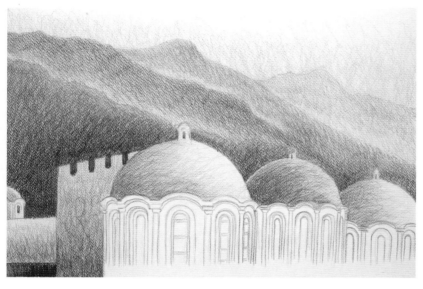

Continue grading the tower and the roof on the left very lightly. The lightest area will be in the upper part so it will contrast with the darkness of the mountains. Work on the hemispherical forms of the cupolas, whose success depends on your ability to control the pressure of the pencil as you gradually color from the darkest tone to the next-lightest one.

Very carefully, since the area you wish to grade is so small, color the undersides of the arches, leaving the columns and the windows to be colored later. It is a matter of controlling the darkness of the line and the density of the hatching.

Apply the darkest tones to the parts of the shadow that are between the cupola's columns. Pressing the sharpened pencil harder to make darker lines, color the curves of the roof and the tower's openings.

Among tonal values, white is the lightest tone and a very important reference value. Try to leave the white of the paper free of color to represent this value in the proper areas.

Architectural gradation often employs cross-hatching to give the foreground more solidity.

Apply a succession of light, wide, well-spaced lines with the light blue pencil to integrate the outline of the mountains with the sky in the background. This effect produces a hazy, atmospheric feeling around the last mountain shape.

The direction of the lines should always enclose the volume of the surface that they describe. The lines are curved on a spherical surface.

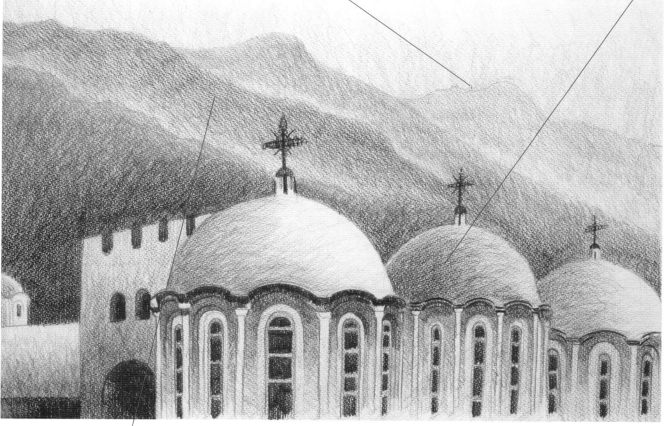

The last step of the drawing consists of detailing the architecture in the foreground, coloring the windows, drawing the crosses, and outlining the tonal effect of the columns. It is a matter of working the elements more with graded values than with pure lines. Drawn by Gabriel Martín.

To illustrate the edges of the mountains, leave small, light graded areas that let the white of the paper show through, differentiating each plane.

THE EFFECT OF VOLUME. The two-dimensional representation of a three-dimensional model is initially an image in the brain; it is later defined on paper with a series of lines that indicate its silhouette and its main divisions. This is achieved by increasing the contrast between illuminated and shaded areas and combining them with a modeling effect that is more abrupt than usual.

13.1

PLANNING AND LINE DRAWINGS. Before you work with the shading, which is the aspect that creates the effect of three-dimensionality, make a line sketch of the model so that you can apply the shadows to a correctly constructed scheme.

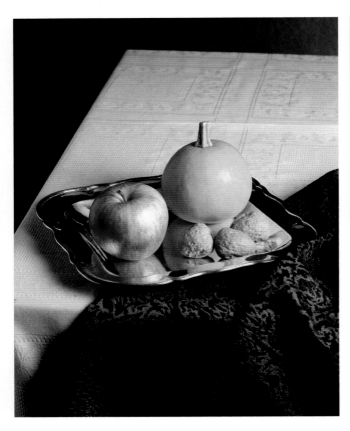

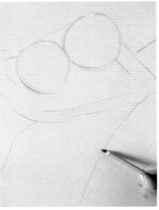

Make an initial sketch of the model with general, linear strokes using a sepia chalk pencil. Your hand should move across the paper with lightness and agility.

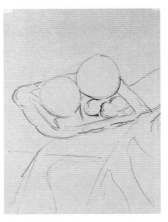

Synthesize the forms and the folds of the cloth, as well as the placement of fruit on the tray. These lines should be darker and more specific.

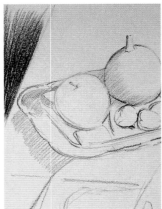

Once the drawing is completely worked out, add the first shading. The light source is to the right, so you should begin by drawing the shadows on the left side.

If you try working on a sheet of colored paper instead of a white one, you will find it easier to apply the tones because you will be able to work as well with white chalk as with sepia.

13.2

SHADING THE CLOTHS. Drawing the drapery constitutes a true exercise in seeing because of the complicated shading of its folds. The drapery's function is not just anecdotal; it is a formal counterpoint that helps harmonize and emphasize the still life, adding, if necessary, a note of contrast to enliven the composition.

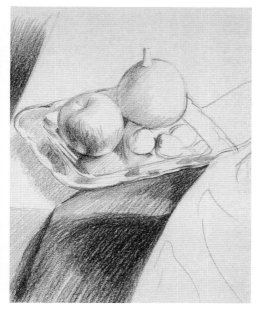

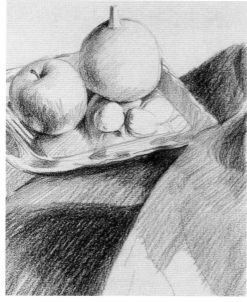

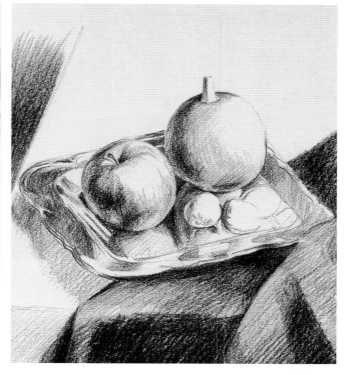

The first piece of cloth seems smooth, with hardly any wrinkles, but it indicates an important fold at the side of the table. Here, begin applying dark grays on the top part; the grays should become lighter as they approach the edge of the table. Draw a separating line there from which you again use dark shading that fades as it moves down the paper.

Do the same thing with the next piece, although this time you will follow a more irregular line. Using a dark sepia, outline the tray, making it lighter as you move away from it. The fold and the fall of the cloth are colored with a medium shading that lets the tone of the paper show through.

The folds are straight lines. Draw them by using the contrast between light and dark areas. From there, the tonal value fades. The key to drawing folds is to notice their structure and not forget the direction of the fabric: heavy curves and pleats that fall diagonally.

If you observe the drapery and folds of clothing in isolation, you can look at them as an abstract composition.

One practical exercise consists of making a sketch of whatever piece of cloth is at hand. This will show you that all fabrics have different folds and varied textures.

13.3

CONSTRUCTING VOLUME. Now you will try a study of light and shadow using a grouping of fruit. You will establish the different tones so that the forms are modeled beginning with a flat representation and finishing with a three-dimensional effect.

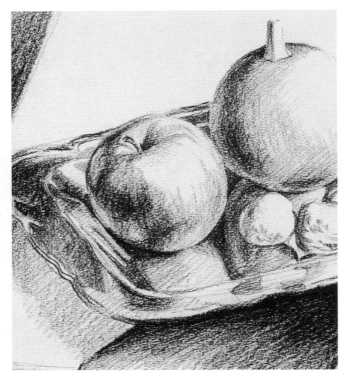

Darken the shading on the left side of the fruit with new applications of chalk. Darken the tray with graded strokes that leave open small areas where the color of the paper can be seen. Draw the reflection of the fruit on the metal tray. The reflection is always darker than the real model.

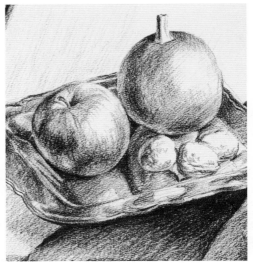

The best way to model fruit is by creating light gradations that move from the darkest area to the lightest that the paper allows. To avoid too many tonal jumps, work the apple and the squash very lightly with the sepia chalk, caressing the paper with the point of the chalk.

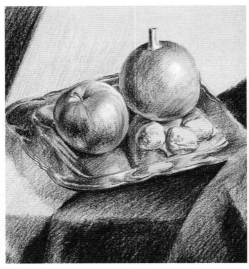

Add the highlights to the fruit with white chalk so that the contrasts between light and dark tones are maximized. Highlights can take the form of a reflected point on the squash or can be created with smooth transitions of tone that are integrated in the underlying shadows.

The direction in which you apply shading should not be random, but should follow the volume of the object. The application is circular in the case of a spherical object, curved on a curved object, and straight on a flat object.

It is easy to create false contrasts, by adding highlights where on the model there is only shadow, so that the shape of the apple is not confusing and can be drawn with greater clarity.

After the shading and the white highlights are finished, you can see how the artist created a successful value study of the subject, achieving a level of modeling that shows the objects in all their volume and relief. We can say that the artist models by imitating in two dimensions what the sculptor imitates in three. Drawn by Óscar Sanchís.

When you draw on colored paper it is important to experiment with the color that it adds. If you leave large spaces untouched, you allow the forms to be clearly perceived and offer a more linear finsh to the three-dimensional effect.

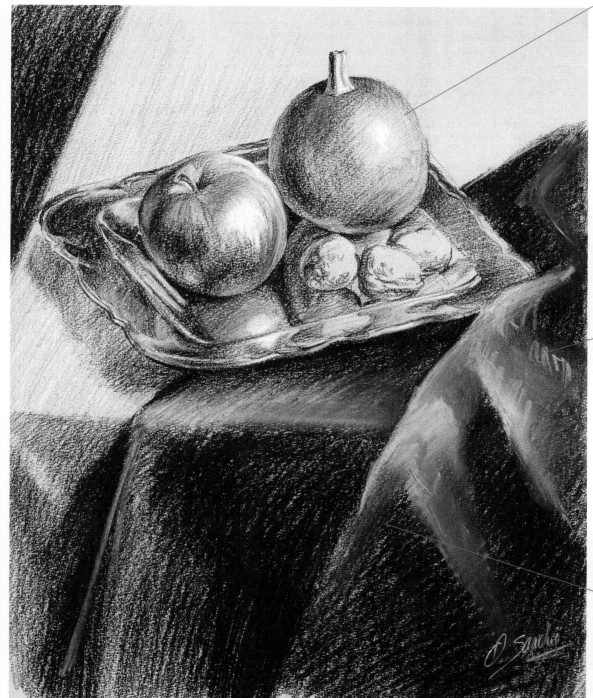

The applications of white chalk on the cloth appear blended and integrated with the shading. This way the transitions in tone are softer and contribute to the description of the delicate texture of the fabric.

The intention, density, and direction of the line varies according to the part of the cloth being drawn.

CONTOUR LINES. Lines should always explain the form of the object. If they are oriented in the same direction as the surface of the object, they will emphasize its volumetric effect.

Apply shading in the form of spiral lines that wrap around the bottle. Simple shading with circular lines is enough to suggest the physicality of the object.

If you continue using contour lines to create several values you can create a softer effect around the silhouette of the object, adding, without really trying, a kinetic, spinning effect to the model.

THE DIRECTION OF THE SHADOW. In your drawing it is a good idea to emphasize the effects of light that you observe, and even to exaggerate them. You can also indicate the direction of the shadow.

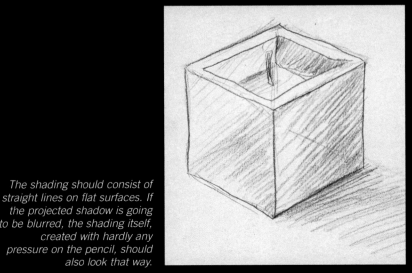

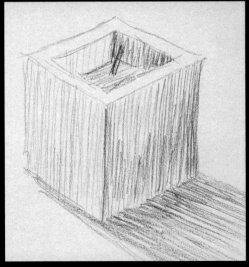

The shading should consist of straight lines on flat surfaces. If the projected shadow is going to be blurred, the shading itself, created with hardly any pressure on the pencil, should also look that way.

However, if you wish to give importance to the shadow projected by the object, giving it more strength and relevance, you should make the lines darker and emphasize their direction.

Since light is a medium without substance, you must carefully analyze the effects it produces or investigate the possibilities offered by drawing materials to illustrate them. When these changes may create a modeling effect that helps to convey the volume of an object.

MODELING SPHERICAL FORMS. Shadows cast by objects, and those that describe a change of plane, especially when dealing with a rigid surface, usually have very defined outlines. On the other hand, spherical forms, soft materials, and textures with little relief project more subtle light and shadows.

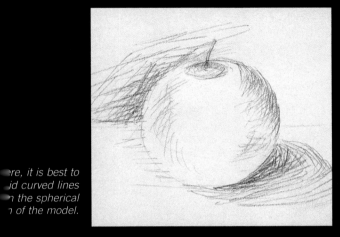

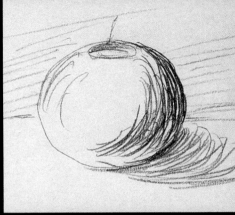

...re, it is best to
...id curved lines
... the spherical
... of the model.

*Line is very im...
graphic vocab...
because it def...
and, above all,...
establishes a s...
or movement,...
reaction, and s...
or a feeling of...*

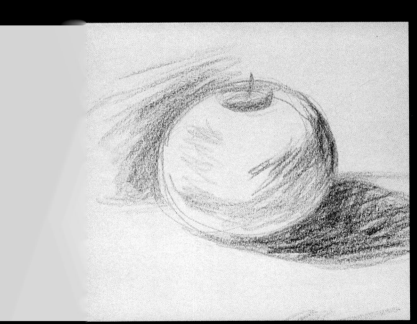

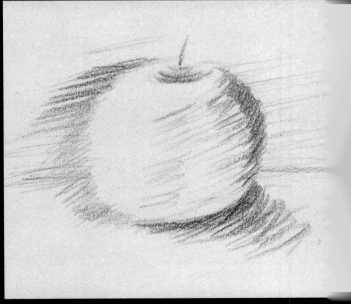

The pencil lines previously drawn for blended modeling do not fill the entire area to be shaded. The area where the final shading will be very light is not touched with the pencil; later blending

The effects of blending can also be created with light lines, made with very little pressure. No outlines are needed. Draw the form of the apple using the contrasting effect of line hatching

Gradations are the best way to illustrate the volume of objects. Begin with very dark tones in the shaded area and gradually move toward white as you advance toward the lighter parts.

Make the initial applications of tone with the side of a sanguine crayon; this avoids the presence of lines and simplifies blending.

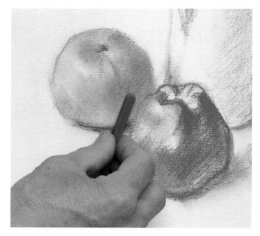

As you work with the tones, redraw the lines and the darkest areas using the point of the sanguine crayon.

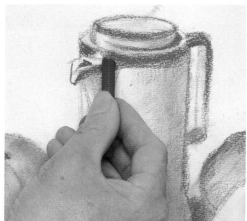

If you approach the drawing using hard, flat shadows, the graphic effect will be more striking, but without gradations the sense of volume will be reduced.

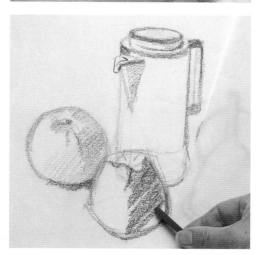

PRACTICING GRADATIONS. Graded values are a conventional method of describing form and volume. The quality of the effect depends on the tonal range that is used. The direct contrast of white and sanguine naturally has a greater impact than the gradual shading of white and sanguine to make reddish tones, although this second method better describes volume.

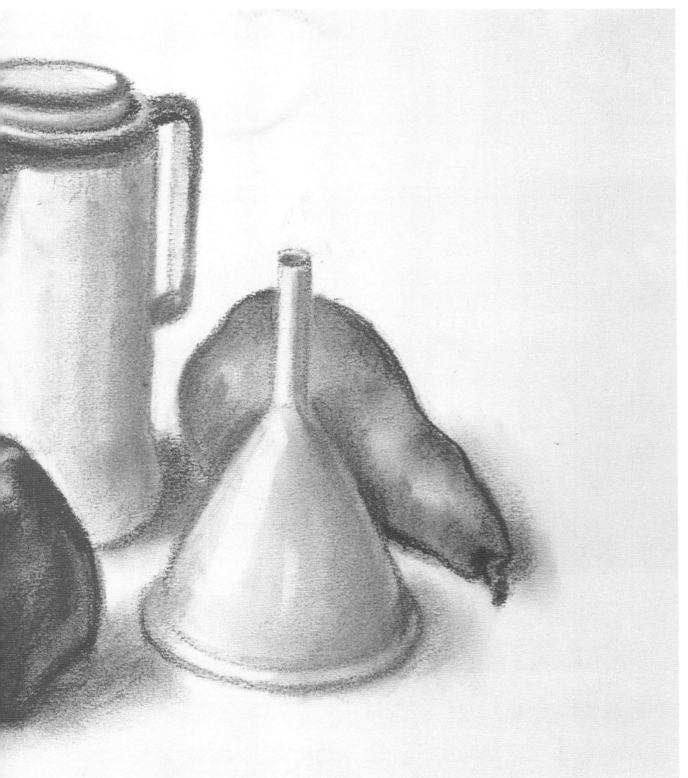

Here are two gradations that exemplify their application to drawing. The first was made by pressing hard on the paper with a crayon and blending very little. The second has been rubbed repeatedly with the fingertips.

DETAILED CHIAROSCURO DRAWING. After all the work in the previous chapters of approximating the structures and proportions of objects, you will find it particularly pleasant to draw light and shadows. Drawings shaded using the chiaroscuro technique, that is, modeled with strong contrasts between the lighted and the shaded areas, is mainly done with vine charcoal and compressed charcoal because it is easy to correct errors and to achieve a wide scale of grays via the blending process.

14.1

COMBINING LINES. Seemingly complex still lifes can be made by combining distinct, loosely drawn charcoal lines. Pay close attention to the following exercise and see how easy it is to learn this technique.

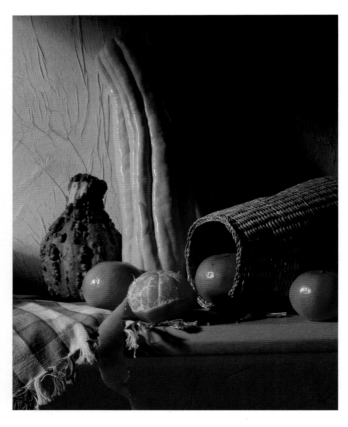

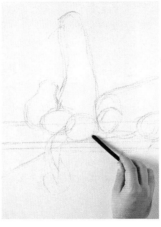

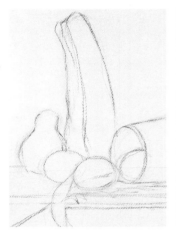

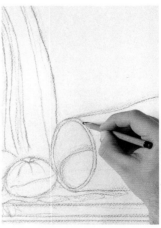

This exercise does not require you to draw very precise forms. Barely touch the surface of the paper with the point of a long vine charcoal stick to make searching and roughly approximate lines. This technique requires strict control of the relationships and proportions among elements rather than great accuracy.

Once you have sufficiently indicated the layout of the main lines, you can tighten up the forms in the still life. You will use a new line, a little darker than before, to outline the model. Without the previous sketch the elements of the model would not be correctly placed.

After some erasing that still leaves the charcoal lines visible, you can resolve the last stage of the drawing. Using a soft compressed charcoal pencil with a sharp point, very carefully draw the exact shape and form of each object. This drawing will serve as a guide for the first stages of shading.

When working on a sketch with vine charcoal, remember to use a cotton rag for erasing.

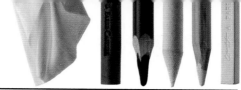

14.2

THE BASE FOR SHADING. The result of the following stage should be a drawing with an initial shaded base that can be used as a point of departure for later effects, correlation, and improvements. The tones will be very flat, monotonous, and without modeling.

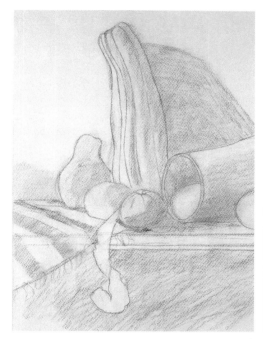

Lightly holding the charcoal stick, mark the darkest parts of the drawing with its point. When applied softly, the shading is quite light but understandable enough. The gray should be a monotone, with no gradations or differences.

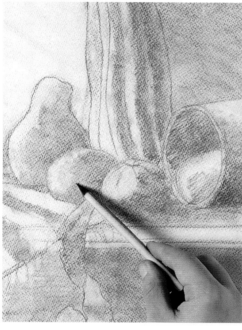

The effect of the shading continues to be light. The process of darkening is slow and progressive. As you apply each new layer of charcoal, rub it with a blending stick. Using tones with slight differences of value tends to produce soft, trivial, and austere effects.

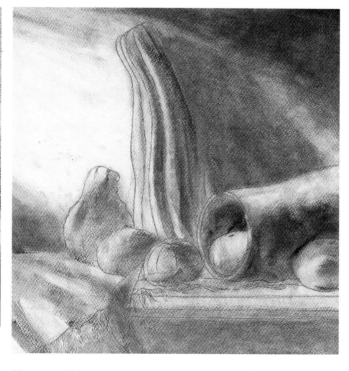

Now you will focus on darkening the shadows and contouring the tones. Use the side of a piece of vine charcoal to carefully trace the forms of the shadows, taking care to follow the outlines of the elements and maintain the proper proportions among them without worrying about the details.

Apply the shading with moderation in the beginning and try blending it in different ways: with your fingers, with a cotton ball, and with a piece of cloth or paper.

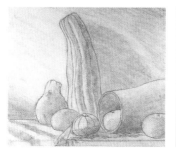

As you shade you can redraw the elements with the compressed charcoal pencil to avoid losing the preliminary drawing. Work very lightly, applying minimal pressure.

14.3

THE CHIAROSCURO EFFECT: REFINING THE SHADING. If you have carefully distributed the light and shadows, the drawing will be at a very advanced stage. All that is left is to increase the contrasts to create a chiaroscuro effect and refine any area that requires it.

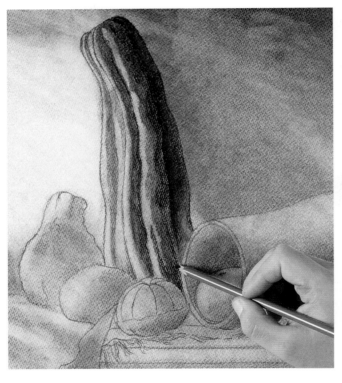

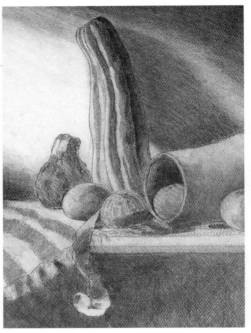

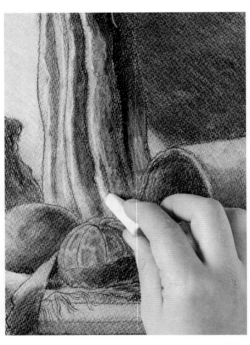

Now, shade with the compressed charcoal stick and pencil. Both make dark blacks that emphasize the chiaroscuro effect. You will have a stronger sense of volume as a result of the greater contrast between light and dark areas. Begin working on the squash, emphasizing its characteristic striated surface.

Darken the background with soft gray tones using a stick of compressed charcoal. Work the shadows that outline the elements with their contrast using the compressed charcoal pencil to avoid drawing over the shapes of the objects.

The final touches consist of making highlights with the eraser and resolving the texture of the napkin. Draw the reflections on the surfaces of the fruits and vegetables with a stick of white chalk. If the area you are working on requires more detail you can use a well-sharpened white chalk pencil.

It is typical to incorporate small amounts of white chalk in the shaded areas. Used in this way, they do not act as highlights, but instead help to lighten a black that is too dark.

Charcoal pencils can be soft, medium, or hard. If little pressure is applied to them they function like normal pencils.

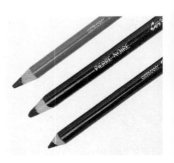

The set of values in a chiaroscuro drawing is referred to as a range. A range can be light or dark. Ranges can also reveal the contrast between extreme values, those nearest to the lightest tones or absolute black; these are referred to as ranges of greater or lesser contrast. Drawn by Gabriel Martín.

The light areas on the squash were made with a rubber eraser. The highlight effect created in this way is evident.

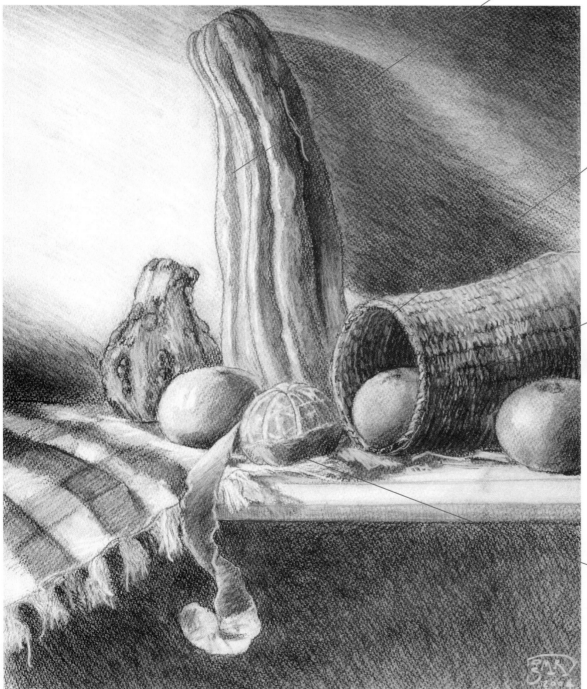

Strong tonal contrasts define the forms of the tones and reveal the relief on the object.

To draw the texture of the wicker basket, first apply the graded shading to the basket. Then sketch the weave over the shading with the white chalk pencil.

Create the texture of the orange by drawing lines with the rubber eraser over the previously shaded surface.

A SUBSTANTIAL DIFFERENCE IN TONE. The basis of any contrast is the evident difference between two tonal areas. Such areas should have clear edges without gradations, rubbing, or blending. The greater the difference in tones, the greater the contrast.

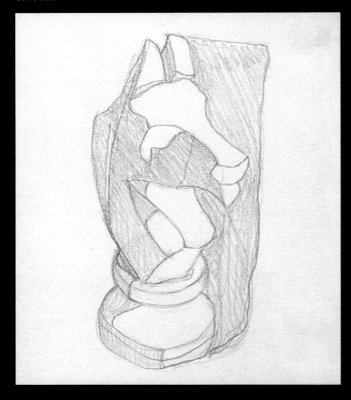

The effect of contrast on a model is achieved by clearly differentiating two areas with different tones. If the shading is light the contrast will be pleasing and not very abrupt.

Contrast is not only created by shading. The direction of hatch lines is enough to differentiate two tonal areas. In this case, the horizontal lines of the table contrast with the vertical lines of the box.

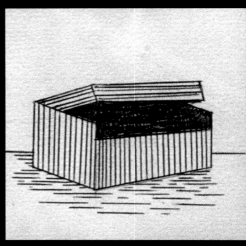

Close hatch lines give the box a general tone that contrasts with the white of the background. On the table a few horizontal lines are enough to create contrast as well.

A light, intensely illuminated object creates the most contrast when it is on a completely dark background. In this case the outline is clearly visible.

The same thing happens when a dark object is placed on a light background.

CONTRAST. The representation of contrasting light will help you define and clarify the models in your drawings. In fact, it is essential that you learn to explore, distort, and exaggerate the effects of contrast in your drawings to better identify objects or create a greater separation between planes.

THE SHADOW SURROUNDS THE OBJECT. When an object does not stand out enough from the background, shading is often applied around it to make it more visible. Many times this shading does not correspond to the real model; it is a technique that the artist uses to create greater contrast.

To emphasize an object it is not necessary to make its outline heavier; it is enough to darken the shadow around it.

Darkening the area around an object to make it stand out from the background even more is a very common technique used by artists.

Working on a flat, medium-tone background allows you to experiment with the whites while darkening the shadows of the object so that its silhouette is drawn by the contrast.

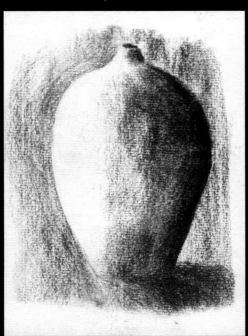

In chiaroscuro, it is not enough to shade and model. The outlines should be clear and defined by changes in tone. Darker shadows heighten the modeling effect.

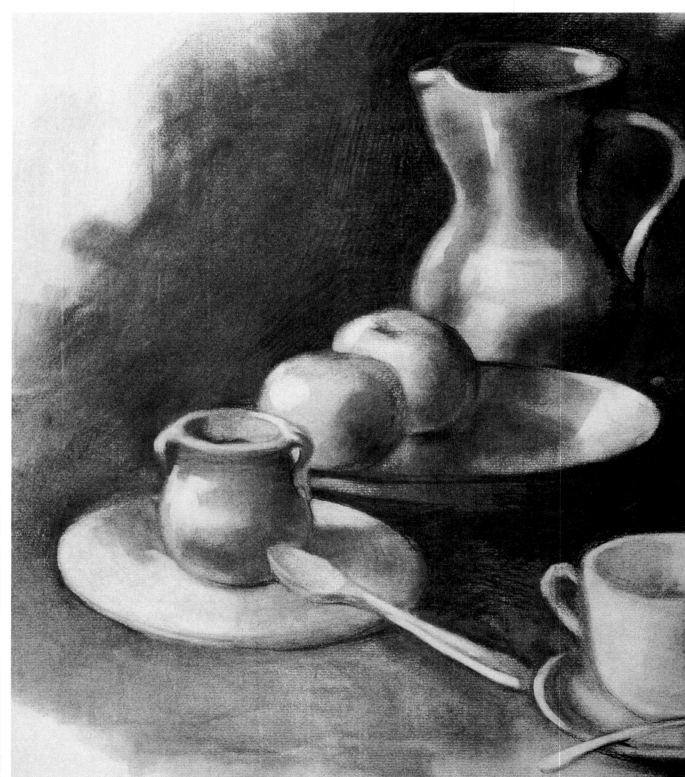

THE EFFECTS OF CHIAROSCURO. A careful analysis of the effects of light and shadow will allow you to get closer still to the elements that will impart realism and volumetric effects to your drawing. Chiaroscuro is the privileged territory of drawing materials like charcoal, chalk, and sanguine, which are considered unstable media, but which let you closely approximate the model by accentuating its volume.

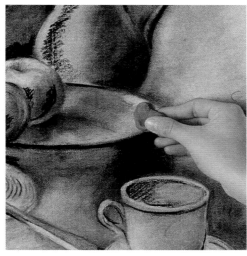

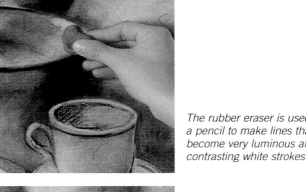

Blending is essential to heighten the effect of chiaroscuro when working with compressed charcoal or chalk. Notice in these two gradations how rubbing B with a blending stick causes its tones to become darker and denser than those of A.

A

The rubber eraser is used like a pencil to make lines that become very luminous and contrasting white strokes.

Rubbing with a cotton rag removes jumps in tone in the intermediate shading.

B

The most precise outlines can be made with a homemade blending tool: a sheet of paper rolled into a flattened cone like a spatula. Working with the wide edge you can do some very expressive blending, with effects similar to those created with a brush.

The Third Dimension

When drawing from nature, most of the time we try to simulate the sense of depth produced by the eye. This effect can be created either by applying a rigorous mathematical perspective, or by what we call an intuitive approach to perspective. In this section we will analyze both systems. Mathematical perspective and intuitive perspective are considered to be complementary, often sharing major roles in the same drawing.

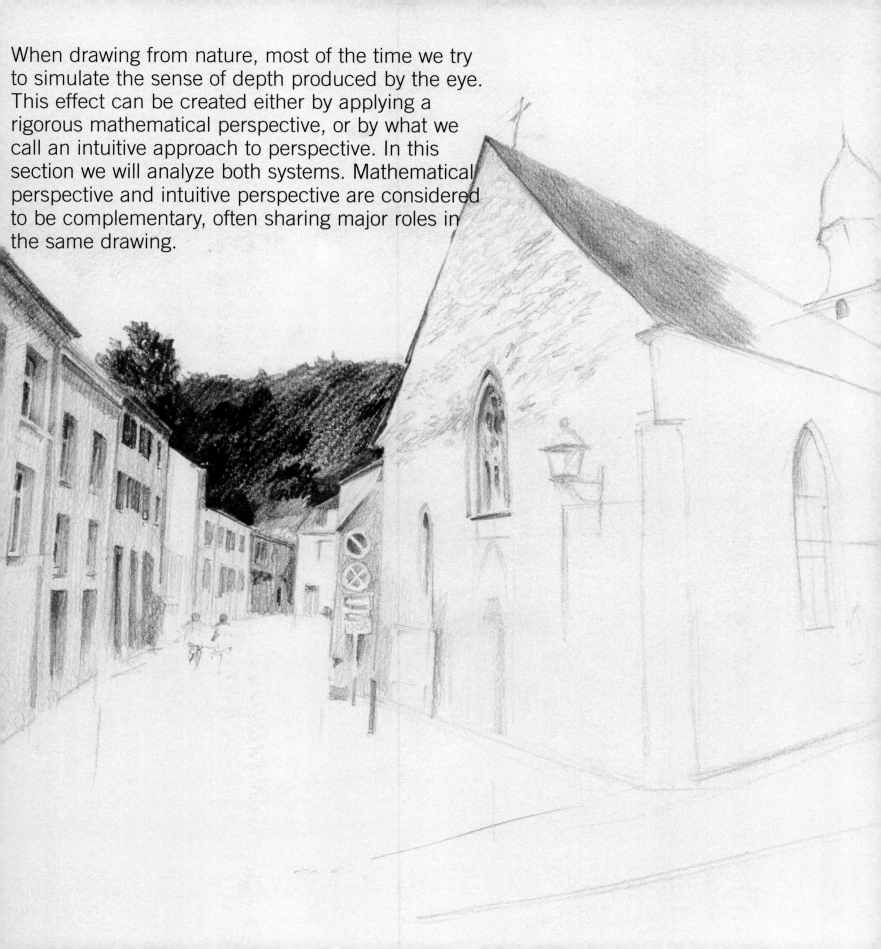

DRAWING DEPTH. Generally speaking, there are a number of visual elements that create space: Details in the foreground are larger and better defined than those in the background; at the same time, colors are brighter and more saturated. Distant objects, on the other hand, seem colorless and blurry due to the atmosphere between us and them.

15.1

THE LINES OF THE LANDSCAPE. As always, the initial layout of the drawing plays a crucial role in the development of the landscape. The different planes that are going to be developed need to be completely defined; you must know the graphic role of each one of the lines that mark it.

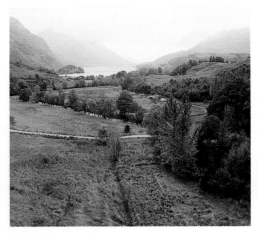

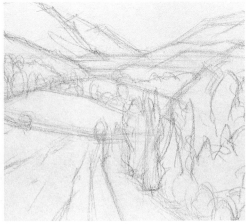

Sketch the general elements in the initial layout, which indicates each area of the landscape. This first sketch is made with the point of the charcoal, held at somewhat of an angle.

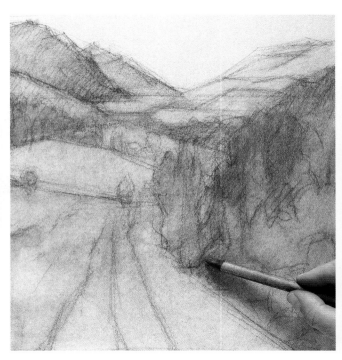

Shade the vegetation in the foreground and middle ground with the charcoal stick, later rubbing the areas with a blending stick. Leave the fields lighter. It is important to study the lighting of each area so that the landscape will have the realism that is needed.

The initial sketch must be well laid out, even if that means forcing some lines to move toward the horizon so that the lines that indicate the perspective create a balanced drawing.

15.2

ATMOSPHERIC AND DEPTH EFFECTS. You must work the background with very light shadows and outlines to create a sense of distance. The foreground, on the other hand, should seem more detailed, showing the textures of the vegetation with very intense blacks.

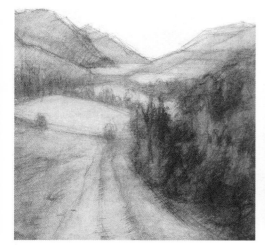

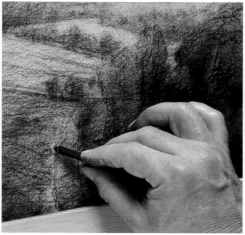

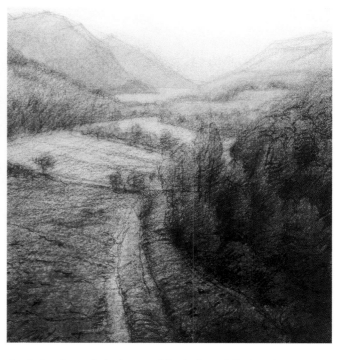

Now, increase the densest shadows of the landscape. Darken the farthest shadows with the charcoal without overworking the group of distant mountains, which should be very light gray with light outlines.

Now is the time to use a stick of compressed charcoal to draw a much more defined separation between the foreground and the rest of the landscape. Compressed charcoal is not easily erased, so you should test the intensity of the tone before you draw the dark areas of the vegetation.

Apply the densest shadows and the texture of the tree leaves in the lower part of the drawing with a charcoal stick and a compressed charcoal pencil. The shadows you made with the vine charcoal, which before were the darkest tones in this area, are now the middle tone areas. Drawing by Carlant.

It is a good idea to draw with the point of the vine charcoal when shading the foreground. It is also important to combine tonal areas with some lines to help describe the texture of the trees.

MODEL AND BACKGROUND IN A STILL LIFE. The perspective effects in a landscape translate very well to a small format, such as a still life, as long as the elements that describe the space and distance are carefully chosen. These visual clues can be very simple: The nearest objects will have darker tones and more details than those located in the middle ground, which will be more sketchy and blended. This exercise is done with dark blue, light blue, and white sticks of chalk, along with a blending stick.

16.1

DRAWING THE FRAMEWORK. The initial guidelines create a framework upon which the precise forms of the model can be built. To work this way you must become accustomed to looking analytically and understand that basic lines will be the keys to the final drawing.

When you wish to make a very realistic drawing, it is a good idea to begin with some light guidelines to help locate the objects correctly and to achieve acceptable shapes and sizes.

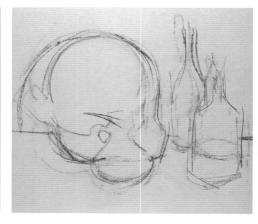

Draw the shapes precisely with dark blue chalk, indicating the outlines of the objects without making them too finished. It is a good idea to use the flat side of the stick when drawing these structured lines. Any corrections should be made in this first stage.

Apply first shading with the blending stick, blurring the outlines of the farthest objects and coloring the background with a very faint blue.

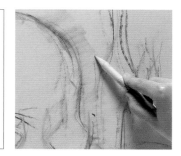

If you draw the structural lines with the flat side of the stick, these straight lines will be narrow, strong, and easy to correct.

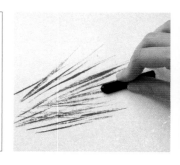

16.2

GENERAL TONES. When the drawing is completely laid out, begin to apply the first shading, creating a study of the depths of the different planes. This second stage of the drawing will be done with the flat side of the chalk, so corrections can be made more easily.

Apply light shading to the paper with the flat side of the blue chalk stick. Work with quick, wide strokes so the shading will be even without filling in the texture of the paper. After you apply the color, blend the drawing by lightly wiping it with your hand.

Color the bottle on the right by mixing the light blue and dark blue chalks to make a clear gradation. Apply enough pressure to the stick to completely cover the area, filling the texture of the paper. Next, you can retouch the outline of the bottle and create highlights on its surface with the eraser.

When you create the values of the volumes in unison, if you darken one object too much the previous light tones can seem too light. To correct this, increase the tones and contrast to balance the grouping.

The blending stick lets you blur a line and make a graded shadow on the paper; however, in some cases it is much simpler to blend with your finger.

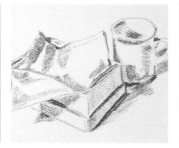

When drawing with chalk you should carefully control the pressure of the stick on the paper, because the lightest tones are created by making very light strokes with the flat side of the stick.

16.3

DIFFERENTIATING PLANES. Once the primary values have been completely developed, you can begin to finalize the planes, leaving the farthest ones sketchy while detailing and outlining the nearest one.

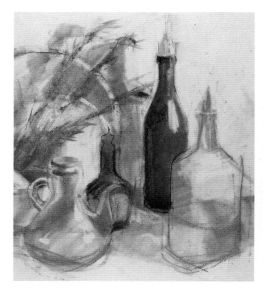

The finish of the objects in the background is vague, diffuse, and without great tonal contrast. The modeling does not look heavy, but rather appears light and atmospheric, thanks to the attractive tonal values made with the chalk.

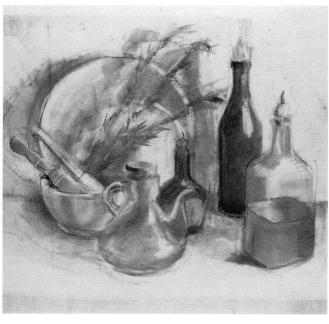

With the background resolved, lightly increase the contrast of the objects in the middle ground and highlight those in the foreground. As you shade the glass objects, rub the surface of the paper with your fingers to model the form and create the illusion of volume.

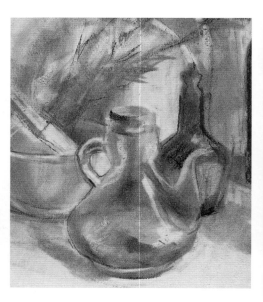

Create highlights on the glass objects in the foreground with the eraser. The darkest shadows on them separate the different planes of the drawing even more, while giving the objects a more substantial feeling.

It is normal for the color to extend past the edges of the objects during blending. In such cases the chalk should be removed and a new outline created with an eraser.

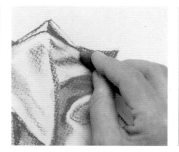

Draw the outlines of objects in the foreground with the point of the chalk stick, controlling the pressure and direction of the line.

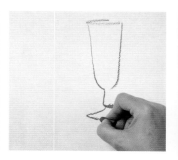

The objects in the middle ground combine some lines with shading. However, they have neither the definition nor the clear outlines of the objects in the foreground.

The objects in the background have little evidence of lines or dark color. They seem to have been created by blending, with little contrast and an airy treatment.

The last step is the application of white chalk highlights. Add them very sparingly. It is not good to add more than are absolutely necessary.

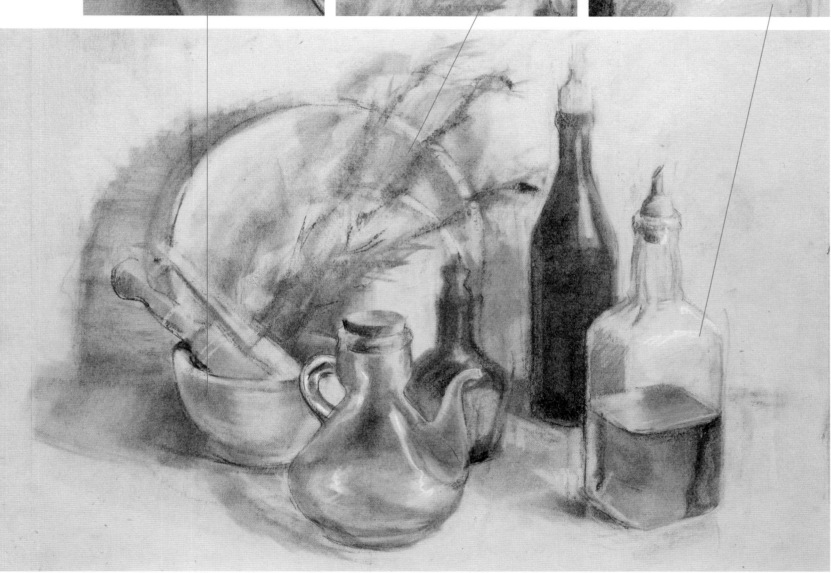

You can see from the finished drawing that creating the impression of space on a two-dimensional surface is a matter of focusing. The objects in the foreground seem more defined and focused, while those that are located just behind them have lighter colors and blurred outlines. Drawn by Mercedes Gaspar.

FADING THE GROUNDS. There are several techniques for illustrating the third dimension in a drawing by using contrast on the nearest planes and fading the farthest ones. The sense of depth is an optical illusion created by representing the water vapor contained in the atmosphere.

To create the effect of the atmosphere, lighten the farthest mountains and rub them with a blending stick. Remember that when you look at a plane near you, your eyes put the farthest plane out of focus.

The Eastern technique of representing depth uses a succession of planes colored with gradations that are darker at the top and lighter at the bottom. The bottom of the gradation on each mountain is left white to simulate the clouds that cover its base.

The Coulisse effect is one of the techniques most commonly used for drawing a succession of planes. Each plane is drawn with a uniform tone, which is lighter for each successively receding plane.

DIFFERENT PLANES. Our eyes are accustomed to defining visual space in terms of foreground, middle ground, and background or distance. By using perspective and atmospheric techniques, it is possible to represent depth and differentiate each of the planes in a drawing. In the remainder of this book, we will study the most common techniques used by professional artists.

DEPTH IN THE COMPOSITION. The effect of depth is not created solely by fading the receding planes. Framing and altering the composition of the picture to reinforce the sense of perspective also contribute to this effect.

If you cause the foreground to stand out with an abrupt change in light, that is, a strong contrast against the background, you can create a feeling of depth in the drawing.

The weight of the line is important for communicating distance in a drawing. Notice how in this experiment, created with a decreasing zigzag line, the widest and darkest line seems closer than the thinnest, lightest one, which seems to be moving away from the viewer.

When composing a landscape you can modify the masses so they converge at a point on the horizon. This convergence leads the eye of the viewer to the picture's background.

Just as the composition can increase the feeling of depth, so can controlling the direction of the lines so that they converge in the same place on the horizon line.

ATMOSPHERIC PERSPECTIVE. An important factor in drawing landscapes is the representation of the third dimension using light, shadow, and blending techniques; the feeling of distance is created by reproducing the effects of the atmosphere. This is an optical illusion caused by water vapor and dust particles in the air, which lighten the colors and soften the edges of the forms in the distance.

17.1

DRAWING THE ATMOSPHERE. The farther away the plane, the more it fades; distant landscape has duller colors and blurry forms. Therefore, you should begin by drawing the atmosphere, which is the farthest planes, and then work toward the foreground.

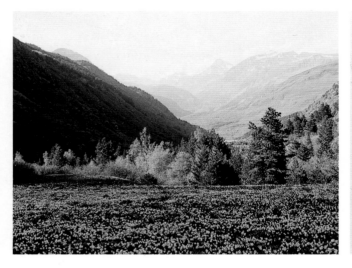

Begin this compositional study by indicating the main areas of the picture, starting with the mountains and ending with the sketch of the trees in the foreground. Work with the flat edge of a piece of sanguine crayon, applying a very fine line that you can easily erase in case of error.

Using a good combination of light shading, made by lightly coloring with the edge of a sanguine crayon and rubbing it with a blending stick, it is easy to create the atmospheric effect of the mountains in the background. As you can see, the preliminary shading is barely visible against the white of the paper.

If you do not feel confident with a sanguine crayon, make the preliminary drawing with a sanguine pencil; this will allow you to rest your hand on the paper to draw better lines.

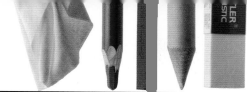

17.2

BUILDING THE TONES. In this drawing, the darkest tones should be applied progressively. Light tones in the distance will be darkened as you shade the nearer planes, as if you were working with a scale of tonal values.

As you move down the surface of the paper, apply the intermediate tones. Each new plane should be resolved with a slightly darker shading than the previous one. It is better to fall short in the intensity of the shading, which you can adjust at the end by darkening it as much as needed with a sanguine crayon.

At this point you have resolved the overlaying of the mountains. The drawing is a gradation, so that the eye of the viewer is drawn into the picture by the subtle variations of tone that suggest an infinite space.

Leaving the space for the vegetation blank, color the large meadow of grass in the lower part of the picture. First, using the point of the sanguine crayon, cover the field with a uniform color; then unify the shading by simply rubbing it with a blending stick.

The atmospheric effect can be conceptualized as a picture covered with a gradation that becomes lighter as it moves up the paper.

17.3

THE TEXTURE OF THE VEGETATION. The texture of the vegetation should not be a mere copy of reality, but should also provide a way of distinguishing a foreground from a less detailed background. Furthermore, the value of the texture becomes a vehicle for dramatizing the forms of the landscape.

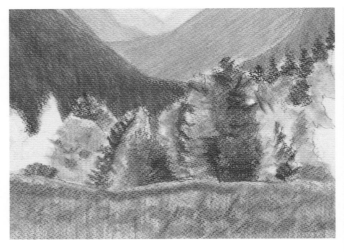

Adding a sense of texture to the group of trees in the foreground makes them appear closer, creating a greater sense of depth in the background.

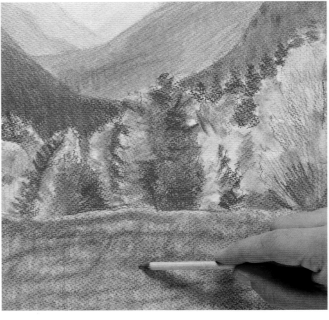

Continue working the texture of the trees and the grass meadow with a blending stick charged with sanguine. Combine the blended color with lines that simulate the branches in the tops of the trees. The grass is not just lines; it is composed of areas of light and areas of shadow.

To suggest clumps of grass, make short vertical strokes with a rubber eraser. When they are seen against the darker, more shaded background, the white areas indicate the shapes of the bunches of grass. This line work defines the texture of the grass in a general way.

Use tonal contrasts to control the light in the foreground. The darker the tone that surrounds the tree, the more luminous it will seem.

Do not apply texture effects to the rest of the vegetation in the landscape; only use them in the foreground. Otherwise, the illusion of depth will be reduced.

The contrast between the dark background and the lighted trees in the foreground is important for the definition of the vegetation and keeps it from looking like part of the background.

Light variations of tone and subtle erasing contribute to making the irregularity of the grassy meadow stand out.

Resolve the most distant trees with very small conical lines in horizontal groups.

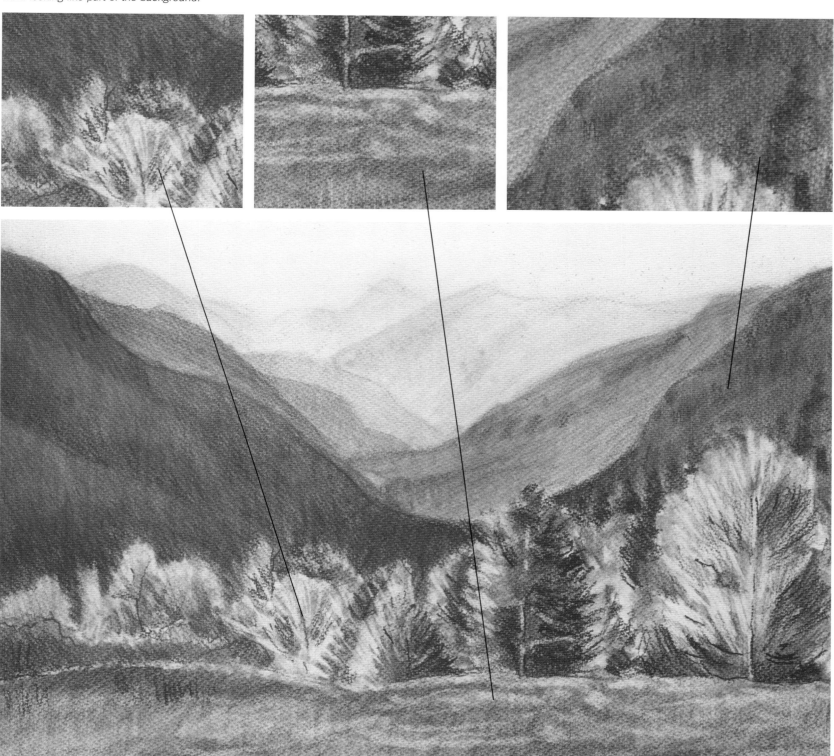

To finish the drawing, continue emphasizing the contrasts and the texture of the vegetation in each area of the picture, such as the grass meadow and the trees. Draw new branches with the point of the sanguine pencil; draw groups of leaves with a corner of the rubber eraser. Drawn by Gabriel Martín.

URBAN LANDSCAPE IN PERSPECTIVE. The laws of perspective are a systematization of mechanical vision; they come into play when the work must be an exact transcription of nature. Knowledge of the basic rules of perspective is very helpful when making drawings of urban landscapes, although it is not an absolute requirement.

18.1

FIRST LINES OF OBLIQUE PERSPECTIVE. Oblique perspective is characterized by having two vanishing points and by the fact that vertical lines are the only ones that are always parallel to each other. This perspective is the most useful kind for drawing buildings.

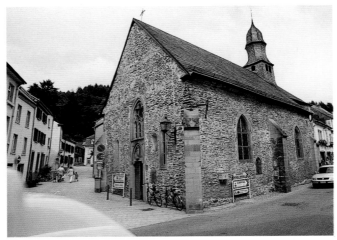

The first step in a perspective drawing is locating the horizon line. This is an imaginary line that lies at the height of our eyes. Draw a perpendicular vertical line across it to represent the corner of the building that you are going to draw.

When you stand in front of the corner of a building, two groups of diagonal lines converge at two vanishing points, one at the left of the horizon and one at the right. It is a two-point perspective.

To finish the initial sketch, project the perspective of the façades of the neighboring houses. Indicate a single point at each side of the paper and from these points project two diagonal lines. Their angles will vary depending on the view that you have of the façades.

Horizon and eye level are basic elements of perspective drawing. The apparent separation between the earth and the sky is called the *horizon line*. It is equivalent to the height of your eyes from ground level.

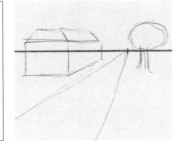

Some artists systematically avoid drawing front views of buildings because they can seem flat and lacking in interest; they prefer an oblique point of view because it creates a strong relief with angles and planes.

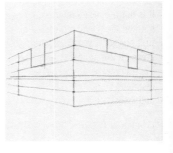

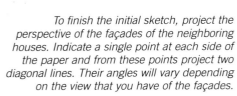

18.2

STRUCTURED LINES. The first lines should be the most structured ones of the drawing; therefore, you need to search out the fundamental lines. This requires you to pay careful attention to the lines and their angles. If this stage of the drawing is correctly resolved, the definitive drawing of the forms will be very simple.

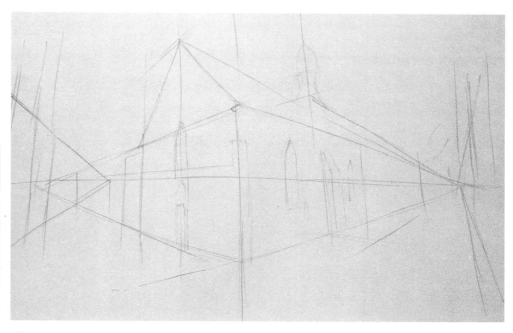

Once the lines of perspective have been established, you have a base on which to begin projecting the vertical lines that define the edges of each façade. Begin by projecting the edges of the central building and the divisions of the façades of the row of houses. Then divide the two walls of the church into two equal parts and draw straight, parallel lines.

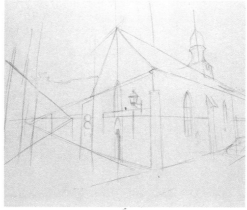

The previous division of the church's walls into two parts will help you locate the peak of the slanted roof and the point of the small bell tower. Draw the angle of the roof from the point where the diagonal perspective lines of the two straight lines intersect. New measurements allow you to locate the windows and the door of the building.

The secret of reaching this level of development is to always work with sure and accurate lines and to constantly measure distances. Once the structure of the scene is finished, carefully draw the forms. Although they are still sketchy, you can distinguish the bell tower, the openings in the walls, a street lamp, and the buttresses of the church walls.

It is not necessary to press too hard on the pencil during these first stages. If you do so, the pressure you apply to the surface we are drawing on will create resistance, impeding a quick and smooth line.

It is a good idea to draw the perspective lines freehand. If you do not have a steady hand you can use the edge of a book or a pamphlet or a ruler as a guide.

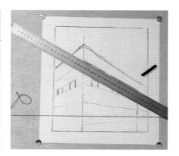

18.3

REFINING THE DRAWING AND SHADING. The play of light and shadow on a building is what makes it appear real and solid. When you apply shading, you must always look for the silhouette—the contrast between the walls and the background. Color large areas of gray on the buildings using the side of the pencil, applying only a little pressure.

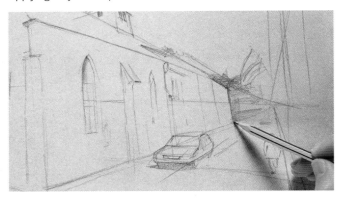

Define the previously sketched architectural details with more accurate and definitive strokes. Including figures and automobiles will add a sense of scale to the drawing. Shade the background using a medium-hard pencil, allowing the first grays to outline the walls even more.

Once you have established the principal lines and planes on the paper, approach the drawing with gray tones. Begin with the buildings in the background; apply light, even lines on the façades of the houses and darker lines in different directions on areas of vegetation. As in previous cases, use a piece of paper to avoid smearing the drawing with your hand.

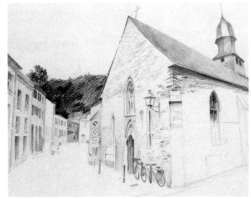

Add more details over the structural lines of the church: windows, a lantern, the parked bicycles and the stonework. Then shade the drawing with light applications of graphite to create a sense of three-dimensional form and space. Resolve the effect of the roof with gray gradations, somewhat blended with the fingertips.

To achieve a dark value it is enough to use a soft lead such as a 3B pencil. No matter how hard you press a hard lead pencil to the paper, you will never achieve a dark line. The paper will tear first.

To an artist who is fascinated by details and textures, the small forms contained in general structures such as a façade offer a quantity of accessory material.

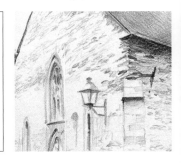

It is not necessary to spend too much time on excessive details or to be too exact with every line to achieve a greater likeness of the model. A smudge to suggest a shadow or a white area to indicate a bright reflection will be sufficient.

The row of buildings in the middle ground has been given a sketchy treatment. Maintaining a contrast between areas with details and others, like this one, without details is important if you wish to keep the drawing from becoming overworked.

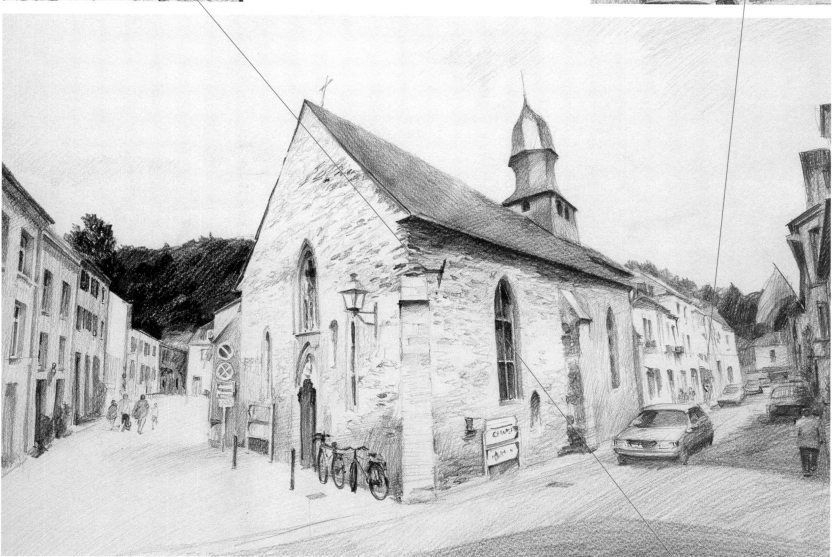

If you squint at this drawing you will see that it is made up of large areas of different tones. In reality, there are four basic values: the dark gray of the vegetation in the background and the church window; the medium gray of the rooftops, the asphalt, and the shaded façades; a light gray on the sunlit façades; and, finally, the white of the paper. Drawn by Óscar Sanchís.

It is not necessary to indicate each block when drawing the texture of a stone wall. Instead, establish general tone with a bit of texture here and there. Often, the suggestion of texture is enough to communicate the effect.

GEOMETRIC STRUCTURE. In drawings, the illusion of depth is created by using linear and graphic approaches and following rules concerning the making of perspective drawings that help describe the geometric structure.

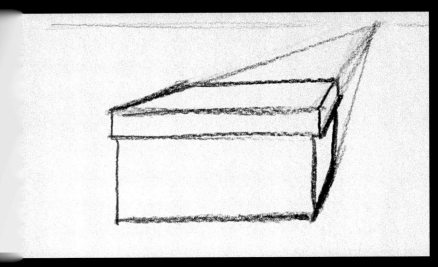

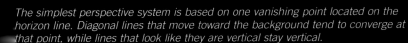

The simplest perspective system is based on one vanishing point located on the horizon line. Diagonal lines that move toward the background tend to converge at that point, while lines that look like they are vertical stay vertical.

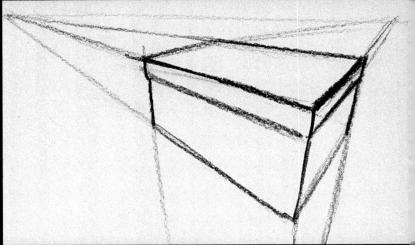

Oblique perspective is another system that is often used by artists. It is constructed using two equidistant vanishing points located on the horizon line. This perspective system is the best way to represent corners or two walls of the same building.

CHANGES IN THE POINT OF VIEW. The position the viewer adopts in relation to the model is important to choosing one perspective or another.

Changing the point of view in relation to the object also changes the perspective, and what would be an oblique perspective if the model were located closer to the horizon line becomes an aerial perspective in the last representation on the right.

PERSPECTIVE TRICKS. When a model is difficult to draw and you wish to create a more realistic representation of it, you should note in the layout all the lines that help show the space effectively. In this sense, the principles of perspective are very useful for correctly drawing these lines.

The relative sizes of the figures located in different positions are resolved by projecting two diagonal lines from a vanishing point on the horizon. If you draw a straight line perpendicular to the figures, you will have the height of each figure according to its distance. The figures here are drawn from an elevated point of view to facilitate understanding of the exercise.

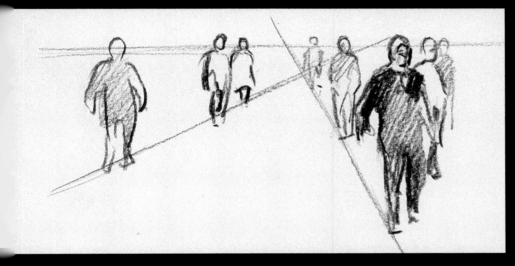

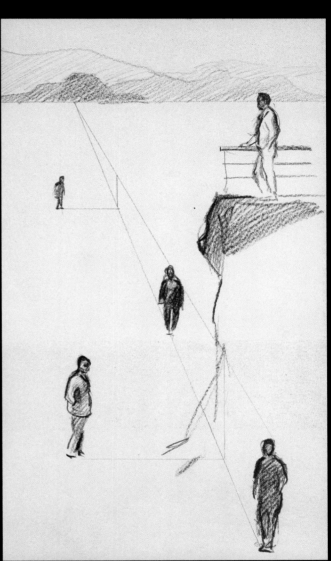

Here we see the relation in size among the figures located on different planes, although unlike those in the previous example, these are located at the height of the viewer. The perspective lines determine the height of each figure in its particular location.

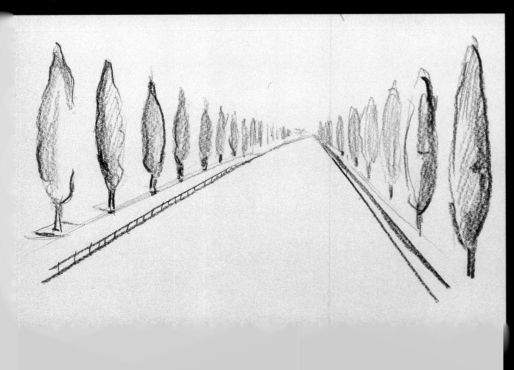

If you place several objects of equal size next to each other in perspective, they decrease in size, and the distance between them decreases as well, as they recede into the distance. One way to illustrate this effect is to draw an avenue with trees planted along both sides.

If you wish to learn to draw landscapes, you should become familiar with one of the most often used techniques for simulating the effect of distance: drawing atmospheric perspective. This is represented as a light haze that removes the color of the most distant areas.

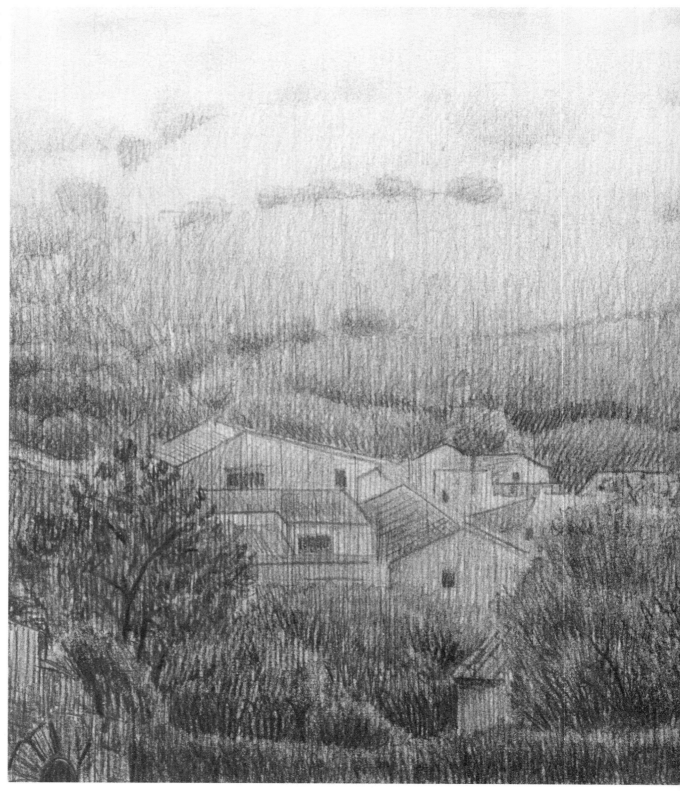

ATMOSPHERE: GRADATION AND BLENDING. The visual phenomenon known as *atmospheric perspective* is a function of tone. The colors in distant planes seem less clear and take on a grayed and more intermediate tone compared with the more diverse and brighter tones in the nearer planes.

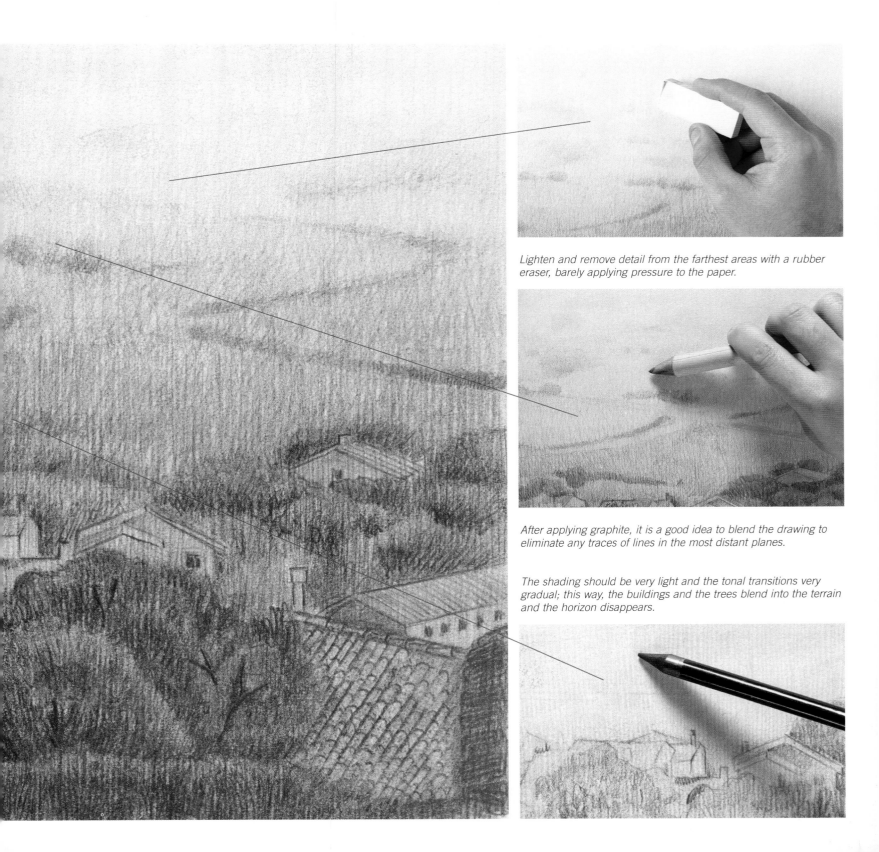

Lighten and remove detail from the farthest areas with a rubber eraser, barely applying pressure to the paper.

After applying graphite, it is a good idea to blend the drawing to eliminate any traces of lines in the most distant planes.

The shading should be very light and the tonal transitions very gradual; this way, the buildings and the trees blend into the terrain and the horizon disappears.

CLARITY OF TEXTURE. An object with texture will be clear in the foreground, while at a distance the surfaces will lose definition and show a lighter and less defined texture.

When an object is in the foreground, near the viewer, its outlines are very clear and contrasting. However, as the object moves away, the drawing's line becomes lighter until it becomes a simple, unfinished stroke in the background.

To draw the texture of the vegetation, represent the grass in the foreground with strong, differentiated lines. Resolve the middle ground with lighter drawing and greater intervals of white. In the background, all definition is lost and only a tone is applied.

To represent the texture of these bricks in perspective, progressively reduce the dimensions of each row as they move away from you. At the same time, lessen the pressure applied with the pencil until the lines disappear in the distance.

TEXTURES IN PERSPECTIVE. Careful observation of the landscape will help confirm that forms in the distance lose their detail as well as the outlines that separate different elements from each other. Something similar happens to surfaces that have a pronounced texture. The graphic equivalent of atmospheric perspective, used in a purely linear drawing, causes the breakdown or dissipation of the edges or outlines of far objects, which can be drawn with weak, broken, or dotted lines.

VALUE AND HATCH LINES. When working with hatch lines, you should make the width and intensity of the lines different based on the plane they occupy. This way, nearer planes will be indicated with more precise and closer lines than distant ones, which are indicated with lighter lines that have more space between them.

The distance between different sets of hatch lines also contributes to the creation of depth. In the foreground the lines are more tightly spaced, while in the distance they open up to leave more white area between the lines.

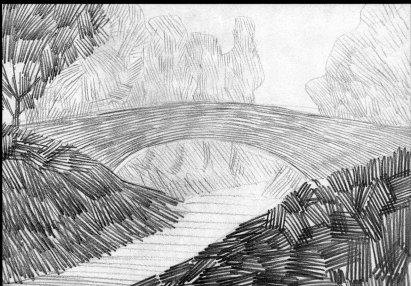

The hatching in the foreground should be constructed with thicker, darker lines. As the planes recede, the intensity of the lines should decrease.

Here is a practical application of this technique. This landscape was created like a series of theatrical backdrops, with four planes clearly differentiated by variations in hatch lines.

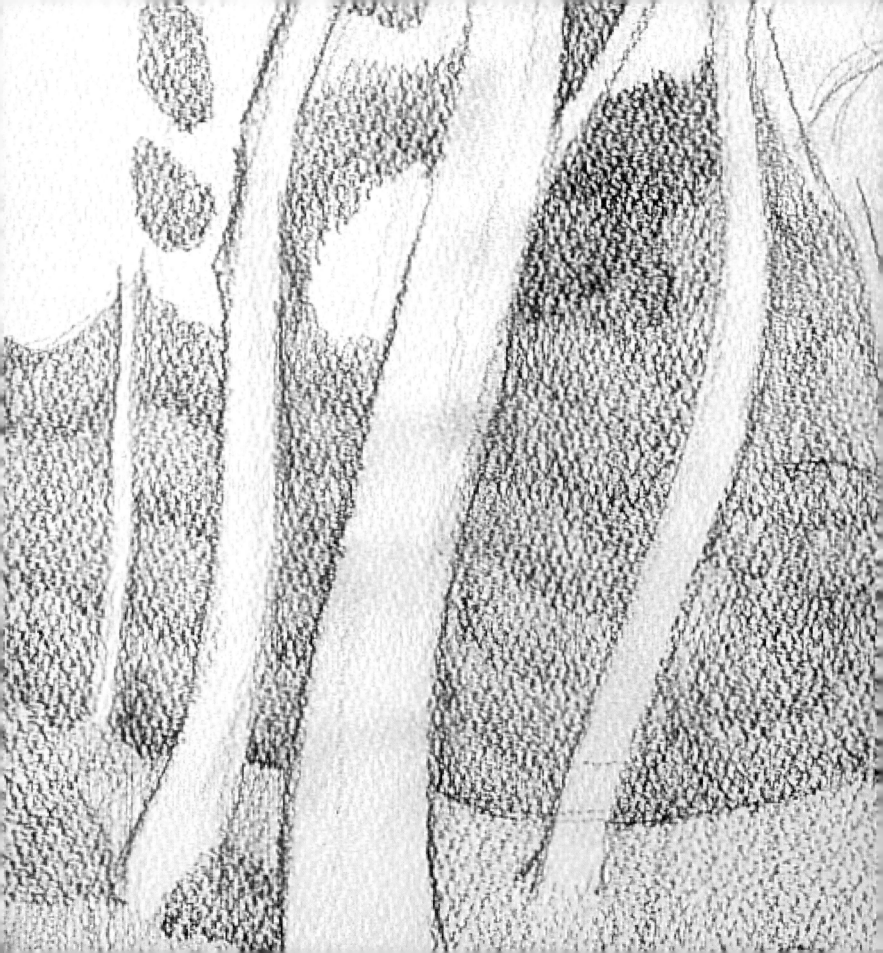

2. Line and Shading in Drawing

LEARNING TO SEE FORM. The mystery of drawing, or the ability to draw, lies in learning to see, that is, to see through the artist's eyes. This ability is available to all of us. To see means learning to identify the prominent features of an object, which not only determines its uniqueness, but also presents it as a complete and integrated visual scheme.

JUDGING, RECOGNIZING, AND INTERPRETING. These are the most important concepts to consider when learning how to draw. This approach includes the visual aspects of a drawing as well as its content and creative elements. First, there is the ability to judge shapes, relationships, and proportions accurately; second, mental activity or imagination enables us to identify the drawing and organize it in a given way, depending on the theme; third, the ability to read and interpret the graphic symbols in the drawing gives it meaning.

IDENTIFYING SHAPES. In order to develop this ability, one must learn to identify the contours of an object and the system of light and shadows that is produced by the effects of light. In other words, one must learn to master lines and shading.

The purpose of this book is to encourage readers to experiment, to observe what happens on the paper, and to let their imaginations soar.

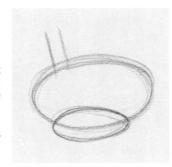

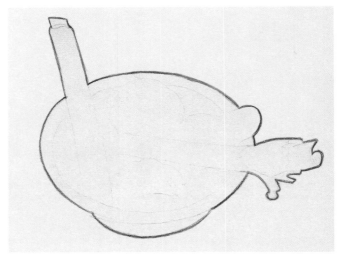

Some people use simple geometrical sketches in order to understand the shape of an object.

It is important to study the contour of an object in order to capture its shape. You can achieve this by ignoring the interior lines.

DRAWING FORM USING LINES. When drawing a given form using lines, it is a good idea to start by drawing some faint lines that can help us sketch the object's contour accurately and achieve adequate shapes and sizes. These guiding lines will provide a skeleton upon which other more accurate and thicker lines can evolve. As one continues, the lines shaping the object are firmer and more intense. Thicker lines create a strong contrast against the background, while finer lines are used for details.

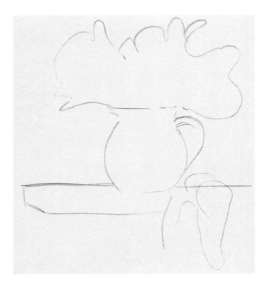

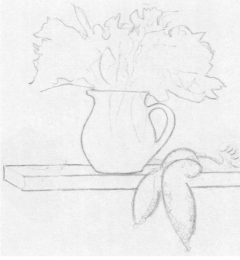

We make a preliminary sketch in order to understand the proportions of an object.

After analyzing the proportions of the object, we outline its contour; thus the shape emerges more clearly.

Using the previous sketch, we draw a combination of lines in order to break its uniformity.

DRAWING FORMS USING SHADING. We can build up the form of an object by just using shading, ignoring its contours and focusing on the masses that we are able to distinguish due to the contrasts in light and dark tones. The light areas help shape the object depicted. When drawing with lines, we first outline the object, and then we draw its contour. When defining forms through shading, we first establish the dark tones and then use them to model the form. Although the result of this approach has less definition than a linear drawing, it offers a wealth of possibilities for defining the object and a more finished result.

The contrast between the masses or tonal areas builds up both outside and inside forms of an object.

The shading process differs a lot from linear sketching. There is less definition of the contour of an object, but you can achieve more depth and body.

It is possible to directly sketch a landscape using shading. You may use the flat side of a piece of chalk to build up each area, using different tones.

Shading is a good method for defining the form of an object when shadows appear clearly contrasted.

LEARNING THE BASIC LINES. In order to create a drawing with a variety of lines or with a richness of shading and gradations, it is essential to be acquainted with the different types of lines that each method uses and to research the many applications that the drawing allows.

LINEAR DRAWING. Drawing using only lines is the most difficult approach, because artists are required to define the contour and tones of an object without using shading. Lines, when drawn by a skilled artist, can describe almost all the visual effects that can occur in a real object. It is therefore worth practicing and mastering different types of lines, loops, spirals, circles, ovals, and hatching.

Before starting a drawing, it is advisable to practice basic lines with the materials we will be using in order to learn their plastic possibilities.

SHADING AND GRADATIONS. Successful shading also requires different approaches to the use of tone. Any graphite pencil, pastel, Conté crayon, or charcoal produces a range of tones, depending on the pressure you apply or the insistence with which you draw on the paper. You should practice with classic gray shading, gradations, pulling shadows, and sfumato. By using these, you can achieve a more three-dimensional representation of the object.

We can practice shading by working lengthwise with charcoal, pastel, and Conté crayon.

LINEAR QUALITIES. In practice, artists can develop distinct linear qualities that we can classify and include in a typology. There are different styles of linear drawings. Lines can be energetic, that is, decisive, thick, and intense. They can be broken, or made up of short lines that break the continuity of the outline of the object. Lines can be hesitant, shaky strokes made up of several superimposed lines. They can be fine, clean, precise strokes built with thin lines of medium intensity. Lines can be modulated or of a variable intensity that causes the line to constantly change its intensity and thickness. A modulated line stands out in order to give more emphasis to one contour, then disappears in order to soften another.

A. *Energetic line*
B. *Fine line*
C. *Broken line*
D. *Modulated line, of variable intensity*

GEODESIC LINES. There is a drawing system that resembles the representation of a topographic area. It deals with drawing the geodesic or level lines of an object to describe its volume. In order to put this method into practice, we suggest making drawings in which the lines follow the direction marked by the surface of the object's relief. This principle is very important in learning to model the different volumes in an object.

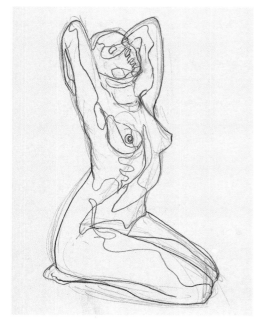

Geodesic lines describe the surface of the object as if it were a topographic map.

A fun exercise consists of drawing a model without lifting the tip of the pen. The result is a drawing that appears to have been done with a long metal wire.

Mastery
of Lines

Line drawing is the most commonly used technique, and it is also the most versatile. Most drawing tools are designed to draw lines. Lines can be used to define the shape of an object, to create light and dark areas and textures, and also to suggest various surface effects. In this section we will explore the amazing potential of lines, and you will learn how to make them work to define form and three-dimensional space.

LINEAR DRAWING. Linear drawing is the representation of an object, solely and exclusively by using lines, without shading. This implies using lines to describe the three-dimensional features of the object. The use of a homogeneous line without modulation allows the artist to concentrate on shapes and on building up the object.

1.1

SOLID FOUNDATION. In a realistically crafted drawing made up exclusively of lines, it is important to pay attention to the outline, that is, to create a solid and accurate understructure, using the right configuration and construction, because the shading effect, absent here, will not hide any possible errors in the drawing.

The previous drawing serves as a reference to finish the outlining of the shape and to introduce new details of the lower part. We now draw the squares of the radiator and give greater concreteness to the car fender. The line continues to be soft without variations in tone.

We use an HB graphite pencil to outline the main shapes and the most outstanding details of the object. First, we draw the incline of the hood and the headlights, then the ventilation of the radiator, and finally the fender. The drawing can be very soft, so that it allows possible future corrections.

Using the line technique, the first objective is to draw the outline and then draw the secondary shapes, those contained inside the drawing.

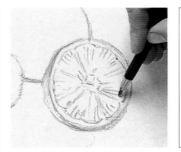

By holding the pencil with its end inside your hand, you can gain confidence when drawing details, and you will have more control over the firmness of lines in short strokes.

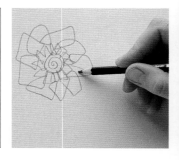

1.2

FIRM AND INTENSE LINES. The graphite pencil enables you to draw clean, sharp lines. You just need to underline the previous sketch firmly and with confidence using a sharp tip and avoiding tones.

There are hardly any big differences between this drawing and the previous one, although the artist has taken an interest in describing surfaces. By drawing new soft lines, he has conveyed the reflection from the lights and from the metal hood.

Tracing over the delicate sketch made with the fine line of an HB pencil, we develop the final drawing by thickening the lines using a 2B graphite pencil. We cover each of the previous lines with a darker one of the same intensity.

With an intense line, all the shapes can be emphasized. This is a very homogenous line, and there is no variation between the exterior outline of the car and the lines that define the metallic reflections. In order to achieve an interesting drawing with so few materials, it is important to represent all the details very accurately. Drawn by Carlant.

In order to work with fine lines, you need to sharpen the pencil with a sharp knife or blade. The knife provides a stronger tip than the sharpener.

THE ENERGY OF LINES. Pencils, whether of graphite, pastel, or oil, can draw lines more easily than they can achieve shading. However, in the hands of a professional artist, lines can describe almost all the tonal effects of the object. If we lay firm lines, alternating the pressure, we can achieve interesting tones, as in the drawings presented here.

2.1

BLACK OVER GRAY. The initial sketch of the drawing is made with a gray oil pencil. We work on the sketch applying very little pressure so that we can erase mistakes. We outline the object using more intense lines made with a black pen.

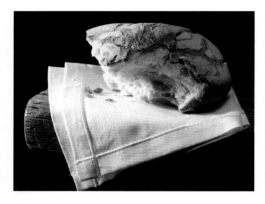

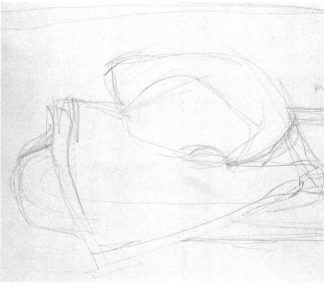

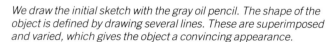

We draw the initial sketch with the gray oil pencil. The shape of the object is defined by drawing several lines. These are superimposed and varied, which gives the object a convincing appearance.

Using the gray oil pencil, we first shade the area above the piece of bread. Only soft lines are needed. The outline of the object appears because of the contrast. Using the black pencil, we draw many intense, thick lines that begin at the outer edge of the bread and napkin, thus darkening the background.

Before starting the step-by-step drawing, a sketch has been made combining different colored pencils in order to decide which is the most appropriate one for the exercise.

Colored pencils, because they are oilier, can easily slide on the paper and change direction. They are therefore ideal for this technique.

2.2

SHADING AND CONTRAST. We mark the shaded areas with firm strokes. On the piece of bread we combine lines of medium tone and straight lines drawn one on top of the other, which will help to outline the object by creating contrast.

We darken the new background with many intense and strong lines drawn over the previous ones. It is possible to create very dark tones by drawing lines in different directions. Because the white of the paper is not totally covered, the tone keeps part of its brightness.

Using a black pencil slightly pressed, we work on the creases of the piece of bread. You just need to draw a soft line on each one, which we will combine with some broken and irregular lines.

Tone variations and gradations on the piece of bread are achieved by changing the density of lines and the pressure applied. By rubbing the tip of the pencil on the paper, nearly the entire surface is covered by interwoven lines, except for the white of the napkin. Drawn by Mercedes Gaspar.

The edge of the eraser can be used to keep some areas white, to fix the outline of the napkin, or to tone down some lines that are too dark.

THE STROKES OF THE EXPERIENCED ARTIST. Strokes made by experienced artists are confident, without interruption, and are quickly drawn. They are clean, with no hesitations or alterations in their direction. They are fresh and agile strokes, made with a firm hand. The strokes of an inexperienced person, however, are often hesitant and slow.

Some beginners make the mistake of drawing hesitantly. Instead of drawing a single line, the tip of the pencil moves clumsily about the paper, superimposing small lines until the strokes become rough and frayed.

This is another mistake, in which the tip of the pencil cannot achieve a quick and clean line, but instead hesitates and stops constantly. The line is made up of a series of small lines.

This is the correct way of drawing with a confident accomplished line. Here the line is clear, intense, and does not show hesitation. It has been done quickly with a single stroke.

THE IMPORTANCE OF RHYTHM. Rhythm is fundamental when trying to achieve good lines. It plays the same role as it does in music. It can be achieved by repeating lines in a systematic and organized manner.

Irregular rhythm creates hatchings made up of sloppy

Here, the same previous sequence is made with

It is very important to maintain the rhythm in the strokes, because that will transmit a clean effect and will direct the eyes of the viewer

THE VALUE OF LINES. Once you learn the basic lines, you must then learn to control their quality and rhythm. For that purpose, it is important not to rest the drawing hand on the paper, but to keep it relaxed, so that it can move as easily as possible.

APPLICATIONS OF SHADING. Let's see now how to apply more experienced strokes and the rhythm of the shading effect. Just as with lines, in order for it to be effective, it has to be done quickly. It needs to be loose enough so as not to overplan each step of shading.

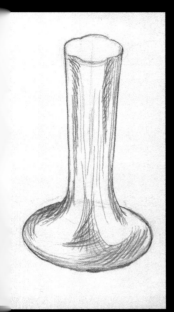 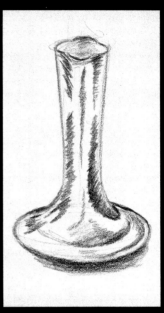 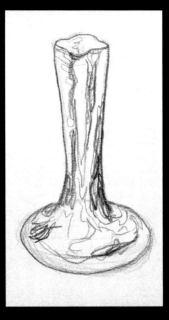 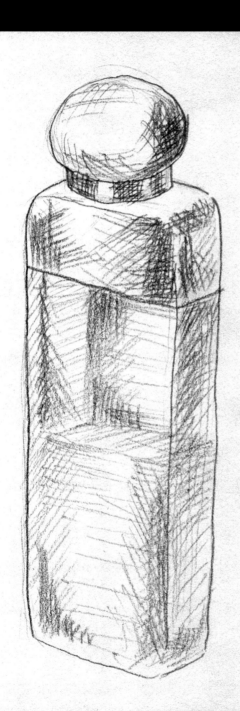

The strokes defining the shading in this vase are vertical, with precise cross-hatching in the area where the tone should be more intense.

Notice the difference from the previous shading. Here strokes tend to be diagonal, shorter, and thicker. The shading drawn from top to bottom on the neck of the vase keeps a clear and constant rhythm.

Sometimes we can break the effect of too much control in shading. Here, though the stroke is hesitant, it is much more rhythmic than the previous ones because of its swirling quality.

The lines that follow the surface of the object explain its volume in a better way. The rhythm of curved hatching gives this bottle's texture a lovely effect.

MODULATED DRAWING. The following exercise combines the sense of form and control of lines with the free and relaxed movements of the arm, or the artist's gestures. In this technique of gestural drawing, lines must be modulated, indicating the thickness of the form they surround according to the type of area, dark or light.

3.1

A CORNER WITH FURNITURE. Some furniture, a flower vase, some simple still life, and so on, are themes that can be tackled right away. We must draw quickly, just using lines, without lifting the drawing medium from the paper. We should draw all the needed lines and strokes in order to describe the object, while allowing the drawing medium to move freely on the paper.

The descriptive contour starts with a homogenous line that we make with a 2B pencil, slightly slanted so that the line is thicker.

The features of the chair are decisive, and the line is stable but flexible. The drawing lacks, for the moment, details and textures. We have only outlined the objects. The resulting lines will depend on the way we hold and move the pencil.

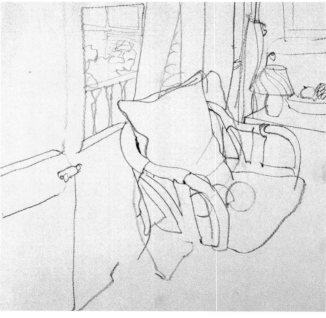

We will now draw the windows, using softer strokes and unfinished outlines. Examine the difference in intensity of lines between the lighter areas near the window. Thick and intense lines indicate darker areas.

The quality of lines depends on the firmness or softness of the pencil, the type of tip, and the pressure applied when you draw. In order to vary line thickness and texture, you can incline, rotate, and twist the tip of the pencil.

In order to learn to modulate lines, you should practice varying their pressure and thickness according to the needs of the drawing, so as to describe volume and tonal changes in the object.

3.2

MODULATING LINES. Lines used to define contours must communicate the nature of the form, its appearance, and the textures of its surface. This means that the interesting forms of the subject must be expressed using lines of variable thickness and intensity.

We will use different gradations of pencils to give greater three-dimensionality and diversity to the subject. Lines are not limited to outlining forms, but also describe the internal contours of the subject, making their unique curved and flat surfaces more understandable.

Finer lines are related to the presence of light on the subject. It is not surprising, then, that the forms seen through the windows have been resolved using very soft lines.

Finally, we stabilize the vertical line of the window frame and draw over the drapes with thicker lines. The modulated line is particularly useful because it can describe the three-dimensional structure of objects, indicating how shapes change and rotate. Drawn by Mercedes Gaspar.

Any object can be defined by its contour or exterior form, but in order to enhance visual reality you must discover the multiple contours that describe its volume or texture.

THE VARIABILITY OF LINES. In simple linear drawings and sketches, you can use a variety of lines to separate different elements. Stronger and more closely drawn lines provide dark shadows, while fine, widely spaced lines create soft, light values.

4.1

POSITIONING THE ELEMENTS. Combining a variety of lines in the same drawing enables us to enhance different elements. Therefore, we will start by drawing the outlines describing each spatial plane, laying the lines we will use to resolve each area.

We sketch the subject with three different lines. We use a thick line for the first element, a medium-weight line for the closer landscape, and one last line, very thin and light, for the horizon. We will start drawing only those contours that are essential in order to understand and to represent the form.

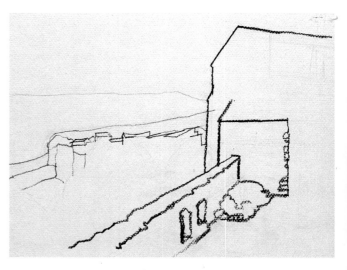

With a 4B graphite pencil, we draw the cross-contours of the stonewall, using a thick shaky line. By using a shaky line we provide information about the texture of the stone. The lines used to define contours transmit both the nature of the form and its texture.

The combination of stick and pencil in the same drawing simplifies the contrast between the thick lines of the foreground and the thin lines of the background.

Many artists prefer using pencils of different degrees in the same drawing to more easily control the thickness and the tones of the lines.

4.2

INTENTION OF LINES. The intention of lines varies, depending on what the artist wants to represent. In some cases, thick lines are used tof show shadows. Inner lines can be lighter in order to describe texture, or they can be made up of broken lines to represent the atmosphere or the loss of definition with distance.

We continue outlining the building with the same thick and intense lines. By making thicker lines, we emphasize the idea of closeness. The line is broader and thicker when there is a shadow. As we draw, we work on some textures of the stone wall.

Again with thick lines, though less intense, we can suggest some textures of the foreground and of the roof of the church. We can draw the vegetation in the middle with an even, medium-weight line that can be achieved using a 2B graphite pencil. The contrast between both lines is unmistakable.

Thick, pronounced lines demand attention. They stand out and appear closer, while the softer lines of the background provide a feeling of distance. The lines that define the mountains on the horizon appear faint and broken to show the loss of definition that occurs with distance. Drawn by Carlant.

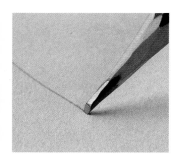

Using a wedge-shape lead and drawing with the flat part, you can achieve a thick line. Using the same lead, but drawing with the side, the line is thinner and finer.

121

SEVERAL EXAMPLES. Now, we'll put into practice different treatments to depict the same subject. We recommend analyzing and practicing them.

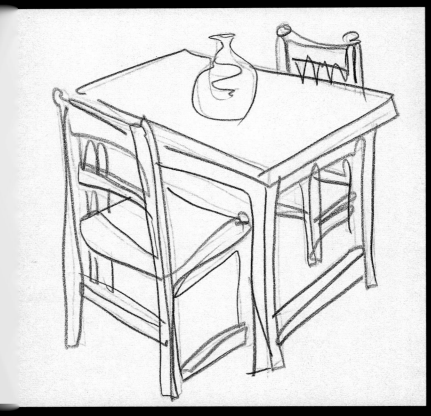

Try drawing with only one continuous line. This will test your imagination and inventiveness. Start from the top and do not lift the pen or pencil until the drawing is finished. You can retrace lines.

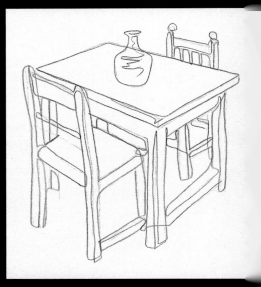

The automatic drawing is translated on the paper as a gestural inscription, using confident and broad strokes to capture the essence of the subject. The spontaneity comes from the energetic movements of the forearm.

The thickness of the line depends mainly on both the pressure applied on the tip and the angle of the pencil. When working with that angle, we achieve a very thick line, but we lose precision.

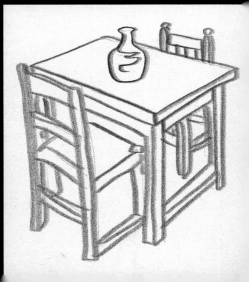

LINE, SPACE, AND INTUITION. There are many tricks used to create the impression of volume and space in a drawing when you work only with lines: breaking the line when you are trying to achieve depth; giving lines a little emphasis when creating a clear outline; hatching the image or working on the same line over and over in order to achieve a shaky contour.

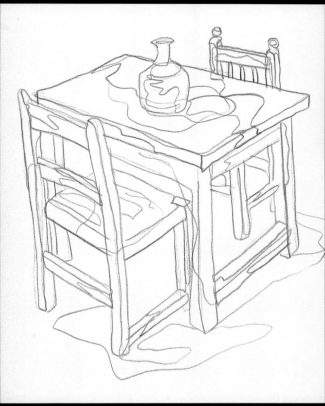

The outlining technique is similar to the curved level lines in a map. They not only outline the contour of the elements, but also define the separation between light and dark areas.

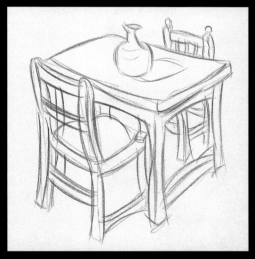

The voluptuous line is awkward, but it provides a very expressionistic effect. The subject is drawn using curves that slightly deform its shape.

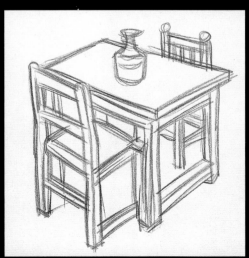

When we draw the subject by superimposing several lines, we are reinforcing the structure. The resulting drawing is very solid and has well-defined angles and edges.

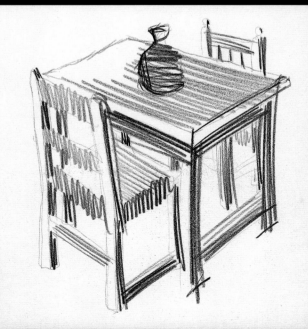

Instead of outlining the objects, the shadows are indicated by hatchings made up of parallel lines. The drawing thus appears very sketchy but well structured. This drawing can be made in only one minute.

URBAN LANDSCAPE USING SCRIBBLES. Hesitant lines and scribbling are a good way of practicing different lines in the same drawing. This drawing must be done intuitively as if it were a gestural sketch. Many artists use this technique when they want to give their work a more expressive and confident mood. Besides, it's fun!

5.1

THE SHAKY LINE. We will work with a shaky line in this first stage. This will provide a bold feel to the first sketch and will create an unsteady drawing, but one that will have a high decorative value, more in agreement with the subsequent use of scribbles.

We will build the cathedral from the superposition of rectangular geometric shapes, with the purpose of achieving a clear construction and of controlling the angles and the proportions of the representation. Using different diagonals, we will indicate perspective. In this phase we use a light brown pencil.

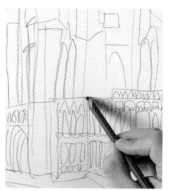

When drawing façades, we apply more pressure with the tip of the pencil. Shapes and structural elements should be drawn automatically, without lifting the pencil from the paper. Despite the fact that this drawing may look clumsy or casually made, there is a certain degree of control.

The architectural details can be as exciting to draw as the buildings themselves. Windows, arches, and buttresses also provide an interesting composition resource (a frame within a frame). In order to emphasize this work, we use a dark brown pencil.

The initial sketch uses a combination of lines made intuitively by the artist. In this drawing, the spontaneity comes from the energetic hand movements that transfer the theme of rhythmic and dynamic lines.

In order to achieve a very expressive wavy line, one should not use a ruler. The drawing will benefit, gaining an expressive quality.

5.2

STRUCTURE AND DETAIL. Any building, as complex as it may seem, can be reduced to a series of small blocks and cylindrical shapes. Once outlined, the building is depicted by gradually introducing the details of the architectural design, in this case Gothic.

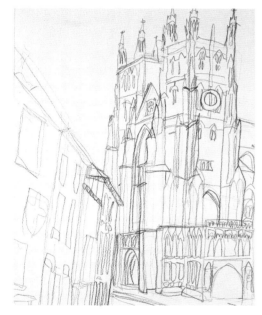

We continue working from the bottom to the top of the paper, pressing firmly with the brown pencil until finishing the cathedral in detail. We render the windows, buttresses, pinnacles, and moldings with much detail, but with little sense of the architecture, dominated by an intuitive gesture and not very meticulous.

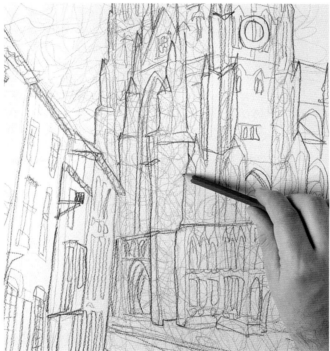

With the tip of the dark brown pencil somewhat slanted, we reinforce the verticality of the building and underline the outline of the buttresses that support the two towers. Then, we scribble lightly but evenly on the paper.

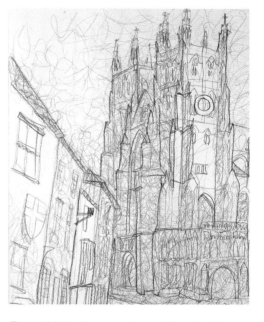

The scribbling is progressive and it invades the façade of the cathedral. Wavy, repetitive, and shaky lines cover the surface of the façade with an initial shade, except the light area in one of the towers. Some of these lines extend to the sky area.

In order to create the effect of scribbling, you have to slightly incline the tip of the pencil. This will avoid an excess of pressure while at the same time preventing strokes from becoming too light.

5.3

SHADING BY SCRIBBLING. We draw connected strokes over the previous structure. From these tangled lines emerges the shape, surrounded by a suggestion of atmosphere. The scribbled lines from the brown pencil contribute to the outlining while creating a sense of surface texture.

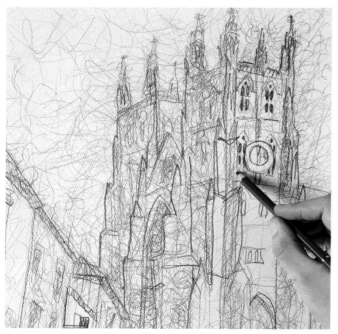

The pressure we apply with the pencil when we scribble is greater each time; this causes the tones of the drawing to get progressively darker. Connected strokes start to become evident in the sky.

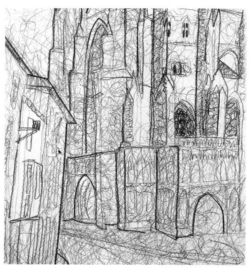

We quickly draw the tonal areas on the façade of the cathedral with undulating lines. Some shorter and slower movements allow the complex tones to emerge from the shaded areas of the building. In order to prevent the continuous scribbling from erasing the structural lines, we reinforce some lines by drawing them more intensely.

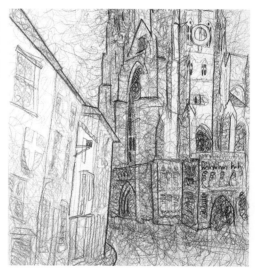

We decided to darken the façade of the cathedral so that it can show a clear contrast of tone with the group of houses in the foreground. Many of these scribbles go over the outline of the building and are integrated into the sky as a gradation.

Scribbles are somewhat risky, but they usually retain a certain degree of control that differentiates them from lines drawn accidentally.

In order to achieve a connected stroke, it is best to sharpen the tips of your pencils more often than usual. The only thick lines that you must have are the outlines of the building.

Using broad intense scribbles, we darken the hollow spaces in the portals and windows, as well as the roofs of the houses. The asphalt of the street shows a clear gradation of tone, achieved by superimposing shaky lines that overlap the base of the building. From this entanglement of lines emerges a finished drawing with hazy outlines and a highly expressive quality. Drawn by Gabriel Martin.

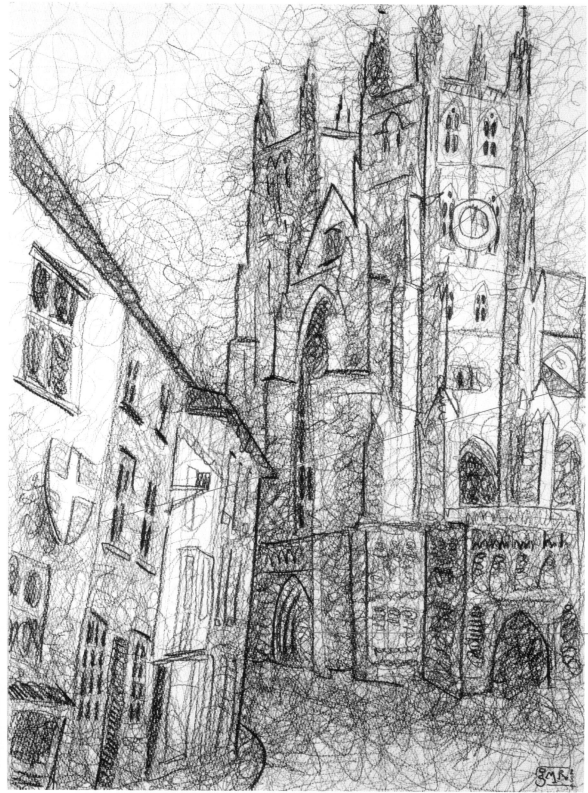

Scribbling is made up of many wandering, swirled lines, which are the result of the movements of the brown pencil on the paper.

If we want to achieve some feeling of volume when using the scribble technique, we must give more clarity to the sunny spots on the façade so that they can contrast with the areas in the shadows.

The façades of the front show hardly any definition. In that way we prevent them from taking prominence from the intricate design of the cathedral architecture, which is the dominant aspect of the drawing.

THE SCRIBBLE LINE. Many artists use scribbling for quick drawings and because it is done without much thought. It is a technique that requires speed and good control of the line. In order to understand this type of drawing, let's look at the most frequent strokes.

When we scribble, we should control the pressure of the drawing medium on the paper. For that, we can draw a box and practice grading using juxtaposed lines that represent a decrease in pressure from right to left.

It is also convenient to practice with vigorous shaky dots that allow a gradation similar to the previous one.

The spiral is perhaps the element most linked to scribbling. Gradation should be practiced by drawing small rounded shapes with the tip of the pencil leaning at an angle on the paper, moving the pencil with unsteady, imprecise strokes.

 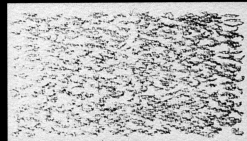 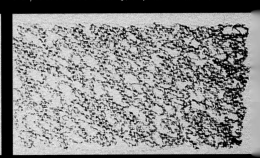

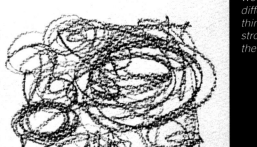

We encourage you to start scribbling, applying different pressure with the pencil and overlaying thin and broad lines. You should do this in one stroke, that is, without lifting the pencil from the paper.

DRAWING QUICKLY.

Many times we are forced to sketch very quickly, especially when the subject moves. The scribble technique helps solve this problem. In addition, the shaky bold lines help to suggest action and movement.

The motion of the figures riding their bikes forces us to scribble in just a few seconds. Although the buildings in the background could be calmly drawn in detail, they must be drawn with the same speed in order to maintain a sense of unity.

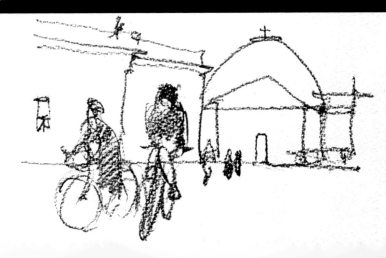

USEFULNESS OF SCRIBBLING. Scribbles are personal visual notes that help us to develop an ability to denote the subject and to develop different linear techniques. It is not necessary to make well-finished or very descriptive figures, or to give explanations about what the figures represent. Speed and expressiveness triumph over academic detail.

SKETCHING THE SUBJECT. After completing the previous exercises, we can now face an actual subject and develop scribbling as a way of taking notes. The most important aspect is to capture the essence of the subject in a dynamic and confident way, without paying attention to proportions or details.

Most sketches are incomprehensible even to their authors. However, since artists have a visual memory that complements the drawing, a few lines or some shadows can recreate in the mind of the artist a vivid impression of the entire scene.

This technique is also very useful when sketching landscapes. You need only remember that the closest objects need more intense lines and those in the distance need fainter lines.

Scribbling transfers the subject to the paper through an inscription of physical gestures made very quickly. Only a few circular shapes, interwoven by a continuous line, are needed to represent a simple still life.

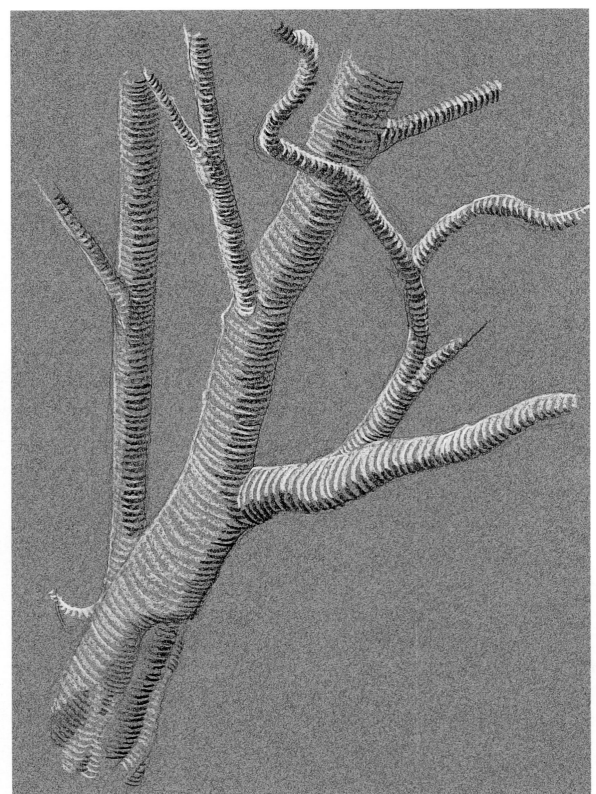

This drawing uses clear spiral lines of white chalk with dark spirals of black chalk in the shaded areas. The technique renders the perfect representation of volume in the branches of the tree.

The detail shows the alternation of white strokes in the light area and black strokes in the dark area. The latter determine the cylindrical effect of the trunk.

SPIRAL LINES. When we draw objects using hatching, the lines must follow an order that can help explain volume. In these cases, the sketching of the object must be made using spiral lines for shading, that is, a group of parallel curved lines that describe the three-dimensional characteristics of the shape.

Spiral lines start from a loop. It is an ideal method for practicing this effect and developing this type of line.

The spiral line is achieved by drawing a curved line in the shape of a C. You need only one stroke with the tip of the pencil. The closer you draw the lines, the greater the effect of volume.

The overlapping of curves or rings produces a sense of volume in objects having a cylindrical appearance.

LEARNING BY DOING

SHADING WITH LINES. The pencil is one of the less complicated and more versatile drawing tools for achieving tonal values. It provides a wide range of light grays, thick blacks, and textures, which can be achieved by drawing lines of various qualities or by gradually shading.

6.1

OUTLINING AND CLASSIC SHADING. When drawing an object in perspective, it is important to study the initial sketch in detail. Once the outline has been defined, we can begin the classic shading, which is hatching made up of parallel lines.

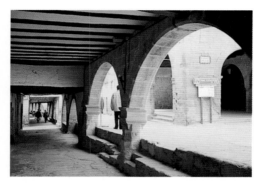

We place the main shapes, taking into account the diagonal lines that define the effect of perspective. The drawing must be linear, concentrating on the architectural contours, which we define in a schematic and proportioned way.

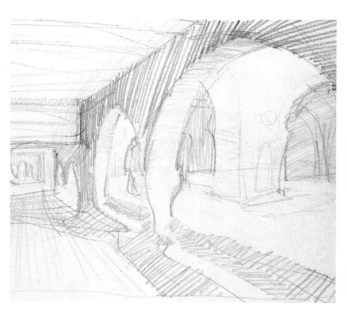

We cover over the main shadow zones of the initial drawing, using the classic shading technique. This is achieved by drawing a hatching of parallel lines that vary in intensity and thickness according to the degree of darkness. It is advisable to work this first hatching with a slightly slanted 2B graphite pencil.

The classic shading technique consists of drawing a short, quick stroke, generally diagonally, in the shape of a zigzag.

The variation in pressure and the distance between the lines of the classic shading technique create various tonal intensities.

6.2

APPLYING HATCHING. In the next step we will put into practice the possibilities of hatching, discovering how the combination of lines creates a singular shading effect. In order to develop hatching we use a 4B pencil.

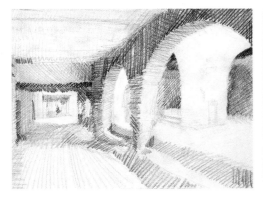

We will apply the cross-hatching against the previous background in order to represent the tonal differences of the shadows. We darken the top part of the arch by hatching lines in a classic manner over the ones previously drawn. The closer together the lines are drawn, the darker the shading becomes.

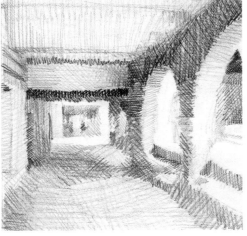

Using softer slightly curved lines, we cover the gallery floor. Using straight vertical lines, we do the same in the ceiling. Hatching does not need to be made up solely of straight lines. We can also use curved or wavy lines to achieve interesting tonal effects.

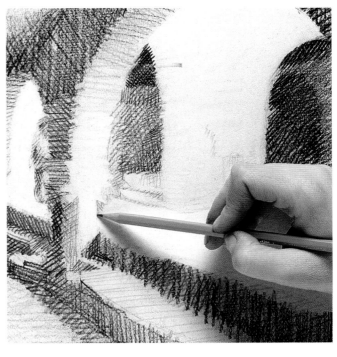

The darkening of each area is progressive. We modify the tone by varying the inclination angle of crossing lines, or by superimposing a new hatching over the previous one. We have respected the façades and the light zones, which still retain the initial white.

It is often beneficial, as a way of preparing, to make sketches that can help us understand the basic shapes of the object and distinguish the main tonal zones.

In order to continue darkening the hatching, we have two options: use a softer pencil and apply more pressure, or superimpose three or more hatchings.

6.3

GREATER PRESSURE. Now we will try to apply more intense tones, using greater pressure with a 6B pencil. This hatching is darker and has thicker lines, made by using a pencil with a blunt tip, or by inclining the pencil slightly against the paper.

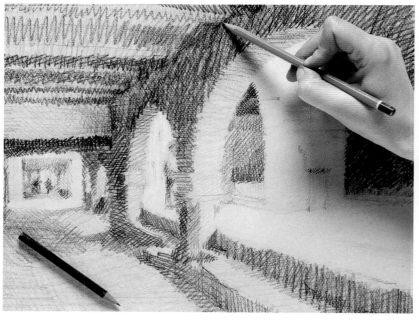

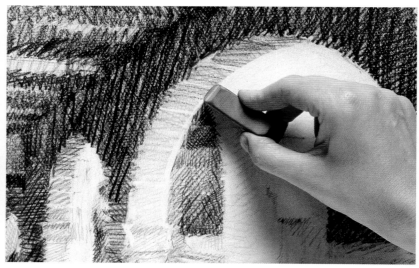

Some eraser effects that will improve the edges are left for the end (between the light and dark areas). This contrast is purely tonal; there are no lines outlining or defining the areas. Contours are achieved by contrast.

We will alternate 4B and 6B pencils in order to represent the joists in the ceiling. We will shade over the previous hatching, drawing thick zigzag lines. Using the same type of lines, we will darken the wall, and using a parallel hatching, we will slightly shade the inside of the arch.

In order to achieve different kinds of hatchings, you need only vary the pressure and the inclination of the pencil against the paper.

In some areas of the gallery, the hatching is made up of a series of clearly visible diagonal lines that create the effect of perspective lines. This effect provides the drawing with greater depth.

When we broaden some light areas, we can see how the cross-hatching is made with a slight pressure. The lines made with the eraser are still visible.

The contrast is kept to a minimum on the light façades for a unified effect. In these cases it is better to suggest than to explain. This effect reminds us of an overexposed photograph.

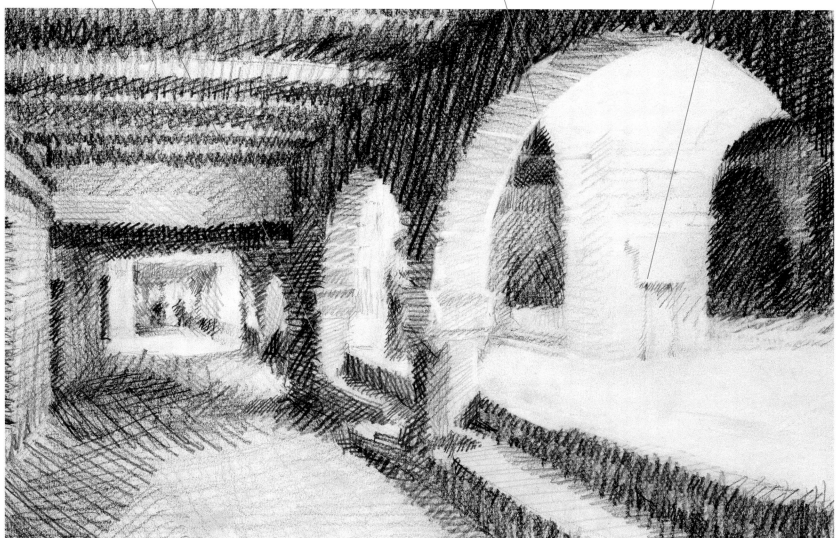

In this finished drawing we can see the quality achieved by drawing using only hatching. These techniques are skillfully combined to make the architectural shapes stand out, to recreate the illusion of three-dimensionality, and to differentiate the range of tones present in each shadow. Drawn by Mercedes Gaspar.

THE DIRECTION OF HATCHING. The orientation of the hatching creates a particular texture for each surface and helps to contrast or define planes. The direction of the hatching should define, if possible, the changes in tone.

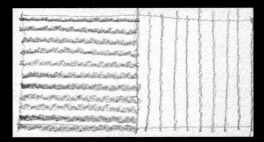
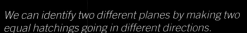

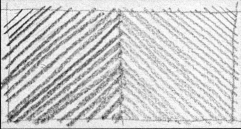

We can identify two different planes by making two equal hatchings going in different directions.

A hatching made up of diagonal lines always offers a contrast with another area treated with the same hatching going in the opposite direction.

The same occurs with two continuous strokes, one vertical and one horizontal. Upon juxtaposing them, we can see a clearly different contour, in spite of the fact that we have not drawn any line separating them.

DENSITY OF THE HATCHING. When the hatching is tight, shading becomes denser, and it covers more, leaving less white space visible.

A cross-hatching using thick intense lines covers much more than one made up of thin fine lines.

The more space we leave between lines, the lighter the resulting tone.

HATCHING. All linear tonal work is resolved using groups of lines, drawn closely together, that have multiple variants. Some lines form screens of various densities, a series of parallel lines, groups of short curved lines, a series of spirals, and so on. They are very frequent strokes that add tonal value to the drawing without departing from the linear treatment.

HATCHING ACCORDING TO PRESSURE. The harder you press your pencil on the paper, the darker the tone of the shadow. Likewise, the softer the pencil, the darker the resulting lines.

When drawing lines, varying pressure distinguishes two different zonal tones. The technique of varying pressure is widely used among artists.

We can also vary the tone by changing the thickness of the strokes, which is achieved by shifting the angle of inclination of the pencil.

The contrast in the hatching made with differing pressure defines space and separates the areas.

HATCHING THAT SEPARATES. The various ways in which a skillful artist can modify hatching make it possible to emphasize contrasts, to separate areas, and to suggest the volume of an object. Let's look at several examples.

Changing the direction of the hatching in an object that has many overlapping areas is very useful in avoiding visual confusion. We can render a stone wall by changing the direction, density, and pressure of the stroke.

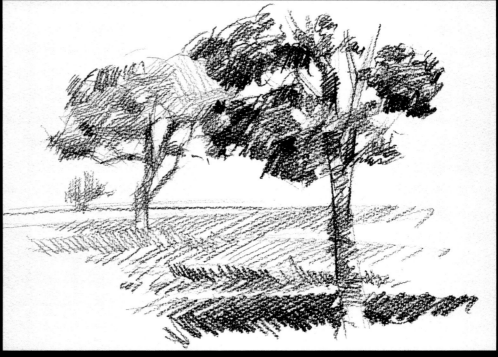

Something similar happens in a landscape. We achieve the feeling of space by using more intense hatching and closely spaced lines in the foreground, and laying lighter, more homogeneous lines in more distant planes.

137

An incised drawing on a scratchboard is the reverse of a drawing made with black ink. All of the hatching techniques and line control used in linear drawings can be applied in this case to obtain middle tones.

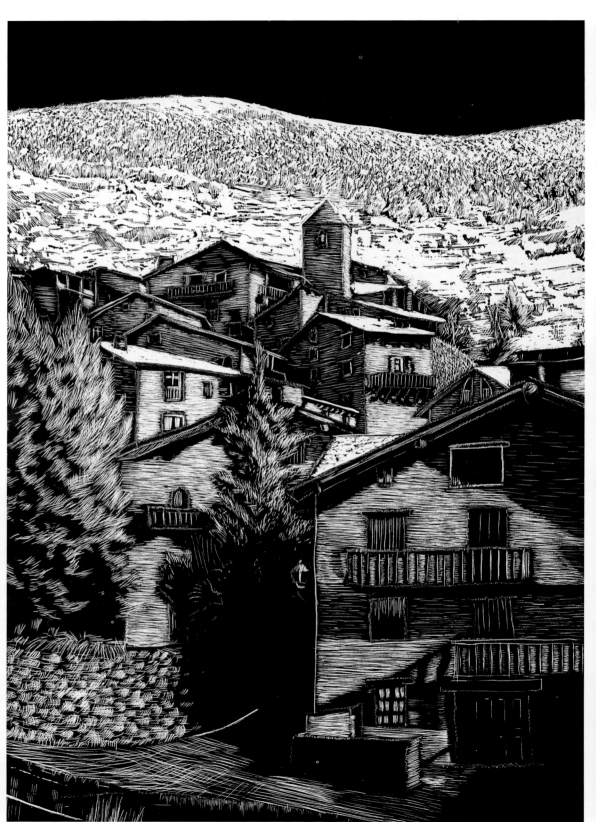

Using a white pencil, we will sketch the object on a small board that has been prepared with a layer of gesso and covered with black ink. Then, using a craft knife, we incise with the tip in order to draw an initial outline of the shapes.

SCRATCHBOARD DRAWING. This is done on a board covered with a layer of black ink. When scratched with a sharp tip, the white underneath is revealed. It is very effective for using hatching or creating pointillist effects.

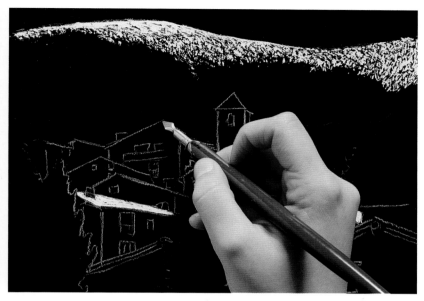

With the pointed edge of the craft knife, slightly slanted and pressing hard, we will achieve the texture of the snowy mountain using a variety of dots and broad lines that produce a pointillist effect.

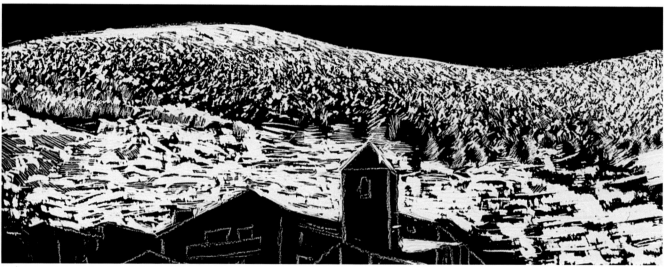

In this technique we do not render the shadows, but the light areas of the object. The black of the board creates the dark areas. We depict the texture of the snowy mountain in the background in a thorough and meticulous way.

We use hatching by juxtaposing different objects, resolved with parallel hatching and cross-hatching, in order to create tone variations on the façades of the houses and roofs.

ARCHITECTURE WITH ORNAMENTAL LINES. The most structured and defined objects are those built by humans: exterior and interior architecture. The construction lines of these objects provide the basic elements of the composition in any drawing. In this sense, the façades of historic buildings provide specific guidelines for spatial organization, the arrangement of details, and the use of a decorative treatment with a series of varied lines.

7.1

GEOMETRY AND PERSPECTIVE. Architectural drawing demands extreme skill from the artist because the artist needs to judge perspective. An artist needs a solid knowledge of perspective in order to create convincing architectural drawings, as well as the ability to interpret the structure of the buildings as if they were superimposed blocks that fit together like a puzzle.

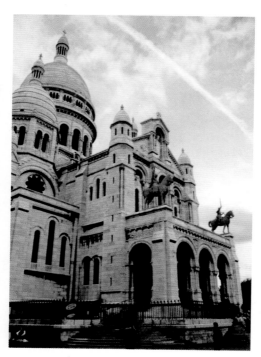

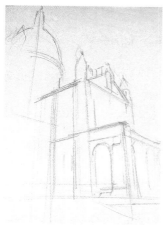

To simplify the problem of drawing complex buildings such as churches and cathedrals, we will reduce them to basic geometrical figures. Any building can be enclosed in a big square or trapezoid block as a step prior to the construction.

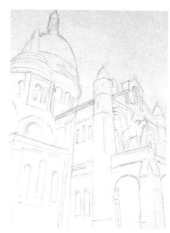

We draw very fine construction lines using an HB graphite pencil. The lines provide a base upon which to build the intricate linear details. The perspective and proportions must be absolutely accurate.

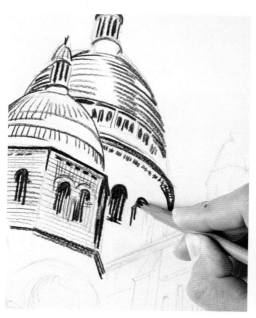

With a charcoal pencil we retrace the contour of the building, using darker lines. We resolve the architectural details and the inside shadows. The lines of the dome follow the spherical shape of the architecture in order to create the feeling of three-dimensional form and space.

The play of lights and shadows on a building makes it appear real and solid. You should observe the object at different times of the day in order to discover which light effects best describe its three-dimensional form.

Perspective theory is complex. Even if you knew all the formulas, you would probably have to incorporate some visual corrections to the drawing to make the object look as we would normally perceive it, instead of becoming a demonstration of the rules of perspective.

7.2

DECORATIVE HATCHING. The texture, light, and volume of the building are created using hatching made up of planned decorative lines that cover each area defining the architecture. Besides registering surface details, light and shadow are used to create a solid structure.

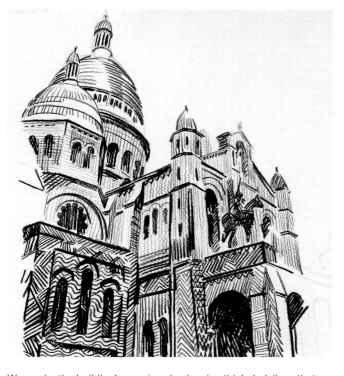

We trace over the drawing with a charcoal pencil. We render the walls using hatchings made up of vertical lines of medium intensity, while the windows have a more intense black. A careful study of shadows provides the drawing with a feeling of strength and grandeur.

We define the architectural shapes and at the same time we extend the shadows, achieved with hatching of wavy, straight, or zigzag lines. The variety of lines and marks helps to suggest the volume of the building.

We render the building's openings by drawing thick dark lines that contrast with the rest of the wall. We emphasize the arches and cornices with thick dense lines. It is important to link the openings and architectural details with the rest of the structure by using tonal contrast.

Arches, columns, and buttresses are not merely decorative items, they support the weight of the building, and therefore they should be outlined using thick decisive lines.

7.3

INCORPORATING DETAILS. This complex drawing must be done in stages. It should be the result of a thorough observation of the general structure and the way in which details relate to it. Often, its history is suggested by the depiction of texture, motif, or detail.

The lower part of the building has a darker tone than the lighter upper part. We emphasize each architectural relief by using decorative hatching achieved with either wavy lines or cross-hatching. Decorative hatching leaves white areas in the façades.

As we draw the lower areas, the lines become broader and darker. It is not necessary to switch to a softer pencil—simply apply greater pressure.

When you draw the base of the building, the hatching is made up of horizontal lines, contrasting with the vertical lines of the walls. By marking over the lines at the base, the building acquires solidity. In order to distinguish cornices and steps, we insert hatchings with zigzag, diagonal, parallel, and wavy lines.

To prevent a theme from becoming fragmented in a series of messy details, you should use similar decorative tones and hatching throughout, which helps unify the composition.

The final drawing shows a solid structure that lifts the building up to the sky, due to the plethora of hatchings made up of vertical lines and to the structure, which has a clear aerial perspective. In order to give solidity to the building, we outline it with a dark line. The dense dark tones of the base help anchor the building. Drawn by Óscar Sanchís.

In the bright façade of the building the hatching should be light, and there must be more space between the lines. We can thereby differentiate this façade from other darker ones.

Apart from the line that defines them, different architectural planes in the building can be distinguished by the change in direction of the lines in the decorative hatching.

Each plane of the building has been exploited for its decorative possibilities, using an exquisite combination of hatching. This approach creates a series of beautiful designs, skillfully connected by architectural outlining, drawn with thick lines.

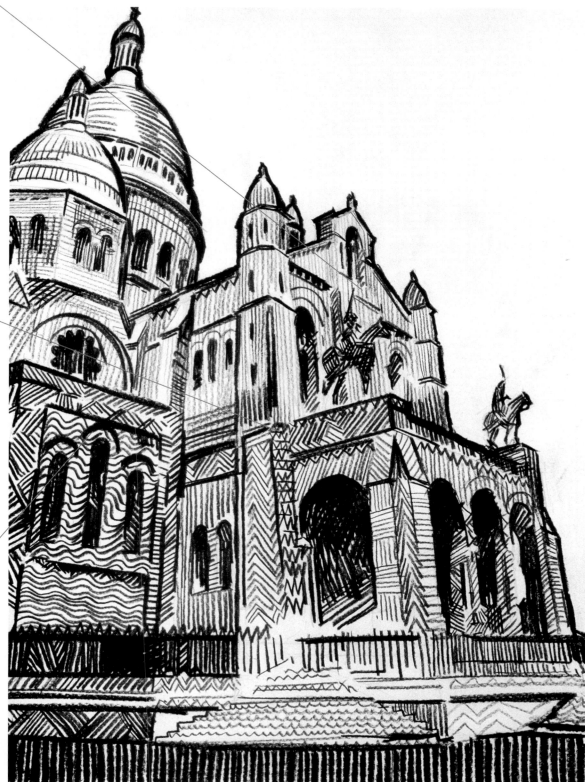

DRAWING HATCHINGS WITH A RULER. In the following exercise we suggest practicing shading using only hatching made up of lines drawn with a ruler. This type of shading, which is applied as if it were a drape covering the drawing, combines hatching made up of parallel lines intersecting at different angles. It is a technique widely used in engraving and in etching, where tones are obtained by means of lines.

8.1

PLANNING AND RESERVING WHITES. It is necessary to render the shape of the object before planning the distribution of shadows. The areas of light and shadow must be perfectly differentiated. The lines you apply will be very helpful when the first hatching is drawn.

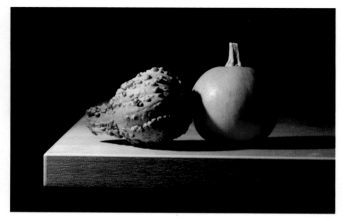

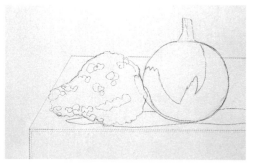

The initial sketch is a planned linear drawing. We not only outline the elements, but we also draw the shadows using internal lines that define their shapes. This allows us to plan the distribution of tones in advance, using these lines as guidelines.

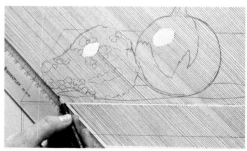

The first tonal effect is achieved by drawing close parallel lines with an HB pencil all over the drawing surface, except in those areas where the light reaches its maximum intensity. In this case, we leave those areas blank.

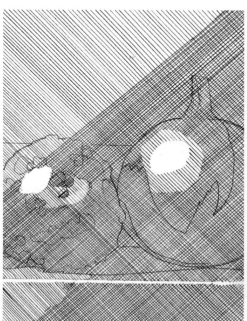

Shifting the crossing of transversal lines modifies the effects created by hatching. The second value is given when you draw new lines over the previous ones.

To achieve the progression of tones we must decide before each new application which spaces we will reserve. In these spaces the previous tone will remain uncovered and will contrast with the new darker application.

You should always use a sharpened pencil. Otherwise, the lines will be too thick and will cover too much of the white of the paper.

8.2

PROGRESSION OF DARK TONES. The progression of darker tones is achieved by superimposing several lines at different angles. Simultaneously, this effect increases with the use of softer pencils and a greater pressure on the paper.

To achieve bright tones, we draw some new hatching, this time with vertical lines using a 2B graphite pencil. The reserved spaces in each application are broader and reveal the effects of previous hatchings.

When we add a more intense hatching, made using a 4B pencil, we notice a clear contrast with the middle tones, which represent bright areas. It is time to work carefully on the wrinkled texture of the gourd, using small tonal patches drawn over the previous shading.

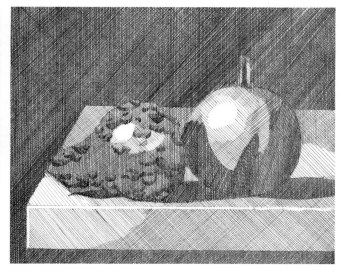

In the finished drawing we can notice the tonal scale and the nuances that can be achieved with this technique. The table appears lighter, so we will render it using only three different types of hatching. Drawn by Almudena Carreño.

The superimposed lines, drawn closely together, connect when seen from a distance, giving the tonal lines a subtle modulation.

THE IMPORTANCE OF CONTOUR. The object's appearance and the artist's interpretation determine the variation of contour lines, revealing the modulations of the surface. When used appropriately, you can sense the three-dimensional qualities of the form as well as its surface texture.

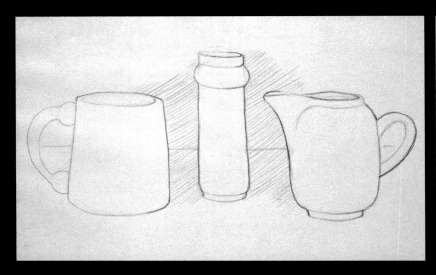

If we want to clearly set the object apart from the background, we must retrace the contour line. This can be accompanied by slight hatching around the object in order to introduce tone.

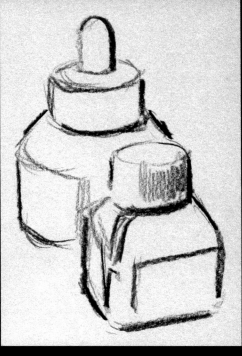

In this other example, lines do not appear to be continuous or homogenous. The variation of intensity and thickness helps describe the volume of the object. The bare patches describe the changes in tension and help to indicate volume.

THE COMPOSITIONAL VALUE OF LINES. Lines play an important role in outlining, and we must keep in mind their role in the composition of the drawing. We need to study the object, deciding what the main lines will be and how they will determine the framing and rhythm of the picture.

This sketch of a landscape clearly shows a zigzag composition. We have retraced those lines that have a greater importance in the composition, using thicker, more intense lines, because they will determine the visual order of the drawing.

H LINES. Lines are the basis of outlining, creating a clear definition and an aesthetic and balanc
d defining the object with a very conventional line, which may cut it off and isolate it from the bac
ented flat, with no modeling. Here are some examples that will allow you to play, discover, and

To broaden the visual and sensitive appeal of the
everal cross-contour lines that describe the advance
part as well as its specific character and texture.

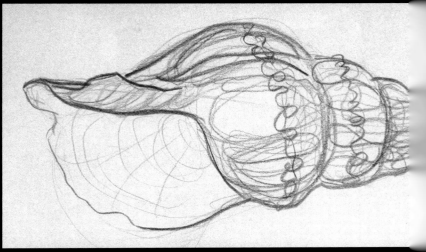

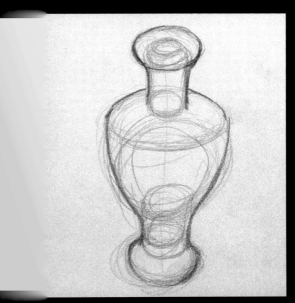

The cross-contours of an objec
intensity than outline lines
information about the decorativ
or tone of the c

It is often advisable to draw the object as if it were
transparent. That means you should also draw
cross-contour lines, which under normal
conditions would be hidden from the viewer.
This method can be best applied when drawing
objects whose shapes are geometrical.

TOUR
vith lines, we should not limit ourselves to just
tour of forms. Some drawing methods do not
contours, emphasizing instead texture and
t.

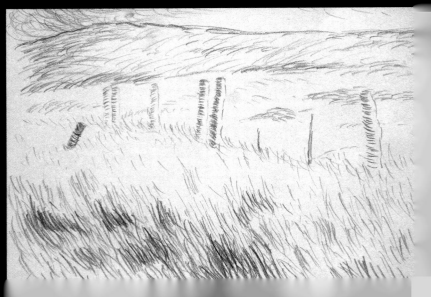

By drawing this landscape with shaky lines that
make the outlines of objects less accurate, we allow
the forms to free themselves from the contour lines
and allow them to integrate with the background,
providing a greater feeling of movement.

We outline the first object lightly, almost as if caressing the paper, with the tip of the 2B graphite pencil. As we draw, we add a hatching of parallel lines, pressing harder where the tone is darker.

With a softer graphite 4B pencil, we will define the shapes of objects, using firmer lines without hesitation. We will spread the shadows of the façades by drawing thick lines, one next to the other, and tilting the tip of the lead.

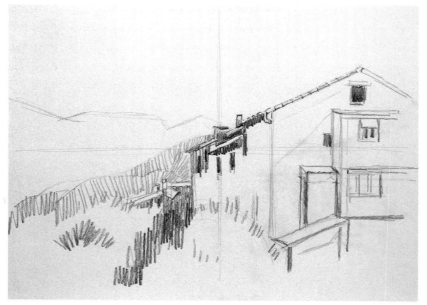

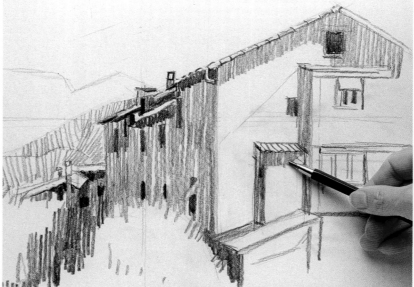

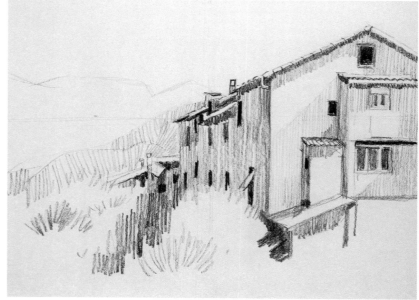

We will vary the pressure of the pencil when drawing the different objects. If it is necessary, we will retrace each object's outline to clearly identify its shape.

LINEAR RURAL LANDSCAPE. The different elements that make up this rural view are presented in a linear drawing that emphasizes the contour of each object. Then, the spatial effect is suggested by light hatching in the shadows of the objects.

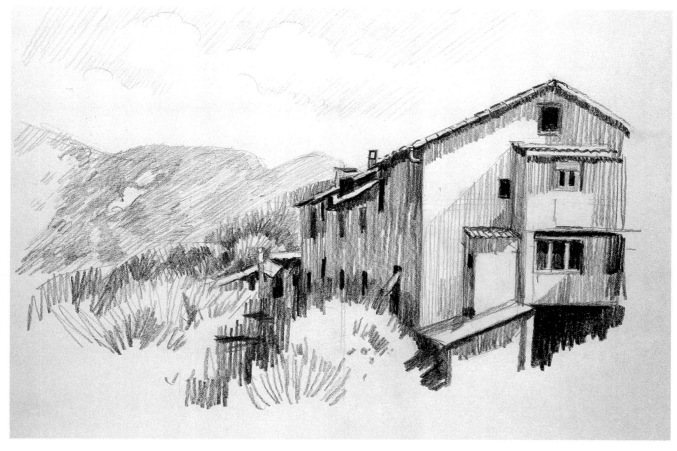

We will separate the different planes by changing the pressure and the direction of the hatching that makes up the shadows. We draw the walls using vertical lines, but we will render the vegetation using a variety of lines. The white of the paper indicates the light areas.

We draw the sky softly. We use diagonal lines, reserving white spaces that the clouds will occupy.

Building
Up with
Tone

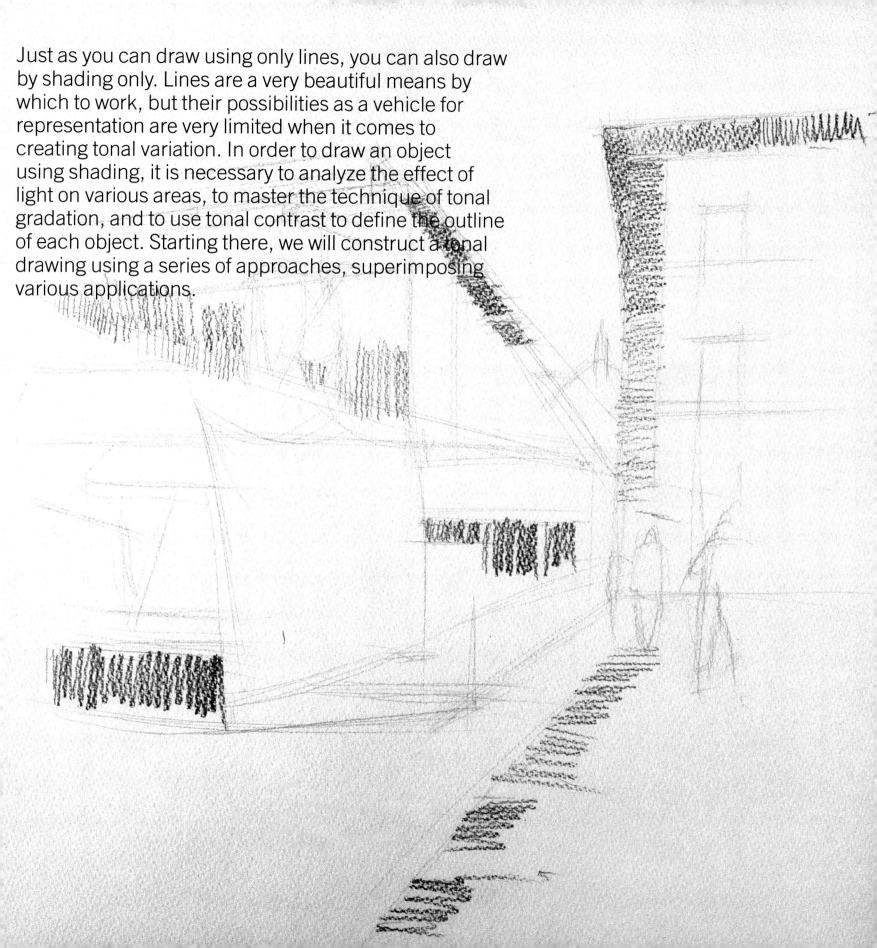

Just as you can draw using only lines, you can also draw by shading only. Lines are a very beautiful means by which to work, but their possibilities as a vehicle for representation are very limited when it comes to creating tonal variation. In order to draw an object using shading, it is necessary to analyze the effect of light on various areas, to master the technique of tonal gradation, and to use tonal contrast to define the outline of each object. Starting there, we will construct a tonal drawing using a series of approaches, superimposing various applications.

BLOCK SHADING USING THREE COLORS. Block shading is a drawing technique that translates shadows into patches of uniform color. In order to achieve a variety of tones, we will use three colored pencils on gray paper. By superimposing these three colors, we achieve three different tones, which allows us to work each area as if it were a field of one color. A very expressive effect is achieved when we juxtapose the different fields.

9.1

DARK PATCHES GIVE STRUCTURE TO THE DRAWING. To create this drawing with colored pencils, we must start from an initial sketch that defines areas of light and dark. Using the darkest colored pencil, we will first delineate the darker shadows as large color fields, giving structure to the drawing.

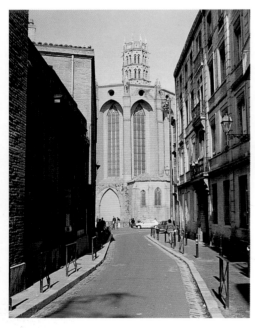

We build up the first shadows with a brown pencil. We interpret the shadows as if they were geometric masses of an intense uniform color.

To draw block shadows, we need a pencil drawing in which we can clearly distinguish the two contrasting areas while retaining a sense of their shapes. We must forget lines and build the drawing with shading alone.

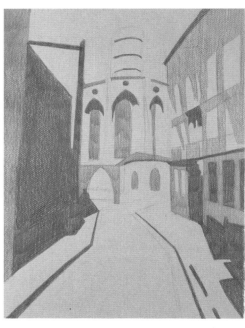

To the previous shading we add a second uniform tone to the façade on the right and the church apse, using the same brown pencil but with less pressure. We now begin to see a resemblance to the object.

To achieve middle tones, we apply less pressure, using the tip of the pencil on the paper. Thus, the color of the stroke is mixed with the color of the paper.

These are the values we will use to construct this drawing, using block shading. You should practice creating small tonal scales in order to know beforehand the possibilities of your medium.

9.2

TWO MORE COLORS. New color applications will balance light and will give a three-dimensional appearance to your drawing. Gray complements the values of brown. White gives contrasting highlights.

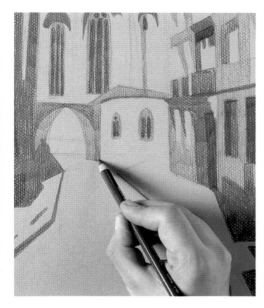

We will use a second color: a darker gray than that of the paper. Using this color, we will finish the details of the church windows and we will darken some windows and balconies on the façade at the right. For compositional reasons, we will draw two square shapes on the dark wall at the left.

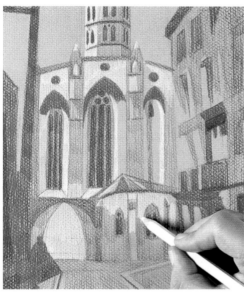

The role of whites is to depict light, to highlight shapes, and to suggest their volumes. For this reason, we will cover the lighter façades in the composition with whitish shading that defines the brown initial edges even more. You should not color all the façades a uniform white. You need only a few touches to achieve the desired effect.

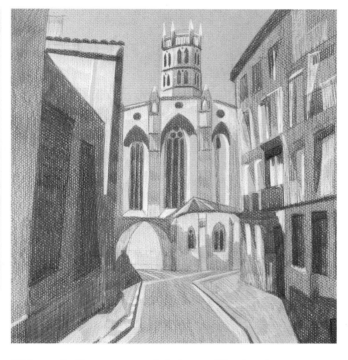

White applications are concentrated around the church apse, drawing the viewer's eye to that point. To finish the drawing, use a medium gray to render the asphalt in the foreground. Drawn by Gabriel Martin.

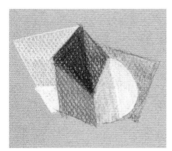

The volume effect in the drawing is achieved by contrast. A color will describe a contour, plane, or outline, depending on the color next to it.

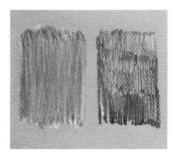

When two colors are superimposed, you should work on small areas, trying to achieve as much uniformity as possible.

153

CUBIST SHADING. The Cubist movement imposed a structured system of shadows, using closed geometric forms and dominant straight lines characterized by solidity, balance, and order. This also helps to define planes and to achieve efficient spatial resolutions.

10.1

GEOMETRY AND WEIGHT. The drawing acquires both solidity and mobility in its composition due to the aesthetic use of geometric shapes. This is reinforced in the first dark areas, treated as highly contrasted blocks.

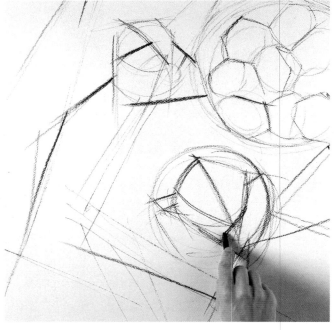

The elementary outline of the objects is based on straight lines that usually link each shape with lines in the background. The shapes, with sides and planes made up of straight lines, are easily drawn, and their spatial development extends beyond the contours of the object.

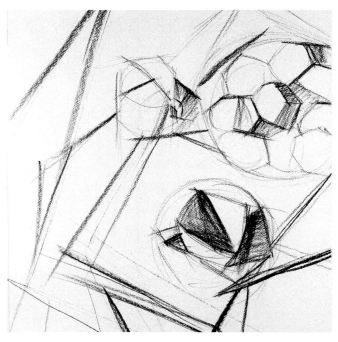

We reinforce the previous structure with darker, thicker strokes that emphasize the construction of diagonal lines in the drawing. Due to the planned geometric structure, there is visual action both inside and outside the contours of the objects.

In order to draw a Cubist still life, the first step is to reduce each element to very simple shapes. Then the outlines can be made over this initial drawing.

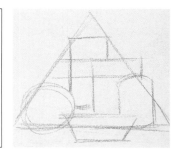

10.2

GEOMETRIC SHADING. Shading, rendered as blocks of flat geometric shapes, creates contours inside objects where the inner planes are combined with the outer planes to create a greater feeling of space.

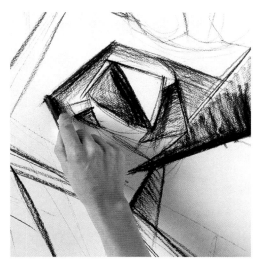

The first shadows should be applied in blocks, closed by a geometric shape that limits them. You should indicate the masses of dark values by using broad shading of defined contours. The shadows are presented as geometric shapes that distort the object and add rhythm to the composition.

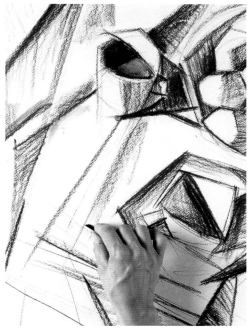

Highlighted areas advance due to the continuous action of dark tones. Each area expresses an active meaning depending on its relationship to the adjacent area. There are several shadows: the ones that emphasize the diagonal lines of the tablecloth folds with thick strokes, the flat shadows of the fruit, and the rough but effective gradation of the cups.

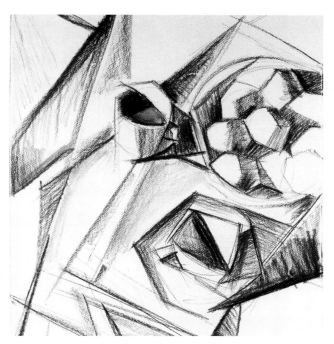

In the tablecloth folds, some shadows appear to have been blended, mitigating the strength of the accompanying lines. In the rest of the shadows, dark areas alternate with light areas to increase the dramatic effect of the composition. The entire composition has been crossed with diagonal straight lines, connected in such a way that they create a dynamic visual effect. Drawn by Esther Olivé de Puig.

The fragmentation and the later recomposition of objects can create a distortion of form, so that the contours of objects are not completely clear.

SOFT SHADING. The first shading effect must be very soft. You should continue with progressive darkening. This method is recommended for beginners as it avoids errors.

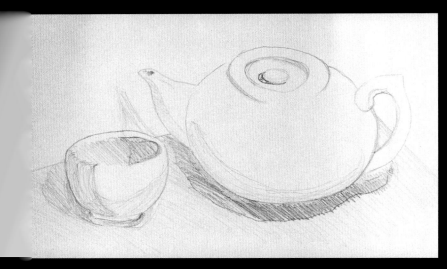

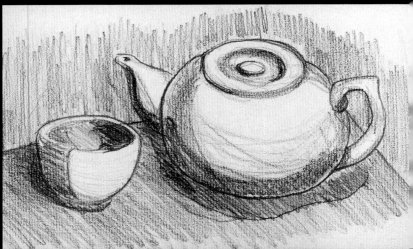

In the beginning, the linear work hardly provides tone information. It is best to first draw some very soft shadows and to shade with the tip of the pencil, slanted at an angle.

We continue working with the pencil, paying attention to shadows. You need only two or three values to achieve an initial tonal approximation of the object.

DARK AND CLEAR TONES. It is necessary to learn how to correctly use the different tonal values, and to keep in mind that darks will be more intense in the darkest shadows and more subtle in the lighter areas of the object.

The difference between dark and light tones is the basis of the modeling and the effect of volume in an object. Dramatic contrasts between two tonal intensities usually are softened using a light gradation.

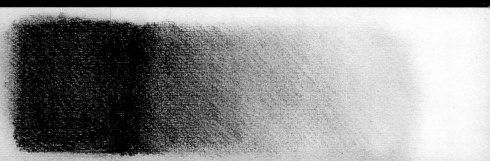

On an area previously darkened, we can lighten a tone by erasing with an eraser.

CONTROLLING THE TONES OF THE DRAWING. Creating a range of tonal values in a drawing is accomplished by varying the intensity of the shading, achieving either an atmospheric or a contrasted effect. The tonal differences suggest the volume of the objects in the composition.

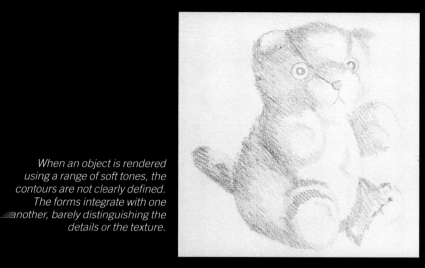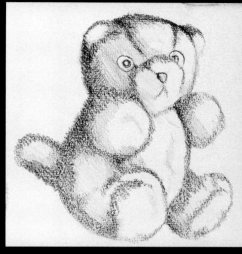

When an object is rendered using a range of soft tones, the contours are not clearly defined. The forms integrate with one another, barely distinguishing the details or the texture.

When the tones intensify, the object is clearly separated from the background, and its volume, interior forms, and small details are revealed.

INTENSIFYING TONE. Choose a simple subject and try to render it by progressively darkening the tone, as if developing a film. Notice the increase in contrast and in the three-dimensionality of the objects.

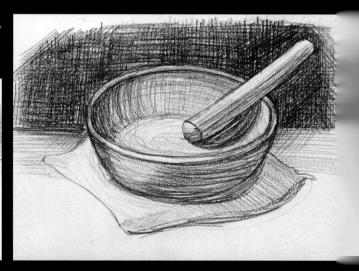

The first value is light, made by barely pressing on the paper. Its only objective is to place the shadows

On top of the previous drawing, we add the middle tones, pressing progressively harder with the

We complete the tonal range by drawing more intense tones. We can distinguish three different tones, enough to give the object a sense

SILHOUETTING LIGHT TONES. If we draw the shadows of a subject, leaving blank the lighter areas of the composition, we are also inadvertently drawing these spaces of maximum light, because of the effect of silhouetting. Thus, shadowy spaces and the ones that have not been touched become equally significant. The following exercise provides an example of this approach.

11.1

DEFINING THE HIGHLIGHTED AREAS. We decided to preserve, using the white of the paper, those areas that receive more light; this makes it much easier to differentiate the lights from the darks. After applying a general shading, the highlighted areas are silhouetted and defined by the gray shading.

After analyzing the subject, decide what highlighted areas you will leave blank. Let's start the drawing by producing a simple linear sketch with an HB graphite pencil. We then create the first shadows as hatching.

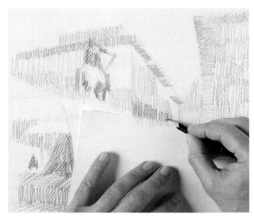

The middle tones are established with a 2B graphite pencil. This means covering the areas of medium intensity with new shading over the previous shadows, in those areas where the shadows show darker tones, but without achieving a complete black.

Using more generalized shading, we establish the main contrast between light and dark. Upon shading the surroundings, the shape of the light areas are defined by the dark planes.

You should focus on the forms and shadows of the surrounding space, and also the silhouette of the form, without paying attention to the body or subject itself.

11.2

ADDING MORE VALUES. On the previously shaded subject, we have sketched the planes of each shadow, and we now add new darks, this time much more contrasted and superimposed. We resolve each area with appropriate strokes for its plane.

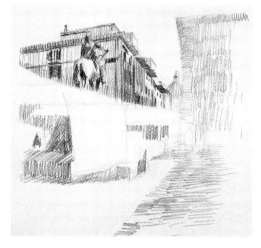

When drawing the shadows of the spaces, without realizing it we outline the light areas. So far, the façades have been resolved by shading them evenly. Now, we will draw the windows, the baseboards, and the cornices. In order to separate values, we will change the direction of the hatching and we will intensify the pressure of the stroke.

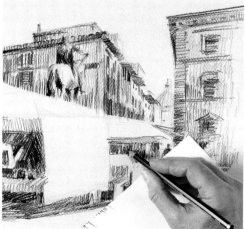

It is time to build up most of the tone using a 4B graphite pencil. We will intensify the dark areas in the windows and the dark area under the cloth. It is advisable to put a piece of paper under the hand to prevent it from smudging the drawing when it rubs against the paper.

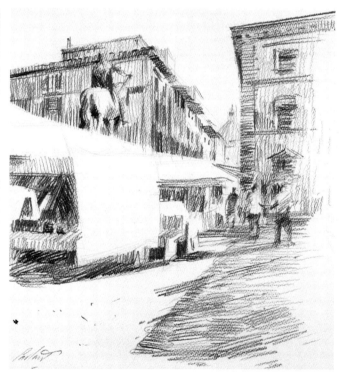

Although it is important to consider all drawings as a unified entity, it is also essential that each detail is resolved using a good sense of observation. Therefore, artists must reserve hatching or strokes for those areas where they are most appropriate. Drawn by Carlant.

Some strokes are straight, some are curved, some are long; they are short, thick, or fine, and they form hatching or zigzag effects. They are used for one reason: to give character to the surface textures that we want to draw.

TREES IN THE LANDSCAPE WITH GRAYS. The shading of a landscape with vegetation usually poses serious problems for new artists, because they do not yet understand the simplicity and variability present in tonal areas. Also, the development of some elements, like trees, and the combination of finished areas with others that are barely outlined add further complications. In this exercise we will show how to shade the vegetation in a simple way, working with graphite sticks of various gradations.

12.1

WIDE SHADING. Instead of starting with small shading that defines details, we will work with wide areas of shading, grouping objects in masses and creating areas of light and dark in juxtaposition.

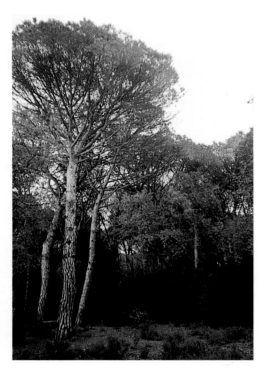

We represent the background vegetation in a sketchy manner and we draw the trees in the foreground. When their location is right, we redefine them with a more confident stroke.

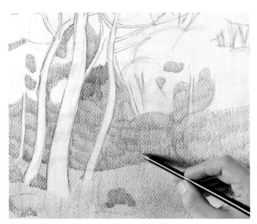

Once the tree trunks are perfectly rendered, we start the first shading in the vegetation of the background, using even grays. We work on the first shading with a 2B graphite stick.

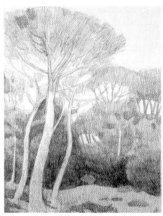

Our preference is to cover the vegetation in the background, forming a darker gradation in the lower part. We build in a lighter gradation as we move toward the top of the tree. In these first stages of drawing, we are not as concerned with achieving intense darks as we are with achieving shades of gray.

Ideally, in order to achieve shades of even strokes, you should use a pencil sharpened in a bevel, drawing on the paper with its flat end.

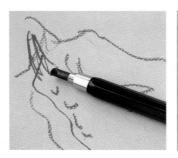

Darks can reach a very intense density of gray with a graphite lead, depending on the gradation of the pencil that you use and on the pressure that you apply on the paper.

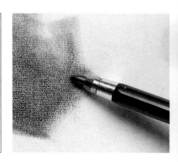

12.2

DEFINING OUTLINES AND SHADING. The outlines of the trees are redefined using a soft but decisive stroke. The shadows and the contrasts are intensified. To darken it is best to work with a 6B graphite stick, which is much softer than the one used in the previous stage. Because of its softness, it will not be necessary to press too hard to apply darker shading.

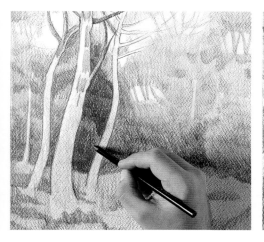

Shorter and more precise dark areas are needed for the top of the pine tree in the foreground. Observe the evolution of this detail during the drawing process: the darker the tone surrounding the tree, the lighter the trunk seems.

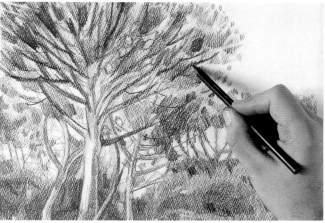

We draw the texture of the foliage, superimposing shadings of variable intensity, and the bark, with softer strokes, applying hardly any pressure. We also extend the contrasts in the grass, where some groups of weeds contrast sketchily.

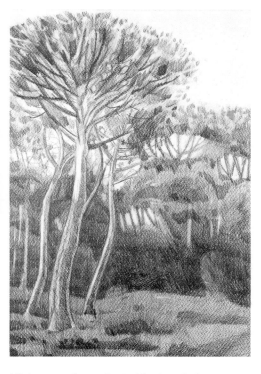

We increase the contrast of the trees in the foreground. The light areas in the bark are made lighter with the eraser. We carefully draw the tree branches with even shades of gray. The tonal changes of the foliage are expressed sketchily without giving textural detail. Drawn by Gabriel Martin.

Use the eraser to open the light areas between the tree leaves and to clean the sky.

DISTRIBUTION OF SHADOWS. The first contrasting effect is achieved with the first shading. The objective is to create the first hint of shadows with contrasting but less precise shading. These are preliminary states that serve as rehearsals and must not be considered complete.

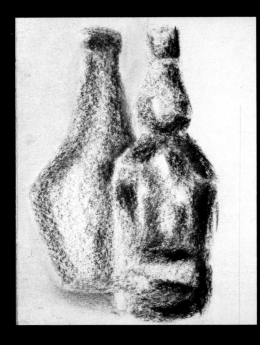

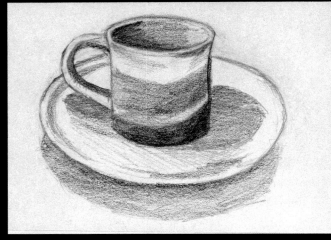

When drawings have lines, shading gives information about the body of the object or emphasizes some contours through contrasts in tone, as happens with the lower part of the saucer or the upper part of the cup.

When drawings do not have lines, shading is a good method for defining an object. In this case, using a charcoal stick you can represent the shape of the bottles, which clearly stand out from the white background of the paper.

CONTRAST OF PLANES. The contrasting effect created by shading is a very common tool to differentiate an object from the background or from various superimpositions of objects. When we treat each plane with shading of a different intensity, we are representing objects using contrast, and we avoid confusing the viewer.

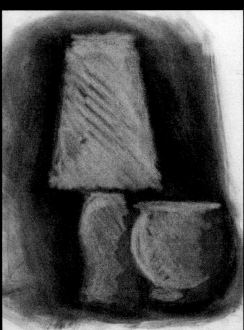

There are two clear methods to separate an object from the background. The first is to work on a very dark background. Lighter objects stand out, thanks to the erasing effect.

In the second case, the background is covered with soft shading, while the object appears with darker shadows. This method is highly recommended when working with charcoal.

SHADING AND CONTRAST. It is necessary to control the effect of contrast while shading in order to achieve
An important difference between one or more tones could be crucial in understanding the form of an object
guishing it from the background. Since the contrast is based on the difference in tonal value, you should unc
to use this tool to emphasize the shape of the object.

EXPLAINING RELIEF. Shading should not merely be an instrument
to define the contour of an object through contrast. It also acts inside
the object and on the surface, to add information about the quality
of the object.

To avoid confusing observers when different objects appear to be superimposed, we represent each object by shading with varied intensity. This way, the lamp seems darker, while the background, made up of a middle tone, defines the clearer rectangular shapes.

Something similar happens with the hat. Shadows provide information about its creases and texture. This allows us to conclude that it is a somewhat old and worn hat.

The small shadows provide essential information about the object. Here, the small shadows on the tube indicate that it is not full. The depressions on its surface indicate that some of its contents have been squeezed out by the application of pressure.

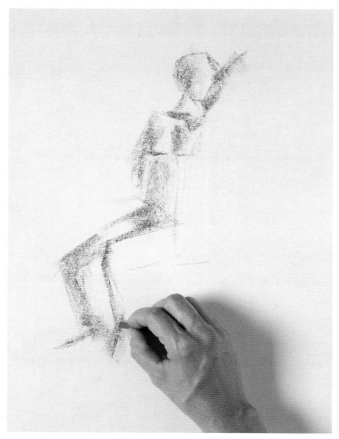

When we start the drawing, we must completely forget the contour of the figure and concentrate on reproducing the shaded area with a thick, wide stroke. Details are not important, only the shadows and the gestural indication of the pose.

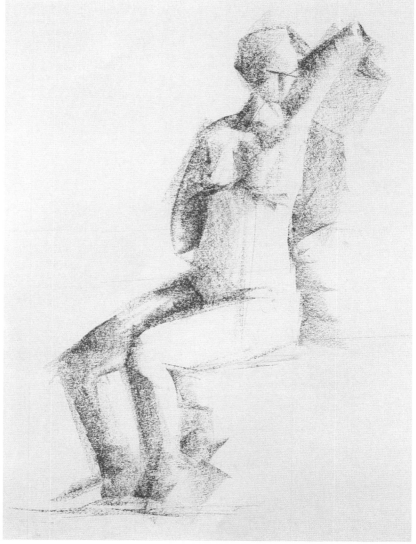

To finish the definition of the highlighted contour of the figure, instead of using a line, we shade the surrounding background, as if it were an aura. Then, by contrast, the white of the paper from the light area will stand out.

BUILDING FORM WITH TONE. The play of lights and shadows on a figure that is illuminated by a lateral light provide perfect conditions for creating a form using only shading. We will achieve this by working lengthwise with a Conté crayon.

The most appropriate way of working with Conté crayon in order to achieve wide areas of shading is to draw with the stick flat against the paper. If we shade using the tip of the stick, we must use the worn tip, held at a 45° angle.

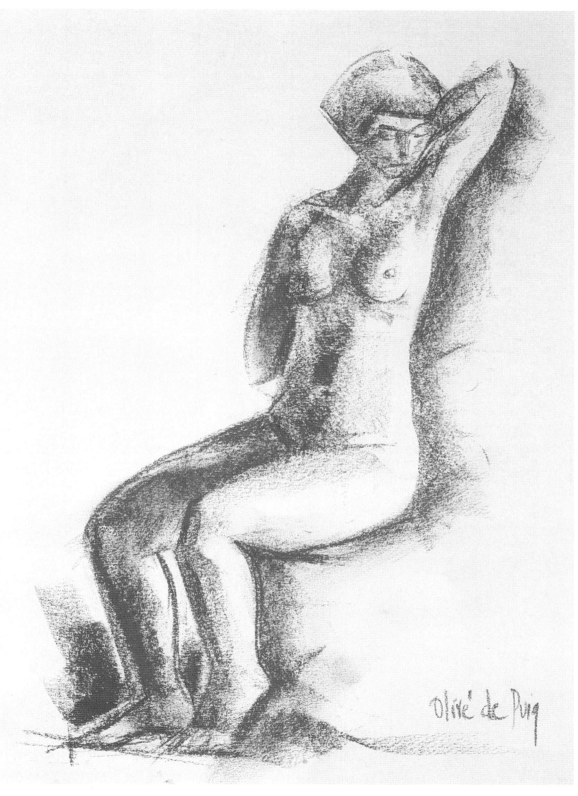

We must drag the stick while pressing hard to separate the light area from the dark one. To achieve better control, use a small piece of the crayon. Use the tip of the stick to create the final lines that define the figure.

AN INTERIOR SCENE USING SHADING. Just as with a drawing made up solely of lines, in which the artist must become familiar with linear forms, a drawing built with wide charcoal shading requires familiarity with tonal techniques. This method of drawing offers a range of tonal values that with practice will provide a wealth of options.

13.1

BASIC CONTOUR OF THE INTERIOR. We will make a basic drawing of the interior of the room, using broad strokes that we achieve by working with the side of the charcoal stick. We define the light and dark areas in a generalized manner.

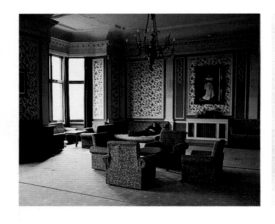

The lighter areas, the floor and the windows, remain free of charcoal. In the rest of the space we apply grays of varied intensity. We use the side of the charcoal stick, applying very little pressure, to create a subtle tonal layer of charcoal that covers a large part of the frame of the scene.

We extend some strokes with the tip of the stump charged with charcoal. The position of the window frames must be very precise. In the rest of the drawing we spread soft shading with charcoal and blend it using the side of the stump.

Even though charcoal can be messy and difficult to preserve, its capacity to reflect tonal gradations is so great that it is worthwhile to learn to use it effectively.

The quickest and most common way of shading with charcoal or chalk is to drag the stick lengthwise. It is applied from side to side, creating thick, broad strokes.

13.2

IMPROVING DEFINITION. We will reduce the brightness of the paper without increasing contrast too much. The objective is to create a limited image that seems to consist only of light and darkness. While we work we will add new shadows so that middle tones begin to appear, which will improve definition and will outline the form of the objects in the room.

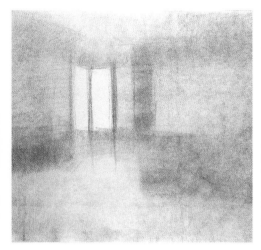

Once we have a base of charcoal, we use the stump to create hazy shading, as if a dense fog has invaded the room.

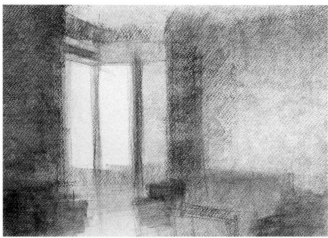

We split the charcoal stick into two equal pieces to achieve narrower strokes and to progressively make the forms lighter. We first define the backlight from the window by darkening the wall on the left. We do the same with the furniture. Using very generalized strokes, we mark the dark area with not very accurate edges.

With the tip of a charcoal stick, we will continue building up the form of the furniture. Charcoal always gives off a matte gray, with very little gloss or luster, and that can only be darkened by intensifying the pressure or by shading over the same place on the paper.

Using the tip of the stump charged with charcoal we can shade and draw subtle lines. The dirtier the stump, the more intense the shading.

13.3

FROM LIGHT TO DARKNESS. Now we will work with darker shading. The definitions of the shadows around the objects become more evident when we apply new layers of charcoal. The edges where dark and light planes meet are reinforced and touched up, and we achieve greater contrast and consequently a better spatial definition.

After the general distribution of tones, we reinforce them by using a small charcoal stick with a rounded tip, thus avoiding unintended strokes. We work with the flat stick, pressing harder in those areas that should be darker: the painting on the wall, the wall on the left, and the shadows cast by the furniture.

With a small piece of charcoal, we will vigorously reinforce the general tonality of the interior, as well as the darkened edges of the furniture and the shadows they cast on the floor. Because the ceiling and the floor are lighter in tone, they define the walls in the background.

We add some rather imprecise straight thick lines that reinforce the perspective of the room. A general patina is applied to the right of the wall in back, rubbing the surface with the side of the stick to make the grain of the paper more visible.

The pressure applied with the side of the stick should be moderate, never too heavy. You should not completely cover the grain of the paper. Absolute blacks are excluded from this drawing.

In the final drawing, the use of shading has surpassed the limits of linear drawing, establishing a range of elements. The tonal value scale is very broad and the contrasts are strong in some areas of the drawing. Drawn by Carlant.

In some areas of the drawing, tonal differences are very subtle. Two planes that have a similar tonal value blend into the same shading.

The linear effects of furniture are achieved by contrast, that is, through the abrupt change between two different tones.

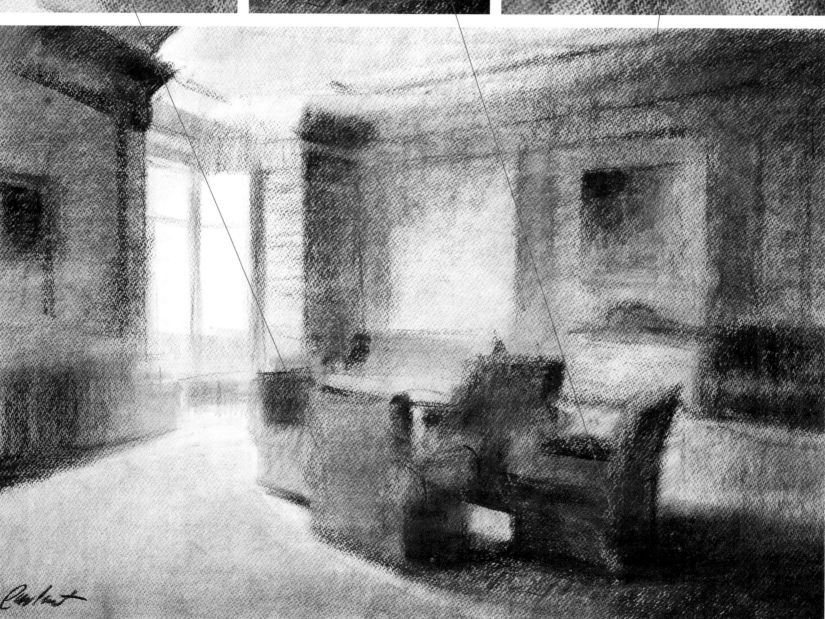

SHADING WITH PASTEL (IN THE STYLE OF SEURAT). French Impressionist Georges Seurat was an innovator in the use of pastel sticks on grained paper. Using black pastel in a tonal way, he formed surfaces and achieved a type of pointillist effect based on the contrast of dark and light. He thus subverted the dominance of the line. In this exercise, we will put his technique into practice depicting a figure on grained paper.

14.1

DARK AREAS. In the first stages of the drawing, it is not important to create intense darks. It is much more important to resolve the dark areas using a uniform gray. This prepares the path to follow in order to define the forms.

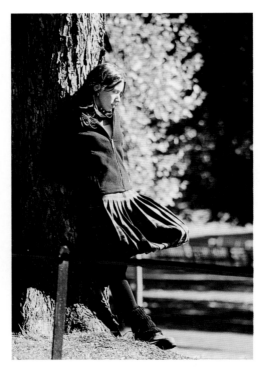

We separate the main parts of the composition, defined by shading made with the side of the pastel stick. With a slight zigzag movement, we represent the figure and the contour of the tree, and by rubbing we create the dark area in back.

Working with the side of the stick, we create the main groups of shadows. This first stage of drawing is essential for the rest of the composition, because the contrast between shadows and light areas constitute the fundamental balance point.

Once shadows are positioned correctly, the drawing becomes more solid when the shadows are blended with a cotton cloth. The pigment in chalk is best absorbed by the paper. This is a good base on which to continue progressive tonal values.

Working on grained paper using the side of a pastel stick is ideal for creating tonal notes with interesting atmospheric effects.

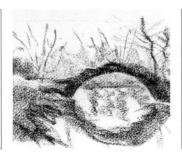

When drawing lines with pastel sticks, you should avoid drawing with the tip. Draw with the flat side of the stick to achieve grainy thick strokes.

MATERIALS FOR EXERCISE 14: cotton cloth or paper towel, stump, black pastel stick and pencil, white pastel stick and pencil, and an eraser

14.2

SHADING WITH INCREASED PRESSURE. We continue working with the side of the pastel stick, creating uniform tonal effects, increasing the pressure applied on the paper depending on the darkness of the shadow. Pressing with the pastel stick, we can almost completely cover the grain of the paper.

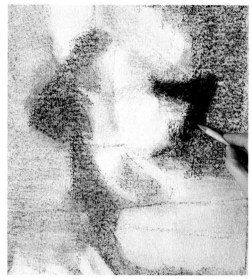

After the initial uniform shading, using the flat pastel stick, we add new shading at the left edge of the figure and the background. In order to darken these shadows, we rub them using a stump until we cover the grain of the paper.

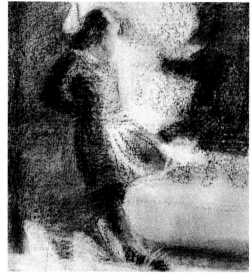

We build up the drawing in layers woven together by shading. We incorporate the first strokes on the folds of the clothing and on the trunk of the tree using the tip of the pastel stick.

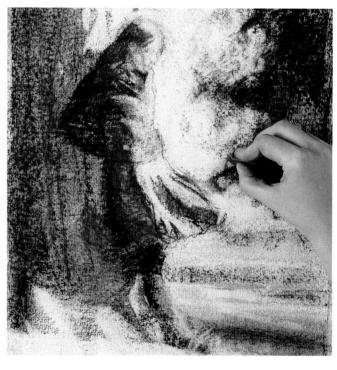

We work with the pastel pencil, with the tip somewhat slanted to better define the edges of the figure. Constant transition between the different degrees of density of shadows allows us to differentiate the folds in the clothing, the tree trunk, and the vegetation covering the background.

By superimposing shadings we can achieve a glazed effect. The tonal value increases, and the amount of visible grain of the paper decreases.

The stump closes the pores in the paper completely, creating a much more intense tone.

14.3

SHADOWS WITHOUT DRASTIC CHANGES IN TONE. The raised surface of grained papers allows the artist to work repeatedly with pastel in an area where two tones meet, so that they blend. You can blend tones by rubbing a tone on the contour of the adjoining one, so that both areas can meet without drastic tonal changes.

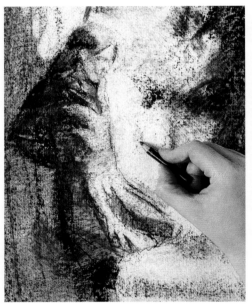

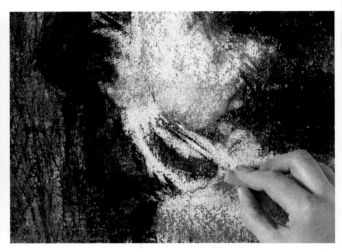

Darks created with pastel can reach a density close to absolute black, depending on the pressure with which we apply the stick. In order to balance this effect, we work some areas with a piece of white chalk, further blending the contour of the figure.

Strokes are more linear now and are darker. Instead of rendering details and nuances, we reduce the composition to a group of light and dark areas that combine and are juxtaposed. We use the pastel stick to describe the folds of the clothing and the form of the head.

If we analyze the drawing at this stage, we will realize that there are two kinds of shading: one is achieved by using the tip of the stick or pencil, drawing masses of strokes that are then blended to build a tonal mass; the other type of shading is created by working with the side of the stick and blending with the stump.

When we rub the stump on a shaded area, the tone becomes more intense because it compresses the pigment, covering the white of the paper.

We have reduced the details to the point of making the figure almost unrecognizable in the highlighted area. The textured effect of the paper grain harmonizes and integrates all the tones in the drawing, producing an atmospheric effect. Drawn by Mercedes Gaspar.

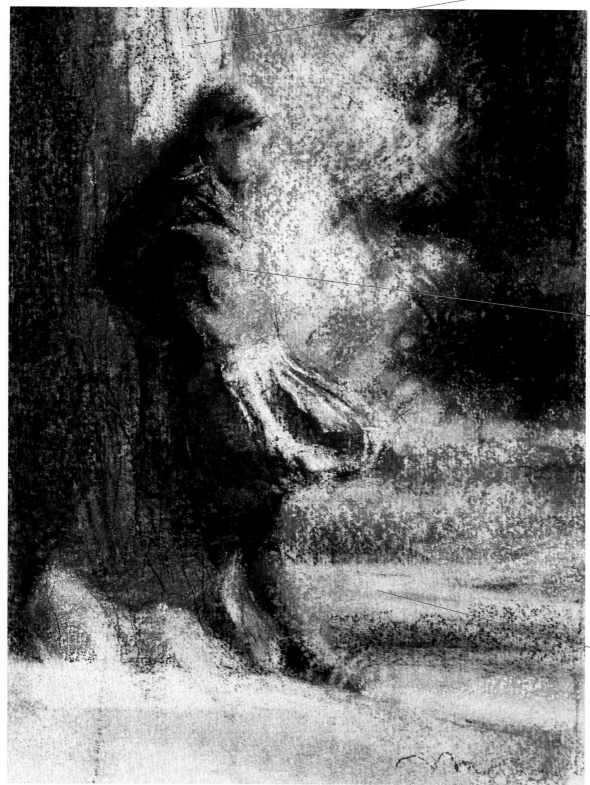

The few lines present in this drawing correspond to the texture of the trunk of the tree and are thick, subtle, and bumpy. Even here the strokes are fine and intense.

Contrast is very important in depicting the folds of the clothing. In the lightest areas we create a few white areas using the eraser.

If we stroke quickly with the side of a white pastel stick, we will achieve a whitish shading that reminds us of the atmospheric effects of Seurat's work.

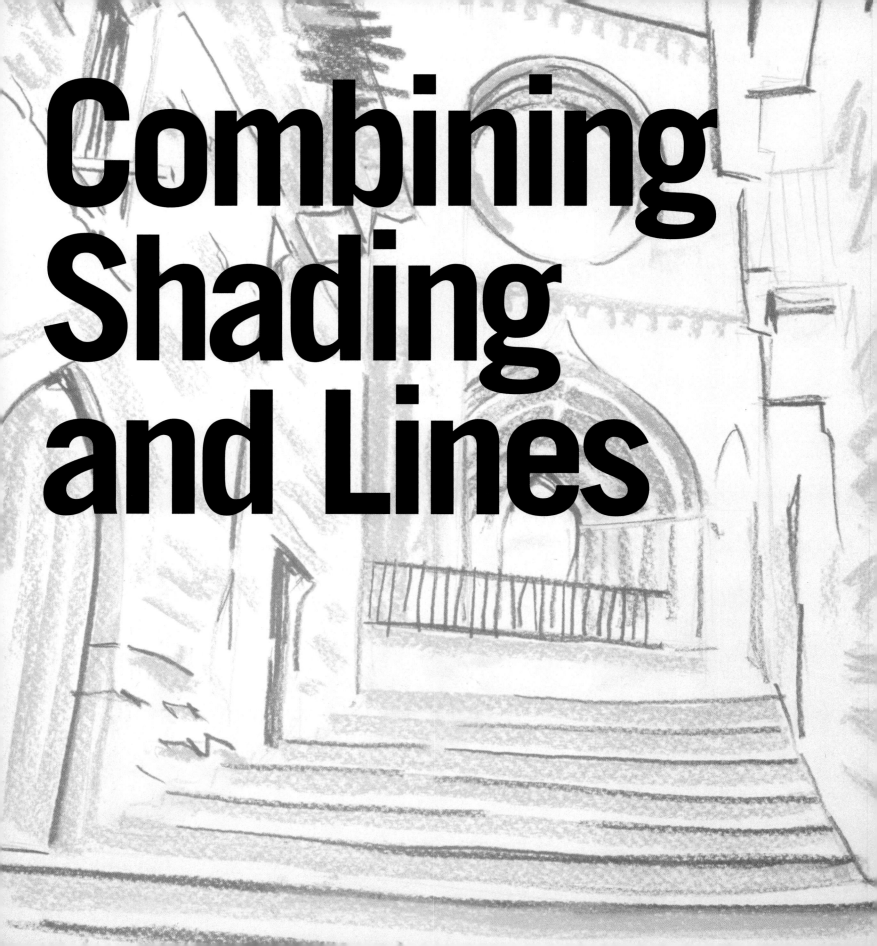

Combining Shading and Lines

As you progress through the exercises, putting into practice linear and tonal techniques and using different drawing materials and tools, you will begin to sense the possibilities of combining various methods. Even though each technique is effective on its own, both approaches may be combined in a drawing to achieve a more convincing result, especially when working with tone, texture, or detail.

CONTOURS OF SHADING. The need to adapt lines and shading creates new methods that emphasize the linear drawing by using broad shading, clarifying the stroke against the white of the paper. Thus, it is possible to emphasize the edge of a line with shading, revealing its solidity, tension, and contrast.

15.1

FIRST OUTLINES. The preliminary drawing is made up of lines drawn quickly and simply, over which we mark the first shadows. The shading is made with wide gray lines that will provide solidity to the subject.

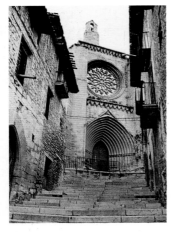

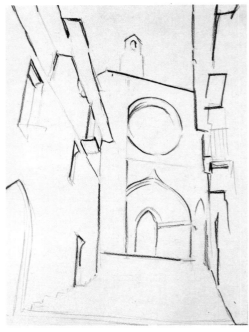

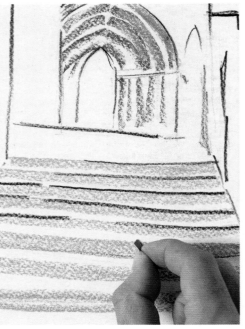

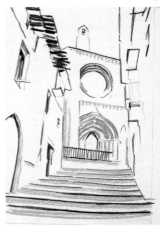

Using the same technique with the gray pastel stick, we now move to the church façade. We resolve the porch using a series of wide lines that define the Gothic arch. We then do the same in the rose window, although we shade only the upper area of the circle, leaving the lower part white because it is lighter.

Over the preliminary drawing, we can emphasize the contours of the architecture using intense lines made with a charcoal pencil.

We apply the first shading on the steps using a gray pastel stick, defining each line by shading the lower area. We use the same kind of shading for finishing the other areas that do not require black lines. We will achieve this by drawing with a piece of gray pastel lengthwise.

The drawing begins with very soft strokes from a charcoal stick. After erasing them with a cotton cloth, the drawing is traced over with a charcoal pencil.

You can show the edges of shadows by underscoring the line with broad shading, so that lines and tones make up a unit.

15.2

THE VALUE OF SYNTHESIS. With synthetic shading we use the values of light and shadow to create areas that complement the information given by the lines. It is important to combine and simplify forms, rather than attempting a literal depiction. It is fine to draw some undefined straight lines and some shading that can define them.

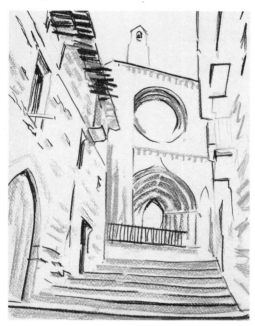

We start drawing the façade on the left, using gray pastel and short strokes that reproduce the texture of bricks. Only a few marks are necessary to achieve the effect. We resolve the wooden joists from the roof with broad lines produced with a charcoal pencil.

The use of broad dark lines between the joists of the roof and the façade of the church emphasizes the volume of these buildings. In order to emphasize some shadows or details in the façade, we use lines again.

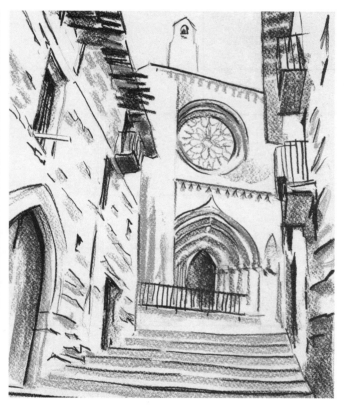

We build up the façade on the right using broad shading and isolated undefined lines. Balconies are resolved with a few parallel lines, and the projection of the roof is depicted with gray shading.

It is not necessary to outline all forms with a black line. In order to make the drawing more interesting, it is better to leave some areas open and unfinished, with an absence of definitive lines.

THE LOGIC OF LIGHT. A drawing can be made exclusively with lines or with shading, but with the combination of both techniques the representation begins to resemble the original model. It is particularly pleasing to draw the lights and darks of a piece of fabric with the help of lines drawn with the tip of a charcoal stick. This enables the artist to make the subject appear three-dimensional, as long as the rendering is based on a logical approach to light. In other words, the lights and shadows must make sense in terms of the source of light.

16.1

CLARIFY THE FORMS. If you make a free, simple sketch of the object, it is much easier to show the folds in the cloth. Do not become confused by the series of folds, since curved lines are tricky. Try to see their basic forms, as one or two fundamental folds determine the position of the rest.

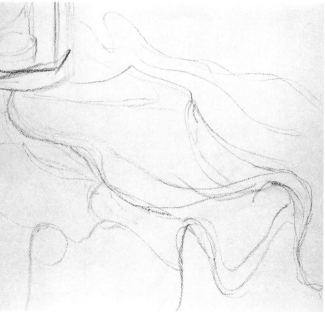

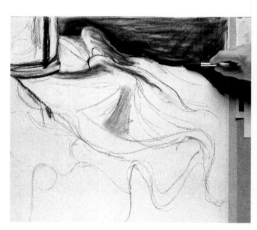

Only when the linear sketch has been resolved do we begin to sketch the first tonal area. Using a charcoal stick, we begin the intense shading that covers the background.

We may conceive of the sketch as a simple outline, without any shading, drawn with the tip of a charcoal stick, applying barely any pressure. We sketch the main folds of the cloth and the position of the lamp.

When using charcoal in drawings in which lines and shading are equally important, it is best to use sticks of different widths and softness.

This is the correct way to hold the charcoal stick when tackling a sketch of large dimensions.

16.2

DESCRIBING FOLDS AND WRINKLES. It is essential to be aware of the direction of the light source when sketching the shadows of the cloth folds. The contrast between the areas of light and dark helps give shape to each fold. Carefully study the direction of the light and place all shadows opposite the light source, the lamp.

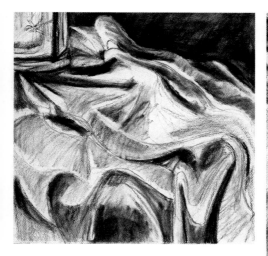

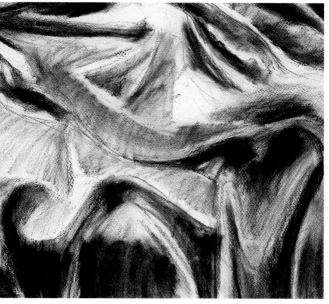

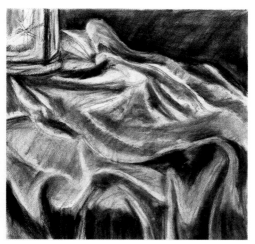

We try to draw the form of each one of the dark shadows hidden in the folds. It is not necessary to build up the folds and their shadows accurately, because it is more interesting to represent the fabric in a sketchy manner.

We cover the rest of the cloth with middle tones, blended with the hand. To draw the folds correctly, we darken the shadows and preserve the light "crests" by leaving the lightest areas untouched, the areas illuminated by the light from the lamp.

Middle-tone shading becomes denser, making the light tones appear lighter. This helps resolve the position of the folds in terms of the light that shines from the upper left.

When you add new strokes using charcoal in the shadows, it is best to rub your hand lightly on the paper to blend the charcoal and eliminate the presence of lines.

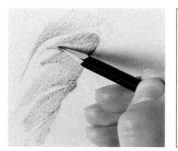

The best way of working with the folds is to mark the edges of the areas of shadows and then fill them with gray shading or graded shading.

16.3

ARABESQUE LINES. Now it is time to incorporate lines into our drawing. Linear strokes should be thick and intense. Lines perform a unifying and decorative function. Curved and wavy lines direct the viewer's eye across the surface as if in an arabesque, emphasizing the edges of the folds.

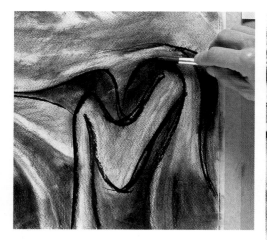

Using the tip of the charcoal, we make strong, dark strokes, underlying the shape of the folds, starting from the bottom of the paper. You should enclose the most intense shadows with curved lines that emphasize the internal movement of each fold.

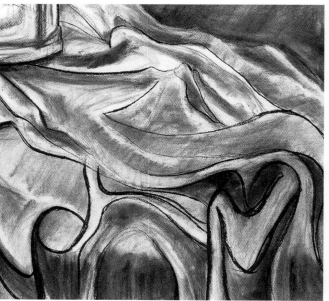

The linear work should continue in a rhythmic manner, defining the undulations of the cloth. In some cases, we exaggerate such curvatures to give more strength to the decorative element in the form of arabesques or swirls. Observe the variations of lines and the way in which they emphasize the light or dark effect in each fold.

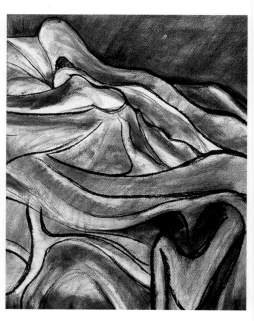

Using the charcoal, we draw freely with wavy lines. The extensive use of gestural marks adds energy and vitality.

If in the final stage you wish to achieve greater contrast between the light and dark "crests" of the folds, you should create some white areas using a kneaded eraser.

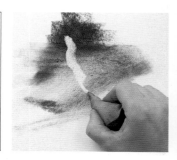

In those areas where the presence of light is more evident, lines fade so as not to affect the quality of light.

The effect of the tablecloth falling on the edges of the table becomes evident from the change in tone, depicted as a light, gradual shading.

As for the last details, we create a few light areas with a kneaded eraser. Although it is essential to treat the work as a whole, it is also important to thoroughly observe variations when drawing the different elements. Drawn by Esther Olive de Puig.

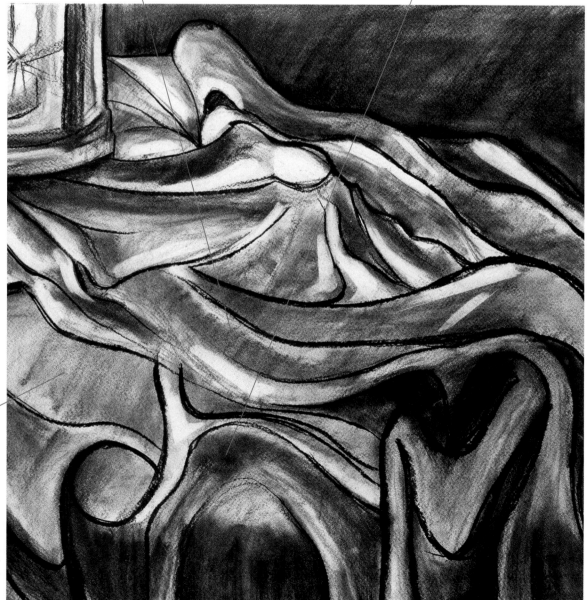

In the middle-tone areas, the distribution of pigment is very irregular. In some cases you can even see the traces of fingerprints.

DRAWING WITH PIGMENT AND A CLOTH. Although you can easily achieve shading by hatching or by using charcoal, artists often prefer to work with powdered pigment. The shading is very sensitive, soft, and atmospheric. Experimenting with powdered pigment in drawings is very useful when depicting effects from different sources of light.

17.1

SHADING WITH PIGMENT. The edging of contours and the form of objects is built up by shading, without drawing lines or dragging a chalk stick. Sensitive shading with continuous tones not only defines the form of an object, but also creates the illusion of three-dimensionality.

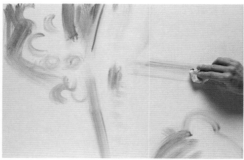

We draw the main compositional lines with a cloth impregnated with burnt sienna pigment. Only a few accurate lines are needed to position the tomatoes, the corn, the diagonal line of the beam, and the curve of the jug. We work as if creating a collage, applying the pigment in brief strokes juxtaposed over one another until we achieve an accurate sketch of the object.

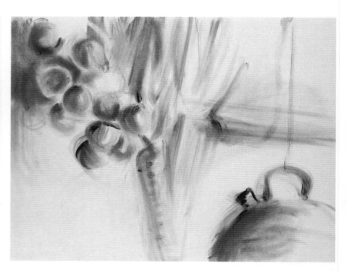

We now superimpose a deeper tone of pigment to suggest the main blocks of tone, that is, the areas that have more intense shadows. As we add new shading, the still life starts taking shape. We will still avoid paying too much attention to the details.

To achieve softer transitions, graded shading, and blending, we need to control the spread of pigment by using the fingers.

In order to produce powdered pigment, rub a stick of a given drawing medium (such as charcoal) with a piece of sandpaper.

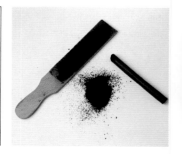

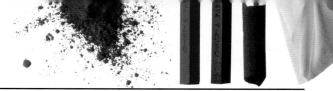

17.2

SFUMATO DRAWING. We will finish the general shading with a sfumato treatment. This means softening the shadows by making very subtle tonal gradations to describe objects without drawing contours or outlines.

We sand an ocher Conté crayon to create powdered pigment. With another cotton cloth and using our fingers, we apply the ocher pigment in the light areas of the objects. In the middle area, this color integrates with the previous applications of sanguine.

We cover the background with burnt sienna pigment. To soften the contours of the elements, we use our hands to combine the ocher pigment with the burnt sienna that covers the background to give the drawing a feeling of solidity.

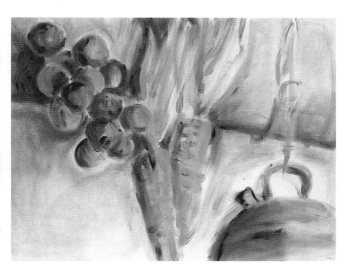

The application of ocher pigment forces us to intensify the shadows, using burnt sienna, so that objects have more volume. We blend the outlines using our fingers, thus producing the sfumato effect and creating an atmospheric whole.

The hand is one of the best drawing tools. You can use it to achieve blending effects and for drawing, shading, erasing, or spreading pigment.

To define the drawing with lines of Conté crayon, you should first experiment with the different possibilities on a piece of paper. The success of your drawing depends on the mastery of strokes.

183

17.3

DEFINING WITH LINES. Finally, lines are drawn over the previous shading to contrast the darkest areas and to define the contour and the texture of the elements that make up the composition.

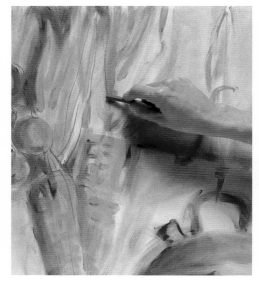

We superimpose the lines. We first work with a Conté crayon of the same color as the pigment applied previously. We make a series of thin strokes that describe the contour of objects and the texture of the dried corn leaves.

We alternate the burnt sienna and the black Conté crayon. Our first objective is to give more realism to the tomatoes and the corn leaves. Strokes must be thin and continuous, and we make them without lifting the stick from the paper.

With a charcoal stick, we create the most definitive contours by drawing thick heavy lines that emphasize the volume and the forms of the objects. You should not just draw one thick line around the contour, but apply it in key places, generally where there are shadows.

Drawing a corncob does not require you to delineate every grain. It is more valuable to suggest than to represent in a literal manner.

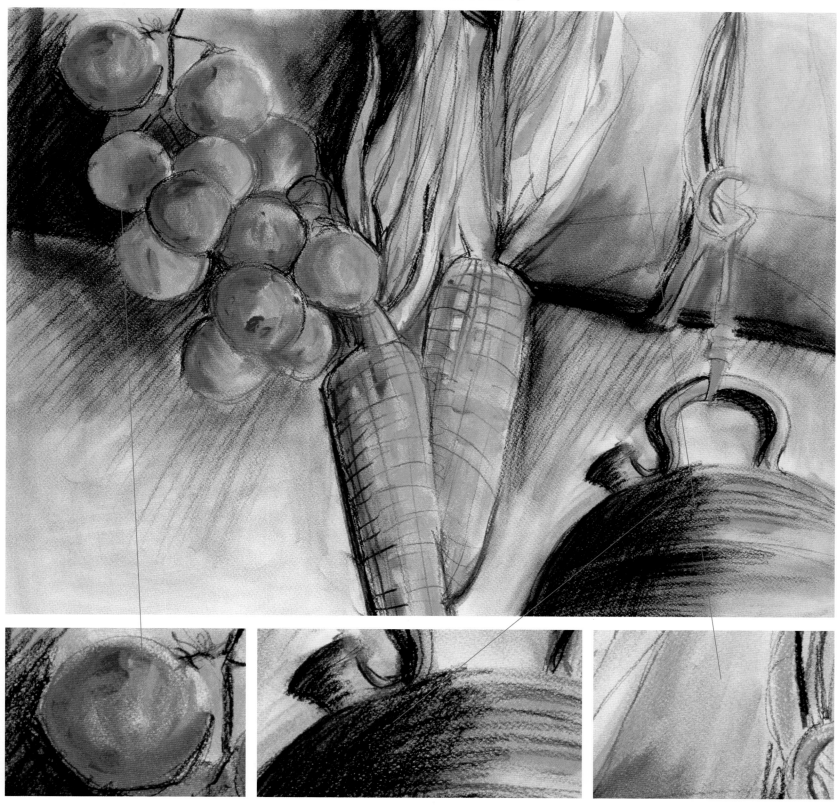

We emphasize the shadows with black chalk, creating contrast in the darkest areas. We mark the lines with shadows that we will not blend. The hatching, made up of strokes of varied intensity, produces graduated tones in the background. Drawn by Esther Olivé de Puig.

In the areas where shadows are darker, we apply the hatching of intense strokes, defining the contour of the object by contrast.

We emphasize the volume of the jug by controlling the direction of the hatching. This emphasizes the spherical shape of the object.

With charcoal pigment on our fingertips, we shade the beam, creating a middle-tone area.

DRAWING A FAÇADE: LINE OVER TONE. The combination of line and tone allows the representation of an object in a more modern style, which allows great expression and a controlled distortion that ignores perspective and proportion. We now present a somewhat distorted drawing that uses intense and blended lines and shadows to create a naive effect.

18.1

SOFT FAÇADES. We outline the façades in a somewhat distorted way, with curved walls, as if they were soft. We start shading over this base until we cover the surface of the paper with middle tones. The final aspect of the outlining must be smudgy and rough.

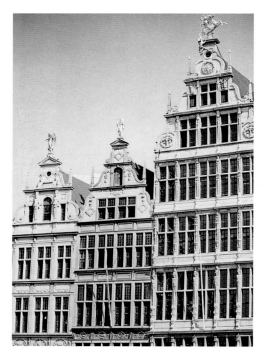

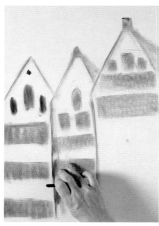

Charcoal is the perfect medium for creating form, and for shading, drawing guiding outlines, and searching for the proportions and inclinations of the lines on the façades.

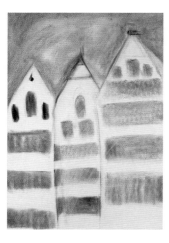

With the side of the stick we smudge the sky and then we rub with the hand to blend the strokes. We spread the first shading of the façades, trying to achieve a tonal effect without paying too much attention to the precise location of the windows.

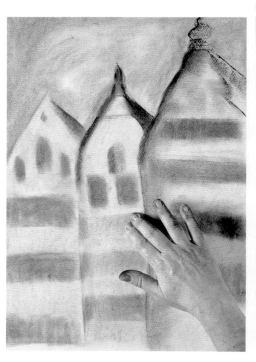

The series of charcoal applications, with the corresponding blending, separates one façade from another and emphasizes the area of the windows and the outline of the roof because they have been resolved using a darker tonality.

You should shade with the entire length of a piece of charcoal stick, flat against the paper. The objective is to create smudged shadows that will blend after each application.

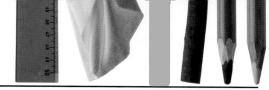

18.2

SMUDGING FAÇADES. We use the charcoal stick again, although this time combined with a sepia pastel stick, to create new shadows on the buildings and to indicate the location of the windows by using distinctive blacks. We thus move from the general to the specific.

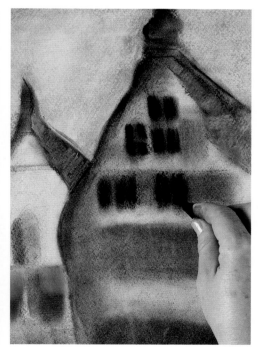

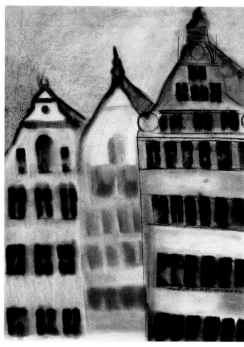

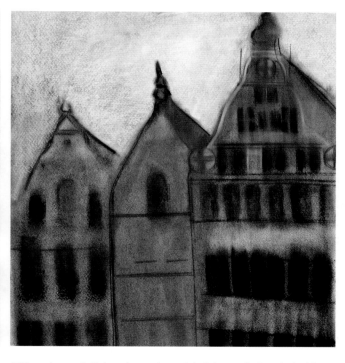

With a sepia pastel stick, we superimpose new shadows on the shading previously made with charcoal. This gives the windows a maroon tone. On this color base, we increase the darkness in the windows by shading with the tip of the charcoal.

In order to obtain the blackest shadows in the windows, we shade intensely with the charcoal, saturating the area with black. You can reduce the intensity of this initial black by blending it with your hand. We start adding some black chalk lines on the façade on the right.

With a charcoal stick and a sepia pastel stick, applied on their sides, we cover the façades with shading. We create uniform shading by blending the shadows with the palm of the hand, and we also rub out the lines. We also mix the charcoal and pastel to create a dark, muddy color base.

To successfully superimpose lines in the drawing, all the shadows made with charcoal must be blended. There must be no traces of the strokes, which might confuse the viewer.

18.3

LINES OF THE FAÇADE. The smudged, blended, and dark drawing from the previous stage is a good base on which to apply intense lines in black or white pastel.

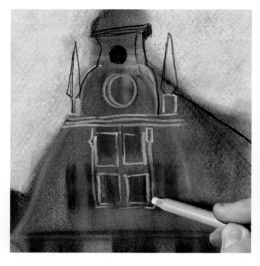

We start drawing the construction lines and the architectural details with black and white pastel pencils, looking for a certain degree of definition in the composition. The sketch is very linear, loose, and imprecise. We merely outline the architectural forms using informal lines.

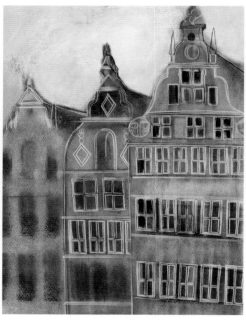

The façade has more definition, due to the use of white lines and to the details resolved using a very naive style. Except for several black lines in the roof and in the base of some windows, the rest of the sketch is made with white pastel to achieve the maximum contrast.

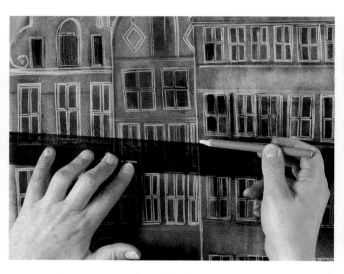

The drawing of details and of architectural ornaments goes on until we have completely covered all façades. It is now time to draw cornices and ornamental soffits. The artist uses a ruler for this task. Although the lines are straight, many of them are drawn slightly diagonal, to conform to the overall style.

When firmly pressing the white pastel on a charcoal-shaded background, the pastel strokes become more prominent, given pastel's stronger pigmentation.

One of the most important factors when working in the last part of the drawing is to achieve a visual imbalance. You can do this by altering the proportions and the inclination of the lines, while retaining some coherence and harmony.

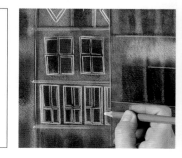

Laborious drawings are made in stages. They are the result of careful observation, first of the general structure and then of the way in which details are related to it. In addition to depicting details, the artist knows how to use shadows to create a solid structure. Drawn by Almudena Carreño.

After darkening the upper part of the buildings, their contours become more clearly defined against the sky, which forms a resting area for the eye and a counterpoint to the excessively ornamented façades full of shapes and details.

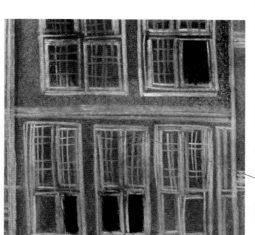

To boost the expressionistic effect of the drawing, the design of the architectural elements must be unstable, with unforeseen inclinations and continuous disproportions that disorient the viewer.

The outer contour of the windows has a broader, more intense line, while the interior lines have been made with less pressure and have been more incorporated into the background.

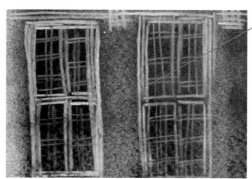

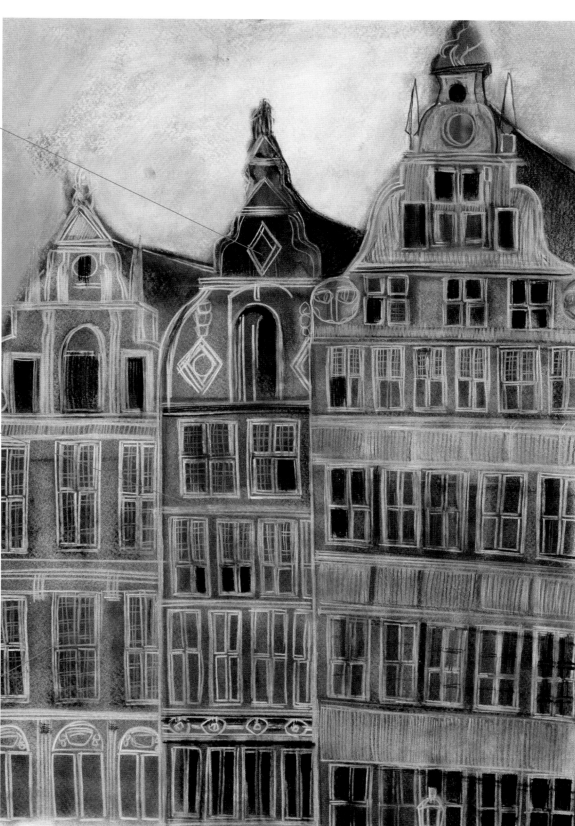

VARIETY OF GRADATIONS. Gradation is created by rubbing the paper softly using a drawing medium. You start with an increasing pressure and zigzag lines. The end result depends on the pressure applied, the range of the gradation, and the tinting power of the medium used.

Gradation with a graphite pencil is done with the tip held at a slight angle. It does not provide very intense blacks, and you can see the trail of the line in the shading.

Using a graphite lead, with a rounded and dull tip, the effect of lines decreases and the shading covers more of the paper.

We place the flat stick against the paper to create gradation with charcoal. The shading is dark and we can see the grain of the paper.

TONE GRADATION. This gradual transition from light to darker tones, or vice versa, occurs in a progressive manner to avoid sudden changes in tone.

ATMOSPHERIC GRADATION. One of the most common gradations in a tonal drawing is the atmospheric one. Its effect is very diffused and hazy, achieved by soft gradations, eliminating any lines and blending with the fingers.

We create a gradation on the side of the bottle by dragging lightly with the side of the pastel stick. We avoid the presence of lines. Lines disappear more easily with charcoal than they do with pastel.

We can achieve gradation in shading composed by hatching by passing our fingers over it.

To create a gradation in the shadows of an object, you just need to shade first with the side of the charcoal stick and then lightly run your fingers over it.

For an object drawn using charcoal powder to create gradation, you can add white areas with an eraser. This is useful to suggest the texture of glass.

On the paper, we apply with a piece of cotton the powder obtained by sanding a piece of pastel. We achieve a preliminary shading effect with hazy, generalized shadows.

A second application, this time covering areas with a smaller piece of paper, gives the rocks a more volumetric finish. The light areas are achieved by allowing the white of the paper to show.

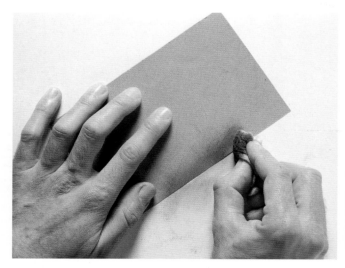

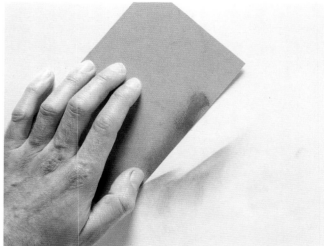

To represent the sharp contours of the rocks, we cover some areas with a sheet of paper. In order to see how the edge of the paper works, we place it on the drawing and rub the surface with the cotton ball charged with powder.

When we lift the paper, we obtain shadows with a straight, well-defined edge.

RENDERING ROCKS WITH LINES AND SHADING. Combining the techniques of drawing with powdered pigment and pastel, it is possible to combine soft gradations and hazy effects with firm lines that offer greater contrast. In order to work with powdered pigment, as in this case, you need to use medium-textured paper to achieve uniform shading.

Once the shading process has been finished, we draw the darker, more definitive lines where the shadows are deeper. We draw lighter lines where shadows are of medium intensity.

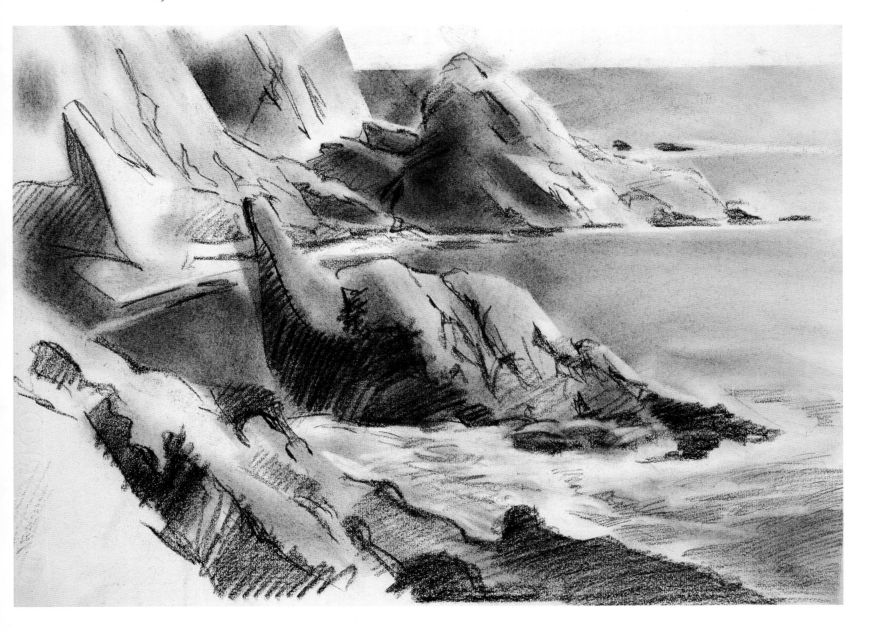

CREATING A VALUE MAP. Marking the edges of shadows with different values beforehand is a useful way to structure them. You create a map of the shadows where they differ according to their intensity.

In order to use this method, you should follow three basic principles:

Use lines of different directions or intensity of values to unify the various areas of tone and to give cohesion to the drawing.

Preserve the difference between intense tonal contrasts, registered in the well-defined edges, and the weak contrasts that characterize the faint edges.

Conserve the highlights. It is very important not to lose the light areas; preferably, leave the white of the paper.

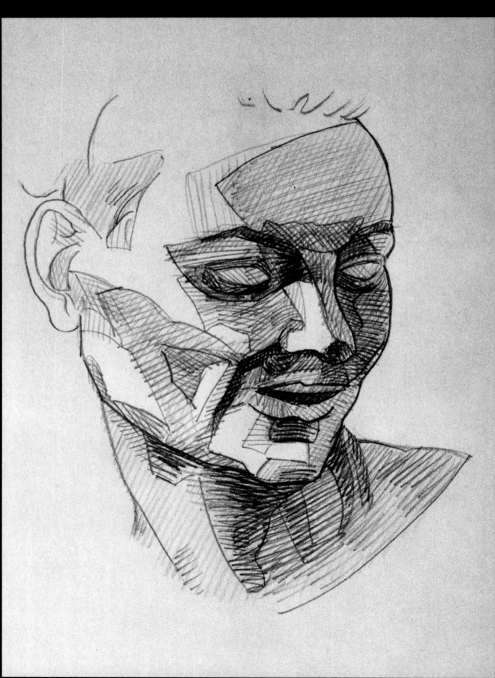

STRUCTURING SHADOWS. In order to shade, we must learn to visualize various tonal areas in the subject—those to which we attribute a similar tone that differentiates them from other areas. This helps when working with planes of darkness of different values, as if we were dealing with clearly defined geometric areas.

DRAWING WITH BLOCK SHADOWS. Lights and darks in a model can be drawn without paying attention to tonal values. You draw block shadows that are shaped as blocks of a monochromatic dark color and that help us analyze the distribution of dark areas.

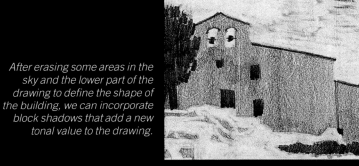

After erasing some areas in the sky and the lower part of the drawing to define the shape of the building, we can incorporate block shadows that add a new tonal value to the drawing.

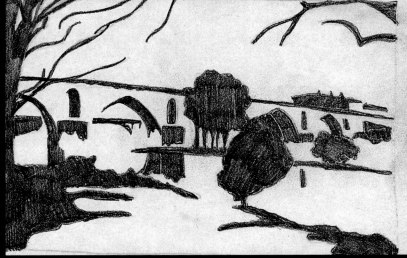

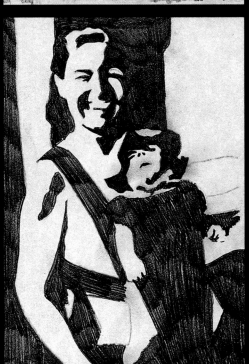

We can use the block shading technique for any landscape. You just need to draw dark shadows that correspond to the dark areas of the model.

When drawing the dark areas as if they were monochromatic dark shadows, we also define, almost unintentionally, the light areas that will remain white.

With the same model, we practice erasing, opening light areas on a gray uniform background. Think of those light areas as if they were negative spaces. You need to build up the model by using lights rather than shadows.

3.
Light and Shadow in Drawing

SHADOW AS AN ELEMENT OF CONSTRUCTION. Shading affects all drawing techniques equally because it is the basis for constructing shapes, it affirms their structure, and it contributes information about the shapes of the objects. In addition, it helps reinforce the physical appearance of the objects and their location in space.

SHADOW AS THE ORIGIN OF ART. Western art originated in shadow. Its beginnings are the silhouette figures on cave walls. Through the centuries, art has ceased to be a "representation of shadow" and has turned into drawing that uses shadow along with other means of depiction and representation.

SILHOUETTE. At the start of the nineteenth century, it became popular to draw silhouettes using a single tone of shadow. Even though light areas were not used, it's easy to distinguish the face in profile.

Incorporating shadow into a drawing helps give it a more pictorial treatment.

Head in profile. Shadow makes it possible for us to grasp the shape through contrasts in tone.

THE SHADOW OF AN OBJECT. Shadow reinforces the objective and tangible concept of the object and makes the whole and the parts that make it up comprehensible. The mere appearance of shadow on any object determines the imaginary relationship of the object with its surroundings. Wherever the light strikes the object, shading is needed to represent the parts that are in shadow and give them a solid shape.

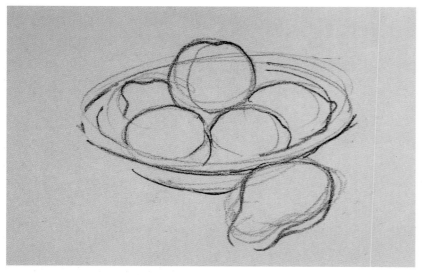

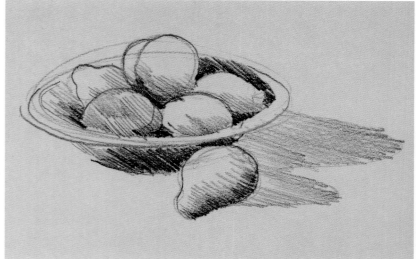

If we compare the two drawings, we see that the still life with the shading has more solidity and physical presence than the one constructed using only lines.

PROJECTED SHADOW. A shadow produces dramatic effects in the drawing because it represents a distorted image of the object. In addition, it helps to fix the model in the surrounding space and to situate the source of light.

A projected shadow constitutes a duplicate of the object on a nearby surface.

The extent and the direction of the projected shadow provide lots of information about the light source and the location of the object in relationship to it.

A HOMOGENEOUS TONE

The first treatment of shadow must be uniform and homogeneous. A uniform shading can be done using several controlled passes with charcoal compound crayons, chalk, or a graphite pencil. Uniform shading complements the information provided by the lines and gives the drawing more solidity and body.

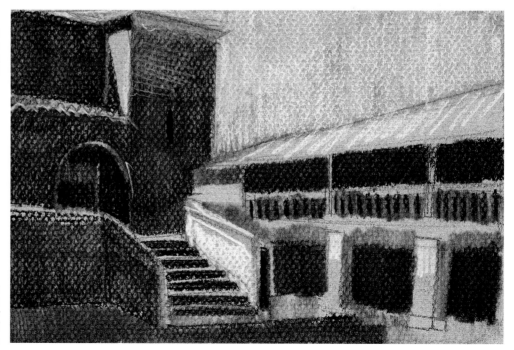

Shading gives the lines more physical presence. A few uniform grays create the contrast necessary for distinguishing the recesses and projections in the façade.

SHADOW AS A PICTORIAL CATEGORY. Line is the unique and distinguishing characteristic of drawing. Shadow breaks the edges, cancels out contours, and negates profiles. The line yields to shading, which is the property of painting. That's why shadow raises drawing to the category of the pictorial.

CONSTRUCTION BLOCKS. Shadow is the absence of light. It can also be defined as "comparative darkness caused by the interruption of sunlight." For the painter, shadows are the construction blocks that are used to create a convincing illusion using the elements of a painting.

If we synthesize the shading, the drawing appears to be a construction made up of blocks of different tones.

THE POWER OF CHARCOAL. Charcoal is the drawing medium most similar to painting. It is a monochromatic tool that is capable of a great range of registers, from large areas of dark, velvety tones to works of fine, delicate lines. Charcoal also makes it possible to shade quickly with dark tones that cover well. In addition, it can easily be erased with the finger, a cloth, or an eraser.

Charcoal produces intense blacks and a finish similar to painting.

THE NEGATION OF EDGES. Shadow cancels out the edges of shapes and sets up confusion. As a result, it creates a certain sensation of atmosphere and instills life into the picture. In addition, shading provides depth and volume, and it helps objects blend in with the background.

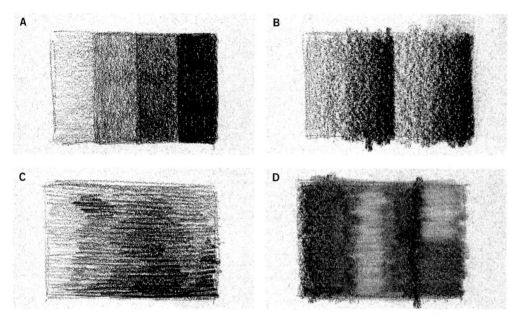

In a linear drawing, shadow softens the edges and produces a lack of precision. This treatment may be appropriate for depicting vegetation.

Shading can be done in a tonal fashion (A) or by using gradation (B), hatching (C), or sfumato (D). The latter two are the ones that most obscure the linear edges and modify the outline previously established by line.

WORKING WITH FEW VALUES. The simplest process for beginning to apply shading involves working with a restricted range of values. Two or three tones can be used to represent dark, medium, and light shadow. The resulting schematic drawing is a good point of departure for developing new shadows, details, and corrections.

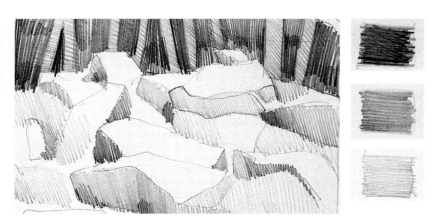

In drawing a landscape, we can begin with blocks of shading with just three values: dark gray, medium gray, and light gray.

In this sketch done in tonal zones, the shadows were created using only a few values by varying the crosshatched lines. The treatment is very synthetic.

201

The Effect
of Light

The essence of the art of drawing is the art of observing, and light is indispensable for observation. Without light, nothing can be observed; in other words, everything that we see is subjected to a certain amount of illumination.

To learn how to draw, it is first necessary to learn how to use light. Light helps in depicting the models, because it defines the shape of the objects, models their surfaces, and situates them in different planes of distance.

In drawing, light doesn't exist in the absence of shadow, and light doesn't exist without dark. The tension between these contrasts and their arrangement in the model is what defines the different planes and locates the light source that illuminates the model.

CONTRAST AS A TOOL OF EXPRESSION. Just as it is possible to draw using only lines, it is possible to draw using only shaded areas. Drawings done merely with areas of tone and shading are filled with atmosphere and charm. By studying how the model receives light, and recording it with shades and tones, it is possible to produce a very convincing sketch.

1.1

SKETCHING WITH TONE. One excellent way to learn how to see and draw shadows is to use a single tone or value. You will be surprised to see how much a single tone can communicate about the appearance of the model.

We begin the representation of the model by using a piece of 2B graphite lead held sideways to trace the shape of the tree trunks in the foreground and the shadows they cast on the ground. We're not interested in details. Our goal is to create a certain contrast between the gray areas and the white of the paper.

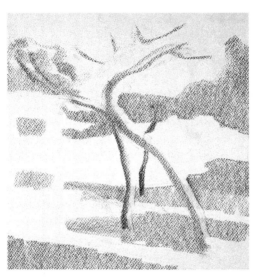

We complete the area of shadow in the underbrush and the lower part of the crown of the trees with new shadings in the previous tone. By way of contrast, the light areas on the paper represent the illuminated parts of the model.

To produce a uniform tone in this first layout phase using shadows, we cut off a piece of graphite lead and use it held flat.

We use an eraser to lighten the right side of the tree trunks and make them appear illuminated.

1.2

CONTRAST USING TWO TONES. Using a second tone makes it possible to differentiate the darkest shadows and the medium tones of the sketch. A greater contrast of the shadows with the white of the paper highlights the illuminated areas.

We put aside the graphite lead. We now take a whole lead in grade 4B, which allows for darker grays. Holding the point of the lead at a sharp angle, we spread out areas of darker gray. These shadings must be less abstract and conform a bit more to the shapes of the model.

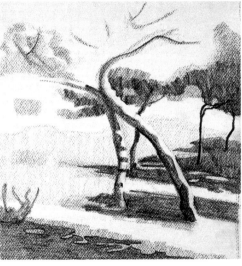

To the previous grays we add a darker shading in the lower part of the paper and in the crown of the trees. Now there are two intensities of gray in each shadow.

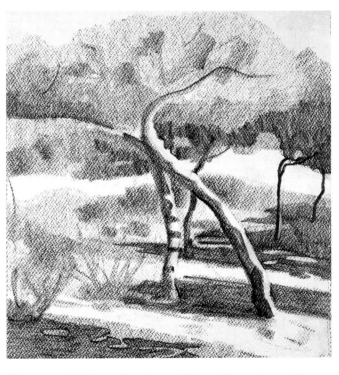

We once again take up the piece of 2B graphite and complete the foliage of the trees with light shadows, preserving the white areas of the paper that represent the illuminated parts. Drawing by Gabriel Martín.

If you want to finish the drawing a little more, you can add more contrast to the shadows and complete the grove by depicting the trees in the farthest plane.

VALUES GUIDELINES. In a drawing, the values guidelines are the breakdown of the subject into all its tonal shapes—light, dark, and intermediate tones. They include the light guidelines, which correspond to the white of the paper, and the shadow guidelines, which we achieve by gradually darkening the tone of the gray.

2.1

GENTLE SHADING AND LIGHT. We begin the drawing by applying a very slight initial shading to the whole shaded area of the model; this will be the lightest tone of shadow. We preserve the white of the paper in the illuminated areas.

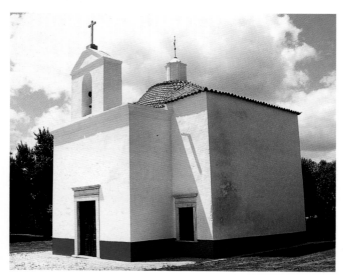

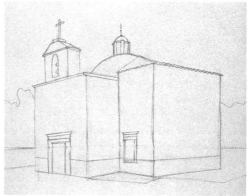

We add the proportions of the chapel to a previously drawn skeleton; it can be represented with two overlapping cubical shapes. When the structure is complete, we carefully draw the openings in the buildings and the other architectural features.

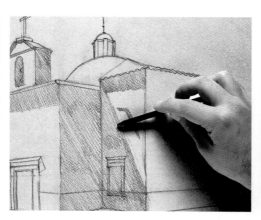

We establish the illuminated areas of the wall, which we preserve using the white of the paper. Then we use an HB graphite lead to shade the façades of the chapel with gentle, oblique strokes, following the direction of the sun's rays.

To draw the building correctly, we draw five vertical lines that represent each of its sides, keeping in mind that the main and the side façades are the broadest ones.

We connect the vertical lines with diagonal ones at the bottom and top to achieve a credible effect of perspective.

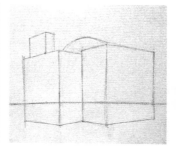

2.2

MEDIUM AND DARK SHADOWS. Any model can be deconstructed into an arrangement of shapes in different values: light, dark, and intermediate. The shadows are uniform blankets that contrast with the adjacent ones through the change in tone. This interpretation of the model makes drawing it much easier.

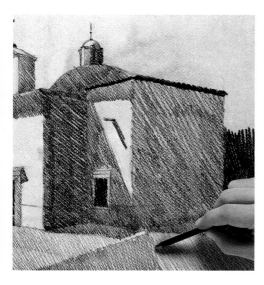

Using a 4B graphite lead we fill in the line of trees in the distant plane and the openings in the building with very dark lines. We use a gray to further darken the shaded façades of the building. The initial gray is retained for the paving on the ground.

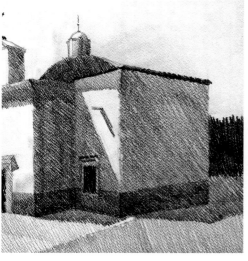

We darken the bluish border along the base of the walls to differentiate it from the rest of the façade. We also add some contrast to the shadow cast by the building to distinguish it from the gray of the lawn.

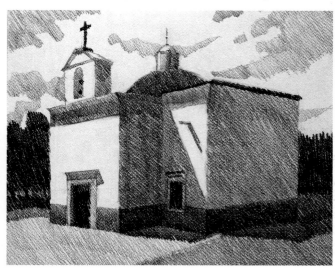

Each tonal area must be clearly differentiated from the adjacent ones to make the volume and the architectural elements of the building stand out. To conclude, we shade in the blue of the sky and leave the clouds white. Drawing by Gabriel Martín.

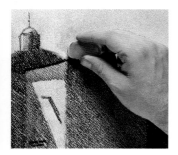

If the hand accidentally rubs across the paper, it may smudge those areas where the intensity of the white must be preserved. To avoid this, it is necessary to clean up those areas with an eraser.

A single tone—a very soft gray— is adequate for depicting the clouds. If we color in the blue areas, the outline of the clouds will appear synthesized through tonal contrast.

STUDYING THE MODEL IN DIFFERENT LIGHT.
For outdoor scenes the sun is the best source of light, but it has one disadvantage: its continual movement. However, this movement also means it offers plenty of variety for shading.

Before starting a drawing, it's appropriate to view the model in all types of light during the day and study how it changes. This allows us to become familiar with the effects of light and to choose the best moment.

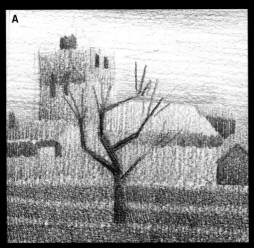

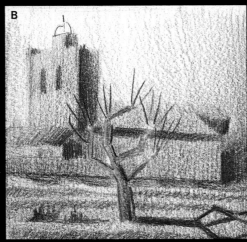

Because of the movement of the sun, the shadows in a landscape vary throughout the day. Here are two examples of the same model with the sun in a lateral position (A), and at dawn (B).

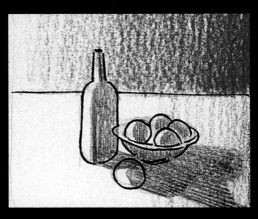

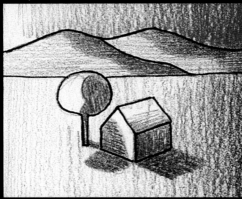

LATERAL LIGHT. When the light hits a model from the side and a slightly elevated point of view, it produces sharp contrasts of light and dark that reveal the shape and the texture of the subject, presenting a broad range of shadows that define the areas surrounding the object. The illuminated parts of the objects remain on the side where the light source is located.

Lateral light causes strong contrasts and casts long shadows on the side opposite the light source.

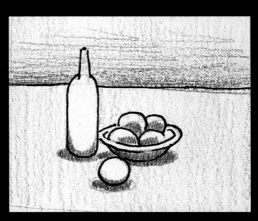

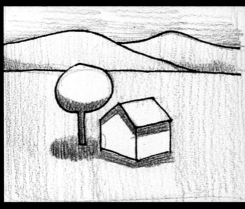

OVERHEAD LIGHT. Light from above falls vertically onto the shapes. It projects very small shadows right under the objects. The lightest and warmest areas of the subject restrict the planes that form a right angle with the light.

Overhead light casts very small shadows right below the objects.

THE LIGHT SOURCE. We can best understand light and shadow and how they behave on shapes by examining the changes that the same model experiences when subjected to light of different types and from different sources.

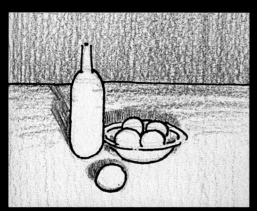

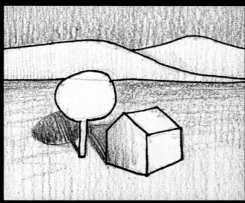

FRONTAL LIGHT. Frontal light reaches the model from the position of the observer, so the foreground is lighter. The farther away the object, the deeper and the colder its tones. Light predominates over shadows in the model, because the shadows are projected behind the objects. Frontal light offers the artist the opportunity to work with a lighter and brighter palette.

With frontal light, the resulting shadows remain obscured behind the objects; they are not visible, and there are no localized shadows on the objects.

BACKLIGHTING. In backlighting, the model receives the light from behind, and the visible planes are in shadow. The features of the landscape are reduced nearly to silhouettes. In this scene the sky is the brightest and warmest area in the composition. The ground plane is lightened and its color becomes warmer as it approaches the light source on the horizon.

In backlighting, the rear of the model is illuminated. The visible planes remain in shadow because the shadows that are cast advance toward the observer.

STILL LIFE WITH NATURAL LIGHT. The light that enters through a window early in the morning is somewhat diffuse, and it produces soft shadows without much contrast. It's excellent for developing gradations with a graphite pencil, one of the means of drawing that makes it possible to model objects with great delicacy.

3.1

A SOLID DRAWING. The shading process becomes much simpler if the line drawing on which we work has well-defined outlines and shapes, and a strong, defining line; that helps avoid confusion and errors that must be corrected. Starting with a solid drawing allows us to concentrate solely on the shading.

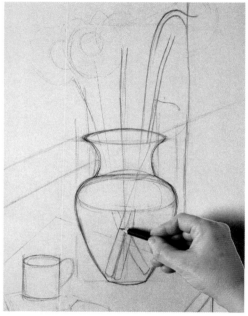

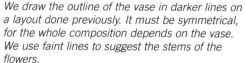

We draw the outline of the vase in darker lines on a layout done previously. It must be symmetrical, for the whole composition depends on the vase. We use faint lines to suggest the stems of the flowers.

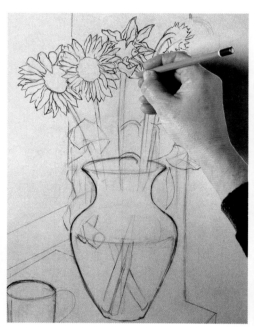

We resolve precisely and clearly the other focus of attention in the subject: the sunflowers. The treatment is totally linear and addresses the exact shape of every petal, in a very naturalistic interpretation.

If we first draw a box and divide it into halves with a straight vertical line and draw the vase inside it, maintaining the symmetry becomes easy.

The thickness and intensity of the line need to vary according to whether it depicts the exterior of an object, in which case it is thicker and firmer, or lines inside the leaves, which are less distinct, thinner, and less precise.

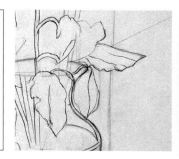

3.2

ATTENUATED CONTRASTS. We apply the shading to a drawing done exclusively with very bold lines, paying attention to every important detail of the model. Gradation and attenuated chiaroscuro (shading from intense light to dark) predominate in this treatment, because the model is bathed in a diffuse light.

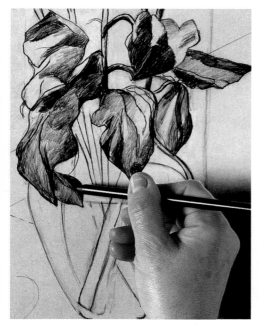

We begin with the leaves. First we decide which areas to leave white to represent the ones that receive the most light. Then we develop the gradations in the other areas using small tonal differences that depict the folded, undulating surface of the leaves.

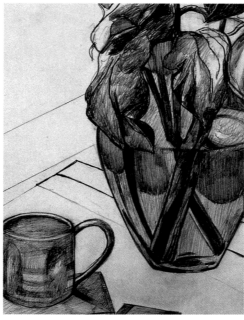

The inside of the glass vase is created using uniform, clearly differentiated tonal areas. There is scarcely any contrast between the grays of the cup and the blocks at the bottom. In this phase it works well to alternate between the 4B graphite pencil and the 6B graphite lead.

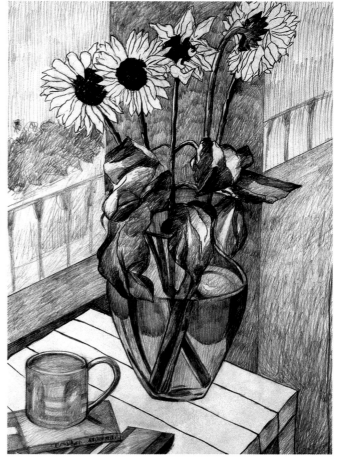

We shade the background using uniform strips of gray by bearing down very gently with the 6B graphite lead. To avoid distracting attention from the main subject—the vase and the sunflowers—the surrounding area is left free from details. Drawing by Almudena Carreño.

The corolla of the flowers is taken as the point of greatest intensity in the drawing. This contrast is an important lure for the observer's gaze.

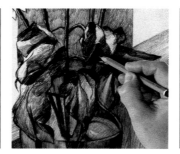

We use a 6B graphite pencil to define some shadows and outlines of the leaves to keep them from blending together and losing their identity.

211

INDOOR SCENE WITH ARTIFICIAL LIGHT. Artificial light is very attractive for drawing an indoor scene, because all the light that fills the scene comes from a single point. Thus, all the sides of the objects facing the light appear in illumination.

4.1

RECTANGULAR AND RHOMBUS SHAPES. We have chosen a corner of a house illuminated by a small electric lamp, and containing a set of simple everyday objects. All the items have a simple shape that can be reproduced using straight lines and rectangular and rhombus-like shapes. We do a line drawing of them before starting to add the shading.

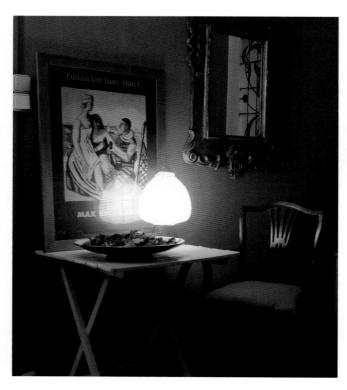

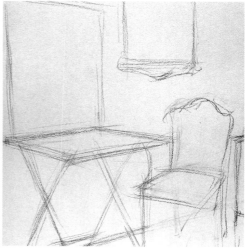

The initial layout attempts to establish the objects using quadrangular shapes in the painting and the mirror, and rhombus-like shapes in the table and the chair. The treatment is very gentle, caressing the paper with the tip of a charcoal stick.

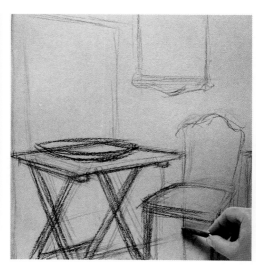

When the faint lines appear convincing, we go over them again to darken them. We attempt to resolve the shape of each object, but without focusing on details or textures.

Doing the preliminary sketch in very faint lines makes it possible to erase very easily and make corrections in case of errors.

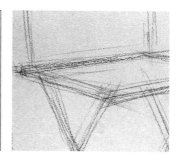

4.2

LIGHT AND ATMOSPHERE. The effect of shading must not only represent the radial dispersion of light, but also recreate the atmosphere and the illumination that bathes the objects. In this case, the illumination is intimate, and the contrasts are moderated. In shading the scene, a characteristic halo of light forms around the source of artificial light, and the rest of the scene appears darker than usual.

Using the side of the charcoal stick, we apply a general shading. We avoid covering the light source, the painting, which acts as a reflective surface, and the mirror in the background. Then we use our hand as a blending stump.

Over the shaded base we cover the walls and the chair with deep black in hatchings of more forceful lines. We leave a white area around the lamp, which serves as a halo of light.

Using a stump and new lines in charcoal, we shade off the shadows to produce more uniform grays. The lamp shades are the only things we leave white. Around them the white forms a smooth gradation until it changes into a nearly absolute black at the back of the room.

During the shading, it's appropriate to alternate between the charcoal and the stump to create a more homogeneous, integrated shading within the environment of the scene.

The radial effect of the light is created by tracing straight lines with the tip of the stump on the shading done in charcoal. We use the blending stump until the rays of light appear.

213

THE ANGLE OF LIGHT. The higher the location of the light source, the shorter and darker the shadow. If the light source is very low, the object casts a long and somewhat gradated shadow that becomes more diffuse the farther it goes.

USING GEOMETRY. The changing nature of light sometimes makes it difficult to represent certain shadows correctly. To resolve this difficulty, we can approach drawing these shadows based on projections in perspective, or simple geometric structures.

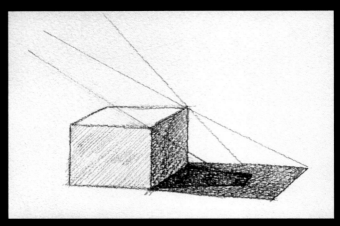

To correctly draw the shadow cast by an object, we draw lines projecting from the light source and passing along the edges of the object to arrive at the plane of the earth.

The shadow cast by a cube is long and displays a slight gradation, because the light source is low and lateral.

FORCEFUL ENVIRONMENTS. Shadow has great suggestive potential. We can take advantage of that to create environments that are filled with force and emotion by introducing secondary shadows projected onto the floor.

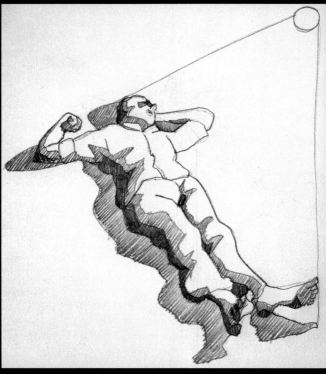

With oblique light, the shadow that the object casts takes on a life of its own and turns into a grotesque double image.

The projected shadow duplicates the shape of the figure and heightens the contrast along the outline on the left, adding expressiveness to the drawing.

PROJECTED SHADOWS. When an opaque object blocks rays of light, it casts a shadow onto a nearby surface. These projected shadows vary in size as a function of how high and how far away from the model the light source is. Projected shadows attach an object to the surface on which it rests and relate it to its physical surroundings, so it's very important to structure them correctly.

OBJECTS AND TEXTURES. Shadows cast onto a smooth surface appear straight and clearly defined; however, if they are projected onto some other object, or onto a textured surface, they change. When a shadow falls onto a three-dimensional object, it changes direction and conforms to the shape in a way that is rather similar to what happens with water.

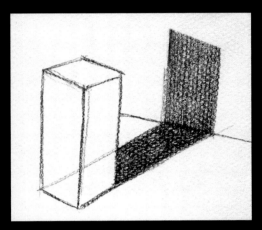

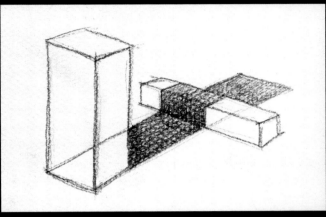

Shadows projected onto a smooth surface exhibit no changes; however, a shift in planes alters their direction.

When the surface onto which the shadow is projected displays texture, irregularity, or an obstacle, the shadow adapts to the surface and the shape of the object.

THE APPEARANCE OF HALF-LIGHT. Having multiple light sources means that instead of a single shadow of a homogeneous, dark tone, there appear areas of half-light that decrease the solidity of the shadows. A similar situation occurs when the light source contains a screen or a broad reflector, because the reflected light produces a halo of half-light around the shadow.

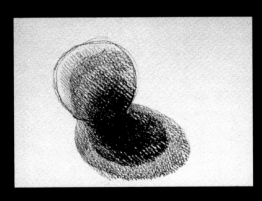

MULTIPLE LIGHT SOURCES. Working under different sources of light poses difficulties because shadows are cast in duplicate, and the area of semidarkness is much more extensive than the dark shadow.

The shadow is the dark area that the object projects when it interrupts the beam of light. The penumbra (imperfect shadow) is the lighter shade that surrounds the shadow. With an oblique illumination, the shadow cast by the object takes on a life of its own, and turns into a grotesque double.

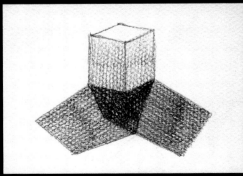

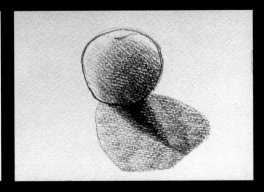

If more than one light source illuminates an object, the shadows projected are multiplied, and the imperfect shadow stands out.

The same sphere seen previously is now illuminated by two sources of light. It's obvious that the shadow has shrunk considerably, at the expense of the penumbra.

DIVISION BY TONAL AREAS. The basis for any contrast is the perceived difference between two tonal areas. A good exercise for learning how to construct shadows involves deconstructing a model into different, clearly delineated tonal areas. This allows us to formulate the drawing using planes of shadow as if we were dealing with a map of values.

5.1

THE INITIAL SKETCH. To produce an appropriate initial drawing, we do a very synthetic sketch of the landscape and another, more careful one of the cluster of buildings. The houses must be drawn well, and we have to pay attention to the pitch of the roofs and the directions of the façades.

 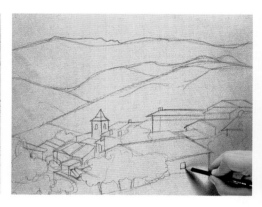

The first layout is schematic. With an HB graphite pencil we synthesize the outline of the mountains in the background, and using very light pressure we begin to sketch the houses by superimposing rectangular shapes.

We determine the ultimate profile of the mountains by bearing down a little more on the ridge lines with the same pencil. We construct each of the houses on the existing geometric scheme, without adding many details.

The design of the houses requires more attention. They must be drawn with precision, using straight, firm lines, avoiding details and the texture of the walls.

5.2

GENERAL TONAL SHADING. Creating the tonal map requires reducing the different tones seen in the model to just a few. The procedure begins by classifying the tones into two groups: light ones for distant planes in the landscape, plus medium and intense ones in the cluster of the village. We work from the general to the specific and begin by covering in the broadest areas of the landscape.

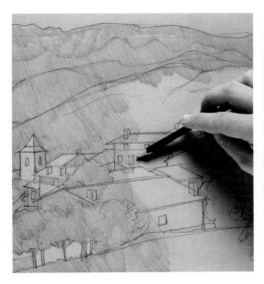

Using the HB graphite pencil held at a slight angle, we apply a generalized shading to provide an initial tone to the whole. This will be the lightest gray used in the composition. We preserve the white on the façades that are struck directly by the sunlight.

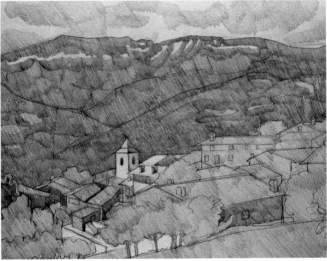

Over the preceding we apply a slightly darker shading to cover the vegetation in the background, except for some small areas on the mountains. Thus, with scarcely two values we succeed in making the cluster of houses stand out from the background.

Constructing the houses in the village with different tones is the slowest and most painstaking phase, because every façade is treated with a shade that is different from the adjacent ones. If we offset every illuminated façade with a shaded one, we achieve a competent and effective treatment of shadows.

To represent the shape and texture of nearby vegetation, we create a tonal scale: dark grays in the lower part of the trees, an intermediate tone in the center, and a light gray in the top.

As the pencil becomes worn down, the fingers approach the point and warm the lead, which softens and becomes stickier and denser, thus making it a little more difficult to create light tones.

5.3

TONAL SCALES AND CONTRAST. To keep the drawing from becoming fragmented, which would interfere with the overall perception of the composition, we have to keep the tonal variation gradual, rather than sequential and abrupt.

We finish shading the façades and highlighting the architectural details by means of tonal contrasts. It's a good idea to use just a few tones to avoid fragmenting the unity and harmony of the composition.

The strong tonal contrasts of the openings and the shaded façades define the shape and the relief of each building. Every wall and roof must be defined with a smooth gradation; the succession of these gradations creates a tonal whole that's fertile and visually very active.

By adding new passes with the 4B graphite pencil we darken the trees at the bottom. We apply a new, even tone on the mountains in the middle distance, leaving small spaces for the shading below to breathe. This new shading helps the outline of the houses stand out more.

In this phase the surface of the paper is covered with lots of graphite. To avoid smudging the drawing with the hand, and to work more comfortably, we protect the drawing with a sheet of paper.

The planes of the façades stand out from one another because of the abrupt changes of tone. This contrast is essential in order to avoid an excessively flat treatment of the houses.

The alternation of tones is crucial to the effect of three-dimensionality and the correct depiction of the irregularities in the landscape.

We darken the base of the mountains in the background with two broad, homogeneous applications of gray that exhibit an irregular outline. We now consider the drawing finished. It has taken us several hours, because a drawing with a complete tonal scale requires a patient development of values and detailed treatment. Drawing by Gabriel Martín.

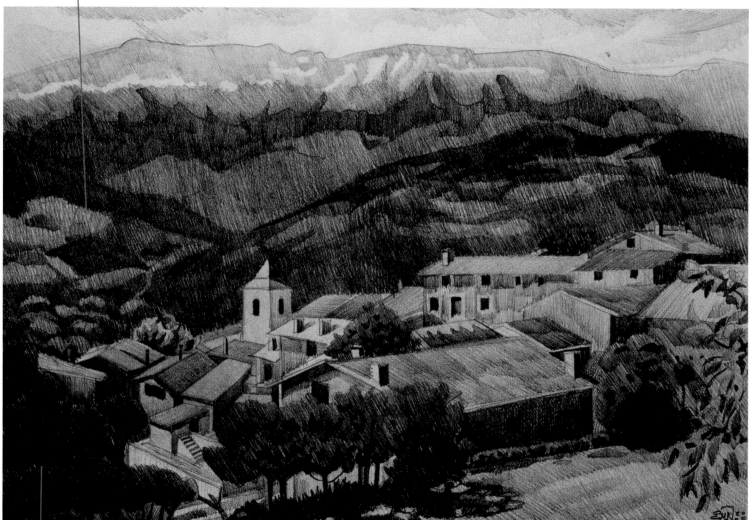

When working in superimpositions we must keep one key point in mind: the saturation of the paper. The paper reaches its maximum saturation point when its grain is totally covered and will accept no more pigment. This determines the darkest tone that the paper will retain. Thus, we have to know the maximum degree of saturation of the paper we are using in determining the darkest tone we can achieve and establish the system of tonal values on that basis.

Using tones of slightly different values on the grass at the bottom produces soft, light, and restrained effects.

VALUE AND TONE. The logic of light requires that we distinguish differences in shades of light and dark. These differences in shades are referred to as *values*. Light colors have a high value, and dark colors a low value. In monochromatic drawing, the terms *value* and *tone* are used in an indistinct manner, but that's not true in painting.

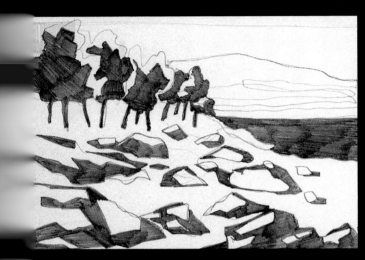

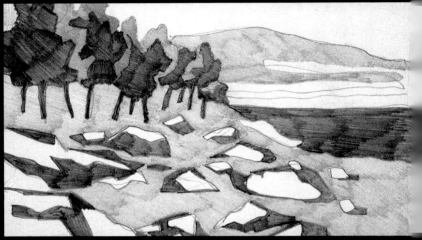

In a tonal drawing a homogeneous dark gray is first used to differentiate the most intense tones.

If we complement the previous shading with a medium gray, we achieve a tonal drawing with just three values: white, medium gray, and dark gray.

PRACTICING TONAL SCALES. Before starting the drawing, it's a good idea to practice some tonal scales on a separate piece of paper to check the subtlety of the lightest shading and the intensity of the total blacks that the paper is capable of producing.

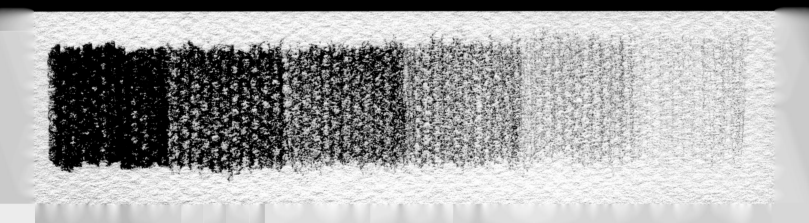

A SYSTEM OF TONAL DESIGNATIONS. The values of the drawing are the different intensities of a color that lightens or darkens a shaded object. The extremes of the valuation are white, the color of the paper, and the darkest tone that can be produced using the given medium. When working in black and white, these intensities are lighter and darker grays.

A SKETCH OF TONAL VALUES. Tonal studies must be expressed in drawing as a subject free from unnecessary details, like a succession of carefully arranged color blocks of homogeneous tone, a puzzle of monochromatic tones that, like a mosaic, offers us a fragmented view of the real model. This involves working with a complete scale of values ranging from absolute white to intense black. Between these two extremes there are literally thousands of tiny gradations.

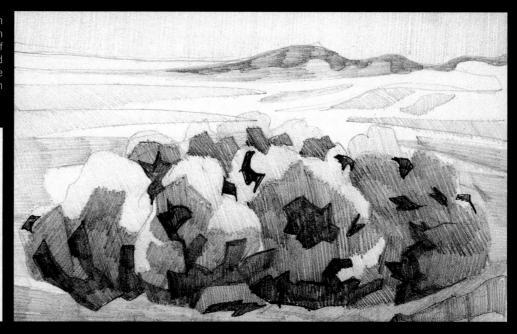

A small sketch will help resolve most important decisions because it makes it possible to foresee the large movements and shapes. It's advisable to work with just a few values—only four in this case.

INITIAL ORGANIZATION. Light and its effects can be used to organize the plane of the drawing before beginning work. Sketches are very useful in planning your composition, organizing the dynamics of its diagonals, and considering how to create an appearance of depth in the landscape.

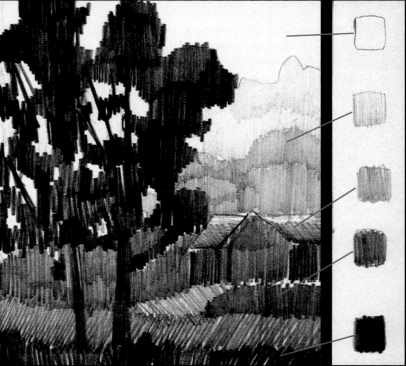

To create the effect of depth, the darkest tones must appear in the lower part of the drawing, and the lightest ones in the top part.

It's easy to see how we have put the adjoining theory into practice in such a way that the tones become softer and lighter as the planes of the landscape recede into the distance.

221

To keep the superimposition of tones from obscuring the shape of the object, there is one recourse that allows us to darken the background with a medium gray; the contrast thus makes it possible to distinguish the outline of the model more clearly.

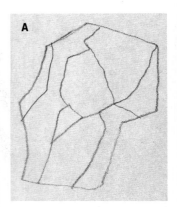

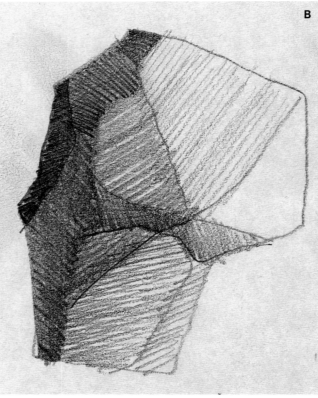

The arrangement of tones is crucial for expressing shape and volume. To observe the effect, let's look at one shape constructed solely with lines (A), and another that includes shading of variable tonal intensity in each of its segments (B). The first comes across as a flat shape; the second provides a sense of three-dimensionality.

The effect of volume is achieved by constructing with tonal blocks. Each section is divided into clearly defined geometric sections. Then it is shaded in with just three or four tones of gray, without gradations or blending.

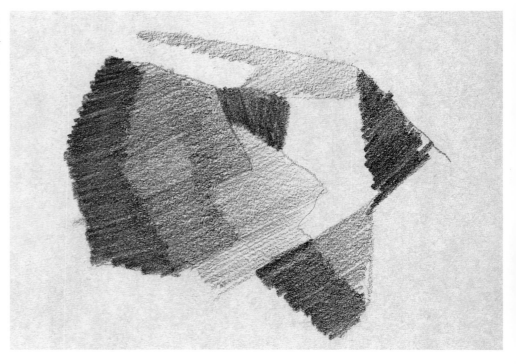

TONAL DESIGNATIONS: A CRUMPLED PIECE OF PAPER. To illustrate the effect produced by illumination on the surface of a crumpled piece of paper, we need to assign different tones to each area. Then, the paper, which is composed of numerous planes of different tones, presents a convincing sense of three-dimensionality. A graphite pencil is the medium selected for illustrating this method. The variations and the contrasts of values are produced by varying the pressure exerted with the pencil and by preserving the lightest areas of the paper.

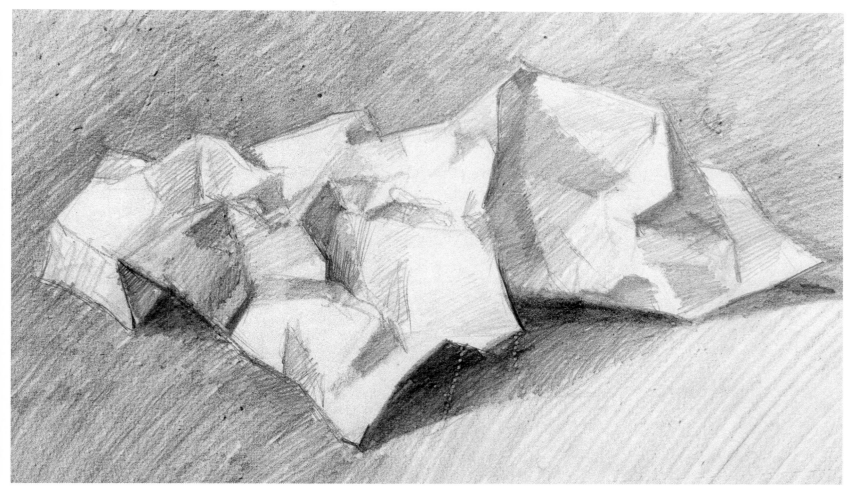

A study of the tones used in the drawing reveals a simple but very effective succession. The different planes are understood through the juxtaposition of well-structured grays of varying intensity.

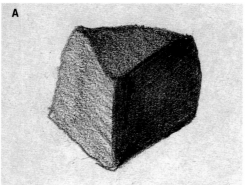

In a drawing such as this one, there is an alternation between two types of shading: Some areas are resolved using uniform tones (A) that give the shape a more solid and compact appearance, whereas in other areas the shading includes hatching (B) that emphasizes the direction of the folds in the paper and constitutes a more dynamic treatment.

Shadow as Structure

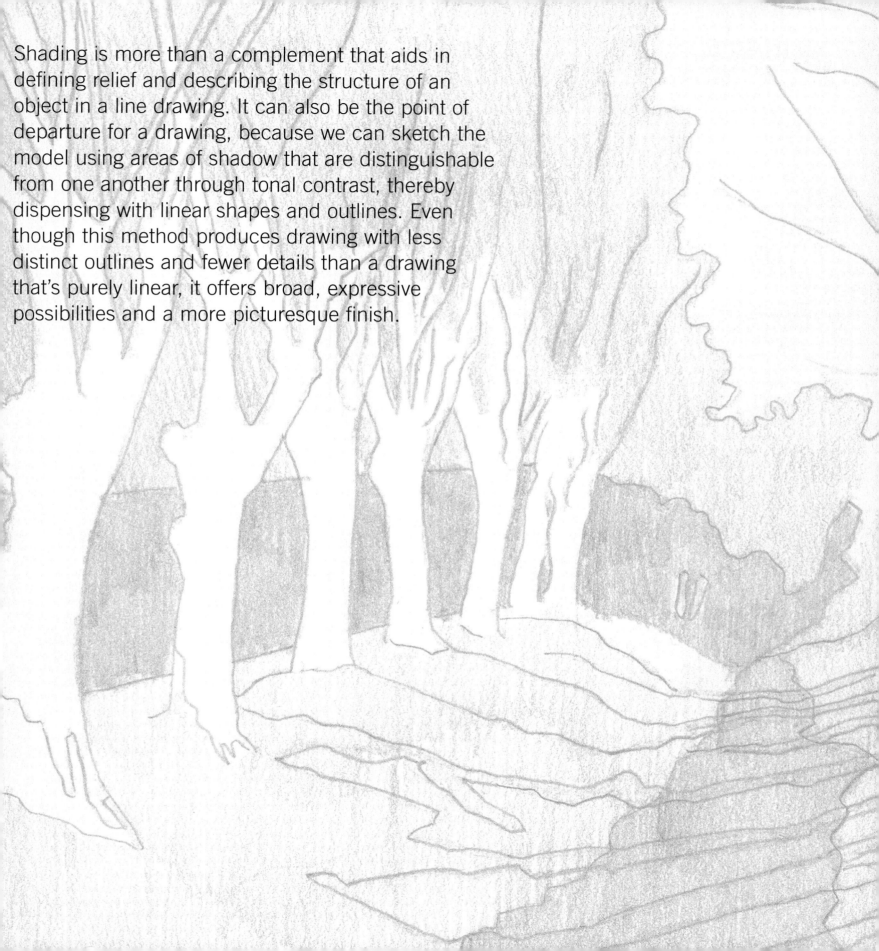

Shading is more than a complement that aids in defining relief and describing the structure of an object in a line drawing. It can also be the point of departure for a drawing, because we can sketch the model using areas of shadow that are distinguishable from one another through tonal contrast, thereby dispensing with linear shapes and outlines. Even though this method produces drawing with less distinct outlines and fewer details than a drawing that's purely linear, it offers broad, expressive possibilities and a more picturesque finish.

NEGATIVE SPACES. In this exercise we will discuss a very useful system for drawing complex outlines: using negative space. Negative space surrounds the model and shares its outline; as a result, when it is shaded in, the object takes on shape. In the exercise the columns with the flowerpots are the positive shapes, and the rest of the space is negative. We treat this negative space with shading that makes the positive spaces take on shape and turn into something real, offering a new perception of the object.

6.1

RESOLVING THE STRAIGHT OUTLINES. The lower part of the model is resolved using gentle grays, forming perfectly profiled geometrical tonal blocks that delineate the edges of the columns. The spaces that the columns are to occupy are left white.

Using an HB graphite pencil we outline the columns, which appear white, by applying grays in the intervening spaces. The major difficulty lies in adjusting the angle of the diagonal lines that delineate the top of each area to create an effect of perspective.

We set aside the HB graphite pencil and take up a 2B to apply new tones of medium grays. Using a slightly darker gray, we distinguish the edge of the wall from the vegetation in the background, which we represent with a slight gradation.

The shading is gentle, with scarcely any abrupt changes in tone. All the strokes follow the same diagonal direction.

6.2

OUTLINING THE PLANTS. The greatest difficulty in this drawing is creating the outline of the plants. To handle this easily, we shade in the background, including the spaces between the flowerpots and the stems. When we're finished, the objects appear in profile against the white of the paper.

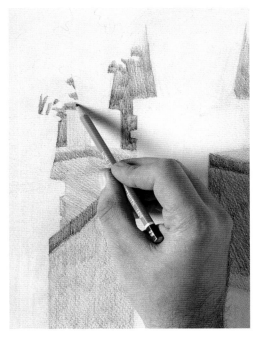

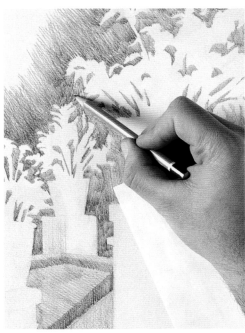

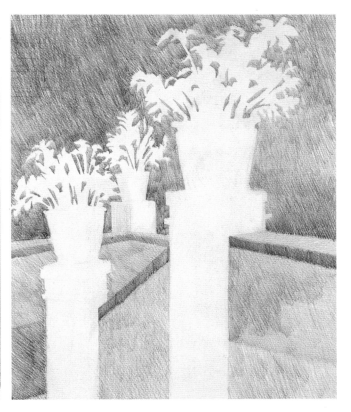

We give shape to the base of the flowerpots by carefully shading in the empty space between them. Then we use small areas of shading to depict the spaces that open up among the stems of the plants.

We continue by further outlining the leaves with additional shading. In this stage of the drawing, the surface of the paper is already covered with lots of graphite, and it's advisable to protect it from smudging by covering it with a sheet of paper.

We finish shading the outline of the columns and the flowerpots. The result is that they all appear to have been cut out of the drawing, leaving behind only their silhouettes. The work concludes here, but it can be perfected by correctly drawing the shapes and shadows inside the objects. Drawing by Gabriel Martín.

The object is not to draw the profile in pencil lines first and then add the shading without covering over the lines; rather, we use the very shading to create the drawing. In this exercise, it's the areas of graphite that construct the outline.

If we wish to differentiate and contrast the flowerpots even more, we darken the background with shading applied in 4B pencil, also remembering the open spaces among the stems.

227

MODELING. The use of a single tone for all the values of shadow is referred to as *modeling*. The illuminated areas are left in the white color of the paper. Thus, the shape of the model is distinguishable solely by means of a solid base of medium gray shadow that covers the whole paper and acts as a contrast with the white of the paper.

GUIDELINE FOR LOCAL VALUES. This is what distinguishes the basic difference in tone that exists between one color and another. This tonal difference is caused by the fact that some colors absorb more light than others. When a polychromatic model is reduced to black and white, the colors must find their equivalents in the scale of grays. As a result, every color is equivalent to a different tone of gray. This equivalence is determined by the guideline for local values; that way, red is equivalent to a gray that is darker than the one used to represent yellow.

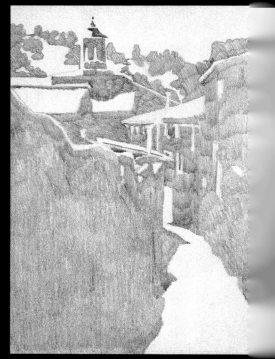

We can summarize a rural landscape such as this one—a narrow street illuminated from the side by intense sunlight— using a single tone of shadow in a type of modeling.

A grove of trees near a brook is drawn using the guideline of local values: every tone in the monochromatic drawing is equivalent to a

The guideline of local colors distinguishes the main tonal contrasts; the black of the hair becomes the darkest tone.

In accordance with the guideline of local colors, the local color of every area in a monochromatic drawing must be translated into a tone.

GUIDELINES FOR SHADING. Some simple guidelines can help us distinguish the tonal variations and the arrangement o shading on the model. A combination of both representations affords an appropriate tonal resolution of the model.

THE SHADING GUIDELINE. Shadows are likewise subject to a guideline. To recreate the shape and three-dimensionality of the model depicted, it's essential under certain light conditions to use the shadow guideline. This is based on the differentiation of the illuminated areas from the shaded ones in the model.

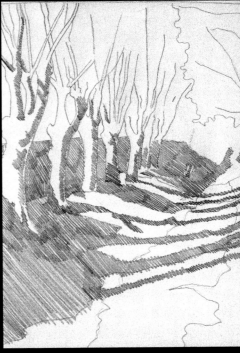

In a drawing based on the shadow guideline we are interested mainly in the distinction between the illuminated and the shaded areas.

The same grove of trees as before is now developed exclusively in accordance with the shadow guideline. The contrast between light and dark areas makes it possible to comprehend the model.

A COMPLETE GUIDELINE OF VALUES. A combination of the guideline of local values and the shadow guideline creates a complete guideline of values. When the light is intense, these two areas seem to have the same value and blend with each other. When the light is more diffuse, the shadow guideline diminishes, and the guideline of local values takes on greater importance.

By combining the guideline of local values and the shadow guideline, we create a complete tonal representation of the theme.

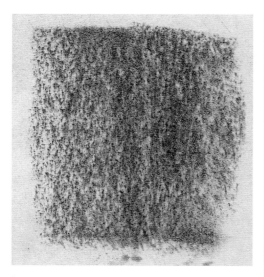

Shading with the stick held flat is fundamental to this type of work with charcoal. That's how we quickly darken the surface of the paper.

To create the homogeneous gray for the background of the landscape, the first shading with the stick of charcoal held flat is blended by simply passing the hand over it. That way we avoid the granular texture produced by moving the stick in a longitudinal direction.

Let's analyze the method for drawing a tree trunk using charcoal and a model slightly more complicated than the one in the drawing. We first use the charcoal stick held on its side to darken the background and the shaded side of the trunk. Then we use the tip of the stick to apply some irregular strokes to the shaded area to represent the texture.

To depict the foliage, we cut the charcoal stick into inch-long (2.5 cm) pieces and create dark, short, superimposed areas of shading, which we immediately blend using the tips of our fingers.

230

SHADING WITH CHARCOAL. Because it's easy to erase, malleable, and easy to modify by creating gradations or stumping, charcoal is the perfect instrument for doing quick landscape sketches. The treatment is not highly refined, but it's quick, efficient, and spontaneous.

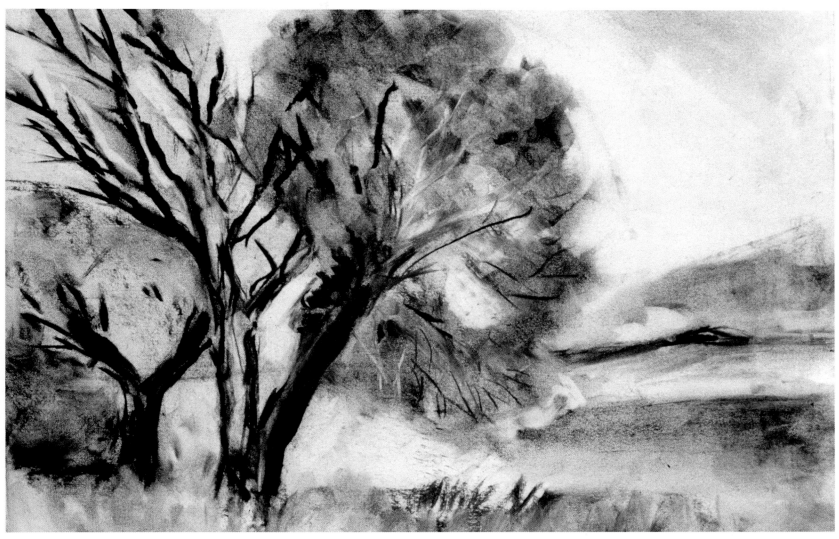

Shading with charcoal makes it possible to darken every plane in the drawing quickly and create a very expressive drawing with an attractive finish.

The effect of texture in the leaves of the trees is produced with an eraser, by opening up areas in the crown of the tree to simulate fine branches that give the overall picture greater texture.

231

COMBINING LINE AND SHADOW. There's no need to limit ourselves to shading, since lines can give more expressiveness and concreteness to the drawing. Shading contributes to highlighting the shape of the trunk and making the tree stand out from the background, and lines consolidate the profiles and provide texture and detail in the foreground.

7.1

VERY FAINT LINE. Using a soft, imprecise stroke and short, very diffuse shading, we draw the olive tree, which appears very soft on the surface of the paper.

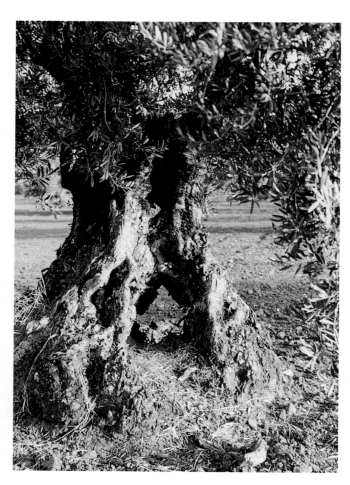

With just a few zigzag lines produced after several attempts, we sketch the outer profile of the olive tree. The shaded areas begin to appear indistinctly, without too much conviction.

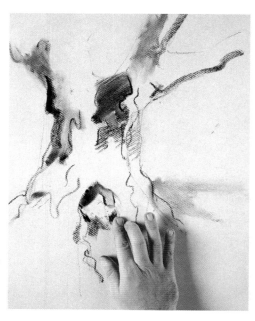

Working with the fingers is essential in stumping the shaded areas and blurring the lines where it's appropriate for the outline to be more diffuse. We sketch the position of the branches using a small stick of charcoal held on its side.

The first strokes are applied very gently, by practically caressing the surface of the paper with the charcoal to facilitate correction if needed.

7.2

SHADING AND ERASING. We construct the shape of the trunk by modeling the surface with shading and erasing. By alternating light and dark areas, we represent the irregular bark, complete with clearly differentiated projections and depressions.

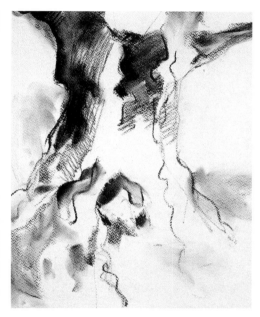

Using charcoal applied to our fingers, we add small touches of light gray at the base of the trunk. We set up the difference between the shaded side and the hollow using a darker gray, which we blend using our hand.

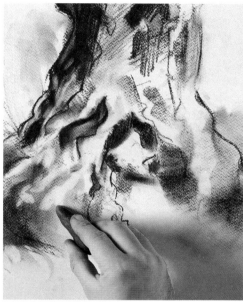

We contrast each fissure with lines and new shaded areas, which we likewise blend. At the top of the trunk the first shading in the form of hatching begins to emerge.

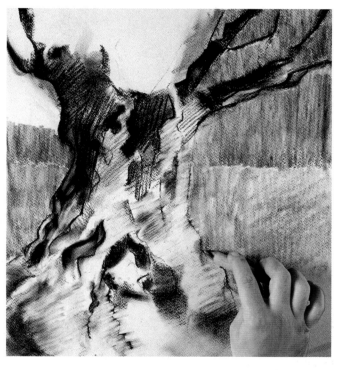

We apply the eraser to the hatching on the right side of the trunk. We finish the olive tree by projecting the branches with thick, dark lines. We cover the background with more shading and shade it off using vertical strokes with a blending stump.

We draw the branches by dragging the side of a charcoal stick to create a fine, very straight line.

7.3

HATCHING AND SCRIBBLING. In this final phase of the drawing we focus on the textures of each surface. To simulate the foliage easily, we use shading with hatching and a random series of lines or scribbles.

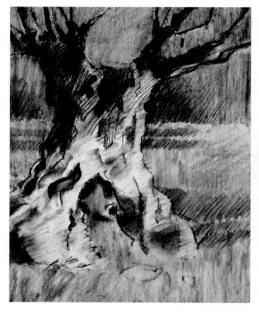

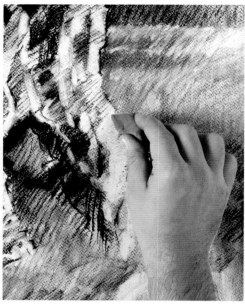

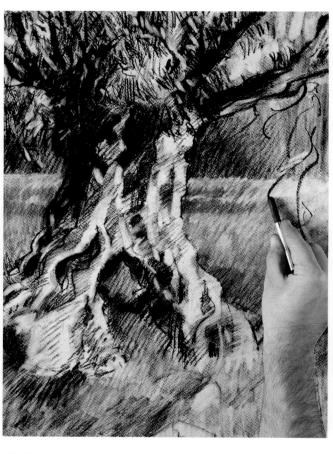

We complete the shading in the background. We resolve the upper edge using a medium gray and the sandy ground with a lighter gray. We slightly intensify the shading around the trunk with subtle strokes to increase the contrast.

We work on the relief of the tree bark by applying shaded areas in the form of hatching. Before adding the foliage, we open up areas in the sky and lighten the trunk with an eraser.

We darken the background using new hatching made up of diagonal lines. By combining the charcoal and a Conté crayon, we represent the series of branches and leaves with random, scribbled lines.

In this last phase, the Conté crayon is essential, because it permits darker lines than charcoal does, and it's a good choice for accentuating the outlines and darkening the shadows.

To highlight the shape of the irregularities on the trunk, we heighten the effect of chiaroscuro by clearly differentiating the tonal areas with pronounced contrasts.

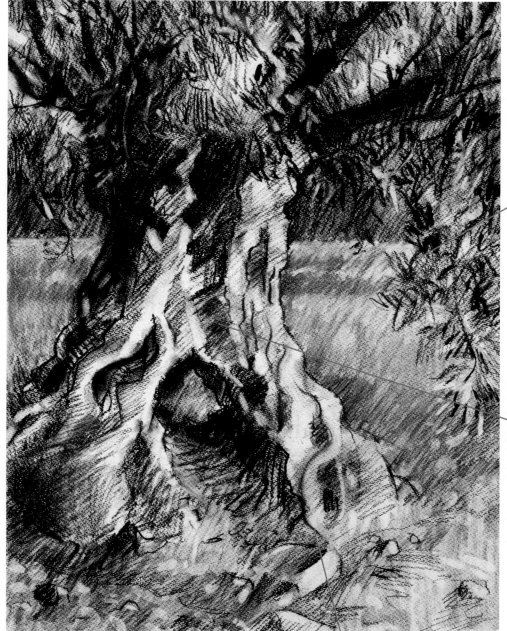

The scribbled lines of the leaves are clearly distinguishable from the blended background. There is a contrast between the lines and the tonal surface that keeps the planes from blending in with one another.

The trunk requires the strongest contrasts. We produce a pronounced shape by using the chiaroscuro effect and effecting abrupt transitions between illuminated and shaded areas.

We finish the foliage with a branch or a cluster of leaves that stand out on the scribbled surface. Then we add a bit of relief to the stony ground at the bottom of the drawing. The finish is very expressive. The branches, the strokes, and the intentional exaggeration of the twists in the bark produce a very dynamic effect. Drawing by Gabriel Martín.

The stones in the foreground are depicted by marking the edges or outlines with soft strokes, and by differentiating the illuminated faces with erasing and shading.

SHADING WITH THE HANDS. Lines are not the only way to shade. We can also use charcoal, chalk, and powdered sanguine. However, the powder doesn't stick to the paper by itself. It has to be pressed in with a piece of cotton or the hands, the artist's natural tools.

8.1

THE HAND AS A TOOL. The first phases of shading are done using a piece of cotton cloth and rubbing with the tips of the fingers, covered with pigment, using broad, quick movements.

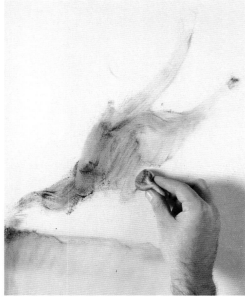

We load a piece of cotton with sanguine powder and color in the darkest areas of the model: the forest floor in the foreground and the cave. After applying the color, we blow on it or tap the easel to remove the loose pigment.

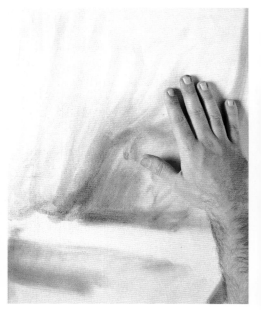

Using the tips of our fingers, we apply more pigment to the paper. We model the veined surface of the rocky wall using a few passes with the hand held open. Using the thumb covered with color, we darken the outline of the cave.

To draw the tree trunks, we cover the tips of the index and ring fingers with plenty of pigment and rub it firmly onto the paper.

We use one finger or the other, depending on the thickness of the trunk or the branch being drawn.

8.2

LINES AND TEXTURES. In this second phase, we incorporate finer lines and effects of texture that provide the drawing with additional information. This treatment is applied by combining modeling with the hands, blending, and erasing.

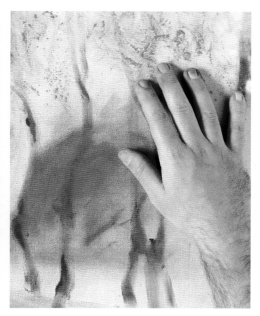

To give the foliage a warmer tone, we use our hands to apply a little ochre pigment to the tops of the trees. We spread the color out in an irregular manner with our hands, moving the fingers like a pianist.

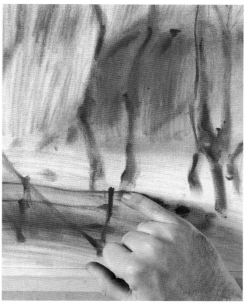

Using the tip of a medium stump and the little finger, we draw the branches on the trees and the wooden fence rails at the bottom. We gradually reduce the pressure in drawing the branches to make the lines vanish.

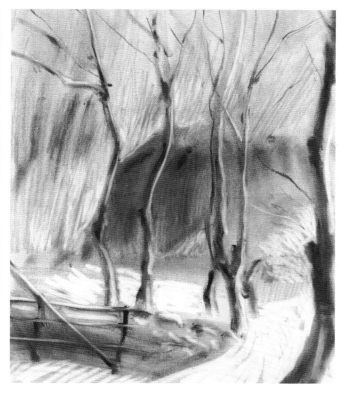

We use the eraser for the final effects of texture: We open up light areas in the road, draw a light line on the tree trunks, and apply a series of vertical lines on the rock wall.

We use the point of the blending stump coated with pigment to draw the thinnest branches that we can't trace with our fingers.

Using the eraser, we open up light areas to accentuate the illuminated areas, and we apply lines that create texture.

LEONARDO'S SPHERE. Leonardo da Vinci studied and theorized about the imprecise outlines of shadows. He observed that the shadow cast by a sphere ight from a window exhibited a gradation that made it impossible to determine its outline precisely. To resolve this question, he invented the well-known *sf.* ive process intended to avoid clear outlines of objects and shadows.

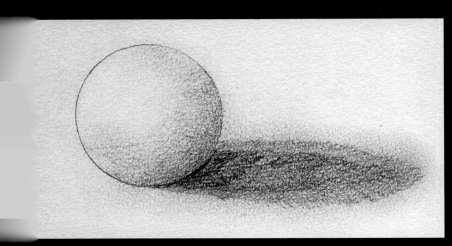

TOOLS FOR SFUMATO. The fingers or a blending stump can b sfumato, but the two systems produce quite different results. The fir control over the gradation because of the direct contact with the pa stump creates a more subtle and homogeneous gradation, its tip control, and the finishes and edges of the shaded areas are much and precise.

Leonardo's principle is based on the impossibility of determining the outline of the shadow cast by a sphere illuminated by diffuse light.

SFUMATO. *Sfumato* refers to a drawing with a misty, atmospheric appearance, with no clearly defined borders, where objects are depicted as blurry spots w no outlines, but with very subtle tonal gradations and soft shading.

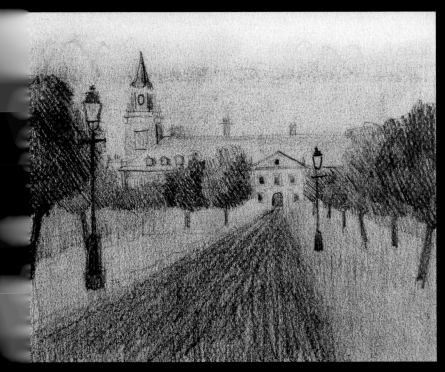

Here sfumato is created using the tips of the fingers. The blending is so gentle that it maintains the tonal gradations created with the pencil.

Sfumato is appropriate for creating landscapes with a foggy or mysterious appearance.

Here sfumato is done with a blending stump. It substantially

DIFFUSE SHADING. Light that bounces or is reflected or filtered by a translucent body reaches the model in a filtered condition. This is what happens with clouds in a landscape, or with a curtain indoors. Thus, the shading must be diffuse, and the contrasts subdued. In these cases, the shadows appear softer and look like dark, indefinite halos that appear softly beneath the shapes. In addition, there is a major transition between the most highly illuminated parts and the shaded ones, producing a rich set of intermediate tones.

STUMPING. Stumping involves spreading out and removing color with the intent to diminish intensity. Stumping makes it easy to create three-dimensionality, but if we go overboard with it, the drawing can turn out murky, and lacking in precision and definition. To avoid that, it's best to have a clear idea of the values, the light and dark areas, and the contrasts between them.

There are different types of stumping, and each one produces different textures or effects with graphite: (1) shading with graphite; (2) shading with the fingers; (3) using a blending stump; and (4) using an eraser.

DIRECTION OF STUMPING. The strokes with the blending stump can be straight or curved, depending on the model. For example, to represent the shape of a figure's muscle or arm, curved and straight lines are used alternately; for the buttocks, the strokes are circular.

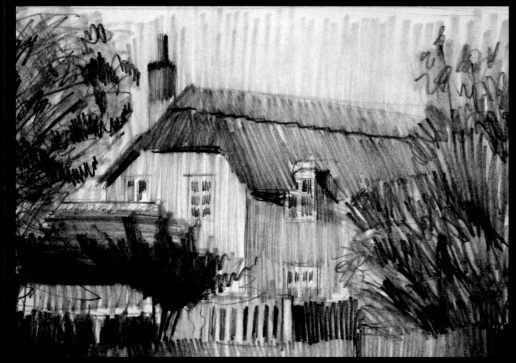

When we wish to control the direction of the stumping, we use the blending stump, which is the only instrument that allows stumping and the creation of lines at the same time.

Whenever we work with stumping, we need to be attentive to the direction of the strokes. Here they are perpendicular in the sky, diagonal on the roof, and random in the vegetation.

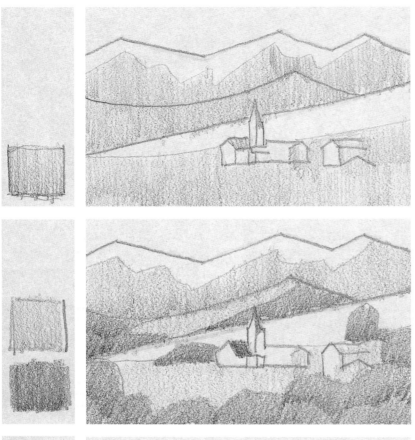

Making use of stumping is essential if we intend to draw an atmospheric landscape in graphite tones. Compare the two tonal scales: In the upper one, which exhibits stumping, the presence of the strokes has nearly disappeared, and the tones appear in diminished contrast and with more integrated edges.

The smooth tonal transitions in the drawing are produced by rubbing with a piece of cotton. It's best to avoid working with the blending stump in this case, for this implement clumps the graphite together more and leaves marks on the surface.

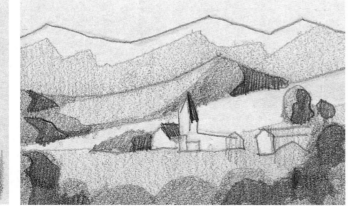

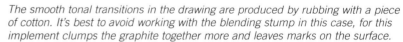

The tonal representation of this landscape depends on the process used. These three sketches explain the best development for doing the drawing, with progressive addition of tones. The first application corresponds to a light gray tone, setting aside the color of the paper for the lightest areas on the mountains. The second instance incorporates a medium tone that highlights the effect of three-dimensionality. We finish up with a dark gray that highlights the contrasts between the planes.

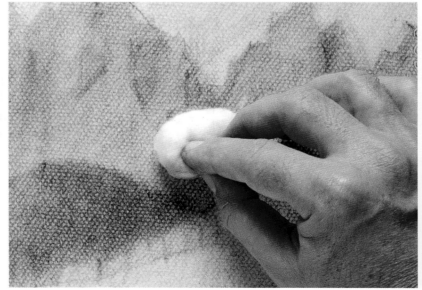

LANDSCAPE WITH SFUMATO. Sfumato has the effect of softening the shading. This technique makes it possible to mix the tones easily and help produce very subtle tonal gradations, such as misty effects, for the purpose of depicting shapes without drawing outlines or profiles. For sfumato it is common to use a graphite pencil because it's easy to blend and smudge, and offers rich tonal qualities.

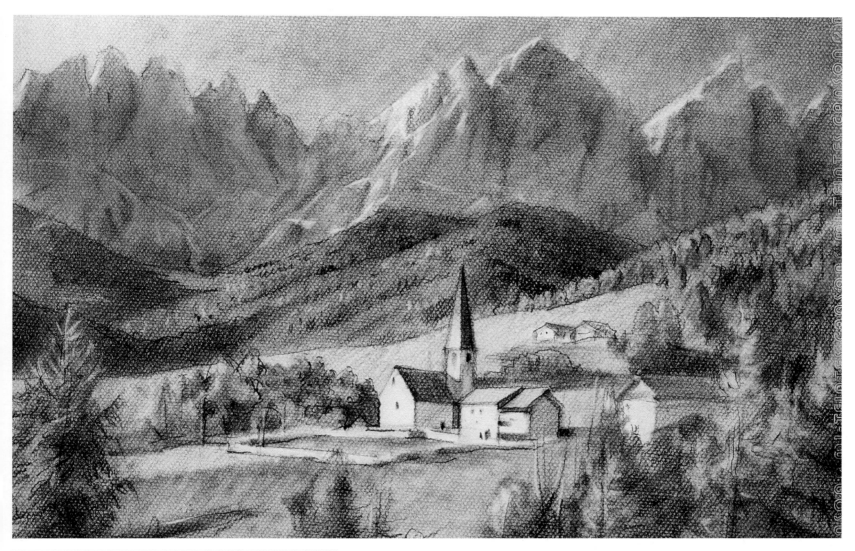

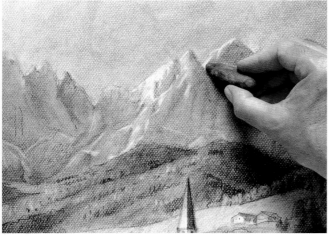

In this mountain landscape done in graphite pencils, we see a very atmospheric treatment because of the stumping effect, which involves softening the lines and contrasts among the shadows by rubbing with the hand, a stump, or a piece of cotton.

Despite the continuous blending, the drawing presents interesting three-dimensional effects created through contrast. The artist has produced this effect by opening up light areas with an eraser, thereby creating greater contrast between the illuminated and the shaded areas.

241

Shading
Techniques

In general terms, shading is a transition from light to dark tones, and vice versa. Although there are many different shading techniques, nearly as many as there are artists, some are considered more appropriate than others for certain works. But in all of them, the main issue is the values of light and shadow. The choice of one technique or another depends on the plastic effect we wish to create and the medium we are using for the drawing. In this section we will consider the possibilities of each of the drawing processes in creating the shading.

MODELING. Modeling involves depicting a subject by shading it with smooth tonal transitions, without leaving visible strokes or lines. The shadows appear represented by gradations, with no abrupt contrast between tones. In this exercise we will study how to shade and model the different areas of a drawing. We will skip over the layout and drawing steps and go directly to the shading.

9.1

SHADING WITH A STICK OF CONTÉ HELD ON ITS SIDE. Before starting to model, we have to shade. The best way to shade a drawing is to work with the stick of sanguine held lengthwise. That makes it possible to cover the drawing quickly, develop gradations with greater ease, and avoid visible strokes, which would be too apparent if we were working with the tip of the stick.

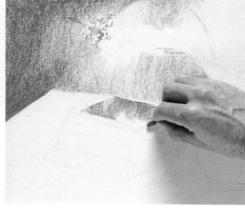
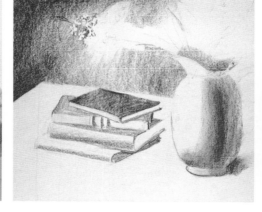

Working with the side of the stick of sanguine, taking care to avoid the area occupied by the flowers, we cover the background with a broad shading in gradation. Then we shade the covers of the books very evenly, setting aside in white the illuminated areas.

In shading the pitcher, we have to proceed very carefully, because its shape is a bit more complex. We define the pitcher with gradated shading that runs from top to bottom.

The preliminary sketch for the drawing is customarily done using a graphite pencil with very light pressure.

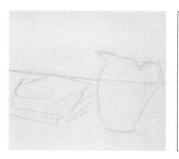

The graphite keeps the powder from the sanguine from adhering to the paper, so after producing a convincing drawing of the model, we lightly erase the lines. The lines that remain must be very light, just enough to guide us in the shading.

9.2

MODELING TO CREATE THREE-DIMENSIONALITY. The effect of three-dimensionality is produced by modeling the surface of every object in smooth transitions of tone; thus, the shadows that are incorporated and exhibit pronounced gradations need to be softened with the tips of the fingers.

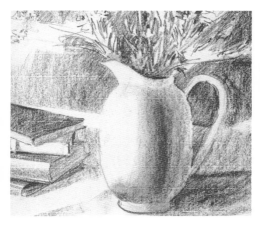

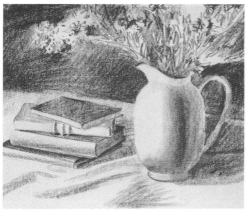

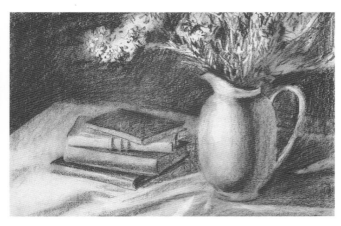

We resolve the flowers using excited, imprecise strokes with the tip of the stick. It's not necessary to draw them stem by stem, but rather to recreate the whole. By once again using the side of the stick, we add the shadows cast by the pitcher, taking care to differentiate the shadow and the half-light with two different tones.

The modeling is very smooth and gradual, with no visible strokes. This is achieved by intensifying the values with new soft shading and blending to create gradations with the tips of the fingers.

If we have done a proper assessment of the subject, we succeed in modeling the shapes, which appear in all their relief and three-dimensionality. With this type of modeling, the artist simulates in two dimensions what the sculptor does in three: giving body and presence to the subject. Drawing by Óscar Sanchís.

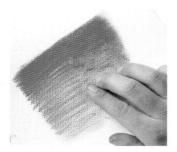

It's a good idea to practice in advance and on a separate piece of paper by modeling with sanguine and creating gradations with the fingers.

VOLUME THROUGH CHIAROSCURO. Now we address a subject with pronounced contrasts between light and dark using the chiaroscuro technique. The shadows created with charcoal are dense and dark. We achieve the effect of modeling almost exclusively with our hands by rubbing, shading, and lightening, thus modeling the shape of the column using contrasts between the light and the shaded areas.

10.1

LIMITED STROKES. We locate the main lines in a quick drawing that uses the smallest possible number of strokes, which we vary in intensity according to their importance. We don't seek a precise rendition of the model. The particular framing of the subject allows the artist to highlight a certain distortion or exaggerate the appearance of recession in the column.

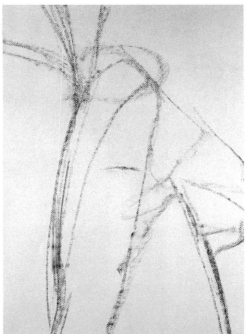

Using the stick of charcoal held flat, we use diagonal strokes to lay out the spiral shape of the column in a very synthetic way. The fewer lines or colored areas we lay out, the less we have to adjust.

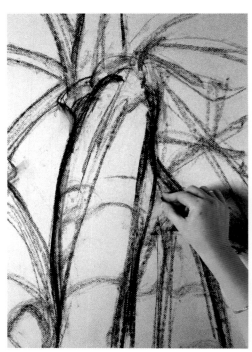

As we progress in the layout, we use the tip of the stick to darken the outline of the column. This allows us to reinforce the main lines.

To make it easier to draw with the side of the stick, we cut the charcoal into shorter pieces.

To create the effect of perspective, we make the column narrower as it gains height.

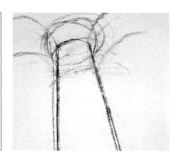

10.2

QUICK SHADING. We quickly darken the background using the side of the charcoal stick to distinguish and isolate the main shapes. Although this produces a soiled appearance, it makes it possible to develop an initial scale of medium tones, which is necessary for the subsequent application of new shadows that produce an effect of chiaroscuro.

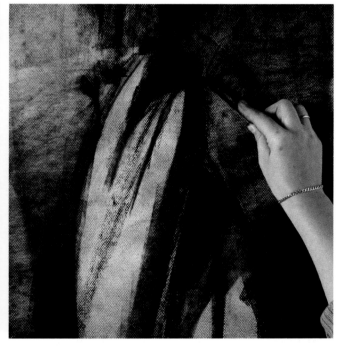

First of all, to differentiate between the light area of the column and the darkness of the arch, we apply an initial shading on the background and extend it to the right-hand side of the column, which also remains in shadow.

We effect an overall blending with the hand held flat on the shading so that it is incorporated more effectively into the paper. Then we shade with darker black, using lots of pressure on the side of the charcoal stick.

We contrast the areas of light and shadow on the column by using the tip of the charcoal, and we even out every new addition of gray with the tips of our fingers. The shadows appear clearly differentiated because of their outlines.

If we smudge the charcoal with the tips of our fingers, we produce the perfect base tone for the stone in the ceiling.

The background is resolved with a simple tonal gradation, which runs from the darkest black at the bottom to a gentle gray at the top.

10.3

CHIAROSCURO WITH THE HANDS. So far we have worked only on the basic shading to differentiate the areas of light and shadow. As we progressively add the effect of chiaroscuro, we will study which of the blacks will be the darkest we can achieve. In modeling we use mainly the hands to form gradations in the shadow and to lighten it, because the hands produce good results in the areas of strong and medium illumination.

Using a stump loaded with charcoal, we sketch the arches of the Gothic nave. To stand out, the lines have to be darker than the preexisting gray without becoming absolutely black, which is reserved for the darkest areas in the background and the column.

To create the effect of smoothness on the stones of the column, we need to use a cotton cloth. We use it to rub the pillars from top to bottom, lightening the shadows and softening the gradation.

The right-hand section of the background displays a darker overall tone than the left. We also darken the right-hand section of each pillar to create an impression of volume. We use the eraser to simulate the joints between the stone blocks.

To create a convincing chiaroscuro, it's appropriate to lighten the areas of greatest illumination with a kneaded eraser. The greater the contrast between light and dark, the more pronounced the impression of volume.

Using the tip of the charcoal stick, we bring the shaded area of the column to near-total blackness.

Using the kneaded eraser as if it were a pencil, we open up light lines that give shape to the capitals.

Once we have achieved the effect of chiaroscuro, we use our fingers to blend the grays of the background. Now we set aside the stick of charcoal and use a Conté crayon, which makes it possible to create more intense blacks. We outline the columns so that they stand out clearly against the background. Drawing by Mercedes Gaspar.

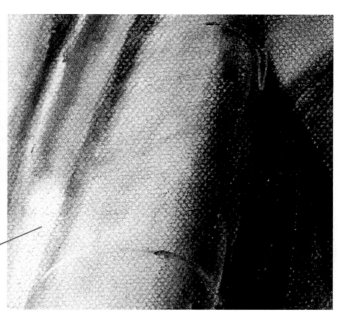

Using a gradation from intense black to light gray, we achieve the three-dimensional effect of the cylindrical columns.

We locate the absolute black along the right-hand edge of the column. The gradation in the background next to this outline is slightly lighter to highlight the feature in the foreground.

GRADATIONS USING CHARCOAL OR CHALK. It's easy to create gradations with charcoal or chalk by using the side of the stick and increasing or decreasing the pressure on the paper.

Gradation using a stick of charcoal.

Gradation using a stick of chalk.

DEEP GRADATIONS. A gradation done in chalk or sanguine takes on depth if we rub the surface of the paper with a blending stump, because the powder penetrates into the pores of the paper and the color darkens.

Gradation done with a stick of chalk and gone over with a stump.

GRADATIONS USING A PENCIL. Gradations in pencil are commonly done by alternating pencils of different hardness. However, a pencil can be used to create a gradation in traditional shading done in parallel strokes by simply reducing the pressure exerted on the paper. When doing gradations in pencil, it's important that the point be fairly dull.

Gradation done with a graphite pencil.

Gradation done with a blue pencil.

MASTERING GRADATION. Gradation is shading that provides a smooth transition from one tone to another so that all the tonal values of a particular scale are represented in order and without visible breaks.

ATMOSPHERIC GRADATION. We can avoid the presence of graphite pencil strokes in the gradation by working with the side of the tip, drawing small circles in smooth, rotating motions. The effect of this type of gradation is more foggy, atmospheric, and delicate than the classic one using parallel strokes.

VOLUMETRIC EFFECT. The gradation is adjusted to the effect of the light on cylindrical and spherical shapes, so it is the most commonly used resource for giving shape to these types of objects.

The presence of pencil strokes is nearly imperceptible in an atmospheric gradation.

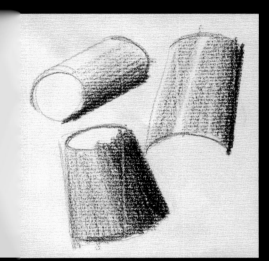

The representation of a cylindrical model takes on volume with a simple gradation.

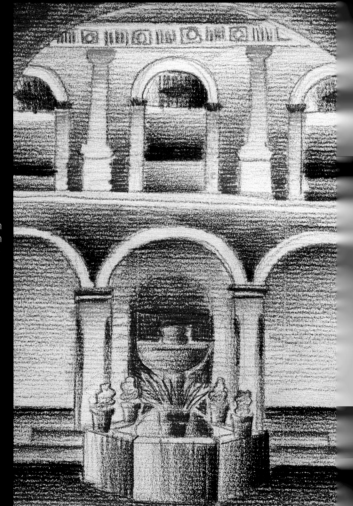

DRAWING WITH GRADATIONS. We can do drawings using nothing more than gradations, which contribute to emphasizing the effect of volume. The result is very interesting, although the distribution of the light and shadow is a little disconcerting and ambiguous.

When applied to landscape, gradation highlights the voluptuousness of the different planes.

HATCHING AS SHADOW. Using hatching to create shadows is an effect that can be used to create various tones and values by spreading out a type of "carpet" of superimposed pencil lines that often cross one another at an angle.

11.1

A SOLID DRAWING. We have to exercise considerable care in doing the drawing, because it will be the basis for all the subsequent hatching. It must be bold, linear, and confident, with lines that delineate the shaded and illuminated areas. The final result depends in great measure on the initial drawing.

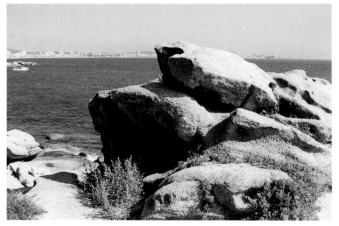

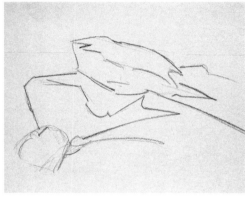

Using a sharpened black chalk pencil, we use lines to synthesize the outline of the rocks. The inner lines, which are also synthetic, highlight the relief of the rock and separate the illuminated areas from the shaded ones.

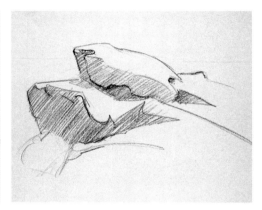

In a very general way, we distinguish the main areas of shadow in the rocky formation by applying an initial hatching in a classical shading consisting of parallel lines. As the hatching is applied, some outlines in the rock are highlighted.

The first shading is done using a simple or traditional hatching, a series of diagonal, parallel lines that present an even shading.

To keep the shading even, the superimposed hatching must be applied at an angle that is different from the first one.

11.2

SHADING WITH HATCHING. It takes time and patience to do drawings with hatching. This technique of shading makes it possible to calculate precisely the value of every light and shadow. It is very important, and perfect mastery is proof that the artist is well trained.

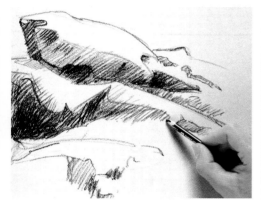

We superimpose the first hatching onto the previous layout in gray to darken the shadows. The darker we want the shadows, the more we bear down with the pencil.

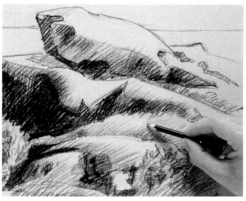

We spread out the intermediate tones using very light strokes. We superimpose a third hatching onto the darkest shadows on the rock. We leave white the areas of maximum light.

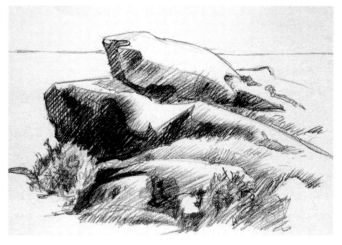

The combination of multiple hatchings produces works with rich tonal values that suggest the quality of the surfaces depicted. In contrast to works done using gradations in pencil, the shadows of a drawing that incorporates hatching exhibit a greater effect of texture. The superimposition of lines endows the drawing with much more visual information and more detail than in reality. Drawing by Óscar Sanchís.

Experimenting with hatching can be interesting. We can impose different types of hatching onto a conventional pattern, varying the line and the pressure exerted with the pencil in each one. This produces a variation in the darkness and the texture of the resulting shading.

Hatching is not only a special method of shading, but also produces an effect of texture.

CLASSICAL SHADING. Classical shading was developed in the fifteenth and sixteenth centuries by the great artists of the Italian Renaissance. This technique involves drawing a series of parallel lines at about a 45-degree angle to cover the whole area to be shaded. The closer together the lines are, the darker the shadow.

An example of classical shading.

HATCHING. Hatching involves juxtaposing and superimposing lines. Because of their uneven nature, they can produce a sensation of vibrations when seen at a moderate distance, and that doesn't happen in areas filled with flat color. It's worth experimenting with all the possible types of hatching, using different media, colors, and lines.

Landscape sketch using classical shading.

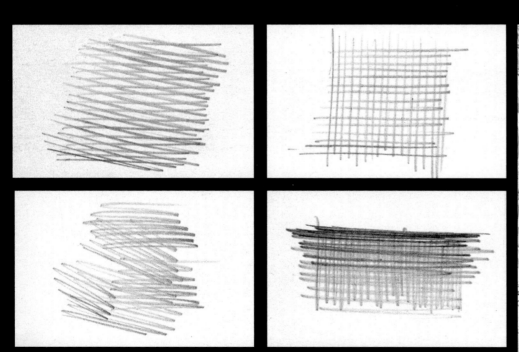

Different types of crosshatching can be produced by varying the angle of intersection and the intensity of the lines.

CROSSHATCHING. In classical crosshatching, the lines cross at a slightly different angle. These angles, which are nearly the same, create a moiré design that makes the shading somewhat luminous because of the spaces through which the white of the paper breathes. Increasing the angle of the intersecting lines creates a different type of crosshatching, and more white space is opened up. In both cases, it is possible to darken the shading simply by adding more hatching over the previous one.

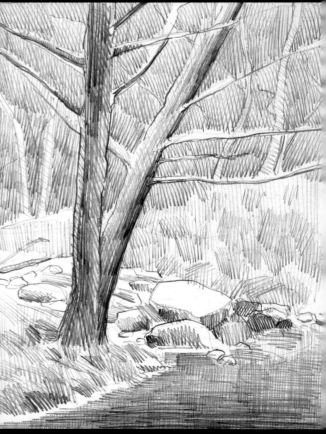

A landscape sketch done by combining several types of crosshatching.

LINES. This involves classical lines in which we vary the pressure and the width of the line to indicate different tonal areas. Applied decisively, lines can give sketches great force.

Application of lines to a drawing.

SHORTHAND SHADING. This relates the structure of the shadow to the expressiveness of the line, linking the type of lines to the calligraphy appropriate to writing. The use of lines facilitates gestural expression to a greater extent than when drawing outlines. This shading doesn't allow for a very precise and detailed treatment; only the specific features that define the shapes are represented.

MODELING. When we manipulate a 4B pencil very smoothly, the direction, the tone and the shape of the pencil strokes are softened. The tonal transitions between the areas of light and shadow are resolved gently. We reserve lines for indicating textures on the objects.

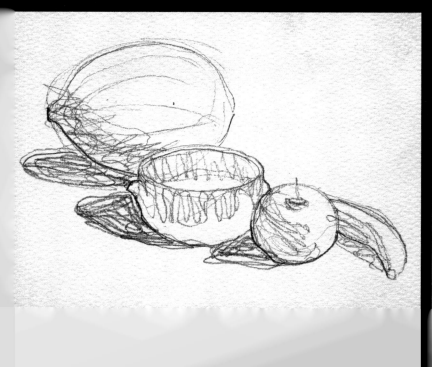

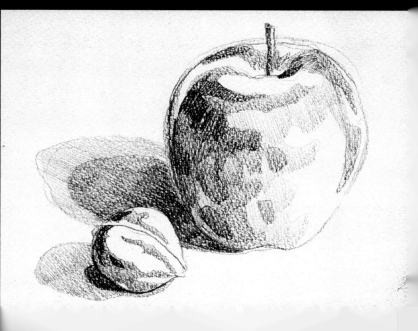

Let's see in this progression how to depict a piece of fruit to make it look like the model. We first color the shaded area using the stick of sanguine held flat.

After blending the previous addition with the tips of the fingers, we apply more shading at the bottom of the sphere and indicate the depression at the top of the apple.

We use the tip of the stick to darken the lower half and outline the roundness of the apple with a dark line. The effect of the representation owes much of its success to the gradation that covers the surface of the object.

The use of the blending stump is the key to creating a convincing effect in the objects included in the composition. When its point is loaded with color, we can create smooth gradations simply by dragging it across the paper.

The background of the composition must appear very sinuous; the shapes nearly disappear and become integrated with the white of the paper. This is achieved with a few fine lines that are blended using the stump.

MODELING WITH SANGUINE. Sanguine is a medium with lots of coloring power. The stroke is smooth, and it facilitates modeling, giving the drawing a rich gamut of medium tones. The modeling effect in this still life is done by controlling the gradation, diminishing the presence of lines, and with an atmospheric blending that avoids stark tonal contrasts.

In works such as this one it's appropriate to use a restrained scale of tones. These four tones, to which we add the white of the paper, are more than sufficient.

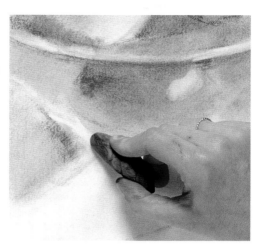

Concentrate on the light areas. As always in such cases, they are created by erasing with a kneaded eraser. Erasing is very useful for restoring the white in an object and expanding the gradation in the drawing.

The effect of depicting the shadows and the general blending produce a light drawing with correct intonation and with scarcely any abrupt changes in the transition from the illuminated areas to the shaded ones.

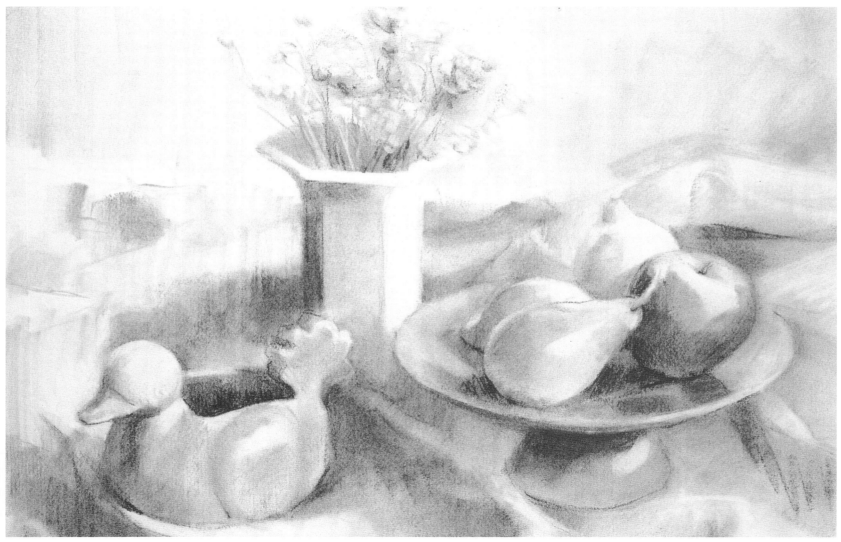

A DRAPE IN CHIAROSCURO. We now propose a study of a piece of fabric. In this exercise we will work with the shape of the folds through a detailed study of light and shadow. The shading technique we will use is chiaroscuro, which involves modulating the light on a background of shadow, thereby creating abrupt contrasts in tone to suggest the relief and depth of the folds in the drape.

12.1

ANALYZING THE FOLDS. Before starting, it's appropriate to study very carefully the shape of the folds. After studying them, we sketch the direction of each fold in a schematic way. This provides enough of the structure so that we can add the light and shadow to it.

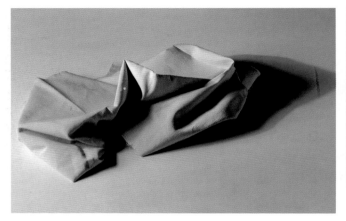

Using the tip of the charcoal stick, we very gently draw the overall shape of the cloth, the shadow projected onto the table, and the main folds.

Using the side of the charcoal stick, and without exerting much pressure, we give the whole drawing a general shading.

We must use short, straight, synthetic strokes to draw the folds of the fabric. They allow us to analyze the structure, and they indicate the direction that the cloth takes in each instance.

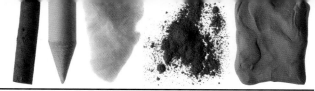

12.2

HEIGHTENING THE CONTRASTS. The second phase involves shading the drape with fairly uniform grays, preserving the illuminated areas so that the areas of light and shadow are clearly differentiated. It's not yet time to apply the intermediate tones.

Using the tip of the charcoal stick we darken the lines that define the cloth, and we reinforce the main wrinkles. We use diagonal hatching to represent the shadow that the cloth casts on the table.

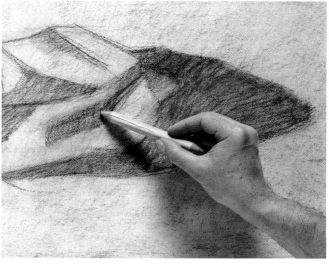

Using the stick of charcoal we add a light line to darken the shaded areas in the folds, and we leave the illuminated areas white. Then we use a blending stump on the lines so that the powder covers the paper better, and darken the initial shading.

We attenuate the initial contrasts by going over the whole with a piece of cotton, until the shading is appropriate for the medium tones. We use the piece of cotton loaded with charcoal dust to darken the top part of the table so that there is a clear gradation from top to bottom.

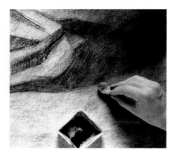

We use a piece of cotton and powdered charcoal for the shading process. That way we avoid visible strokes and very gradually shade the flat surface of the table.

Charcoal covers more effectively than pencil, and makes it possible to incorporate more energetic shading. It offers a broad range of tones and allows spreading by blending and manipulating it with the fingers and the blending stump.

12.3

CHIAROSCURO EFFECT. In this second phase we gradually intensify the dark shadows with new additions of charcoal. The drawing takes on a surprising effect of three-dimensionality because of the contrast between these blacks and the white of the paper, which we preserve in the illuminated areas.

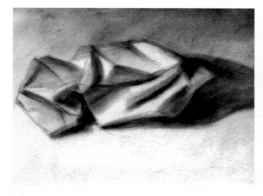

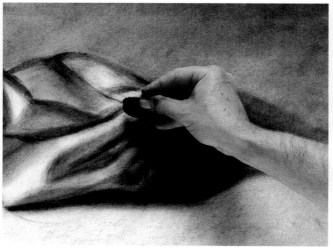

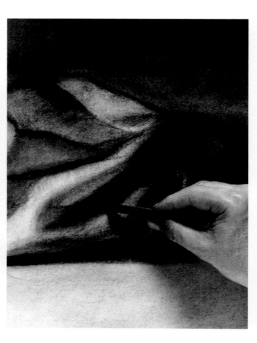

We begin the study of the folds by reinforcing the inside of each wrinkle with new, darker strokes. We darken the shadow so that it stands out from the overall shading of the table. In darkening this shadow, we give more definition to the right side of the cloth.

By combining the work with the tip of the charcoal stick and shading with a cloth pad, we finish applying the medium tones and the effect of gradation on the broadest folds. We work carefully, because we need to preserve the white in the illuminated areas of the folds.

The last strokes are the darkest ones. Using thick, dark black lines, we accentuate certain wrinkles and heighten the chiaroscuro in each fold with darker gradations.

To draw folds correctly, we illuminate the part that sticks up and shade the fold in a gradation that extends from the lightest part on the outside to the darkest on the inside.

One alternative to the foregoing is to mark off the edges of the shadows and fill in each of them with grays or gradations.

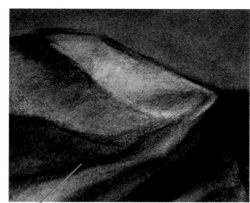

To keep the cloth from sticking to the background and blending with it, we go over the upper edge of the fabric with a thick, dark line.

We intensify the contrasts that establish the chiaroscuro effect on the various dark areas of the cloth. We also darken the large, dark shadow on the table. Drawing by Carlant.

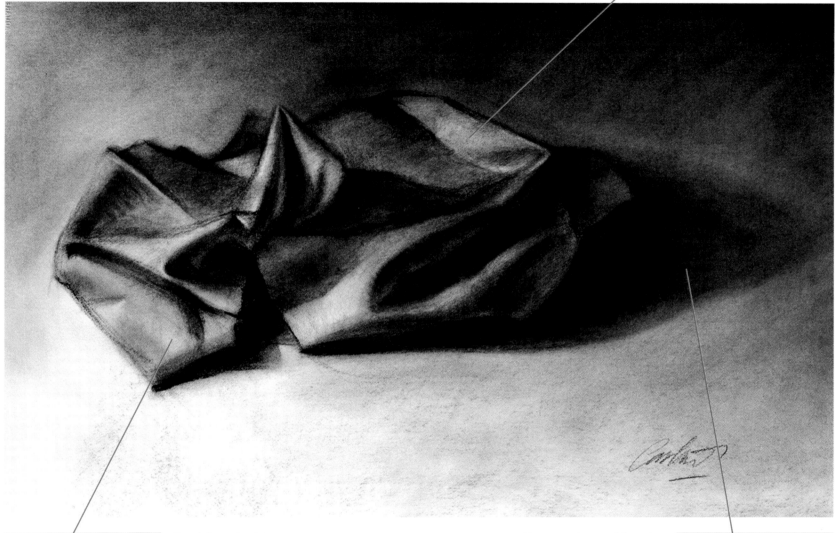

To reinforce the light areas, we restore the white of the paper by making some small erasures with a kneaded eraser.

It's appropriate to differentiate between two tones in the shadow: the dark tone that corresponds to the shadow, and the medium gray of the half-light.

A TENEBRIST STILL LIFE. Tenebrism plunges objects into an atmosphere with little light and surrounded by shadows, in a setting where shadow triumphs over light. Media that are considered unstable—charcoal, a Conté crayon, or black chalk—are ideal, because they offer little precision in outlines and help us approach things through a tactile approach, through doing and undoing, and through doubt.

13.1

SKETCH ON A TONAL BACKGROUND. The initial drawing needs to be precise and austere; the proportions must be adjusted and the shapes must be defined without devoting too much attention to the details. We have chosen a brown support because it's the color that dominates in most tenebrist themes, and that makes it easier to represent the intermediate tones.

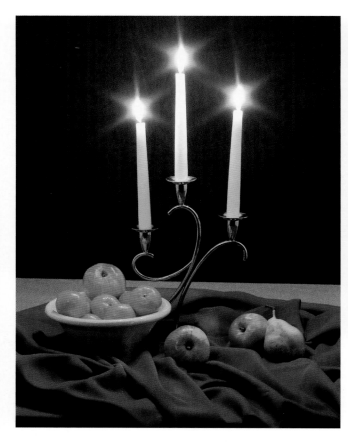

In this work, the layout is not as important as in others, because we cover it almost completely in shadow, which allows us to hide or correct errors in drawing. The initial shapes are sketched with the side of a charcoal stick.

We affirm the main shapes of the still life using more precise lines: The fruits are simple circular shapes; the folds in the cloth, synthetic lines. The design of the candleholder requires a little more attention.

It's very useful to learn how to draw lines using the side of a charcoal stick, because with a simple turn of the wrist we can make fine, straight lines or broad, thick strokes.

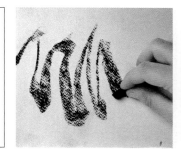

13.2

THE CANDLELIGHT. The scene must be illuminated by the light source represented by the candles. This must be done in an effective and theatrical way, so that the contrast between the light from the candles and the rest of the work is dramatic. The medium tones are represented by the brown color of the paper, which we allow to breathe between the areas colored with charcoal.

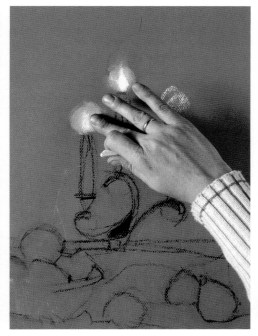

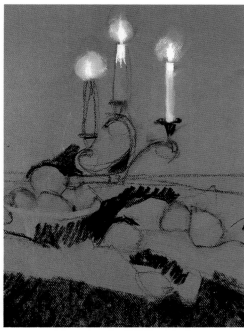

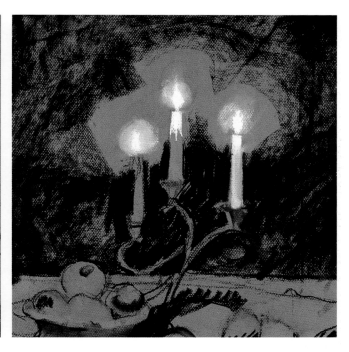

Using a stick of white pastel, we color in the flames of the candles with an intensity that covers completely. To depict the halo from the light, all we have to do is blend the initial white with circular motions.

In addressing the effect of the light, we color the upper part of the candles with new additions of white. Using the side of a charcoal stick and bearing down, we apply black evenly to darken the shadows in highest contrast on the tablecloth.

We cover the background in an intense black. We work with the side of the charcoal stick to cover the broad areas. We need to use greater precision in coloring the background around the shape of the candleholder, so we use the tip of the stick. We leave the halos of the candles brown.

The candle is resolved using a white gradation, which is lighter at the top near the flame and somewhat gradated, mixing with the color of the support as we move downward.

After the general coloring with the side of the charcoal stick, it's appropriate to darken the shadows, making them blacker and more opaque. For that purpose we pass the flat stump over the surface of the paper.

13.3

OBSCURITY AND DARKNESS. Now we proclaim the absence of light, the sensation of darkness. In so doing, we invade the surface of the paper with dense, large shadows. This dark mantle stimulates the sense of sight by blurring the familiar shapes of the objects and energizes them through dramatic contrasts.

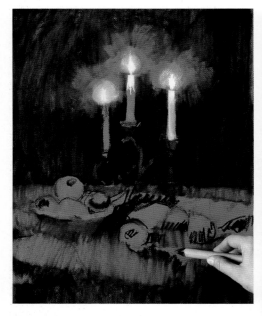

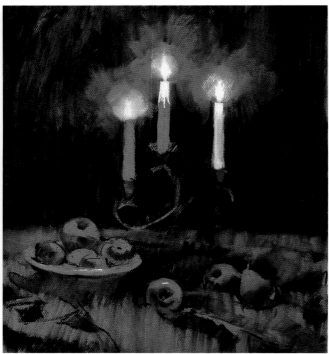

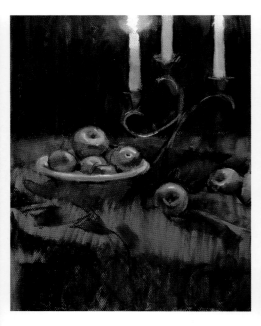

Using the tip of a thick blending stump held at a slight angle, we blend the black of the background until it turns into a darker, opaque shadow. We use strokes with the blending stump to close in on the halo of the candles, and we rub the stump on the light areas to give them texture and integrate the color of the paper into the whole.

We use light touches with the stump to darken the appropriate areas of each fruit, keeping in mind that the shadows are always on the side opposite the light. Using an eraser, we restore the shape of the candelabra that was lost in the previous step.

Once again we take up the white pastel and finish coloring the candles by developing the gradation previously described. We apply highlights of white to the fruits and the fruit bowl to create reflections and emphasize the three-dimensionality.

The white parts of the fruits must be subtle, less intense than on the candles. To achieve this subtlety, we can color them using a blending stump containing some white, instead of using the stick.

It's a good idea to restore or retouch the shape of the candelabra, which will probably get lost during the process, to keep its shape from blending too much with the background or dissolving.

The halo of light from the candles is created with a simple tonal scale that begins in the stark white of the flame, passes through the intermediate tones created by coloring the background with brown, and ends in the intense gray and black in the background.

We further darken certain areas in the background and the shadow in the lower part of the fabric with a Conté crayon. All that remains is to add a few touches to the candelabra and blend the top edge of the table with the background by means of gradations. In some still lifes, the shadowy effect is used to suggest spirituality and a gloomy, enigmatic mood, with a dramatic sensation. Drawing by Mercedes Gaspar.

We use small reflections created with fine, subtle lines of white pastel to create the metallic texture of the candelabra.

The initial ochre color produces an excessively shiny effect, a contrast that is not well integrated into the shadowy, dark whole; thus we darken it with some intermediate tones by applying a light layer of charcoal with a blending stump.

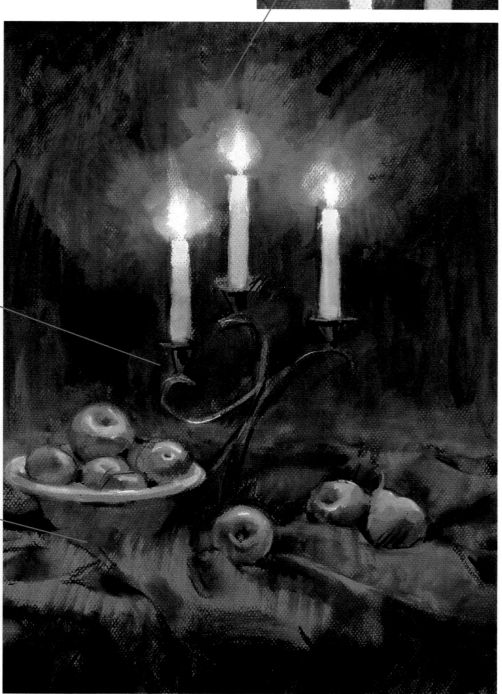

Highlights are the reflections from the light source that are visible on shiny or highly illuminated objects. They commonly are applied in the last stage of a drawing to keep them from complicating the process of shading. For the white to stand out, they must be applied over areas that have previously been darkened.

Although the traditional way of drawing is to work the shapes of the model using lines and then developing the shadows, we will now see that a drawing can also be done by starting with the most brightly illuminated areas, by highlighting with white, erasures, or reserves, and then addressing the shadows.

Reversing the customary work process helps us consider the effect of direct light and correctly evaluate the effect of chiaroscuro in the model, because these are the aspects that demand our attention and guide us in the process of developing the drawing.

SKETCHING WITH LIGHT. In sketching a subject under strong illumination by using only light, very close observation of the light and how it strikes the model is crucial to the exclusion of shading. We will work on a grayish-blue paper that permits the greatest possible effect from lines and gradations done in white chalk.

14.1

AN EXPRESSIVE TREATMENT. Drawing presents an intentionally expressive mood, which we achieve by slightly distorting the interior space and the objects. Once the elements are outlined, we give them body by marking the most brightly illuminated areas with large swaths of white.

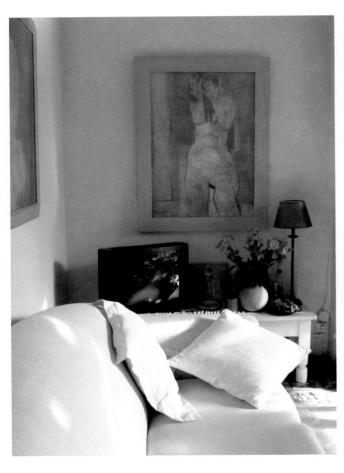

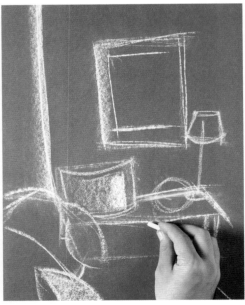

Before starting the sketch, we analyze the abstract characteristics of the space and the basic shapes. We first sketch with simple lines without paying much attention to the precision of the drawing. We even choose to distort the objects slightly.

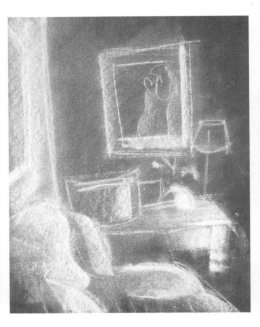

We add the touches of bright light with the side of a stick of chalk, bearing down on the paper to produce a coat of white that covers thoroughly. We focus on the abstract qualities of the colored areas instead of trying to reproduce the items precisely.

After coloring the most brightly illuminated areas in white with the side of a piece of chalk, we blend them with our hand.

14.2

DEPICTING THE LIGHT. We add new passes in white to the illuminated objects and thus lighten the color of the paper. We modify the lighted areas using more varied and defining tones, properly combining the white of the chalk and the blue of the paper to produce a three-dimensional effect.

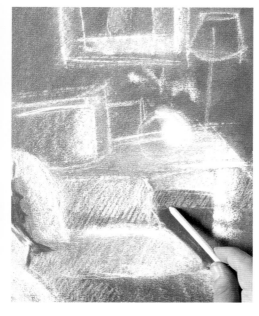

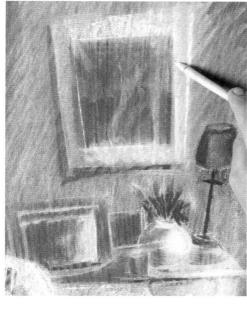

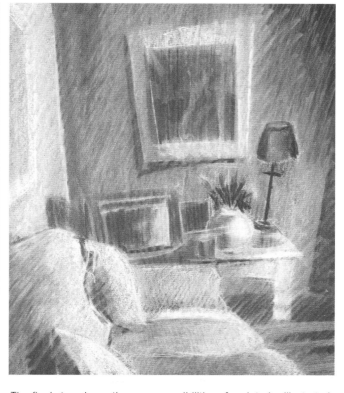

Using the tip of the stick, we define a little more clearly the shape of each object. We use lines to establish profiles. An eraser is used to darken the cushions. We create medium tones by adding new, very soft whites.

We apply gradations to the walls of the room using medium tones that are created using gentle strokes that don't entirely cover the color of the paper. This phase noticeably improves the overall appearance of the sketch.

The final step shows the many possibilities of an interior illustrated exclusively with white objects. Objects appear as negative shapes in dark gray that stand out from the light background. Drawing by Gabriel Martín.

We restore the blue of the paper by opening up white areas with an eraser to create contrast and make the objects on the table stand out from the wall.

We can achieve a very attractive finish by creating chromatic contrasts with blue and orange colored pencils.

TONAL DRAWING ON COLORED PAPER. The color of the paper on which we draw is a factor that deserves consideration, because it's the base on which the lines will be done. In addition, the color of the paper is the color of the background in the drawing. It's advisable to select a medium tone so that it simultaneously contrasts with the whites and makes it possible to create everything from medium to dark grays and black.

15.1

A VERY LINEAR DRAWING. The layout involves a line drawing using a single stroke, with no shading. Before beginning to situate the lights, it's a good idea to have a perfectly constructed sketch. We will use an HB graphite pencil.

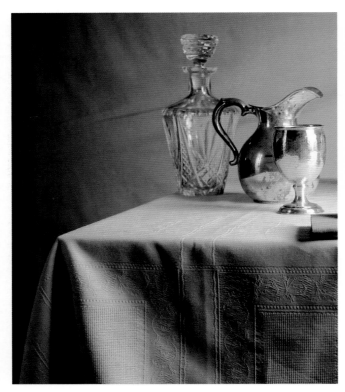

Using an HB graphite pencil we make a clear drawing of the shape of the table. Two or three straight lines and one curved one are adequate for creating the scene for the still life.

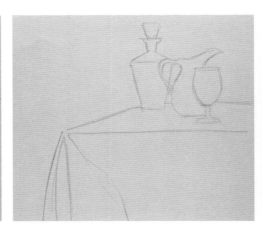

In a very linear and schematic way, we situate the glass bottle, the pitcher, and the cup on the table. All we need is a drawing using the outlines that suggests the shape of the objects, with no shading, reflections, or textures.

To prepare a tonal background on white paper, we cover it with flat charcoal and blend in the strokes with our hands. The medium gray must be even and dark enough so that the white stands out with force, yet light enough so that dark grays and blacks are possible.

The initial treatment of the objects needs to be very schematic, without shading and details that impart textures.

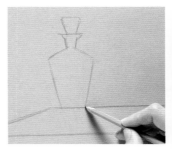

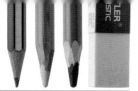

15.2

GRADATIONS ON GREEN. By adding gradations we set up the first tonal differences. Because of the contrast produced by black chalk, we distinguish the darkest tone, the lightest tone, which corresponds to the areas colored in white, and the medium tone, which is the color of the paper.

We use an eraser to lightly erase the graphite pencil. We leave a faint line—just enough to make out the sketch. Using a white chalk pencil we draw gradated white areas on the folds of the tablecloth and the background, and we color in the table using a continuous tone that covers well.

Using the white chalk pencil, we shade in the area of the tablecloth with a medium gray tone and customary diagonal lines, allowing the green of the background to breathe. To create longer, continuous strokes and keep the shading from appearing labored, we grasp the pencil at a point slightly higher than usual.

Using a black chalk pencil, we shade the background with a gradation ranging from the darkest black at the left of the picture to the green of the paper at the right. We leave blank the areas occupied by the objects.

Before starting to shade with chalk pencils, we must erase the graphite lines, because the chalk won't stick to them.

15.3

SHADING THE TABLECLOTH AND THE STILL LIFE. We intensify the contrasts in the previous gradations and blend the shadows. We project the shadows onto the table, develop the folds, and suggest the textures of the objects. Despite appearances, this phase is no more difficult than the previous ones, although we must study the shadows and the illuminated areas very carefully.

Now we will combine black and white in a single area. We shade in the wrinkle in the tablecloth using black chalk, and apply a gentler shading to the part that hangs down.

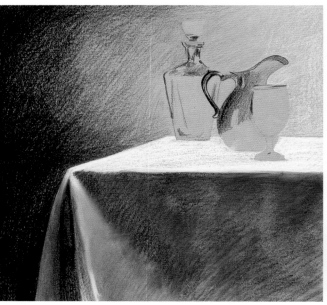

We blend in both colors using the tips of our fingers to soften the transition from one tone to the other. The gray appears more whitish on the fold, and a darker tone prevails elsewhere.

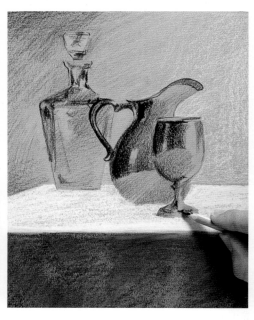

We shade in the objects using just two values. We represent the pitcher and the cup with gradations and the glass bottle with softer shading to provide credibility for the shape, creating strips that help us describe the smooth texture and the reflections.

In blending with our fingers the shading done in black and white chalk, we create a gray color with a certain violet tint. The blending softens the transitions from one color to another.

By blending with the tips of our fingers, we eliminate any remaining visible lines, which bother many artists.

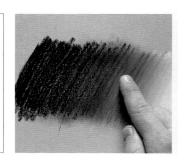

The background consists of a gradation made up of grays, in which the pencil lines are still visible. The color of the paper plays an important role in harmonizing the entire work.

To complete the drawing, we locate a few reflections on the objects in the still life. In the final product we can see that the pronounced contrast between the white and the black on the green paper highlights the effects of chiaroscuro, defines the areas of light much more effectively, and creates darker shadows. Drawing by Óscar Sanchís.

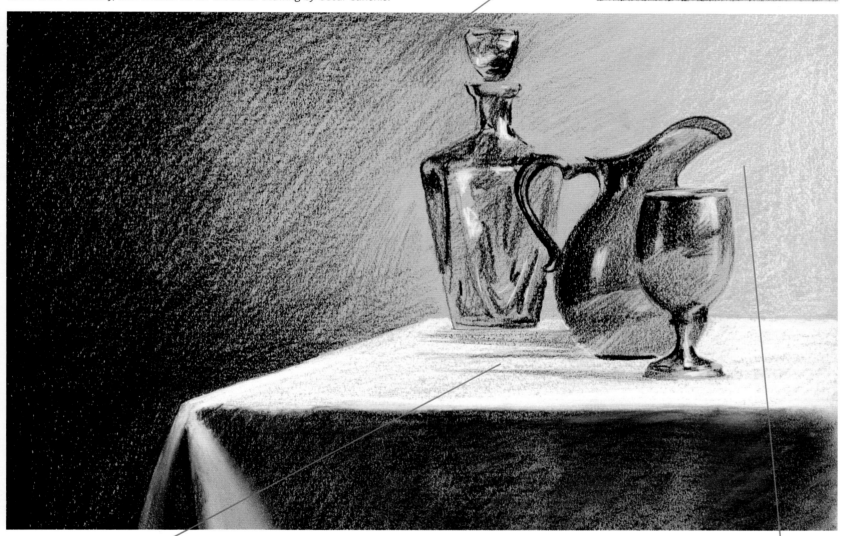

The shadows projected onto the tablecloth don't show much contrast; they are in a very light gray that just makes them identifiable. It's necessary to use the tip of a blending stump to work in such a small space.

The highlights have to be very subtle. If necessary, we run our finger over the reflections to blend them into the surface of the object.

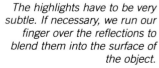

BACKLIGHTING IN LANDSCAPE. The effect of backlighting in a landscape tends to darken the foreground, place shapes in silhouette, and intensify the luminosity in the sky. Sunbeams invade the landscape and blur outlines, creating gradations of light that diffuse the features of the cliffs, as through a glaze.

16.1

SHADING THE PLANES. Before dealing with the backlighting, we use sanguine to shade the nearest planes of the landscape, and bister (a fairly dark brown) on the cliffs in the background.

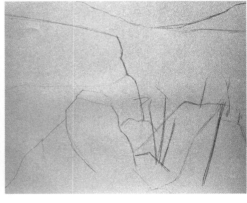

We separate the main planes of the picture by drawing the outlines of the rocks with an HB graphite pencil, without addressing textures, vegetation, and other details, since we will cover everything with shading in chalk.

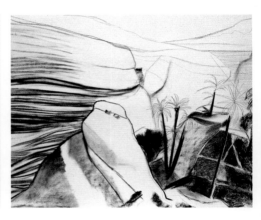

We intensify the outlines on the outcropping in the foreground and the trunks of the palm trees with black chalk. Using bister chalk, we begin to darken the terrain on the right and the rocks of the cliff, which we represent with a succession of curved, thick lines.

If we have any difficulty with certain details of the landscape, we can use a preliminary sketch. All we need is a few lines to serve as a guide for spreading out the shading.

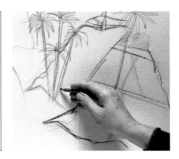

To provide contrast for the leaves of the palm tree in the background, we color them in schematically with dark lines in sanguine.

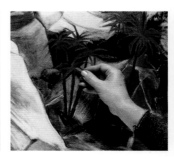

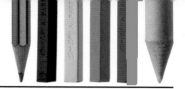

16.2

BACKLIGHTING WITH WHITE CHALK. To create an effect of backlighting in a landscape, we darken the background with more shading. The sky must remain white, and the strokes in white chalk must spread out in a fan shape, like a light that fills the landscape and inhibits our view of the outlines of the rocks in the distant plane.

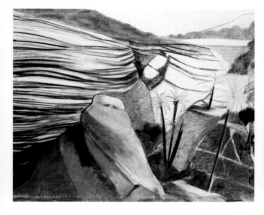

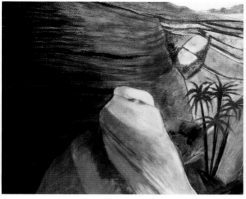

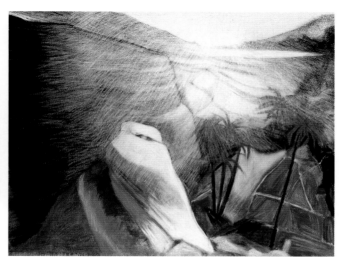

Using the stick of sanguine, we shade in the rock outcropping in the foreground. Because the sanguine is a warm color, it's most appropriate for the close planes. Dark shading predominates in the rest of the drawing.

We can create a dark tone by using our hand to blend the bister shading with the dark lines of the cliff in the background. Working with a blending stump and the modeling effect make it possible to depict the shape of the rock in the foreground correctly.

Once we have finished the shading of the landscape, we color in the sky. Using a stick of white chalk, we extend a hatching of concentric lines that diminish in intensity as they get farther from the sky. The hatching begins at a single point in the sky and fills the whole drawing. Drawing by Almudena Carreño.

The lines done in chalk represent the rays of the sun that fill the landscape. Their intensity needs to diminish as a function of their distance from the light source, forming a gradation of whites.

SKETCHES IN WHITE. If we use paper of a medium tone, we can do an interesting exercise in sketching with white plaster, chalk, or pastels. By coloring with the side of the stick, we can create attractive studies of light.

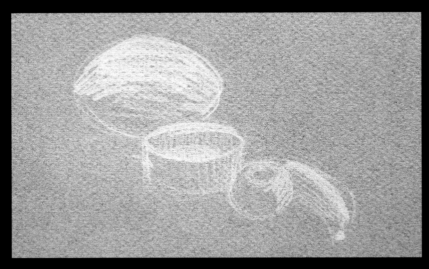

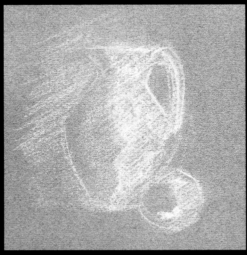

Sketch for a still life done in white colored pencil. The shaded areas are left in the color of the paper.

Using a few colored areas done with the side of a stick of chalk, we create a synthetic sketch of how the light strikes the subject.

GRADATIONS OF LIGHT. Just as we use gradations of shadows to make the model appear more three-dimensional, we can use gradations of light for the same purpose.

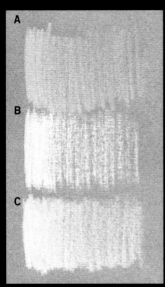

Three gradations on a gray background: white pencil (A), a stick of chalk (B), and Conté pencil (C).

This urban landscape was done entirely with Conté pencil, using gradations of light.

HIGHLIGHTING AND THREE-DIMENSIONALITY. Accents of light presume the direct presence of the source of light on the objects in the shape of light spots or intense reflections. They also contribute to underlining the shape through their strong contrast with shaded areas.

LIGHT THROUGH LINES. To recreate the beams of light that fill a scene, we can draw the light using a series of parallel, diagonal lines.

If we include the light source in the same still life, we can draw the beams of light using radial strokes that originate with the lamp.

CONTROLLING INTENSITY. The intensity of the white used for highlighting details or representing light depends on the pressure applied with the drawing implement. A line of intense white is very difficult to erase if a mistake is made, so it's a good idea to proceed judiciously and avoid exaggerating the reflections, especially in the early stages.

COLORING THE SKY WHITE. Some illustrators who specialize in landscapes commonly color the sky white to give the landscape greater luminosity, highlight the contrasts, and reaffirm the shape of the horizon and the crowns of the trees.

In this landscape, a layer of white gouache has been applied to the sky to highlight the outline of the mountains.

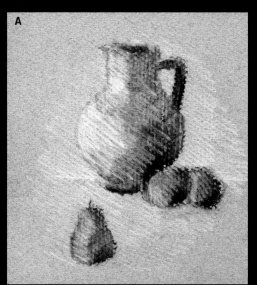

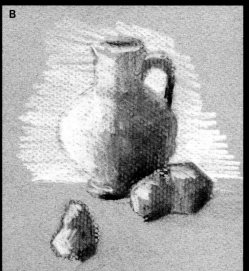

Here we see two different treatments of the highlights done in chalk: a still life with gentle highlighting (A), and another one using highly contrasted and forceful highlights (B).

277

ERASURE TECHNIQUES. Now we will combine work with graphite and an eraser on the same support. The eraser is used in precisely the same manner as a pencil or any other means of drawing. In a drawing done with shadows, the areas to be illuminated are erased to restore the white of the paper and create sharp contrasts with the adjacent areas.

17.1

LINES AND CURVES. To draw architectural scenes such as this one, we use diagonal straight and curved lines that locate each of the façades by creating the effect of perspective in the street.

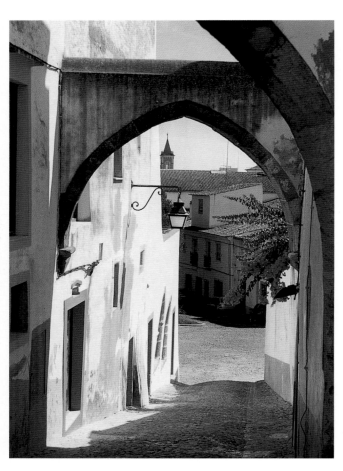

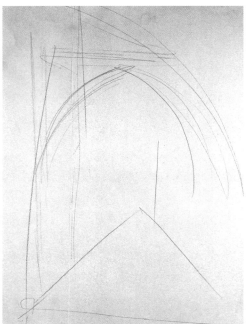

Using a dull 2B graphite lead we draw the diagonal lines that define the perspective of the street. We use a few curved lines to sketch the arch. We don't have to pay much attention to detail, because we are not aiming for a very realistic drawing.

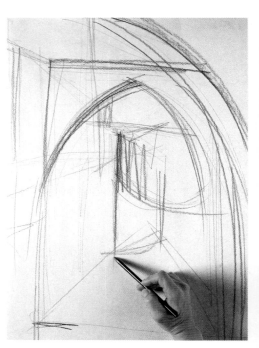

We firm up the sketch by rendering the model with a new series of bolder lines. We can superimpose several lines with the intention of choosing the right one, for this is still an exploratory stage.

In urban scenes, the direction of the strokes is important. In this instance, most of the lines move in perspective toward the background.

Professional artists commonly superimpose several lines to firm up outlines when they sketch. When the drawing is a little more advanced, we select the most appropriate lines and erase the rest.

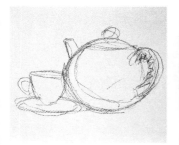

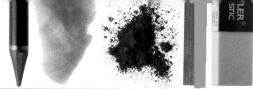

17.2

APPLYING THE MEDIUM TONES. To open up light areas with an eraser, we need to darken the surface of the paper with shading done with the flat side of a graphite stick and smoothed out with the hand. That way we create an overall medium tone that favors contrast. Drawing with an eraser is particularly indicated when the subject presents marked contrasts of chiaroscuro.

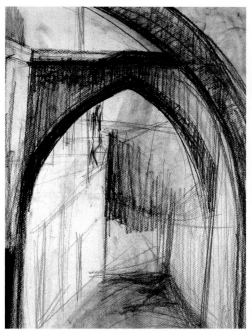

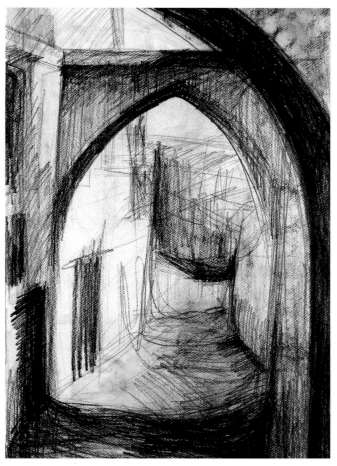

We impregnate a piece of cotton with graphite powder and apply a faint gray to the surface of the paper. We continue darkening the paper with the side of a square stick of graphite.

We add contrast to the arches in the foreground with traditional grays that are applied rapidly and appear agitated and rather imprecise. We accentuate the shape of the arches with thick, dark lines. We use our hand to blend the shading as it is added.

We intensify the graphite lines in the first and second planes, thus creating a fairly dark, medium tone. The contrast is very important in resolving the light and dark areas in every area. The shading is not very precise, and it barely addresses details and shapes.

The darker the tone of the shading, the greater the contrast with the light areas opened up with the eraser.

We shade in very quickly with the stick of graphite held on its side.

17.3

ERASING. Now is the time to use the eraser as a drawing implement. We use it to lighten the illuminated areas, refine the quality of lines and tone, and create highlights where the drawing presents a continuous tone.

We erase partially to lighten the areas of minimal light, such as the far end of the alley. The tone lightens as we pass the eraser over it gently. This effect can be used carefully to suggest the medium and dark tones.

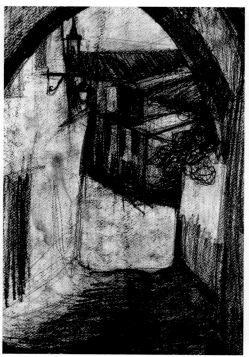

We use the graphite lead to provide contrast to the texture of the surface of the street through lines of varying intensity. We use thick, shaded lines to draw the series of houses at the end of the street.

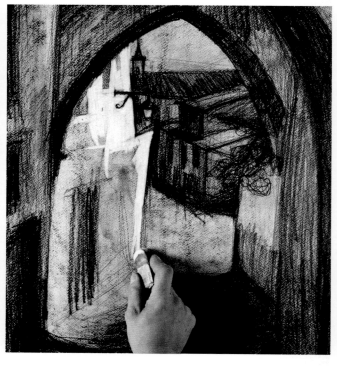

We use the edge of the eraser to open up the light areas on the façades bathed in sunlight. The harder we press with the eraser, or the more frequently we repeat the stroke, the brighter the white areas.

The eraser becomes soiled with pigment, so it is necessary to clean it from time to time. To do that, we merely need to rub it on a clean sheet of paper.

The technique of drawing with an eraser works only on smooth paper. On very rough papers, the pencil lead usually penetrates into the fibers, making it very difficult to remove the marks.

Because there are many ways to use the eraser, we need to diversify its use. If we always move it in the same direction, the drawing will appear static and flat. Thus it's appropriate to change the angle of the stroke we apply with the eraser, or to cross the eraser strokes.

Once the effects of erasing are done, we use the sharp point of a graphite lead to resolve the architectural details of the doors, windows, streetlights, and joints between the stones in the arch. The doors and windows appear in strong contrast. Drawing by Esther Olivé de Puig.

These erasure techniques are very useful in creating angles of light and reflections in dark, tonal areas.

Between individual erasure strokes we leave small spaces in the previous shading to represent the rough texture of the wall.

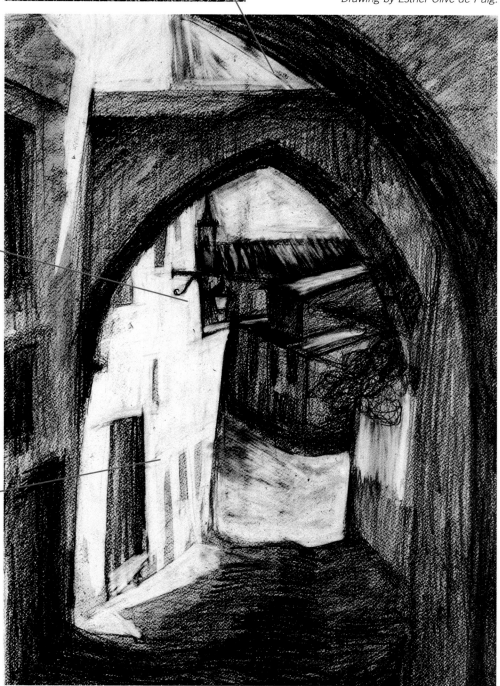

LIGHTENING WITH CHARCOAL AND CHALK. It's fairly easy to lighten an area of shading done with charcoal or chalk. All we have to do is go over the surface with a clean cloth or the tips of the fingers to remove part of the layer of pigment.

We can lighten charcoal by using a kneaded eraser.

To soften the light areas we go over them with the tip of a cotton cloth.

SKETCHES WITH LIGHTENING EFFECT. In learning to draw light, a good exercise involves doing sketches by lightening a gray base with an eraser. Therefore, we will do some brief studies in which the presence of light helps us identify the outline of the objects.

OPENING UP LIGHT AREAS IN CHARCOAL. The most effective way to open up light areas in charcoal is to use a kneaded eraser, for the particles of pigment can be removed cleanly from the paper without having to rub excessively. To erase broad areas we use the kneaded eraser in the shape of a ball; to create small touches of light, we mold it into a cone shape and erase with the tip.

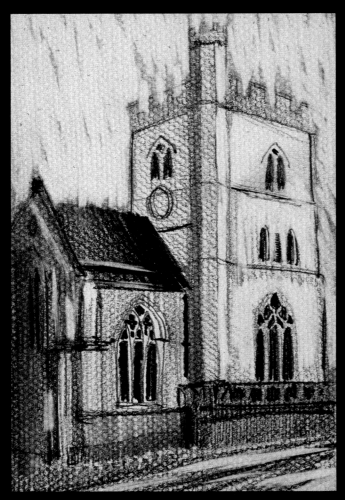

The kneaded eraser is very useful for lightening areas when working with charcoal or chalk.

In this sketch of a church, areas on the façade and in the sky have been lightened using an eraser.

Even lightening using an eraser on graphite shading.

Erasure in the form of a gradation on graphite shading.

LIGHTENING. This technique involves removing a little pigment to uncover the white of the paper in certain areas or points. In drawing with charcoal or chalk, this is a usual practice for introducing a point of light in a tonal area.

HATCHING WITH THE ERASER. We can apply a series of linear hatchings with the tip of an eraser or an eraser pencil applied to an area previously shaded. We can also produce linear drawings using the eraser on a background of blended color.

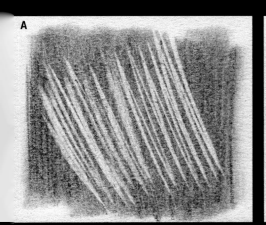
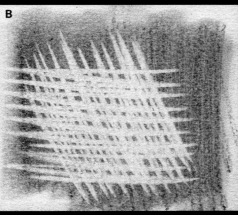

Two possibilities of hatchings done with an eraser: the traditional hatching (A), and crosshatching (B).

BLENDING WITH AN ERASER. An eraser is not just an implement for opening up light areas; it's also an excellent way to blend. If we make an even pass with it over a previously shaded drawing, it unifies the whole with a series of lines reminiscent of a drawing done with hatching.

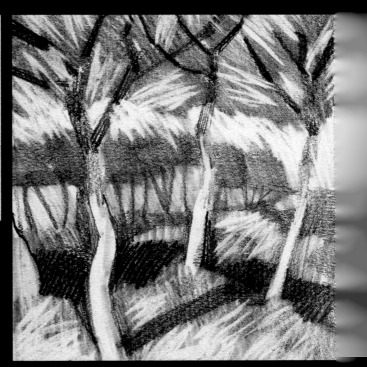

In this landscape sketch, the texture of the vegetation has been created using hatching produced by an eraser.

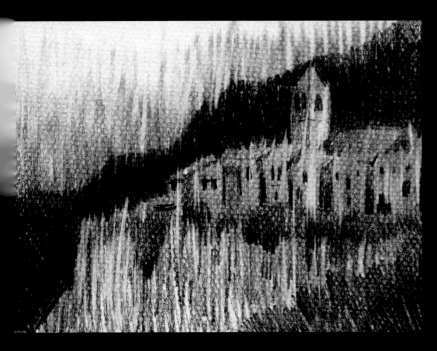

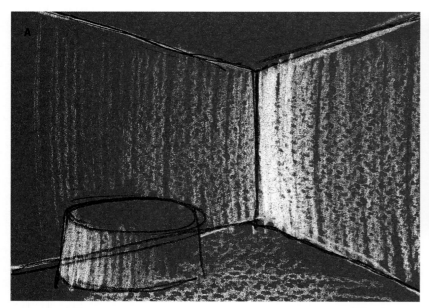

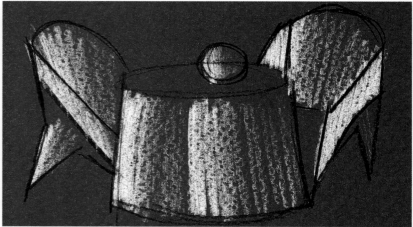

The shape of the objects in the room must be understood as a series of simplified geometrical figures. In that context, the light is depicted by creating gradations with a white pencil.

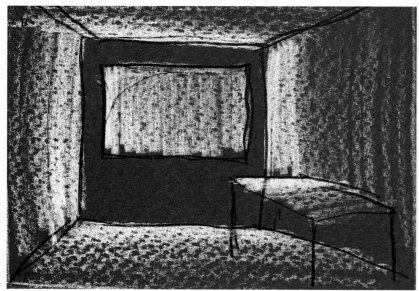

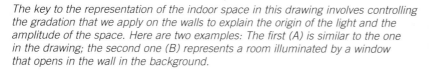

The artist resolves the texture of the folds in the tablecloth using wavy hatchings, which are superimposed over the gradations that establish the shape.

The key to the representation of the indoor space in this drawing involves controlling the gradation that we apply on the walls to explain the origin of the light and the amplitude of the space. Here are two examples: The first (A) is similar to the one in the drawing; the second one (B) represents a room illuminated by a window that opens in the wall in the background.

Imagine that the effect of light from the bulbs in the lamp that hangs from the ceiling is achieved by superimposing over the white of the background a series of radial lines originating from the illuminated lightbulb. This is another example of the addition of lines to the preliminary shading.

INTERIOR IN WHITE PENCIL. The possibilities of drawing with nothing more than a white pencil on colored paper are vast, and exploring them is worthwhile. Using white chalk on colored paper, it is possible to achieve a very broad scale. Objects take on shape thanks to the light. It's not necessary to depict the shadows, because the darkest color is that of the paper.

When the artist finds it difficult to differentiate between two adjacent zones that exhibit the same tone of white, the most appropriate course is to change the direction of the strokes. Then the difference is not communicated through tone, but rather through contrasting lines.

The artist has placed greater emphasis on lines and hatching on top of the initial gradations. Whereas the gradations set up the sense of space, the lines provide details and clarify the shapes.

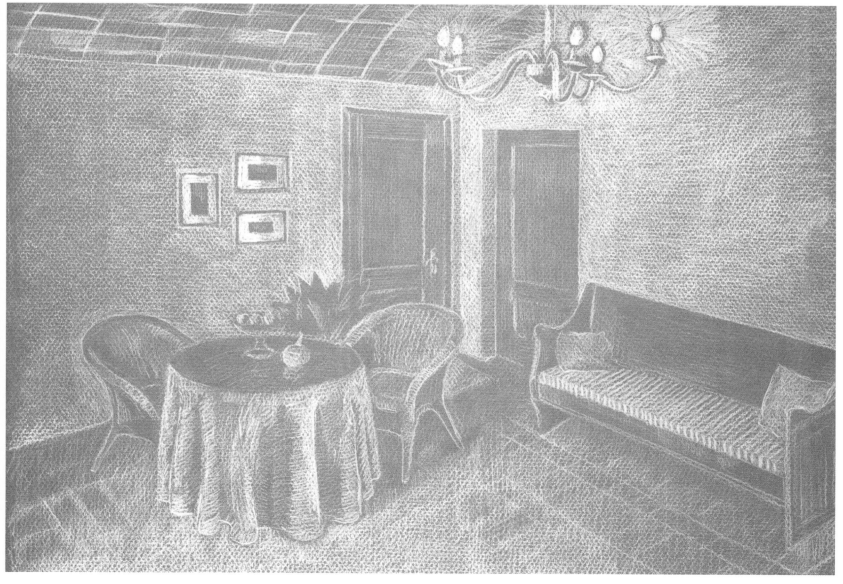

DRAWING IN WHITE. Using a white piece of chalk or pencil, it is possible to draw a model by merely representing the areas of light, without addressing the shadows, which remain in the color of the paper, preferably a medium tone. In these drawings it is not necessary to use any darker colored pencil or stick.

DRAWING IN NEGATIVE. If we work with white paper, the usual practice involves darkening the shadows and leaving the illuminated areas white. However, when drawing on a dark colored paper, we have to work in reverse, progressively lightening the illuminated areas with light colored chalk or pastel. Drawing in this way is neither easier nor more difficult than drawing in the conventional manner; we merely have to work in reverse.

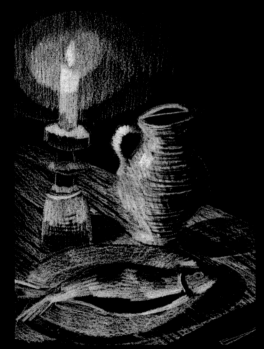

Lightening on a dark paper is done using white, and is reminiscent of a reversal of a gradation in grays.

In this rural scene. we use white to color the areas that receive direct light; the result is a convincing representation.

BLACK AND WHITE. By combining black and white on a neutral support (ochre or medium blue), we can produce three-dimensional results that suggest marble relief. In these instances it's appropriate to exercise care with the gradations from one color to another and avoid dramatic contrasts.

To draw with white on black paper. we have to paint the light as if we were dealing with a photo negative.

The previous gradation is incorporated into a cylindrical shape to reproduce the effect of three-dimensionality.

The tonal gradation from white to black presents great contrast. It is appropriate for highly three-dimensional works.

DRAWING WITH WHITE. White is commonly used in the finishing phase to emphasize the illuminated parts of the model, represent reflections, or depict the light source if it appears within the drawing. It may also be a drawing medium unto itself, which may be omitted or complemented by a few strokes done in a dark color.

FORTUITOUS WHITE. When we draw with charcoal on colored paper, the use of white can be fortuitous in emphasizing contrasts, giving life to a dull subject, activating the expressive tone of the drawing, and highlighting the effect of three-dimensionality.

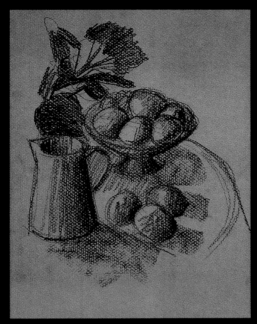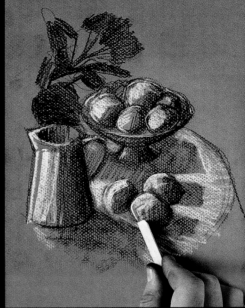

In comparing these two drawings we can see that the use of white chalk heightens the expressiveness, thanks to the greater contrast between the illuminated and shaded areas.

AVOIDING AN EXCESS OF WHITE. When we use white chalk to highlight the reflections on a model, we must avoid the error of saturating the objects with this color. Otherwise we lose the expressive force of the highlights when they are applied correctly, with restraint, and in small, pinpoint areas.

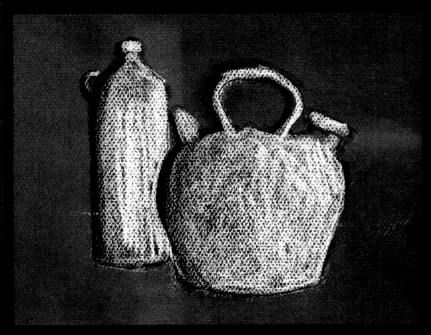

Here is an example of a still life that shows excessive use of white. By covering nearly the whole surface of the object in white, we lose the highlighting effect and the sense of three-dimensionality.

287

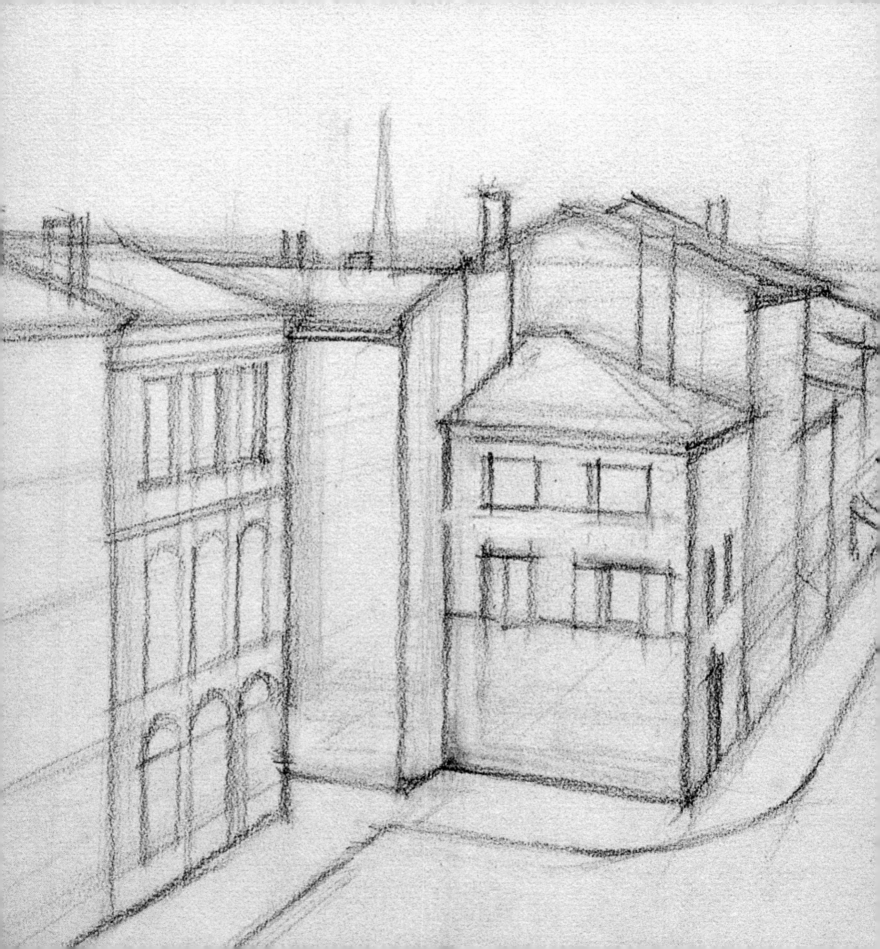

4.
Perspective Drawing

PERSPECTIVE AS A TOOL FOR DRAWING. To represent a model, which in real life has three dimensions, on a sheet of paper that has only two, we must use perspective. Perspective is very helpful when we need to organize the space and to structure depth.

LINEAR AND INTUITIVE PERSPECTIVE. When we wish to represent depth when drawing from nature without the rigorous parameters of mathematical perspective, we apply it intuitively, that is, "by eye," without the use of geometric rules.

HORIZON LINE. Before drawing in perspective, the artist has to establish the eye level or horizon line. This is an imaginary line located at eye level when we are looking forward. If the painting is divided into two areas separated by a horizontal line, the one below is considered the land and the one above the sky.

Pencil drawing of a landscape executed with intuitive perspective.

THE HEIGHT OF THE HORIZON LINE CHANGES. The horizon line is not constant; it changes according to the position of the viewer. To create a painting that has great depth, we choose a very high horizon line. A low horizon line removes the emphasis from the land and puts it on the sky.

A high horizon line emphasizes the terrain, while a low horizon line gives greater importance to the sky.

When we divide the paper with an imaginary line, the lower part is usually considered the land, while the area above is the sky.

Each theme dictates its own natural horizon line.

EACH THEME HAS ITS OWN HORIZON LINE. Each genre has its own perspective, which helps to structure the space. In still lifes, the horizon line is usually above the subject because the chosen point of view is almost always high. In representations of full body figures, the horizon line divides the painting in two. In seascapes and flat landscapes, the perspective horizon is the same as the real horizon. If the landscape has mountains, the horizon line is somewhat below the upper edges of the mountaintops.

LINES AND DEPTH. The effect of depth in a drawing increases when we draw lines that move away from the edges of the painting and converge at the center of the paper; they immediately create an illusion of depth. When these lines converge on a fixed point on the horizon line, they are called vanishing lines.

When various lines converge at a common point on the horizon, the effect conveyed to the viewer is one of psychological distance.

CREATING THE SPACE. Knowledge of perspective is without a doubt very useful for setting up and constructing space and depth. In geometric or linear perspective, a series of diagonal points and lines project the object toward the background of the drawing, but there are other compositional approaches that should not be ignored.

The diagonals that cut through the plane of the drawing are the first indicators of distance.

DIAGONALS THAT SET THE SCENE. The perspective effect is easily achieved if the landscape has a diagonal element that arranges the objects from front to back. This diagonal can be a riverbank, a hill, a fence, or any other linear element that cuts through the composition.

POSITION IN THE VISUAL FIELD. An object drawn higher or lower on the surface of the paper is perceived the same way by the viewer as one seen on a horizontal surface. As the object moves farther away from the foreground, the viewer has to move his or her eyes up, or lower them as he or she approaches it.

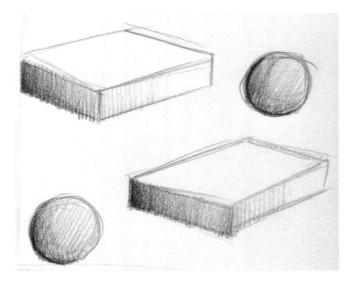

Psychologically, the same object placed at a higher level on the paper appears to be farther away.

SUPERIMPOSED OBJECTS. The objects that are closer to the viewer conceal the ones located farther away; therefore, when we draw some figures over others, we create an immediate feeling of depth. As a result, the contours of the most distant elements are interrupted by the figures placed in front of them.

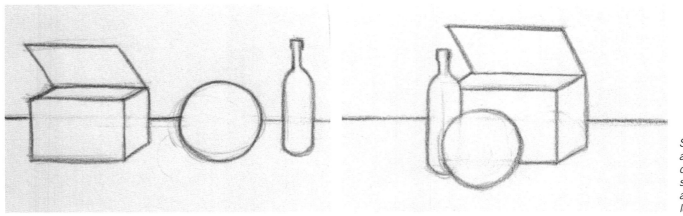

Superimposed objects convey a sequenced feeling in the distance. When they are shown separately, they look like they are on the same plane and thus lose any reference of depth.

DIFFERENT SIZES. If two figures of similar size are placed so that one is farther away than the other, the former appears smaller to the viewer. In a drawing in which different size objects are involved, a familiar element, such as the human figure, helps convey the depth and size of the space represented.

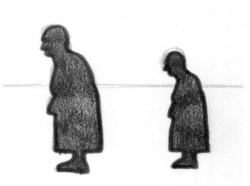

The same figure drawn in a smaller size appears to be farther away than the other one.

This effect is even more pronounced if the smaller object is placed higher.

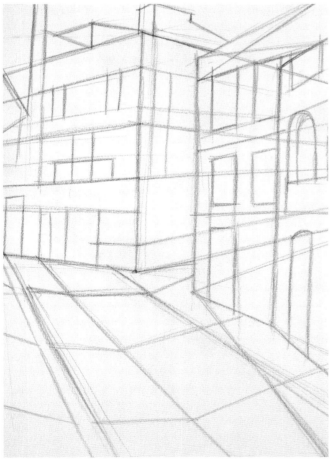

It is important not to abuse the rules of perspective. Using too many lines is confusing, cumbersome, and makes the drawing less appealing.

AVOIDING TOO MANY GEOMETRIC STRUCTURES. In addition to the compositional methods shown so far, there are many more complex geometric approaches that help create a feeling of depth. It is important to be aware of them without overusing them, unless the work involves an architectural project. Putting too much emphasis on technical rules will result in a drawing that lacks creativity and spontaneity.

Linear
Perspective

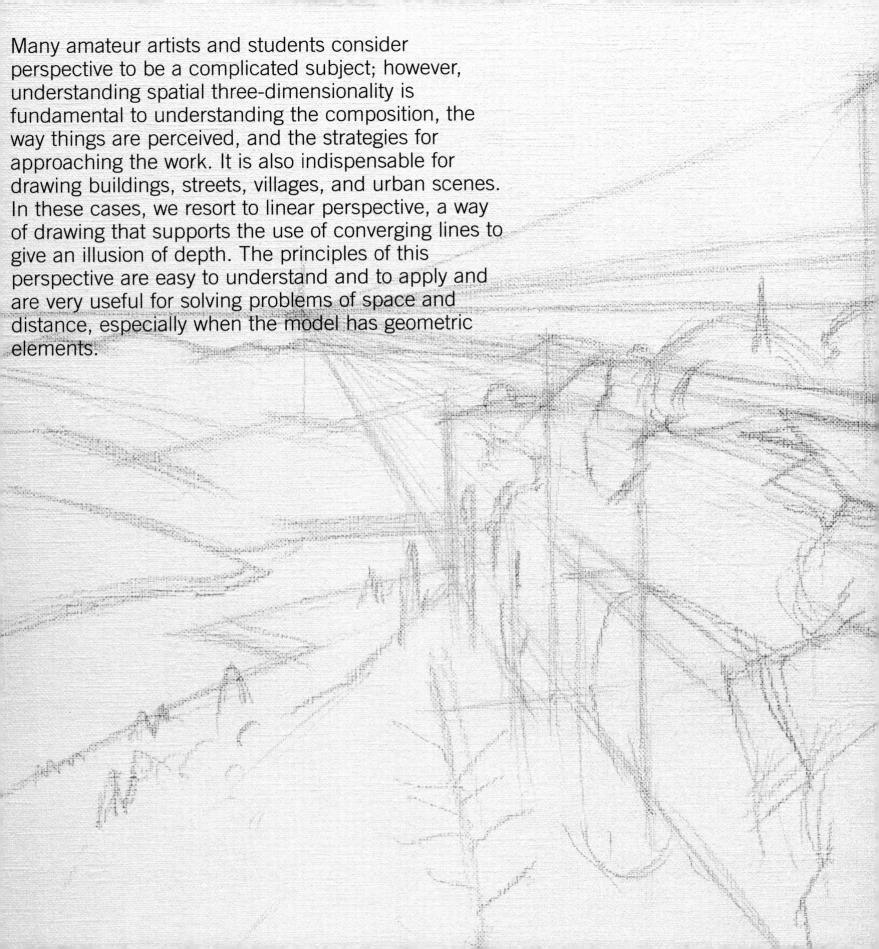

Many amateur artists and students consider perspective to be a complicated subject; however, understanding spatial three-dimensionality is fundamental to understanding the composition, the way things are perceived, and the strategies for approaching the work. It is also indispensable for drawing buildings, streets, villages, and urban scenes. In these cases, we resort to linear perspective, a way of drawing that supports the use of converging lines to give an illusion of depth. The principles of this perspective are easy to understand and to apply and are very useful for solving problems of space and distance, especially when the model has geometric elements.

CENTRAL PERSPECTIVE. This projection in perspective is derived from conical perspective, with a single vanishing point. It is used to explain the use of the vanishing lines in expressing the distortion of the space in the distance. Exercise by Gabriel Martín.

1.1

IT BEGINS WITH A SQUARE. To draw a small street with a strong effect of depth, we look for the center of the perspective, the point where all the lines that define the bases of the walls and the inclination of the roofs converge. Once we have located this point, we draw a square around it.

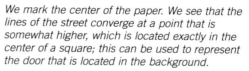

We mark the center of the paper. We see that the lines of the street converge at a point that is somewhat higher, which is located exactly in the center of a square; this can be used to represent the door that is located in the background.

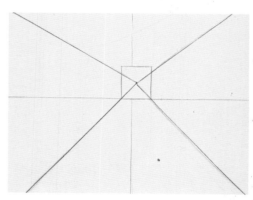

From the point located in the center of the square, we extend four diagonal lines that represent the vanishing lines of the walls. These vanishing lines are the basis for understanding the space distorted by perspective.

We can use a ruler or a triangle to draw the vanishing lines.

1.2

DOORS AND WINDOWS. With new perspective lines we draw the main openings on the walls. Rectangular and square shapes for doors and windows also appear distorted by the effect of perspective.

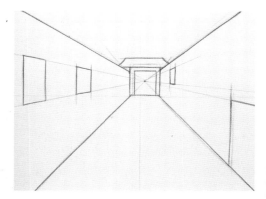

The roof and the frame of the door in the background are sketched in. New vanishing lines are projected from the same central point to define the positions of the door and the windows.

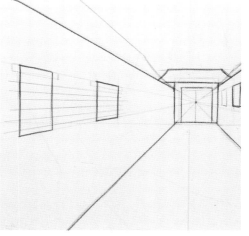

New diagonal lines that are projected from the same central point define the angles of the boards that cover the windows more accurately. With a new line we define the profile of the roof.

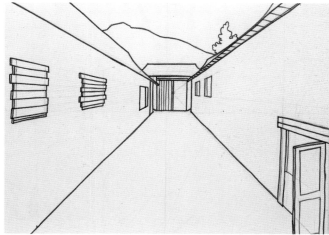

Finishing the drawing is simple. With a brown marker, we redraw the lines based on the previous perspective lines and then clearly define the doors, windows, and the outline of the mountain in the background. All this is done freehand.

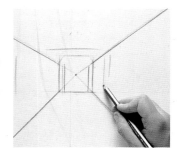

The vertical lines for the windows can be drawn freehand. These lines must always be perpendicular and parallel.

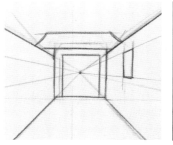

Central perspective is characterized by an array of vanishing lines from a point situated in the center of the drawing.

A WOODEN BRIDGE. We leave central perspective to draw a simple object that has a single vanishing point, which is located far away. The object is a wooden bridge that has a quadrangular structure, which is very distorted by perspective. Exercise by Gabriel Martín.

2.1

A GLASS BOX. To make the work easier, we think of the bridge as if it were a rectangular glass box, so the far sides and the angles are visible. In other words, we approach the structure of the bridge as if it were transparent.

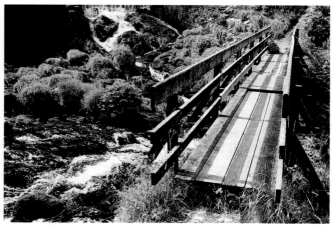

We draw the horizon line, which is placed very high on the paper. Then we locate a vanishing point from which two diagonal lines that define the base of the bridge are projected.

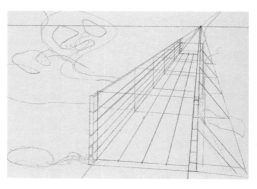

We divide the base of the square in the foreground into four equal parts. From these sections we project three new diagonal lines toward the vanishing point. We repeat the procedure with the left handrail, although this time we divide it into six parts.

We construct the box for the bridge by imagining two square shapes on the foreground and the background. These are the parameters that establish the length of the wooden structure. We connect the top corners of the squares with the vanishing point.

The divisions that mark the crossbeams on the handrail should not be the same, because the width of each crossbeam is different.

2.2

LINE AND TONAL PERSPECTIVE. We reinforce the line drawing with additional darker pencil lines, further defining the forms and creating the feeling of depth with tonal gradations. Then, we incorporate the element into its surrounding landscape by applying medium-intensity shading.

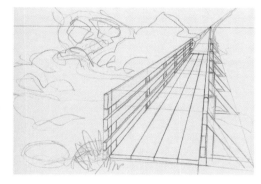

With the colored pencil used to draw the perspective, we go over the main contours and outlines of the bridge to define its structure. The main lines of the surrounding landscape are drawn with soft, spontaneous lines

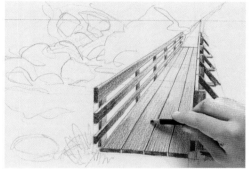

To further reinforce the effect of depth, we apply tonal gradations to the wooden walkway, darker on the foreground and lighter as we move farther away. The crossbeams of the handrail are also shaded the same way.

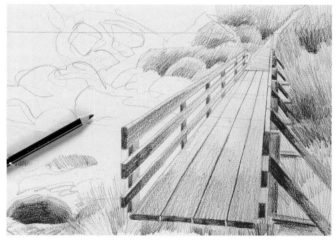

Finally, we incorporate the bridge, which until now has been treated as an isolated element, into the landscape around it. It is enough to draw the areas of vegetation and to apply graduated shading.

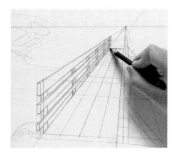

We define the profile of the object in perspective by going over the lines previously drawn with a ruler. It is not necessary to use the ruler again.

Adding gradations to a drawing done using linear perspective strengthens and enhances the effect of depth in the model.

A SINGLE POINT. The object's angled lines always point toward some point on the horizon called the vanishing point, which is the place where all the lines of the drawing converge.

VANISHING LINES. The vanishing lines are very useful for distributing the space or the objects in space. With diagonals, it is possible to suggest the depth of the object represented, which becomes narrower as it moves farther away from the viewer.

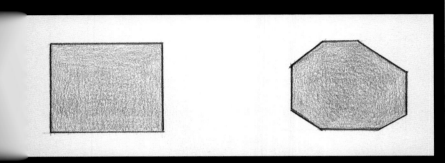

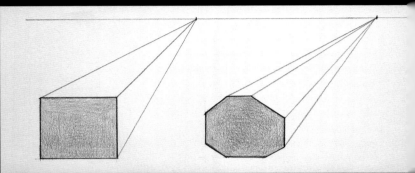

When the objects that we are representing have a side that is parallel to the drawing's surface, perspective is constructed with lines that connect the corners of the objects with a point on the horizon line.

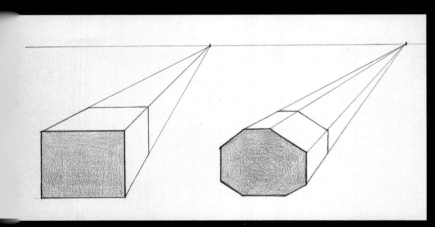

Vanishing lines help project the flat geometric figure into three dimensions.

TRAIN TRACKS. A classic example of parallel perspective is the drawing of train tracks. They get closer together the farther away they go, until the lines converge at a point on the horizon.

When we think about oblique perspective with a single vanishing point, the classic example of the train tracks always comes to mind.

VANISHING LINES AND PARALLEL PERSPECTIVE. Parallel perspective is used when one side of the model in front of us is parallel to the drawing's plane. Diagonal lines move away from the viewer, starting at the sides of the figure represented, and seem to meet at a point in the far distance.

ABOVE AND BELOW THE HORIZON LINE. When we look at objects around us, we see only the tops of some of them and the bottoms of others. This is due to the fact that the former are below the horizon line and the latter above. When we see neither the top nor the bottom part of the object, it is because it is located on the horizon line.

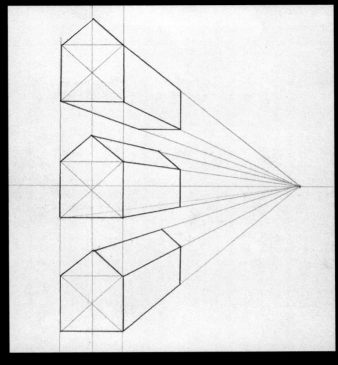

It is very helpful to draw the same building above and below the horizon line to see how the position of the artist affects the representation.

A TILED FLOOR. This is drawn with a linear one-point perspective; the vanishing point has to be located in front of the viewer, above eye level. The lines of tile joints must then simply go from left to right, parallel to the surface of the drawing.

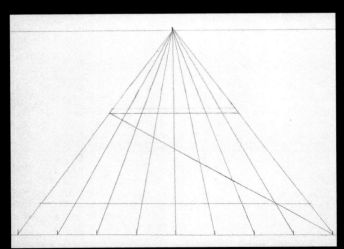

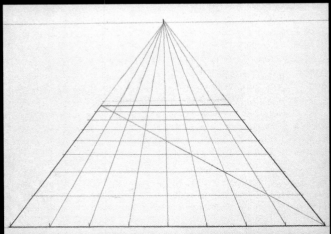

We divide the floor's base line into eight equal tiles. We connect each point with vanishing lines that converge at the vanishing point on the horizon. One diagonal line that runs across the edges of the squares is used as a guide to draw the rest of the tiles.

Every point where the crossing line cuts through each of the diagonals is used as a reference to draw a horizontal line parallel to the base line. This way, the floor tiles gradually become smaller as they move farther away.

301

DRAWING BOXES. We develop the previously explained cone of vision, this time with a model that is a little more complex: a chapel on top of a rugged boulder. To construct this architectural element we use boxes and cubes drawn in perspective. Exercise by Carlant.

3.1

PROJECTING GEOMETRIC SHAPES. The successful outcome of the exercise rests on the ability to translate the volumetric forms of the chapel and the rocks into simple geometric shapes whose constructive lines converge at a point located on the horizon line.

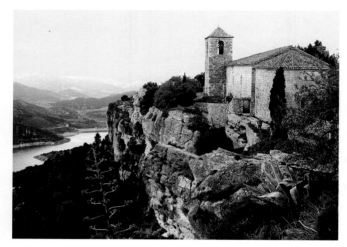

We draw the horizon line. On it, we locate a point from which diagonal lines will emerge, which will be used to construct the boxes that form the body of the chapel.

The chapel's bell tower is created with a rectangular body, the nave with a cube, and the apse with a cylinder. This rectangular design in perspective is also used for the rock formations.

When the model is located on a high elevation with respect to the surrounding landscape, the perspective horizon has to be placed necessarily above the real horizon.

3.2

ADJUSTING AND OUTLINING. When the "blocking in" phase is completed, the outlines are drawn more precisely and the landscape's organic elements are added; this means describing the shapes of the rocks and the vegetation.

We go over the lines that describe the outline of the chapel again with a graphite pencil. We draw new lines over the previously sketched lines to define the shapes of the mountains and the placement of a few of the trees.

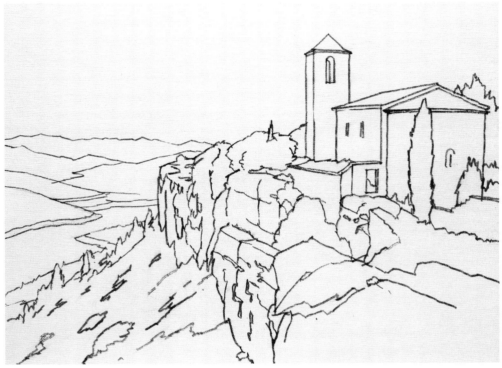

The sketched lines of the rock formations give way to more organic shapes. We focus on the irregularities of the rocks and vegetation-covered areas. To finish, we define the drawing by going over the outlines with a brown marker.

The pencil lines are erased to avoid confusion in the final drawing. The finished drawing is simple, not overly decorated, the shadows and details are clean, and it has a strong feeling of depth. The vegetation has been treated very simply.

The lines are erased at the end, after waiting a few minutes for the marker to dry completely.

To introduce tonal elements in the drawing, we paint the areas of vegetation with a brown marker and short, loose lines.

FAÇADE WITH WINDOW AND DOOR. This is another exercise with conical perspective. This time the elements we are going to draw do not require a volumetric projection but rather the representation of a flat surface moving away from us. We will work with forms that look flat and are slightly distorted to conform to the perspective of the façade. Exercise by Carlant.

4.1

DISTORTED SQUARES AND RECTANGLES. It is obvious that perspective makes regular geometric figures look distorted to create the effect of depth and distance in the drawing. Following this principle, we establish the basic lines and the degree of distortion of the door and window.

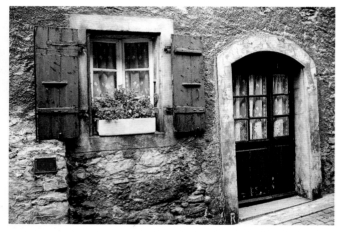

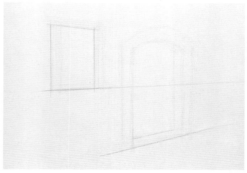

For this model, which has little depth, it is not necessary to draw a horizon line, especially since the only vanishing point is outside the paper. Therefore, from this imaginary point we draw the diagonals that define the base of the door and the top and bottom parts of the window with a ruler.

The same lines that define the window frame are used to represent the shutters, especially if we keep in mind that all the vertical lines are perpendicular to the edge of the paper and parallel to each other. The flat arch of the doorway is drawn freehand.

If it is difficult to draw the door's flat arch, first, we draw a straight line and we use it as a reference to draw a rounded line that is more symmetrical and graceful.

For this first phase it is important to draw very lightly with a pencil, so that it will be easy to erase any mistakes at the end of the project.

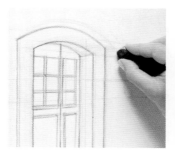

4.2

MANY SQUARES. The perspective approach does not pertain only to the basic structures. The door and the window (shutters, glass, frames) contain many quadrangular shapes that should also be drawn according to the rules of perspective.

We go over the perpendicular lines of the door with darker lines. The door panes are drawn by projecting new perspective lines that establish their shape and correct distribution.

We extend the vanishing lines for the window frame to represent the shutters. The window flower box is drawn with a new vanishing line. Once the structure is completed, we shift our attention to the shape and details of the wood of the shutters.

We sketch the vegetation in the window box and finish the window and the glass. We redraw the lines of the doors with soft lines, which give the architecture a sturdy feeling.

Since the windows are slightly open, they are drawn completely differently from the perspective approach of the rest of the drawing. That is, they should not be constructed with the same vanishing lines that have been used to project the façade.

TWO POINTS INSTEAD OF ONE. The oblique view of the model forces us to draw the objects in two-point perspective. The one-point perspective is static and formal and does not conform to the way we actually see the objects. Therefore, by using a 45∞angle on each side of the line of view, we can locate the vanishing points where the top and bottom sides of the cube converge.

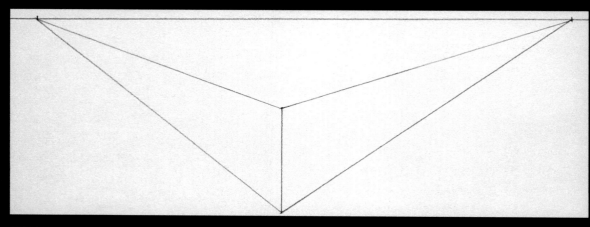

To draw a cube with oblique perspective, we take an edge of the square as reference. From each side of the straight line we project two diagonals to two vanishing points located at either side of the horizon line.

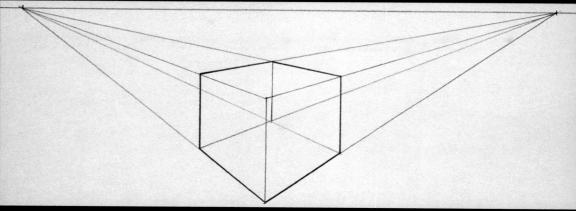

New vanishing lines are added to project the other sides of the cube, which we draw as if it were transparent.

DISTANCE TO THE VANISHING POINTS. The distance of the vanishing points with respect to the object plays an important role in its representation. The closer the points are to the model, the more distorted it will appear. It is important to place the vanishing points at a distance, otherwise the images will look distorted.

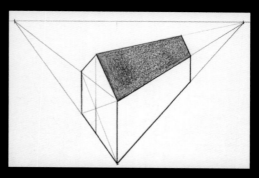

The vanishing points located near this house make the image look distorted or forced.

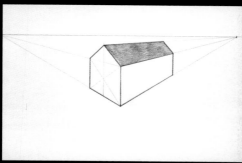

The same house, drawn with the vanishing points farther away, looks much more natural and closer to the real object.

OBLIQUE PERSPECTIVE. Whether in landscapes, interiors, or cityscapes, objects rarely look appealing if they are placed parallel to the plane of the drawing. They are almost always placed at an angle to the picture plane.

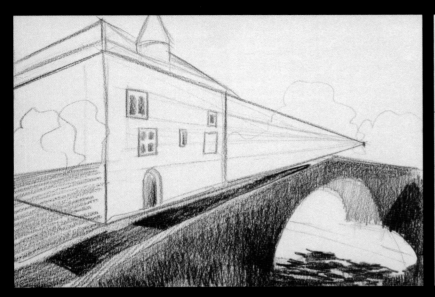

Oblique perspectives are very useful for drawing buildings where the corner moves forward to the viewer.

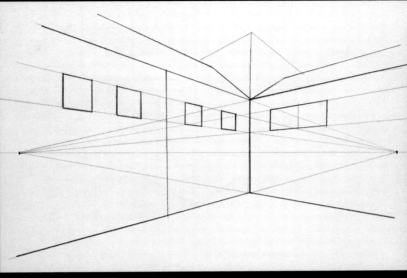

If we reverse the direction of the diagonals that project the two vanishing points, the corner that we are drawing moves away from the foreground.

A GRID FOR CITYSCAPES. Faced with the challenge of drawing a cityscape, when the groups of houses look chaotic, we use a grid with two-point perspective that resembles a tiled floor based on two vanishing points on the horizon. The different groups of houses, decreasing in size as they approach the horizon, are placed on this grid.

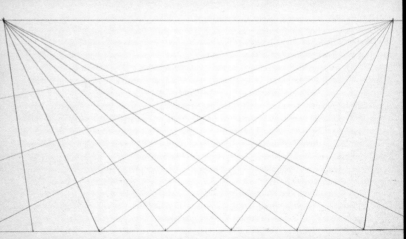

To make a grid we draw diagonal lines from the two vanishing points.

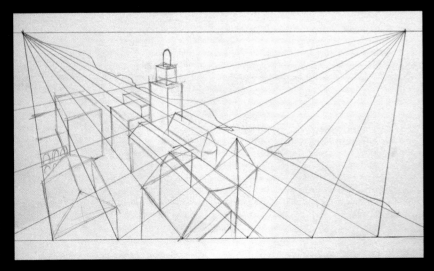

Using the grid as a guide, we begin arranging the buildings in an orderly fashion. We just need to project them as if they were geometric shapes.

DRAWING AN INTERIOR. The exercises that we have done so far involved one-point perspective, very simple configurations in which all lines converge at a single point on the horizon. Now, we are going to work with two-point perspective to draw an interior, even though the treatment is less rigorous and the perspective used is quite intuitive. Exercise by Almudena Carreño.

5.1

WE BEGIN WITH THE CORNER. After constructing a few boxes according to the rules of oblique perspective, it is very easy to erect a vertical line of any size at the corner of the room to create an interior. The originality of this drawing resides in the fact that we focus on the room's angle and disregard the horizon line.

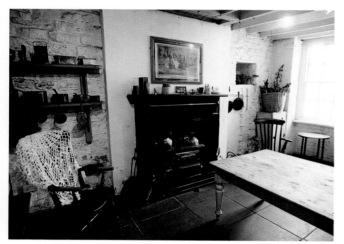

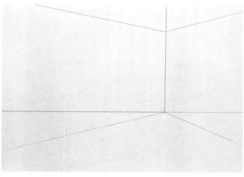

The starting point is a vertical line that represents the corner of the room. Two diagonal lines are projected from the upper and lower parts to define the ceiling and the floor.

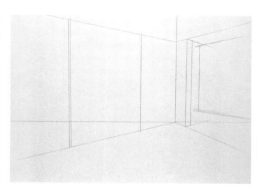

We cut through the two walls with vertical lines to establish the chimney and the window. All the lines must be parallel to each other. The placement of the lines is done by eye.

When executing the drawing, it is important to keep in mind that one of the vanishing lines of the walls is located outside the drawing.

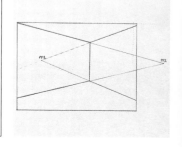

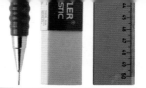

5.2

DRAWING THE FURNITURE. This should not pose any problem, since the pieces of furniture are regarded as simple geometric shapes drawn in perspective. The vanishing lines for the furniture converge at the same vanishing point used to construct the interior walls.

The furniture pieces have a specific number of vanishing lines. Where the furniture is parallel to the walls, it shares the vanishing points with the latter—for example, the paintings on the walls, the shelves, or the hearth. Once the basic lines are established, each piece of furniture is drawn in more detail.

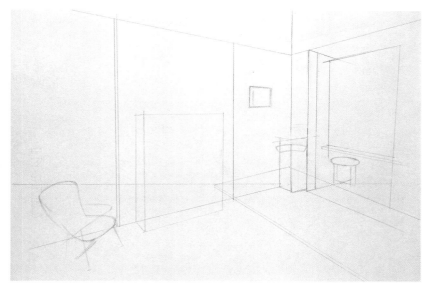

We sketch a preliminary structure for the furniture using vanishing lines. The effect of perspective is much more pronounced on the table in the foreground. The chair, with rounded edges, is drawn by eye.

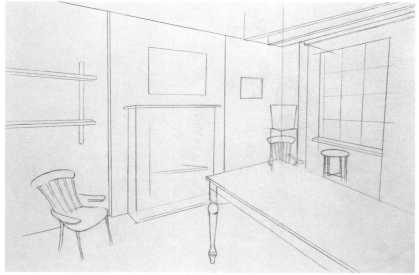

If we analyze each element individually the project is not difficult. The furniture should not be copied exactly, rather, an approximation should be drawn using geometric shapes in perspective.

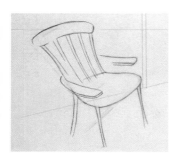

Most of the furniture pieces are not as complex as they look. They are based on cubes, drawn in perspective, connected to each other and at the same time combined with others.

309

THE CORNER OF A HOUSE. Here we take on a different challenge involving oblique perspective. It consists of the corner of a house; the difficulty stems from the vanishing points, which are very far away from the plane of the drawing. This requires working with a large board that makes it possible to extend the field beyond the paper's edges. Exercise by Carlant.

6.1

ADDITIONAL PIECES OF PAPER. The first difficulty resides in the fact that the vanishing points are located on the drawing board, far away. To solve this, we attach two additional sheets of paper on each side of the drawing for the vanishing points.

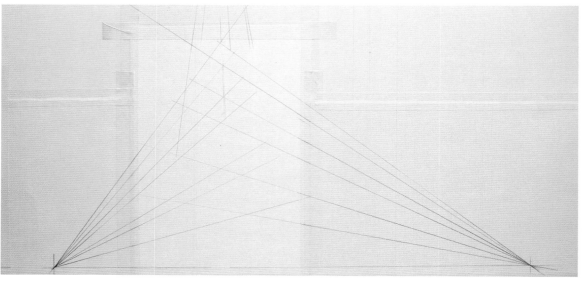

With two pieces of paper we extend the work surface, making the vanishing points visible. From each one of them we project the diagonals that define the angle of the building's walls and the placement of the windows.

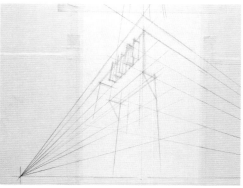

The lines go into the drawing on both sides, defining the height of the roof, the window shutters, and the base of the gallery. The architectural structure is completed by drawing the vertical lines. They are not completely parallel because they converge slightly as they move upward.

Before we begin to draw, we locate the vanishing points. In this case, we project the diagonals from the photograph using a ruler or a measuring tape.

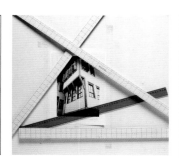

All the window shutters are open symmetrically to make it easier to draw them with vanishing lines.

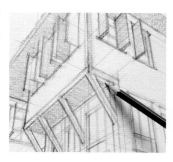

MATERIALS EXERCISE 6: 2B and 4B graphite pencils, plastic ruler or measuring tape, eraser, adhesive tape, and sheets of paper

6.2

THE ARCHITECTURAL ELEMENTS. These are not drawn freehand like we did in other instances; they are constructed more rigorously with vanishing lines. In this drawing, all the elements are subject to the effects of perspective.

We reinforce the rectangular structure of the building by going over the outlines. We draw the shutters and the windows with perspective lines. They should narrow as they recede into the distance.

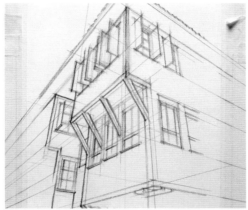

The line drawing concludes with the construction of the wood beams that support the gallery. These narrow with perspective, and the distance between them is decreased. We finish the remaining windows that conform to the vanishing lines.

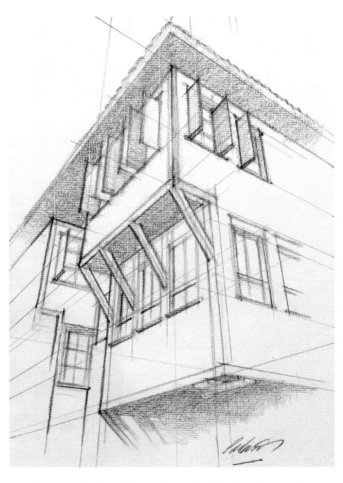

We finish the drawing with evenly applied shading. Perspective explains the effect of depth and the volume of the building, but the shading creates contrast and emphasizes some areas against others.

The shading is applied very gently; the pencil is held at the end to avoid applying too much pressure.

The diagonal wood beams that support the balcony are also drawn in perspective. The way these are arranged reminds us of train tracks vanishing in the distance.

CASTLE WITH RECTANGLES AND CYLINDERS. It is very common to encounter circles and cylinders in perspective when drawing architectural elements and urban scenes. In this exercise, we approach them not only from the perspective point of view, but also emphasizing the angular distortion of the camera lens.

7.1

DEFINING THE ANGLE OF VISION. In the following subject, it is important to define the angle of vision prior to drawing the cylinders involved. The analysis of the model shows three cylindrical towers located at different heights, an element that affects the shape and angle of its walls.

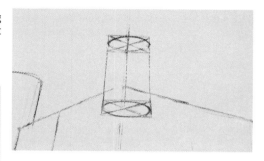

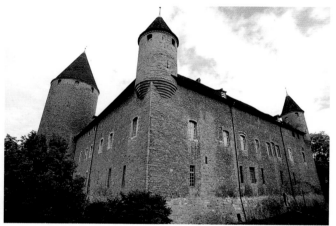

To draw a cylindrical tower in perspective, we resort to a rectangle. We draw an ellipse in perspective for its top and bottom areas. The cylinder is drawn by connecting both ellipses.

We begin drawing with a charcoal stick, approaching the body of the building in perspective at an angle, with two vanishing points located outside the drawing's plane. We subdivide this surface with diagonal lines for the walls and then establish the positions of the towers.

The diagonals that cut through each ellipse provide a center point that we connect with a line. If we extend the line, we project the tip of the tower's pointed roof. We do the same with the other towers.

The angular effect distorts the buildings and makes them look as if they were pyramids.

The work combines some parts done with a ruler and others drawn freehand.

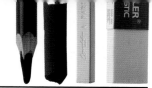

7.2

THE ARCHITECTURAL FEATURES. We introduce the structure of the castle over the basic drawing created with simple geometric shapes projected with angular perspective; we project the windows, roofs, and the other important features.

From the vanishing points located at either side outside the drawing, we project the lines that will define the windows. These become smaller as they move away from the closest edge of the building.

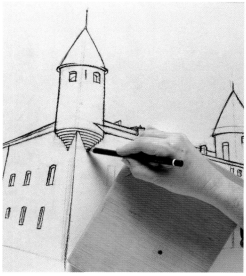

We outline and draw each architectural element with a heavy line, paying attention to the construction details. Since charcoal lines erase easily, we rest the hand on a wooden board.

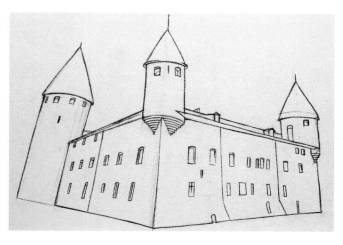

After improving the quality of the line, the castle looks solid, with clear outlines. This is the time to erase any sketched line that is still visible.

When we draw the lines of the façade, we indicate that the upper surface of the wall is exactly vertical, and the slanted lines show that it is wider at the base.

7.3

INSTILLING PERSONALITY. The shading phase is decisive in this perspective representation because it provides personality and warmth to a drawing that is dull, technical, and lacking imagination. The shading adds an artistic quality.

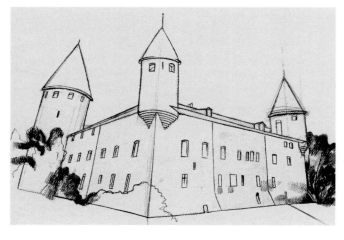

We sketch and darken the areas occupied by trees in the foreground, which later are going to end up covering part of the building. The shading is applied with a stick of charcoal held sideways.

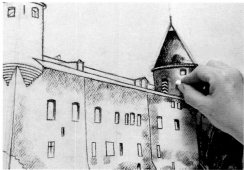

We shade the walls of the building without applying too much pressure on the stick of charcoal. Gradations and nuances are created on the shading by going over the gray areas with a stick of white chalk.

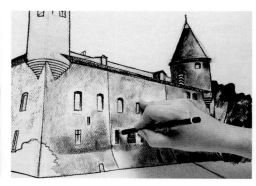

We apply charcoal, lightened with white chalk, on all the walls of the castle. The windows require more detailed attention, so we go over the shading again with a charcoal pencil.

When shading is applied with the side of the stick, the paper darkens very fast. The more pressure that is applied, the darker the shading will be.

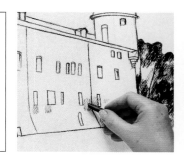

The effect of the tonal gradation is the one that best describes the volumetric effect of the cylindrical and conical shapes of the towers.

The shading on the walls is applied irregularly. This is necessary if we intend to convey an uneven look to the surface of the stones on the wall.

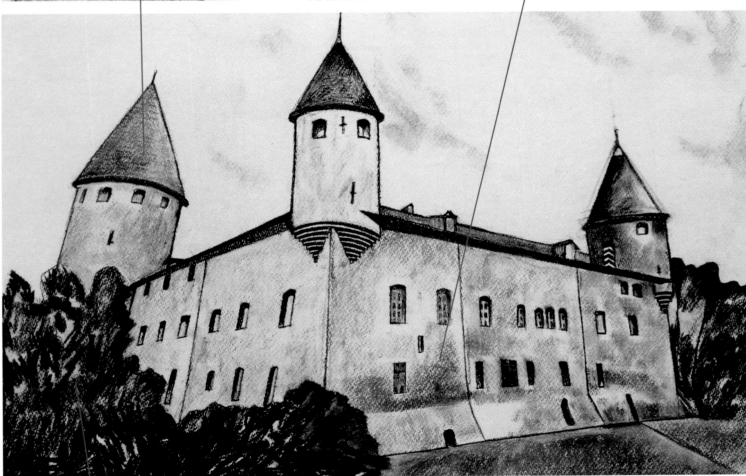

The vegetation in the foreground is drawn very spontaneously, covering existing parts of the castle. The grass is a medium tone, blended with the hand. A few shaded areas in the sky indicate the presence of clouds.

The approach used for the vegetation in the foreground is very vigorous and somewhat abstract. The top lines are drawn heavily to cover the ones located below and to create strong contrast with the background where the castle is located.

CIRCULAR SHAPES IN URBAN SETTINGS. Hardly any circular shapes can be found in natural settings, as opposed to urban scenes, where these are very common. Most of the time we see the objects from top to bottom; therefore, the circular shapes turn into ellipses.

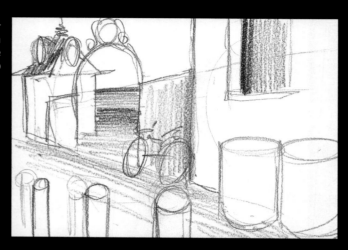

Many circular shapes in perspective can be found if we look around urban scenes.

DRAWING A CIRCLE. Inside a square we draw horizontal and vertical axes. With the help of these axes we draw the circle freehand, as carefully as possible. If we want to show the circle in perspective, we simply lower the square that contains it.

A FLATTENED CIRCLE. Inside the flattened circle we draw the axes that will help us define the ellipses in perspective that will become the flattened ovals, which, depending on the point of view, go from the circular shape to an almost straight line, including all the intermediate phases.

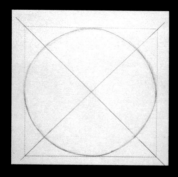

We draw the two diagonal axes of a square. From here, we draw a circle freehand with the edges barely touching the sides of the square.

We draw a square in perspective. We draw the diagonal axes and the ellipse very carefully, trying to make its sides touch the four sides of the square.

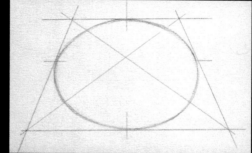

AVOIDING POINTS AND BULGES. Two mistakes should be avoided when drawing an ellipse inside a square in perspective. No matter how narrow the ellipse is, it should never end in a sharp point. Also, we should avoid bulging and unattractive curves.

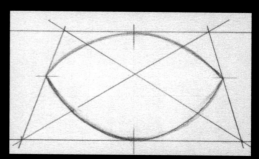

The curves of ellipses should be soft and must never end in sharp points as shown in this drawing.

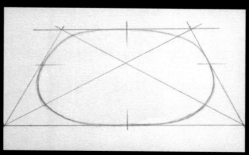

If the curves are not properly controlled, the ellipse can look bulging, somewhat square rather than round.

CYLINDERS, ELLIPSES, AND CIRCULAR OBJECTS. Until now we have talked only about rectangular shapes, but we cannot ignore circular and cylindrical ones, because many of them can be found everywhere.

DRAWING CYLINDERS. To draw cylinders, we can use the technique for drawing ellipses. To do this, we draw two parallel ellipses and we connect their sides with two straight lines. The result is a cylinder. Then we erase the sketched lines, leaving the cylinder.

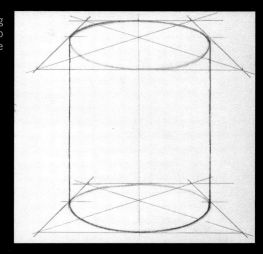

A perfect cylinder is created by drawing two ellipses, one above the other.

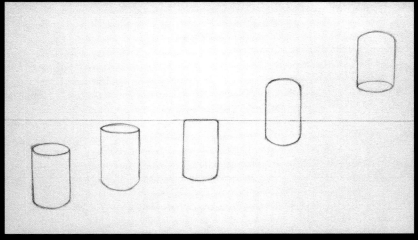

The shape of the cylinder is determined by the perspective of the ellipses and the point of view. Notice how the cylinder changes according to its placement above or below the horizon line.

DRAWING OBJECTS INSIDE THE CYLINDER. Once we become proficient at drawing ellipses, we can draw any round object without a problem.

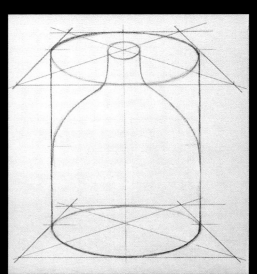

Cylinders are a good resource for drawing round, conical, or cylindrical objects in perspective.

VANISHING POINTS OUTSIDE THE DRAWING. The problem that arises with having a large distance between the two vanishing points on the horizon line is that both could fall outside the confines of the drawing. If this is the case and we want to construct the drawing exactly, we attach two sheets of paper with masking tape to the left and right of the drawing; then we can draw the horizon line and locate the vanishing points.

If the vanishing points originate outside the paper, we add a couple of pieces of paper to extend the vanishing lines.

SIDE MEASUREMENTS. Another way of working with vanishing points located outside the drawing is to mark measurements on both sides of the paper and then to project the vanishing lines. This method is very useful for drawing buildings with many windows.

Using a ruler, we divide the perpendicular lines of the sides of the building into nine equal parts.

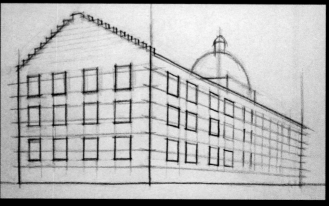

We connect all the parts with straight lines to create the perspective view of the windows on the façade.

VANISHING POINTS OUTSIDE THE DRAWING AND SIDE MEASUREMENTS. In this section we are going to deal with two interesting subjects: how to incorporate the perspective lines of the vanishing points that are outside the drawing, and how to do the same with vertical measurements that complement the vanishing lines of a landscape.

PLUMB THE VERTICAL STRAIGHT LINES BY EYE. The ability to work measuring by eye is very useful. With the drawing board in a vertical position and one eye closed, we move our heads slightly to the left and right until the edge of the board can be used as a plumb line to determine the size of each part of the objects. Then we mark those points on the edge of the board and project them downwards.

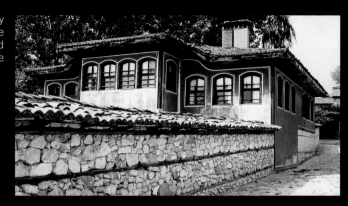

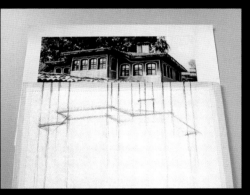

Closing one eye and standing in front of the subject or a photograph of it, we indicate the position of the vertical lines on the upper part of the board.

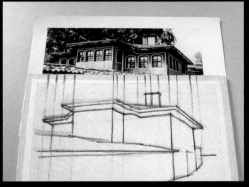

We project the marks of the upper part of the paper with parallel lines.

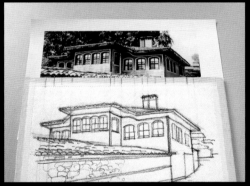

The vertical lines combined with the perspective provide greater control of the measurements of the drawing.

A TAUT STRING. There is another way of dealing with vanishing points outside the paper, especially if using an easel. It consists of tying a string to a nearby nail, column, or beam to keep it tight and to use it as a guide for drawing in perspective. This method is very practical, especially for large paintings or drawings.

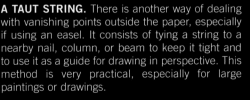

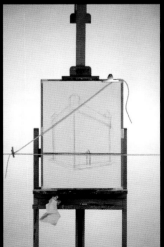

The taut string acts as the horizon line. With a second string held tight with clips, we project the vanishing lines on the paper.

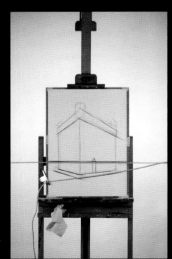

We can move the string as needed. The vanishing points are at either side of the taut string.

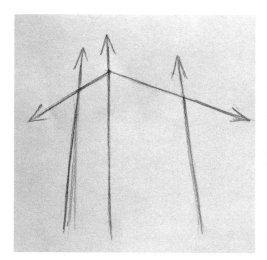

When we draw a building, the upper line for the roof converges at two points on the horizon line. However, the ascending diagonals go toward a single point beyond the model.

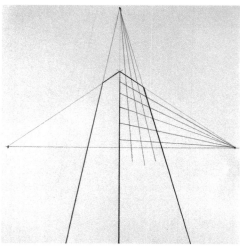

With this exaggerated perspective of a skyscraper, we see how the three vanishing points work to create the feeling of height in the building.

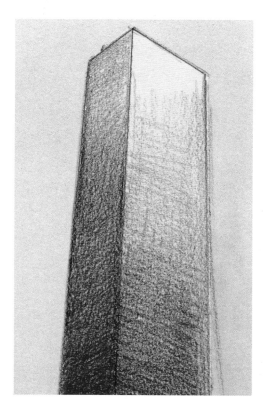

Aerial perspective can be enhanced by shaded gradations that help emphasize the vertical distance of the building.

When we draw a very tall building, in addition to the vanishing lines that come from points located at both sides of the subject, we must consider a third one located in the sky, which makes the walls of the building narrower as they go upward.

To locate the third vanishing point of the perspective, we simply need to extend the lines of the pillars that support the deck in the foreground. These are not parallel lines; rather, they converge at a very distant point.

AERIAL PERSPECTIVE, LOOKING UPWARD. Until now, all the perpendicular lines have converged in a vanishing point on the horizon line. This is not always the case. In some cases, the vanishing lines converge at a third vanishing point located way above or below this line. This happens when a very tall building is involved.

Solutions and Resources

In the first section we have mainly worked with the basics of linear perspective, explaining how to construct regular forms from diagonals that converge at one or several points located on the horizon line. However, from now on, the forms are going to be much more complex: some subjects include inclined planes, stairs, and designs with many vanishing points. In the next chapter, we will look into linear perspective in depth to offer solutions to the problems that may arise, and also to provide resources and ideas that will be very useful in such cases.

A STREET IN PERSPECTIVE. After studying the previous exercises, we know enough to create a more complex drawing; in this case it will be a street with rows of houses on both sides, which gets narrower as it moves farther away. This subject is an effective means for understanding perspective projection in an urban setting and for pulling the viewer's eye into the drawing. Exercise by Carlant.

8.1

FAÇADES IN PERSPECTIVE. The first step consists of establishing the horizon line and projecting the main vanishing lines of the buildings. To add some difficulty to the exercise we have chosen a model that includes a small plaza that interrupts the line of façades on the left.

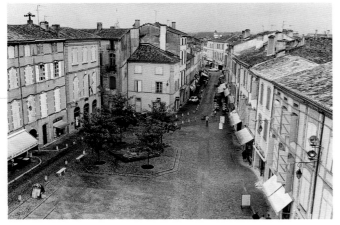

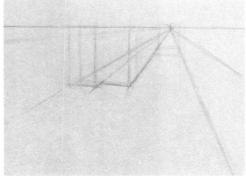

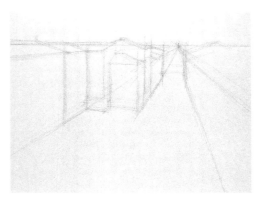

With a 2B graphite pencil we draw a high horizon line. Several diagonals extend out in two directions from a central perspective point to establish the position of the façades. We draw four lines on the left side to indicate the corner of the small plaza.

The vanishing lines of the previous step are the references upon which the buildings are constructed. We begin with those that surround the plaza. To make things easier, we approach the buildings as if they were rectangular shapes with volume.

Every time there is a change of direction on a street with buildings at different distances, one must remember that each line of façades has its own vanishing lines.

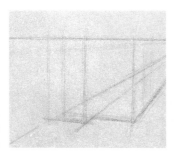

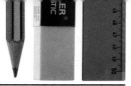

8.2

FROM PROJECTION TO STRUCTURE. After laying out the street's perspective, we focus our attention on the structures of the buildings, which are drawn by combining different geometric shapes, such as rectangles, cubes, and pyramids. In this phase, we continue working with the 2B graphite pencil.

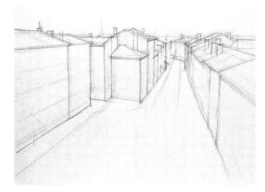

The line that defines the base of the buildings is the same vanishing line used from the beginning; the variation of the roofs is greater due to their different sizes and slopes. At this point we draw the lines for the windows.

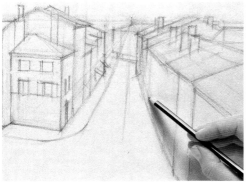

Until now the façades were empty; they had no architectural features. Doors and windows are drawn with very light lines.

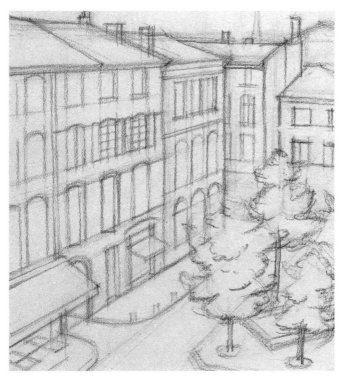

To draw the windows we begin with the opening in perspective, then we add the details, paying close attention to their shapes, the windowpanes, and to the positions of the shutters. We draw very lightly, using a 2B pencil.

The buildings are constructed with rectangular shapes or boxes and triangles or pyramid-shaped tops for the roofs.

To draw the doors and windows we project new vanishing lines over the façades to align them correctly. The window is carefully drawn freehand.

8.3

ARCHITECTURAL DETAILS AND SHADING. The forms are increasingly more complex; the façades are covered with windows, the plaza with trees, and the sidewalks with posts and cars. We set aside the structural aspects to pay more attention to the architectural details and the urban elements.

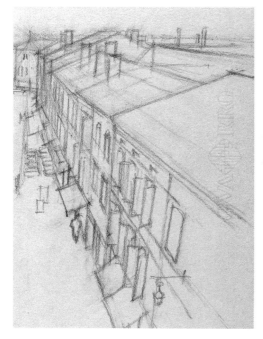

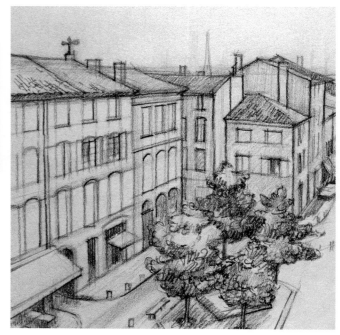

The shading is applied after the line drawing is completed. With a 4B pencil we apply light shading to avoid covering all the lines. We rest our hand on a board to prevent smearing the drawing with the fingers.

The treatment used on the left side of the street is applied to the façades on the opposite side. The vanishing lines determine the positions of the windows and the store awnings. The foreground should have more detail than the façades located farther away.

Gentle shading on the roofs of the houses creates greater contrast with the sky in this area and highlights the three-dimensional effect of each block. We go over the straight lines to define the outlines.

People are depicted very loosely. They look like simple marks.

The group of trees is not affected by perspective. The approach is much more intuitive with very spontaneous and organic forms.

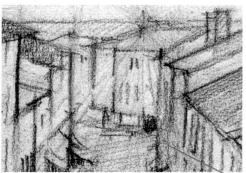

As we look down the street, the urban elements and the architectural features are less detailed and specific. However, the original linear structure drawn by projecting vanishing lines must remain constant.

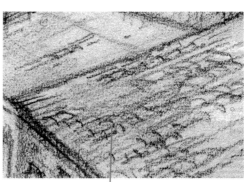

On the roofs closer to the foreground we introduce a few elements of texture, very lightly drawing several rows of shingles.

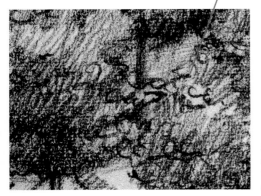

The effect of volume on the trees in the small plaza is created with gradations applied with the 4B graphite pencil held at a slight angle.

The shading on the pavement of the street is very light and is applied by gently stroking with the tip of the pencil at an angle, forming areas of barely visible diagonal hatching. The intensity of the gray on the trees constitutes the greatest contrast in the drawing.

PERSPECTIVE OF THE ROOFTOPS. From the top of a lookout point, a tower, or a bell tower, we can see the rooftops of the houses nearby. If these are all lined up, perspective can be useful to organize the elements and to emphasize the effect of depth. Exercise by Carlant.

9.1

CHANGING DIRECTION. When the distribution of the rooftops shows a change of direction, the drawing is constructed with as many vanishing points as there are directions in the line of roofs. The direction is determined by the layout of the streets. In this case, two vanishing points are sufficient to carry out the exercise successfully.

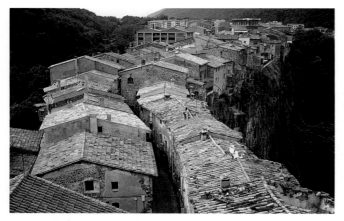
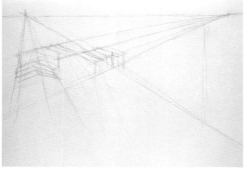
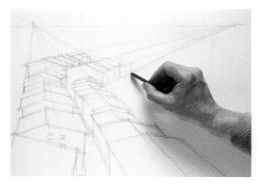

The horizon line is high. We mark two vanishing points on each side of it. With the first vanishing lines we draw the houses located in the distance. From the left side we project new lines to guide us with the drawing of the roofs that move toward the viewer.

We use the diagonals that extend from the vanishing point on the left side to construct the rooftops of the foreground. Halfway through the painting there is a change of direction in the street; this requires continuing the drawing with the vanishing lines that turn toward the point on the right.

Here, the layering of elements is especially useful to create a staggered sequence of visual objects to suggest a feeling of depth, even though other perspective resources are used to deal with the space.

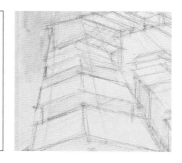

9.2

DRAWING THE SURROUNDINGS. After constructing the houses and the rooftops following the rules of perspective and geometry, it is a good idea to create a context for it—in other words, to create the natural backdrop, the space that contains the architecture. Since we are working with sanguine, we use this to introduce some tonal effects.

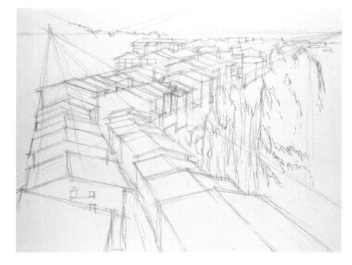

Drawing lightly with the tip of the stick, we introduce the cliff and the group of houses into the landscape. Little by little, the horizon line disappears and the technical and mechanical drawing of the perspective loses its rigidity upon blending with the organic forms.

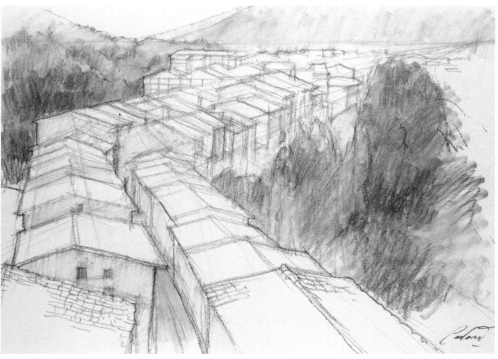

We finish it quickly by shading with the tip of the stick placed at a slight angle and without applying much pressure. The tonal effect is lightened with a blending stick; we rub it gently over the houses and more vigorously over the vegetation. A cotton rag may also be used.

The work carried out with the blending stick is very delicate. Shading must be soft, blending the lines gently but without erasing them.

STREETS THAT GO UP AND DOWN. On a slope, or a street that goes up or down, there are two horizon lines, a true and a false perspective. The principles applied to create steep slopes and inclines are identical to the ones used for a flat horizontal surface, with the exception that the vanishing points stem from a false horizon line that is located a little above or below the horizon line.

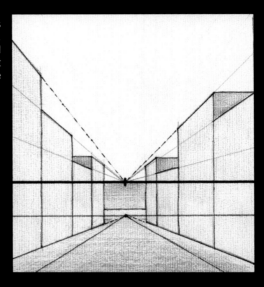

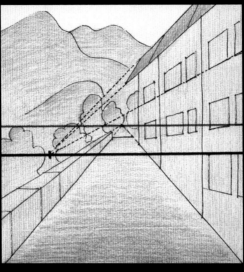

On a slope, the horizon line for the street is located a little below the real horizon, out of which stem the vanishing lines for the buildings.

On a slope, the false horizon is located above the real horizon.

COASTAL AND RURAL TOWNS. Many coastal and rural towns have steep streets. While the street has its own vanishing point, the houses are represented as usual, by taking the horizon line as reference.

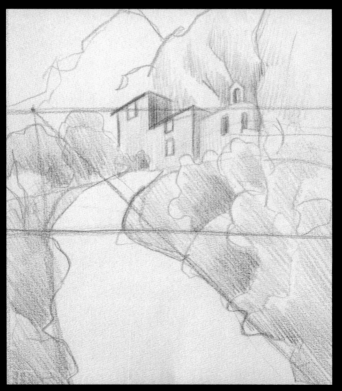

In rural towns, we find many slopes that can be used to practice the false horizon.

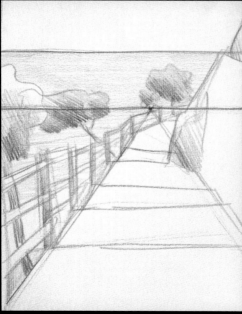

In the steep slopes of coastal towns, the false horizon is located below sea level.

INCLINED SURFACES AND STEPS. Many artists include slopes and inclines of steps in their drawings to create a feeling of rapid movement and rhythm, and to play with the steepness of the planes. At first, the steep surfaces can throw the artist off, but the work is simplified if perspective lines support it.

A FALSE HORIZON. In a rural landscape with steep slopes, one cannot speak of a real horizon, as we know it. Here, we must identify a false horizon located below the real one to draw houses located at different heights on the hill.

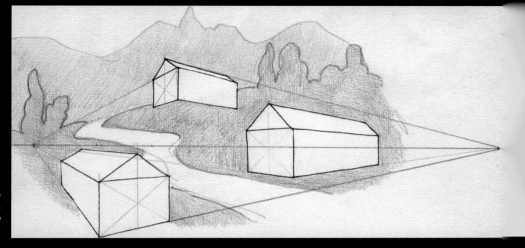

It is necessary to create a false horizon to represent the elements that are distributed throughout the slope.

STEPS. The perspective of the stairs, the same as that of the rooftops, is based on the presence of the ascending and descending planes. As we go up, not only do the steps get narrower, but also the distance between them is reduced.

GOING UP AND DOWN THE STAIRS. Normally, when we go up and down the stairs we see them in very distinct perspective, because not only do we see them from above or below, but we also have to add the height of our body.

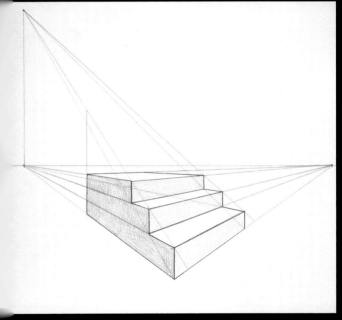

Drawing stairs in perspective requires the use of two vanishing points to draw the steps, and a third one (aerial) to establish the degree of inclination.

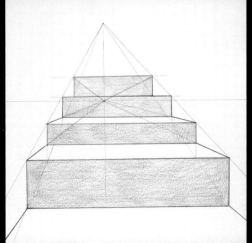

Steps seen from below. The incline is decided with a single vanishing point, while the width of the steps is determined by the central vanishing.

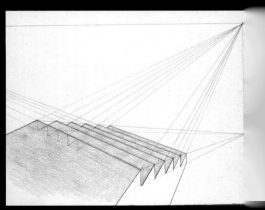

Descending steps are more difficult; they also require three vanishing points that are located far away from each other.

DRAWING STAIRS. Drawing stairs like those shown in this picture should be manageable at this point. To make drawing them easier, we reduce the number of stairs and increase their steepness. Drawing by Carlant.

10.1

A VARIATION OF A SLOPE. Drawing stairs may seem difficult. However, it is only a variation of a slope on which we project new lines that divide the space to represent the steps. We begin drawing with an HB graphite pencil.

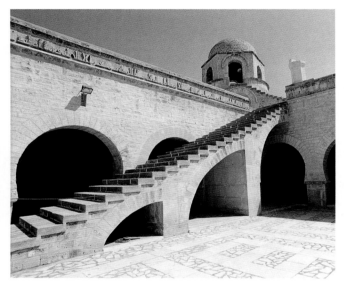

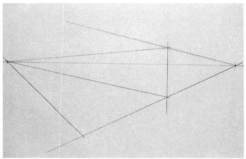

Before we do anything, we determine the optical height and decide the placement of the stairs in the drawing. Beginning at the vanishing points on the horizon line, we project the diagonals that allow us to draw the first sketch.

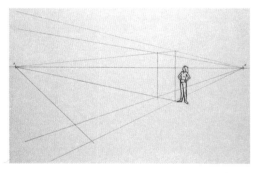

From the intersecting points of the vanishing lines, we project perpendicular lines that determine the width of the stairs. Next to one of these lines we sketch a figure, which will serve as a reference to determine the size of the steps.

The line on the background is used as a reference to determine the height of the steps. We check the accuracy of the segments by comparing the lower segment against the figure to verify that it agrees with the height of a real step.

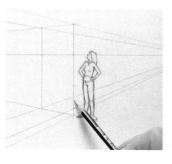

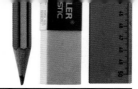

10.2

THE HEIGHT OF THE STEPS. Using a segmented line, we establish the size of the steps. From both vanishing points we project lines that use these measurements as a reference to determine the height and angle of the steps.

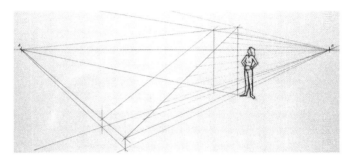

We decide on the height of the steps. To do this, we divide the perpendicular line in equal parts. From the vanishing point on the left side we project lines that cut through each one of these divisions and meet the diagonals that determine the angle of the stairs.

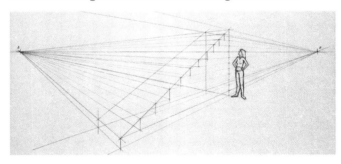

From the vanishing point on the left we draw new diagonals in perspective that merge with the previously established intersections. These lines determine the angle of each step.

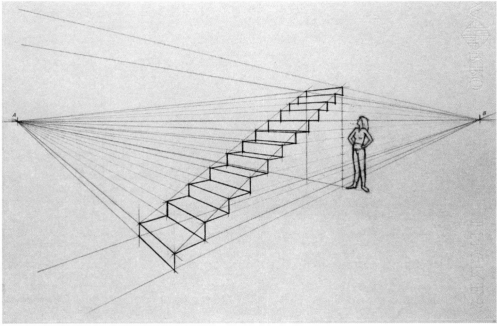

Using the previous lines as reference, we only need to project the perpendicular lines for the stairs; all of them are parallel to each other. With a 2B pencil we darken the drawing and finish the exercise.

Beginning at the first step, we connect the top and the bottom of the staircase with two lines as if it were a flat sloped surface.

A BRIDGE WITH ARCHES. All around us there are many objects that have curves (elliptical, circular, parabolic, among others) that require greater involvement with perspective drawing. In this exercise we face the challenge of drawing the ellipses of the arches on a bridge, which also cast a reflection on the water. Drawing by Carlant.

11.1

DISREGARD THE PHOTOGRAPH. To represent the bridge in perspective correctly, we begin with a real subject, although in this case we have simplified the shapes to make the drawing easier. With this in mind, we will imagine that the top of the bridge is a flat and straight road without any elevation, and that all the arches have the same width.

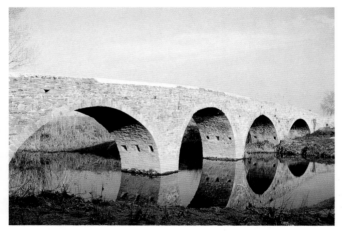

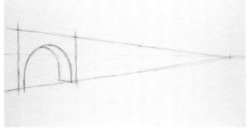

We establish the horizon line a little below the middle of the paper. On its right, we locate a point from which we will project the diagonals for the bridge. We draw a square, which will house the first arch.

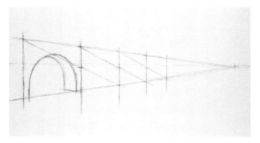

We draw a diagonal from the top corner of the first perpendicular line, which cuts exactly through the second one and then touches the vanishing line. This last point establishes the width of the second arch. This procedure is repeated until all the arches have been drawn.

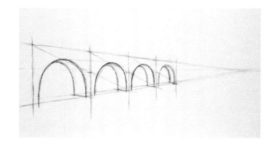

Inside each rectangle we draw the different arches, paying special attention to the elliptical shapes described by them. To draw the ellipses correctly we draw a line through the perspective center of each rectangle.

If we draw two diagonals that connect the edges of this rectangle in perspective, we will find the center of perspective. A vertical line drawn through this point will help us find the center of the arch.

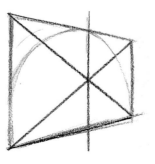

11.2

PROJECTING THE REFLECTION. Let us imagine that the water in the river is a mirror and that we repeat the previous process to represent the arches of the bridge, but this time inverted. Then, we shade the drawing establishing the real image from the reflected one by changing the color.

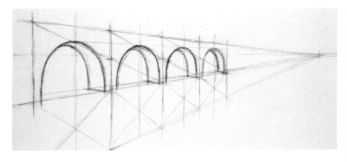

The next step involves drawing the arches reflected on the water by repeating the same procedure but inverted: draw the vanishing line, extend the width of each arch, and find the center of perspective by intersecting the diagonals.

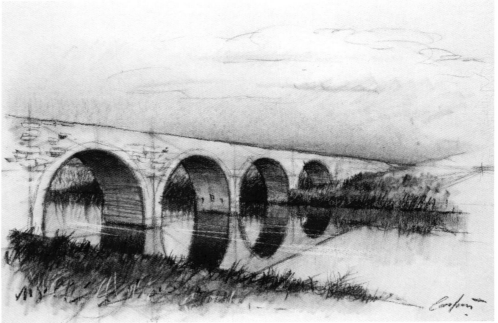

When the line drawing is finished, we need to shade the bridge and the textured effects; the vegetation that grows on each side of the river is loosely drawn.

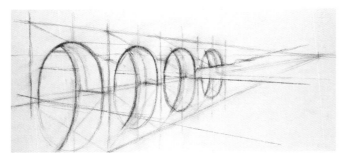

Once the center of perspective and the perpendicular axes have been determined, we draw the inverted arches freehand. They must be symmetrical to the real ones and, together, form a perfect ellipse.

The shading effects with brown chalk are very soft; a blending stick is used to form gradations.

SIZE DECREASES WITH DISTANCE. Texture gradient is one of the first resources used to represent depth. If we look at road fences, we notice how the posts become shorter and the distance between them narrower the farther away they are. We will use a method that can help us achieve this effect.

A field full of different size stones can create this partial gradient effect.

The posts of a fence on the side of the road become shorter and the distance between them narrower as they move away.

DRAWING POSTS. To figure out the decrease in their distance we follow several steps: we draw the first post and we project the lines on a vanishing point. We draw a second one wherever we feel it is most appropriate. We draw a line that begins at the top of the first post, cuts through the center of the second one, and ends on the vanishing line. This last intersection should mark the third post. The method used for the second and third posts is repeated with the rest of the posts.

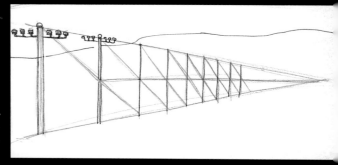

Using this method, not only the height of the objects decreases but also the distance between them.

MOVEMENT GRADIENT. Just as the distance between the objects or the telephone posts decreases, the speed of the object also decreases the farther away it is. A movement gradient increases the effect of depth in a landscape when we see it from a moving vehicle.

From a vehicle traveling at high speed the shapes of the objects appear to be in motion; they move sideways.

The buildings and the trees in the foreground next to us move faster than the ones in the distance, and the difference in the apparent speed correlates to our distance with respect to what we see.

TEXTURE GRADIENT AND THE CENTER OF PERSPECTIVE. Texture gradients are the main reason that we see the rows of telephone posts, trees, or columns decrease in depth. In addition to the size reduction experienced by those vertical points of reference, the space between them also decreases.

CENTER OF PERSPECTIVE. Often, it is necessary to mark the center of an object to draw it properly, to complement it, or to add new geometric shapes that represent it in perspective correctly. To find the perspective center or middle point of an object, we draw two diagonal lines from its corners. The perspective point is located where these two lines intersect. This approach does not change at all if the square is in perspective.

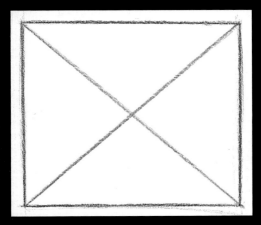

If we connect the corners of a rectangle with diagonals, the perspective center is at the point where they intersect.

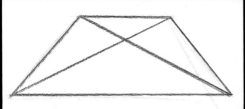

The same method is applied for a rectangle drawn in perspective

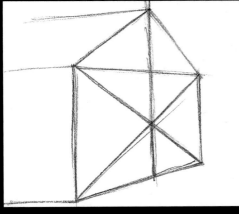

Being able to establish the perspective center is very useful for drawing the triangular shape of a roof in perspective.

From the perspective center, a perpendicular line is drawn to help us draw an arch in perspective.

DRAWING A RUG. We determine the center of perspective of the rug, which is a rectangle in perspective. This is very useful for drawing the designs on it, provided that the rug is subdivided symmetrically.

We approach the rug as if it were a rectangle falling away from us. The diagonal axes determine the center and contribute to the proper distribution of the decorative designs.

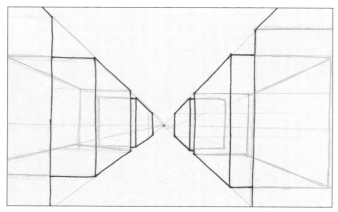

To better understand the structure of the drawing, it is a good idea to reduce the forms to simple transparent cubes that are projected from a single central vanishing point.

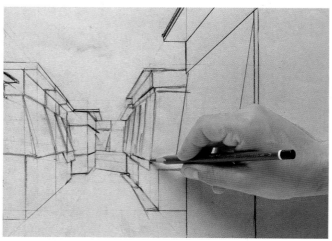

Then, the artist has conformed the initial cubes to their final form as market stands, focusing on the canopies and the slopes of the shutters.

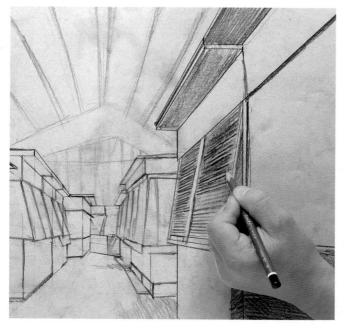

The many lines of the shutters have been drawn freehand, taking their slope into consideration. The lines are not parallel; they are arranged in a fan shape.

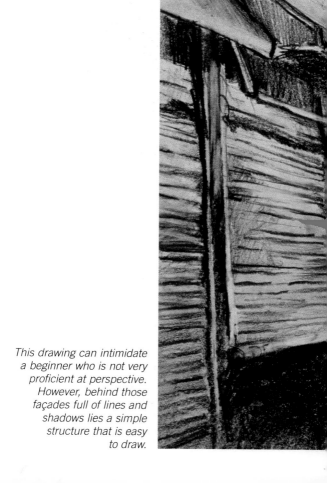

This drawing can intimidate a beginner who is not very proficient at perspective. However, behind those façades full of lines and shadows lies a simple structure that is easy to draw.

INTERIOR OF A MARKET. Drawing interiors requires the use of some of the rules of perspective. With them we will create the correct distribution of the space and, in this particular case, the correct representation of each market stand. We recommend using a single vanishing point and approaching the forms as if they were transparent cubes.

In the drawing the artist has not depicted the letters over the canopies; they are very blurry. If they were to be included, a good way to do it is by writing them inside rectangles drawn in perspective.

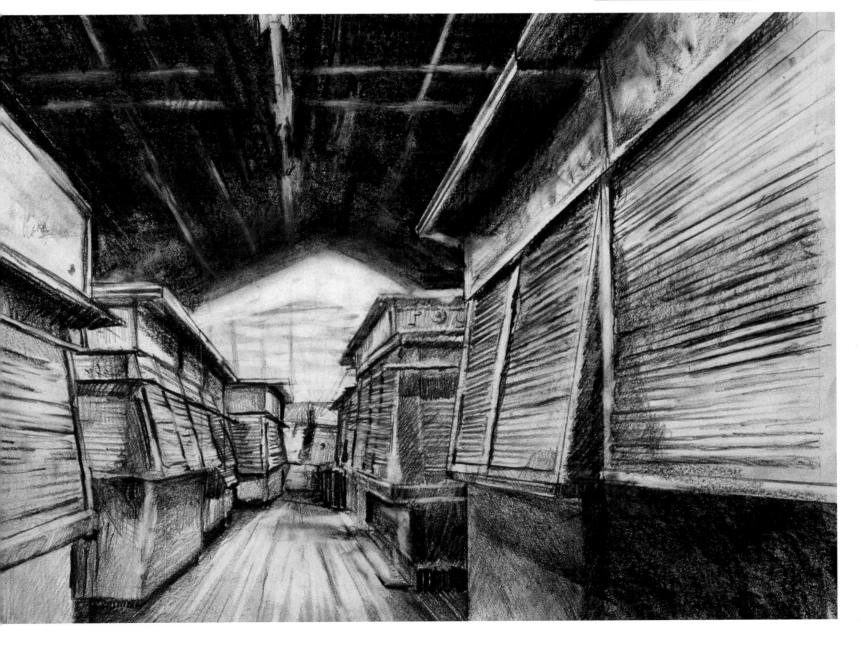

ANGULAR PERSPECTIVE. To draw a small space, like the interior of a vehicle or a small room, the best approach is to use angular perspective. This method, however, produces a strongly distorted effect, which needs to be examined. Drawing by Gabriel Martín.

12.1

THE INTERIOR OF A VEHICLE. The idea of angular perspective is to include in the drawing's plane the space that is not within the viewer's field of vision; to take it all into consideration we would have to move the head sideways and up and down. This is a problem because the elements outside this visual field begin to get distorted and rounded.

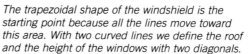

The trapezoidal shape of the windshield is the starting point because all the lines move toward this area. With two curved lines we define the roof and the height of the windows with two diagonals.

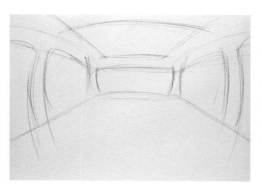

The perpendicular lines for the windows show a more pronounced curvature as they move farther away from the windshield. The same is true for the crossbar in the sunroof.

Angular perspective drawing distorts the lines as they move away from the hypothetical central vanishing point. The closer they get to the viewer, the more curved they look.

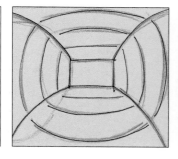

12.2

A SPACE DISTORTED BY CURVES. This way of approaching a space tends to distort the sizes, to make all the straight lines, forms, and distances rounded to indicate depth. Therefore, distortion is the main resource for representing depth within the plane.

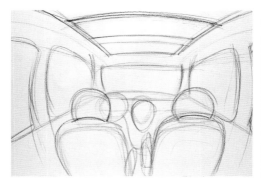

From this point on, the work is very simple. This does not prevent us from drawing the steering wheel, the seats, and the dashboard by combining several circles.

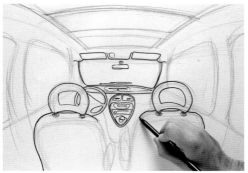

Each element of the vehicle's interior is drawn in more detail over the preliminary lines. We use a marker to make the lines more visible.

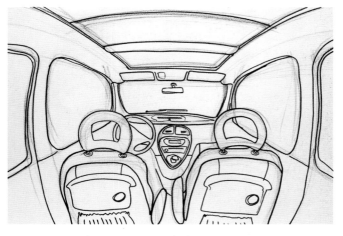

The line made with the marker is very simple, drawn with a steady hand in a single stroke. Using the marker, we refine the components of the car, even adding some details. The work is done quickly to avoid making it look like a photograph.

Once the line drawing is finished, we begin shading to emphasize the volume of the seats and to enhance the feeling of depth with gradations.

FORCED AND EXAGGERATED PERSPECTIVE. Distortion is the key factor in the perception of depth, because it decreases the simplicity and increases the tension present in the visual field. This encourages us to manipulate, force, and conform the vanishing lines of a drawing to our creative requirements. Drawing by Esther Olivé de Puig.

13.1

PULLING THE OBJECT. Distortion always gives the impression that the object has been elongated as if it had been pulled. This is exactly what we are going to do—to project several foundation lines as if they had been pulled or forced out of shape to create the effect of depth.

We begin the exercise by establishing two vanishing points: one in the center, from which we will project two diagonals; and the other on the upper part of the paper, which will help us draw the bell tower in perspective.

Many lines extend out of the central vanishing point to define the tops of the façades and the angle of the windows and balconies. We mark a second vanishing point over this one to help us distort and force depth.

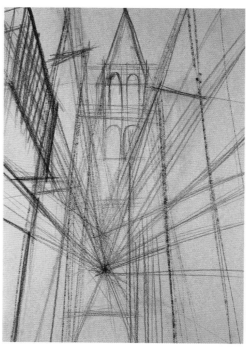

Instead of converging all the vanishing lines into a single central vanishing point, we make them converge at two. This approach is not highly recommended from a technical standpoint, but it offers good expressive results.

If we drag the stick of charcoal lengthwise across the surface of the paper, it will be easier to control the steadiness of the lines.

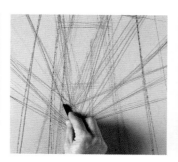

13.2

DEFINITION AND COLOR. From the perspective lines, we draw the architecture of the bell tower and the definite lines for the façades. Since we are working with a medium-tone paper, we add a few elements with sticks of pastel to enhance the volume.

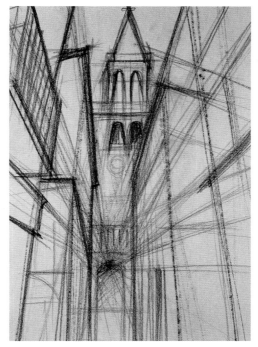

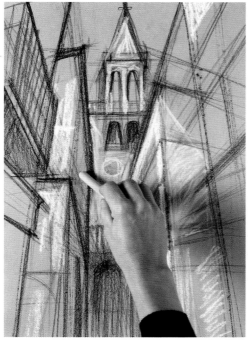

With the tip of the stick of charcoal we draw the structure for the bell tower and we reinforce, with darker lines, the profile of the façades. Notice that the lines for the façades are not perpendicular; instead, they open in a fan shape.

Once the line drawing is finished, we highlight the effect of volume by applying color over the illuminated areas with sticks of white and yellow ocher pastel. The shaded areas are left gray, like the color of the paper.

The forced angle of the vanishing lines exaggerates the distance. The planes enhance the three-dimensionality, exhibiting greater depth than normal and acquiring volume, thanks to the effect of the color.

The dark lines should be combined with subtle blended effects that, depending on the dimensions of the paper we use, can be done with the hand.

The white highlights over a medium-tone background, in this case on gray paper, show the contrasts and further define the volume of the façades.

AN OCTAGONAL FOUNTAIN. The construction method that we use in this exercise will help us draw prisms, such as pentagons, hexagons, octagons, and other similar shapes, in perspective. These figures are usually present in urban settings like kiosks, canopies, lampposts, and fountains. Drawing by Carlant.

14.1

DRAWING WITH ELLIPSES. The objects that present an octagonal structure can be inscribed into a circle, so it is possible to use the method for drawing ellipses to depict the shape.

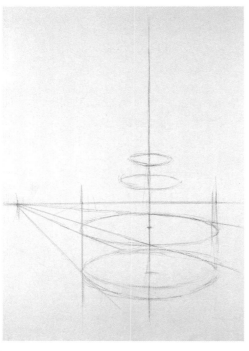

Beginning with some vanishing lines and a vertical axis, we try to define the shape of the fountain by projecting four ellipses. To do this, first we study the section devoted to the projection of ellipses.

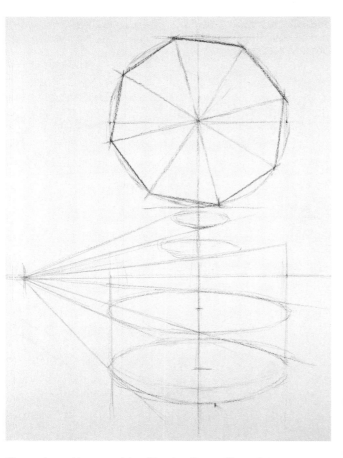

The main problem consists of turning these ellipses into an octagon. To do this, and using the vertical axis, we draw a circle over the ellipses. With a ruler, we divide it into eight sections.

We must avoid drawing any radius of the circle over the perpendicular axis, in order to prevent having too many lines on the same point. To solve the problem we just need to rotate the circle slightly.

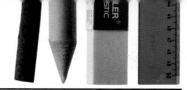

14.2

PROJECTING THE OCTAGON. From the top circle, divided into eight parts, we project the lines that will make it possible to transform the ellipses in octagonal forms in perspective. This simple method assures absolute accuracy.

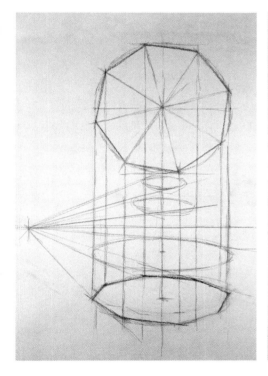

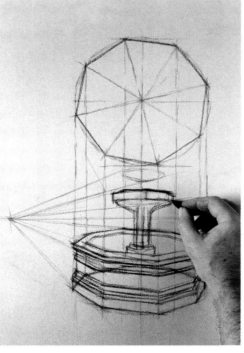

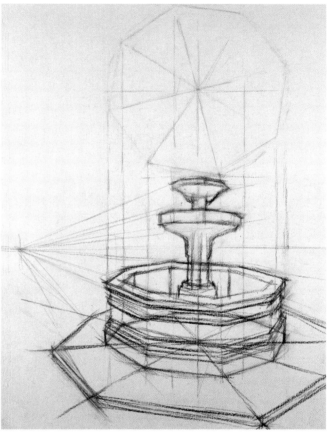

The top circle becomes an octagon. From each of the octagon's corners, we project several perpendicular lines to the lower ellipses. Each one of these intersecting points becomes a corner of the octagon in perspective.

After each ellipse has been converted into an octagon, and using the perpendicular lines as a guide, we erect the body of the fountain, paying attention to the slope of the moldings on each of its sides.

The upper figure is erased since it no longer has any use. From the center of the lower ellipse we draw several lines that pass through each ellipse. We use this projection to represent the step, also octagonal, which surrounds the fountain.

To avoid problems with the slope of the moldings, we must remember that they should always be parallel to the lines that form each side of the octagon.

345

14.3

DRAWING THE BACKGROUND. Having finished the most complicated part of the exercise, we need to complete the fountain with new details and to draw the architectural background that surrounds it. This must be shown as a simple background, without too many details or contrasts.

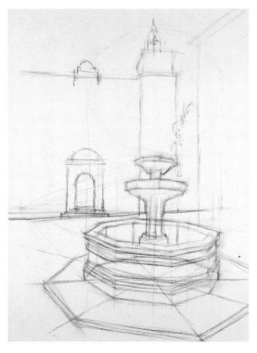

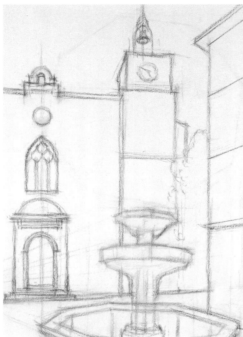

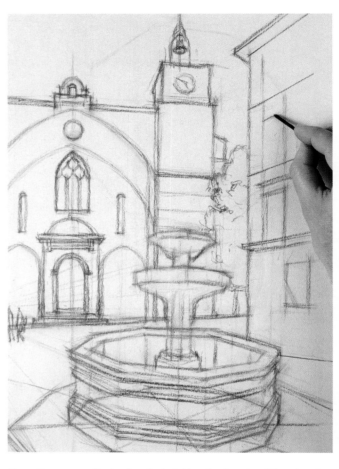

The focus of the drawing now turns to the water jet and to the architectural features of the building in the background. Even though until now we have worked with a medium charcoal stick, we change to a thinner one.

We project vanishing lines to mark the windows on the right side of the façade. Drawing the architectural elements of the church is easy, a simple exercise of symmetry.

From the perpendicular line that divides the façade of the church into two parts, we draw the arches. We finish the bell tower by reinforcing some of the outlines. The windows on the façade that sit on the vanishing lines we laid out before are drawn one by one.

Right after the line drawing is finished, the fountain's main lines are reinforced with the medium charcoal stick. We use this also to apply light shading.

The shading applied with charcoal is very light. In this area, the blending stick, which blends and evens out the tones, has a more important role.

All the precision shown in the drawing of the fountain is lost in the background, which appears lightly drawn with few details. This is ideal to create contrast.

Even though the octagonal elements of the lower part of the fountain have been drawn very meticulously, the upper ones have been done by eye, to avoid prolonging the exercise.

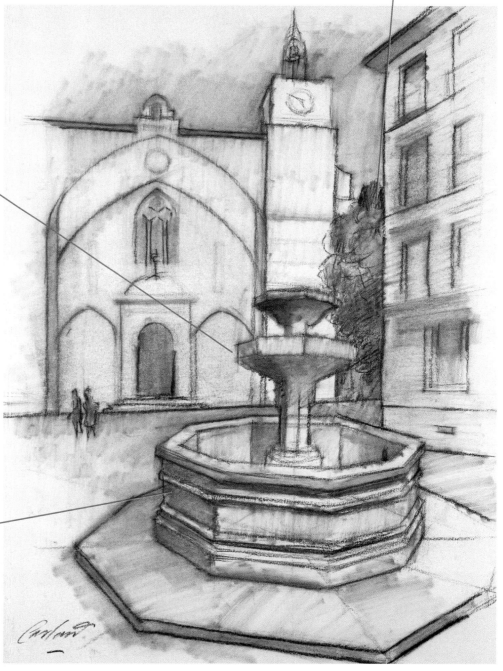

The octahedron, the octagonal form in volume, is done as if it were transparent. This will be very useful for drawing the interior parts of the fountain that are visible.

If you love technical drawings, you can leave this one as a line drawing. If the desired look is more elaborate, we recommend applying some shading and to continue working on the forms with a blending stick until the drawing looks like the one shown here.

PERSPECTIVE OF REFLECTIONS. Until now we have looked at perspectives of objects on land. However, the effect created by them on the water also deserves a brief examination. These reflections conform to a specific construction scheme. Drawings by Almudena Carreño.

15.1

PROJECTING PERPENDICULARS. The reflection of a natural subject is created by drawing perpendiculars that extend from the object in the direction of the water's surface. It is important to understand this basic premise before attempting to draw reflections on water.

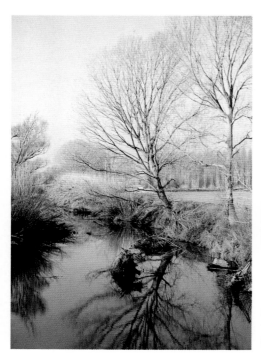

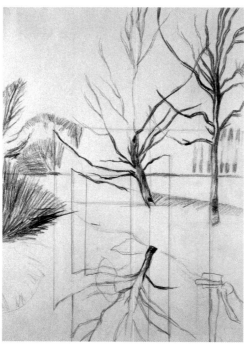

We draw a few trees next to the calm waters of a river. From the ends of the most outstanding branches and from the trunk, we draw several perpendicular lines that are projected over the surface of the water.

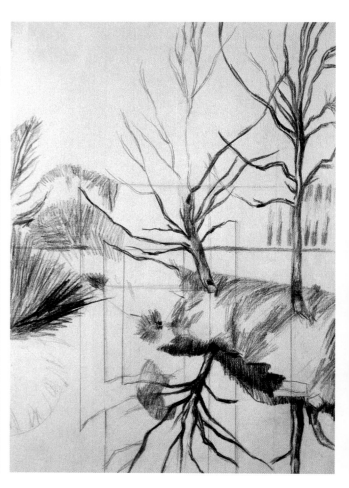

From these perpendicular lines we construct the reflection. When shading, it is important to keep in mind that the reflection is always a bit darker than the real object.

MATERIALS EXERCISE 15 AND 16: gray colored pencil, eraser, and plastic ruler

16.1

BUILDINGS AND CANALS. Now we will address the problem of reflections in perspective. The photograph includes a group of historic buildings that are reflected on the pristine waters of the canals. First, we deal with the architecture.

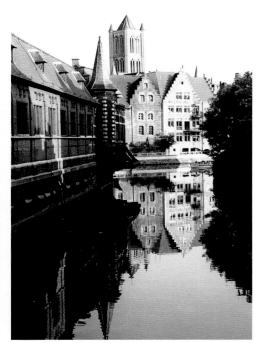

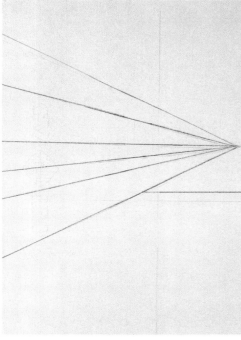

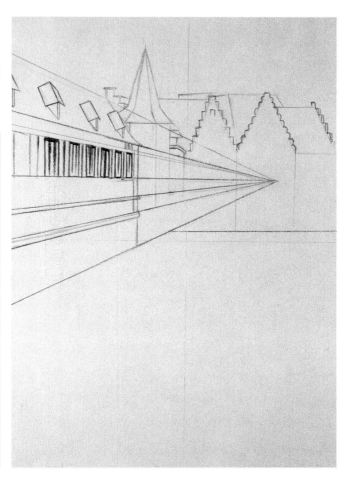

We begin with a single perspective point, from which several diagonal lines emerge in a fanlike arrangement. These are going to allow us to draw the façade in perspective. The horizontal line does not indicate the horizon, but the height of the water.

The vanishing lines establish the top of the roof, the window alignment, and the water level. The façades in the background are shown parallel to the plane of the painting; for this reason they look flat, without perspective effects.

We must be meticulous when drawing the structural elements of the façade; any error could show up duplicated on the water.

16.2

DRAWING THE REFLECTION. Now we are ready to project the mirror image of the buildings on the water of the canal. We draw perpendicular lines that act as points of reference for the measurements and new perspective lines that allow us to draw the vanishing lines for the reflection.

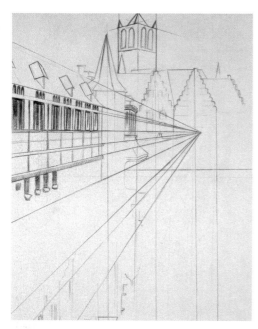

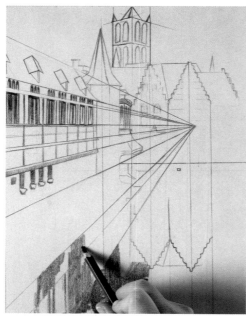

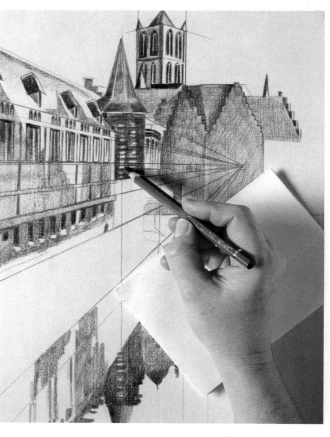

We select a few key points from the buildings: corners, edges, towers or similar features, and from these we project perpendicular lines on the water.

From the vanishing points we project new lines that establish the angle of the façade's reflection. There should be enough perpendicular and diagonal lines in perspective to construct the inverted image of the building.

Keep in mind these two important aspects when shading: any small detail will fade in the reflection, and the reflected image will be somewhat somber and darker looking than the actual subject.

The architectural features of the buildings in the foreground show greater detail and contrast, while the façades in the distance look monochromatic and lack architectural detail.

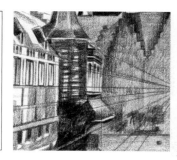

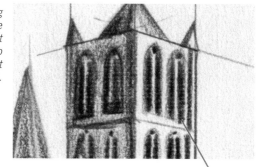

We cannot use the existing vanishing point to draw the church tower that is shown at an angle. We must establish two new vanishing points located at either side of this piece.

A color image reflected on the water is always less vibrant than the original. Here, the artist has taken artistic license in a few instances by drawing the windows only in the reflection, lightening their overall tone, and reducing the reflection of the architectural details.

The tonal effects that appear on the façade are repeated on the reflected image, with the exception of irrelevant details, which are blurred out or diffused.

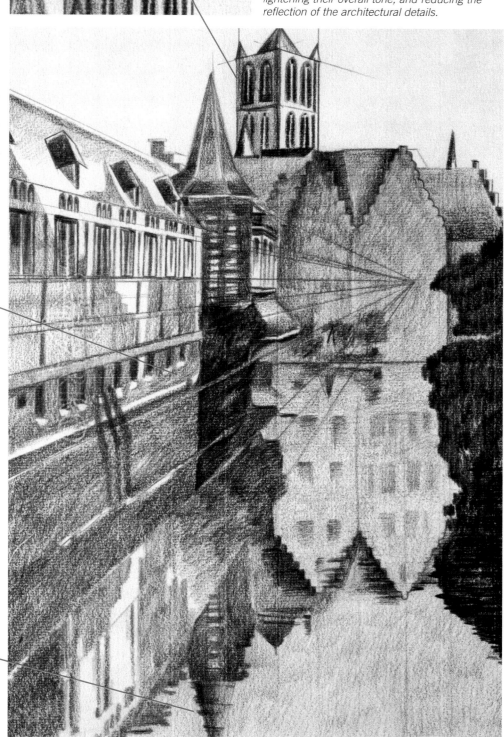

As the reflection goes farther away from the original source, from the edge of the canal, the contour lines look uneven due to the effect of the ripples in the water.

DIFFERENT TIMES OF DAY. The size and dimension of the shadows cast by the sunlight depend on the position of the sun in relation to the artist, the angle of the painting, the time of day, and the shapes of the illuminated objects. With respect to the shadows cast by the sunlight, it is important to consider that these are in constant motion.

PARALLEL AND OBLIQUE SHADOWS. The shadows cast by the sunlight that illuminates an object represented in parallel perspective are also parallel. Their length depends on the angle of their vanishing lines.
In a figure projected at an oblique perspective, the sun rays are parallel to each other and determine the length and shape of the shadow by intersecting with the vanishing lines of the ground.

The sun, as it rotates, modifies the direction and shape of the shadows.

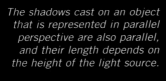

The shadows cast on an object that is represented in parallel perspective are also parallel, and their length depends on the height of the light source.

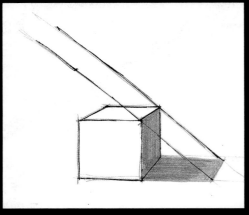

In oblique perspective, the shadows are the result of the sun rays intersecting with the vanishing lines.

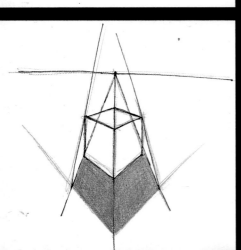

SHADOWS IN PERSPECTIVE. In a drawing, it is often impossible to ignore the shadows. The forms created by these are as interesting and as important to the composition as the objects themselves. These should be drawn carefully because they are also subject to their own rules of perspective.

SHADOWS IN ASCENDING PLANES. The shadows cast over an ascending plane are shortened, while those that are cast on a descending plane are lengthened. To calculate the length of a slope's shadow (an angled roof), we extend the sides of the chimney until they touch the horizontal plane.

When the angle plane is ascending, the shadow shortens; the opposite occurs when the shadow is at the descending side.

SHADOWS OVER VOLUMETRIC BODIES. The lines and the extension of the shadows are determined by the intersection of the sun rays with the vanishing points, but their definite form depends on the surface over which they are projected.

ARTIFICIAL LIGHT. The shadows cast by artificial light extend from a point located immediately below the light. These shadows are well defined near the light source, as well as in its main direction, but they are fainter the farther away they get.

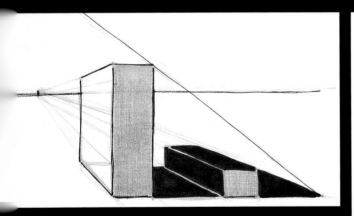

A shadow cast over a three-dimensional object ends up adapting itself to the volume of the form.

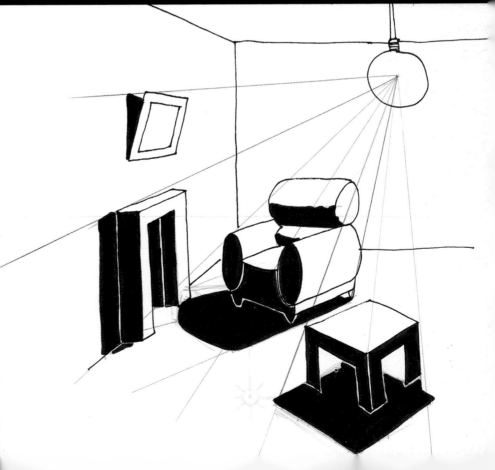

When the lamp inside a room is located close to the ceiling, the light beams extend in a radial fashion. The light beams cast shadows in every direction.

Depth
without
Lines

In landscapes, architectural elements are less important; therefore, linear perspective does not work. There is another type of perspective in which distance is conveyed through the use of color and gradation, which play a crucial role in the perception of distance. Therefore, in atmospheric perspective, the foreground is clearer and has more contrast, and the colors are more saturated. The middle planes have less color saturation and forms are less defined, while the ones farthest away lose contrast completely, and the color becomes gray. This approach is less analytical and rigid and gives the drawing a more expressive and artistic finish.

DEPTH EFFECTS WITH COLOR. In open spaces tonal values look very different when we compare the foreground with the background. The color of the closest elements always shows greater contrast within a scale of values than do the views in the distance, which appear less vibrant, with less tonal intensity. Drawing by Gabriel Martín.

17.1

SKETCHING THE LANDSCAPE. Before we begin shading, it is important to block in the main elements of the landscape with lines, paying special attention to the foreground and to the different planes that define depth.

We use rounded lines to define each plane of the landscape. These mimic the superimposing fields, forests, and distant hills. Over this sketch we draw the chapel freehand.

Over the lines that define each area we draw the contours of the most important rock masses. Then, we go over it again with a brown pencil, as we did with the chapel.

The building should be drawn in perspective with a single vanishing point. We can think of it as a cube to which the roof is added later.

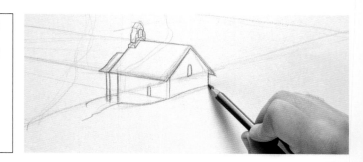

17.2

SHADING AS IF IT WERE A STAGE SET. The tonal value should be applied as if it were a scale of values that turn lighter the farther away they go. Each plane is seen as if it were part of a stage set with consistent shading throughout.

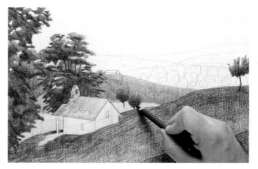

We darken the foliage of the trees with layers of color drawn with a brown pencil. To represent their volume we apply small gradations that show the light oscillation created by the leaves.

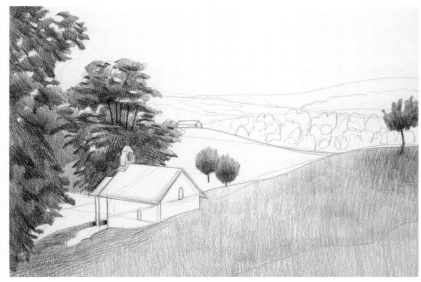

We cover the field and the trees in the foreground with bright green. However, the colors fade away the farther we go, so the field in the middle ground looks lighter than the one in the foreground.

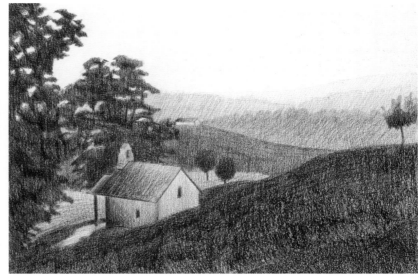

We color the hills in the background by stroking the paper gently with the pencil. We try to draw the contours of the closest elements more vigorously to make them contrast sharply with the areas in the distance, which appear more faded. To achieve this, we intensify the values in the foreground.

The progressive change in value is a good way of defining depth. This transformation has no relationship to great distances or atmospheric effects.

Shading with colored pencils is done through overlaying colors. Overlaying produces more intense and homogeneous colors.

RESOURCES FOR DRAWING LANDSCAPES. We will make several small studies of landscapes in which we will use the following graphic features: diagonal compositions, roads that guide the eye through the landscape, tilled land, rivers, and fences.

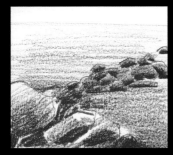

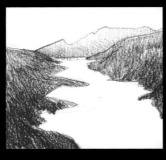

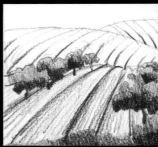

A way to enrich vast spaces is by adding details, such as furrows on the surface that show the direction of the land and thus emphasize perspective.

A diagonal composition projects the elements to the background, enhancing the effect of depth.

A meandering river directs the viewer deep inside the drawing.

It is a good idea to try out different designs and line directions to find out how effective they are.

A ROAD IN PERSPECTIVE. The illustration shows how to draw a path or a road with curves. After each curve, the road has a new vanishing point, provided both sides of the road are parallel to each other. Naturally, all the vanishing points are found on the same and only horizon line.

If we have difficulty drawing a road that cuts through the landscape, we must keep in mind that each change of direction requires a new vanishing point on the horizon.

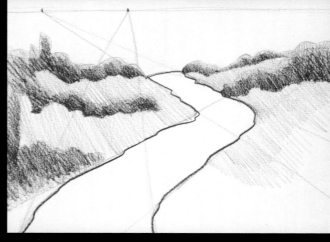

After laying out the different elements, the vanishing points disappear to give way to thicker lines and to shading.

COMPOSITION AND DEPTH IN LANDSCAPES. Some compositional resources enhance the effect of depth. So, properly drawn roads that recede into the landscape create the effect of depth in a painting.

POSTS AND TREES AS REFERENCES. Electrical posts and trees define a road and help the artist portray its depth or ruggedness. If we look at this drawing carefully, we will notice that the trees become smaller as the road recedes; one tree is even partially hidden in the background, which indicates that, behind that hill, the road goes down and turns right.

The fence and the trees that are located at the edge of the road establish its depth and ruggedness.

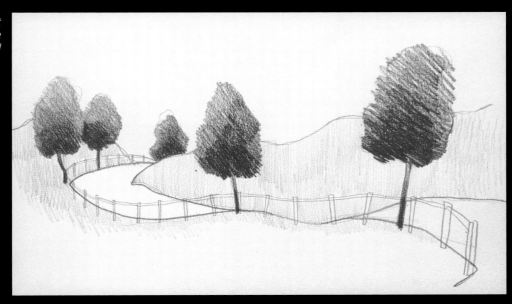

UPS AND DOWNS. Another way of emphasizing the effect of depth, while portraying the terrain, is to describe its ruggedness with a road that cuts through it. This way, the changes of slope and direction in the road portray the changes in the terrain.

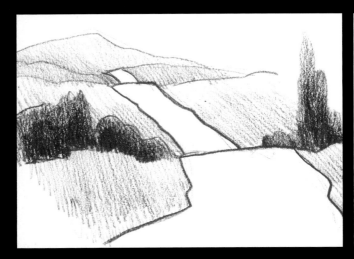

These slope changes are portrayed through cuts, together with slight changes of direction, in the road.

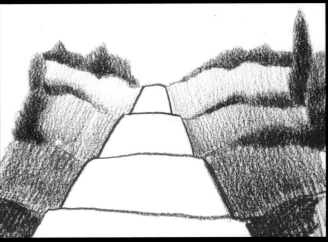

When the road is straight and is located right in front of the viewer, the rising of the slope is portrayed with cuts that fragment each section.

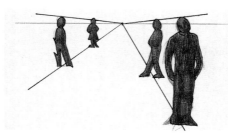

To better control the shortening of the figures—in general—with distance, we project the imaginary lines that connect the lower extremities and the head of the figures, until they reach the vanishing point located on the horizon line.

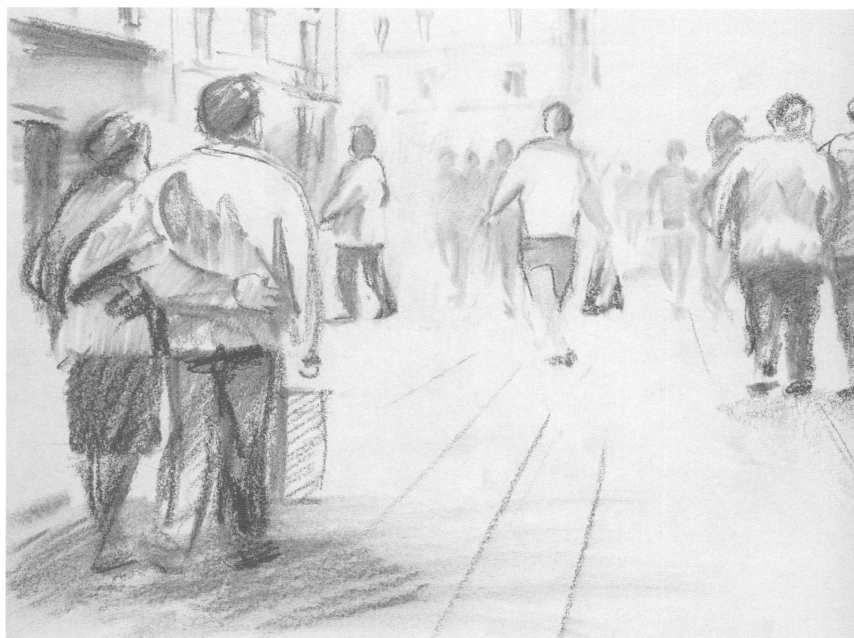

THE HUMAN FIGURE IN THE DISTANCE. Drawing people strolling in the streets is always challenging. They are not much different from any other object, though. Since we are so accustomed to seeing them all around us, the artistic license that we may take in drawing them will become very obvious.

Nothing prevents us from changing the size, the shape, or the placement of a tree, a mountain, or a house, but it is different with people because any mistakes will be very obvious and easy to identify.

It is difficult to draw life figures because they are in constant motion. In these cases, we must reduce the physical features with a quick, spontaneous sketch.

The artist is able to differentiate the figures located in the background from those in the foreground by making the former lighter, as with atmospheric perspective.

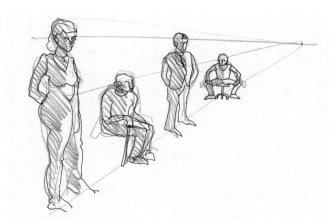

To draw figures by combining different poses—for example, standing, sitting on a chair or on the floor—all we need to do is to reference the head of the figures that are not standing against the ones that are standing to establish where the head of the former would reach if both figures were together.

361

LANDSCAPE WITH CHINESE PERSPECTIVE. Chinese art uses a variety of atmospheric perspective that blurs out the most distant colors and forms. Therefore, the peaks of the mountains located far away appear to float in the sky, while its base disappears completely due to the effect of the fog. Drawing by Gabriel Martín.

18.1

VOLUPTUOUS AND ROUNDED FORMS. The line drawing shows a design with rounded profiles, aiming at capturing the rhythm and voluptuous effect that provides an arabesque style, especially in the fore- and middle grounds. The drawing is done with a dark gray pencil.

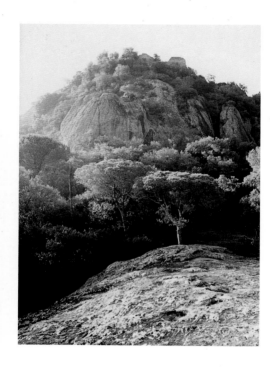
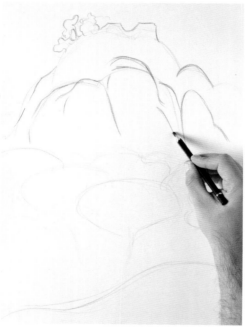
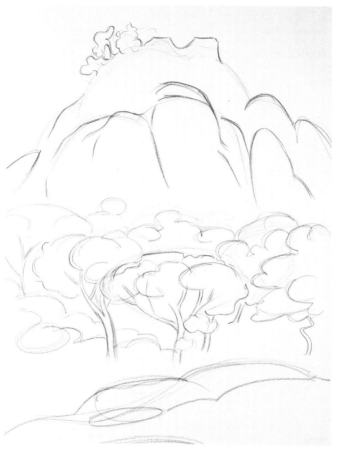

We interpret the model with voluptuous and rounded lines. The mountain appears higher and more majestic than the real one, and the area of the rocks in the foreground is reduced.

The arabesque and rounded shapes, in zigzag, direct the eye of the viewer from the bottom of the drawing to the mountaintop. The idea is to modify the shapes of the actual subject to suit our needs.

It is not necessary to erase the sketch lines, since these will be concealed behind a layer of shading.

18.2

MAKING GRADATIONS FOR THE MOUNTAIN. We shade the landscape, beginning with the background and moving to the foreground. The rocky mountain should have a darker gradation of shading on top. The bottom of the mountain is white, bathed by imaginary light.

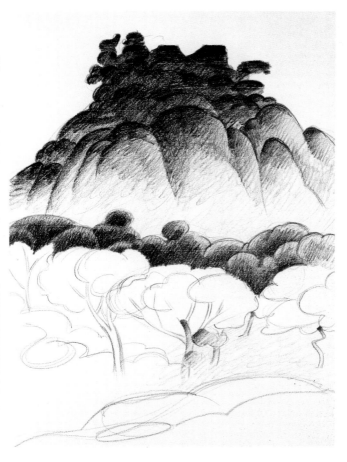

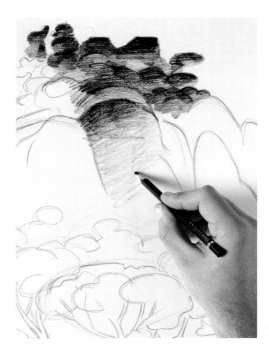

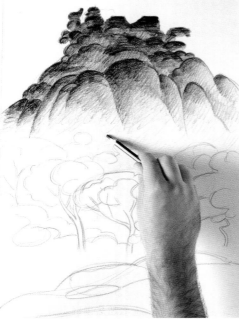

The mountaintop is shaded with dark black by holding the tip of the pencil slightly at an angle. Each form and each volume (trees and rock features) must be represented with gradations.

Each area represents a contained gradation, but all these areas put together give the mountain an overall feeling of shade progression. The pressure applied on the pencil decreases as we reach the bottom.

When we reach the bottom, we continue with the vegetation in the middle ground, producing a sudden tonal change between planes. The light that bathes the base of the mountain gives it a poetic and magical feeling.

To understand the graduated volumes correctly, we must create constant contrast, superimposing dark contours over light backgrounds and vice versa, even if that means departing from the real model.

18.3

THE IMPORTANCE OF UNPAINTED AREAS. The empty spaces that appear in the lower part of each area enhance the effect of depth. The goal is to construct each plane with graduated shading; this way, the mountaintop, the trees, and the rocky ground are emphasized vividly, while its base appears blurry due to the effect of the imaginary fog.

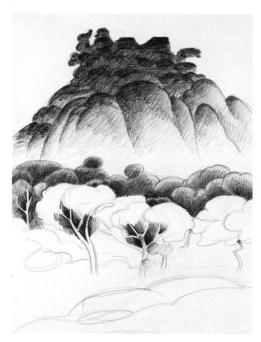

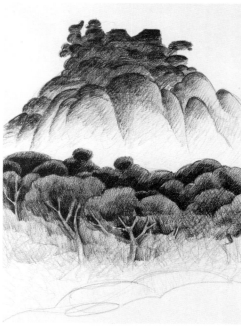

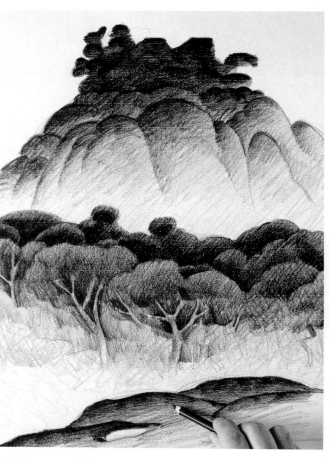

Carefully, we recreate the foliage of the forest with gradations. The shapes have been simplified by making them rounded, which makes shading easier. It is a good idea to shade the trees in the background first, followed by the ones closer to the front.

The foliage of the trees in the foreground is of medium gray, while the ones in the background are drawn with a black pencil, adding very dark shading to enhance the gradation. The tree trunks require more detail.

The lower part of the trees is drawn with gradations until we reach the white of the paper. The foreground is represented with a sudden jump in color, which occurs when we draw the upper profile with a black pencil.

It is a good idea to go over the shading of the treetops, so each color mass stands out in contrast against the one below. To achieve this, we superimpose black lines over the gray shaded areas.

The tree trunks and their branches are represented using contrast. Basically, we darken the background with black, and the branches stand out against it in contrast.

When every plane of the landscape has been established, the distance is suggested either by the absence of color, with white spaces covered by fog, or through the clear and sharp presence of the different heavily shaded elements of the landscape.

We finish the sky with a gradation applied with horizontal strokes, without applying too much pressure on the pencil.

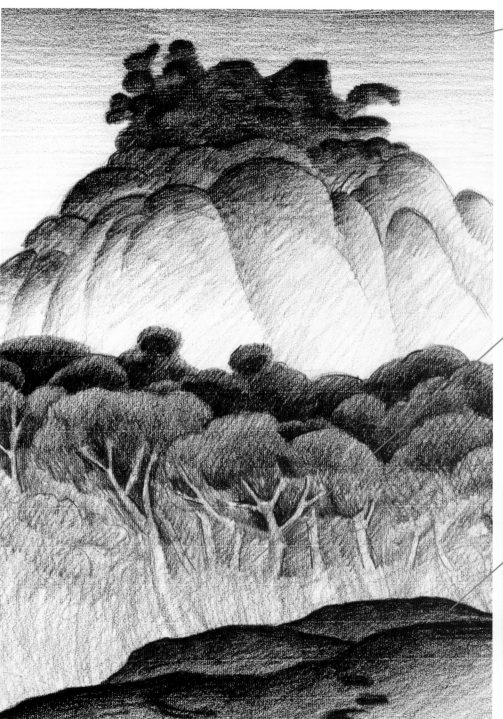

Leaving areas unfinished, shaded with very light tones, almost white, is important so that the viewer can complete the drawing mentally, and also to create contrast in this Chinese-style approach.

When the drawing is finished, we go over the upper contours of each plane, shading them with a black pencil. We apply a little more pressure so the forms become sharp and distinguishable.

ATMOSPHERIC PERSPECTIVE. This perspective is based on gradations of light, saturation, definition, texture, and even shading. In nature, this phenomenon is due to the density of the atmosphere through which we see the objects.

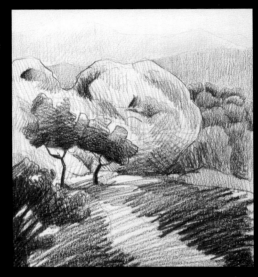

Atmospheric perspective dictates the degree of coloration for the different planes of the landscape. Colors fade away as the objects recede.

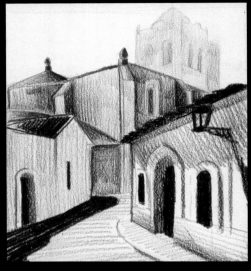

The atmospheric effect is not exclusive to landscapes; it can also manifest itself in an urban setting. We can observe here the way the tones have been applied on the façades in the foreground and the bell tower in the back.

CONTOURS AND VALUE IN THE DISTANCE. Careful observation of a large landscape will help us confirm that with distance the contours get blurry and tonal values decrease. The opposite is true for close-ups, where each object is sharply defined and easily visible.

A TREE IN THE DISTANCE. The values of a tree in the distance are very soft and airy, which gives the form a supernatural look. These drawings capture the mist in the air, a phenomenon that fades the light and makes the sky and the ground merge together. The effect of depth is more obvious if we compare it to trees nearby that have more defined lines and different shading gradations.

Looking at these two illustrations, we will notice that the one on the left appears to be farther away since it has lighter colors.

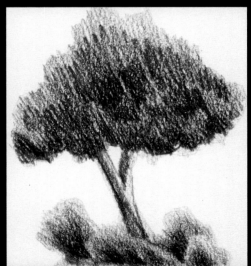

A tree at short distance has well-defined contours and visible degrees of shading.

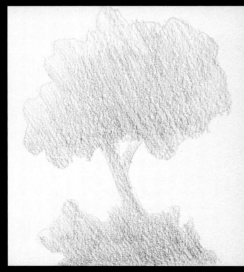

The same tree in the distance has a ghostly appearance; there is no contrast, and its contours are not well defined.

ATMOSPHERIC EFFECT IN THE DISTANCE. Atmospheric perspective is based on the optical effect produced by the light absorbed and reflected by the atmosphere (a foggy layer of dust and mist). This fog dilutes the light and makes the receding colors lose their contrast. For centuries, artists have mimicked this natural effect by using light and soft tones at the horizon.

FOREGROUND WITH CONTRAST. When we use the atmospheric effect, the objects that are well defined appear in the foreground, where there is greater contrast. Light and dark colors and the outlines of illuminated and shaded areas are sharper than in the distance. The inclusion of an object in the foreground thus enhances the feeling of depth.

We will look at the importance of contrast in the foreground by studying this model of a diffused landscape.

By including a close-up view of a group of trees, the effect of depth is maximized through contrast.

VERTICAL PERSPECTIVE. Asian art showed Western artists that vertical perspective could also provide an interesting approach to space. In vertical perspective, the farther away an object is, the higher it is represented. The culmination of this effect was Chinese perspective, which introduced thick fog at the base of mountains.

Chinese perspective combines the verticality concept with soft gradations that create a mysterious fog at the base of the mountain.

Asian vertical perspective is very clear; the higher the plane, the farther away it is.

LANDSCAPE WITH GRADATIONS. The simplest and most direct way to represent distanc with atmospheric perspective in landscapes is through gradation using any of the usu techniques: hatching, sfumatto, lines of different thicknesses, and so on. Drawing t Gabriel Martín.

19.1

SURFACES WITH GRADATION. In this exercise we will observe that a graduated effect applied to a surface automatically provides a feeling of distance. It helps explain how the color of a surface becomes lighter as it recedes.

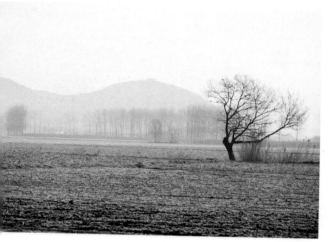

We draw a horizontal line almost in the middle of the paper. Over this, we draw the group of trees in the background and the rounded shapes of the mountains very loosely.

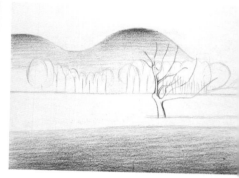

We shade the mountain with a gradation, makir the top darker. A second gradation is applied to the terrain in the foreground, although this time we invert the tonal intensity. We sketch the tree with thin lines and careful consideration.

To apply the gradation, the pencil is held at an angle to avoid exercising too much pressure. This way, the line is very soft and does not create too much contrast.

19.2

CONTRAST WITH GRADATIONS. We shade each area of the landscape with gradations. It is a good idea to change their intensity and direction to increase the contrast between the different areas—in other words, to make sure that the profiles are visible as a result of the color contrast.

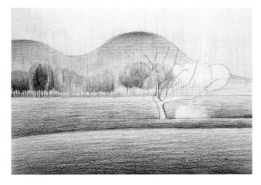

We shade the sown fields in the middle ground with an ample gradation. Each tree in the distance is drawn individually and shaded with a gradation, making sure their outlines and forms become clearly distinguishable from the mountain in the background.

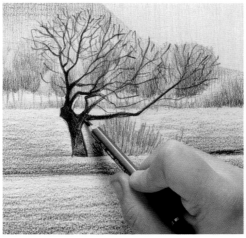

After covering all the areas with soft to medium intensity, we focus on the tree in the foreground. We draw it by applying a lot of pressure with the pencil, so the brown is very dark.

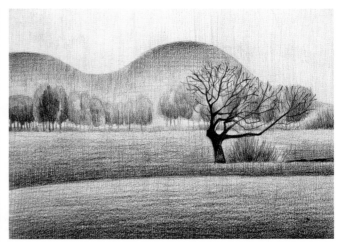

As we can see in this finished drawing, gradations provide the necessary elements to suggest the effect of depth.

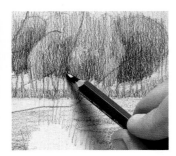

The absence of lines forces us to construct the trees with tonal contrasts; therefore a light profile is superimposed over a dark one and vice versa, to create a layer of objects.

TEXTURES IN PERSPECTIVE. To represent different surfaces that have the same texture in perspective, the intensity of the graphic elements that are used to recreate these surfaces is gradually reduced and summarized. Drawing by Esther Olivé de Puig.

20.1

PERSPECTIVE LINES. Before we begin drawing a surface or texture, it is a good idea to construct the different architectural planes that form the drawing with perspective lines. This procedure is done with a stick of sanguine Conté crayon because it makes softer and thinner lines than black chalk.

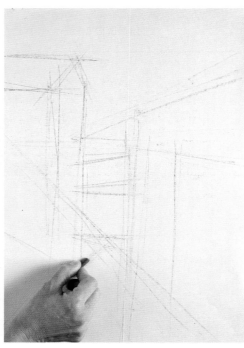

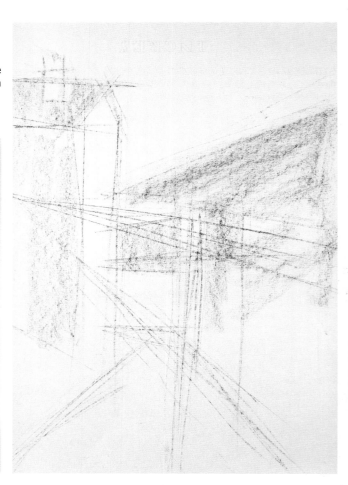

We locate a vanishing point at a midpoint on the left side of the paper to project lines that define the angle of the window and the roof of the building in the foreground.

The buildings in the mid- and backgrounds do not create any perspective issues, since they are parallel to the painting's surface. Once the line sketch is finished, we apply the first shadows with the sanguine bar placed flat against the paper.

20.2

STONES AND SHINGLES MADE OUT OF CLAY. Now we draw the stones and arrange and form the clay tiles of the building in the foreground. The dark line and tonal contrast are key to represent texture, so black chalk takes the place of sanguine.

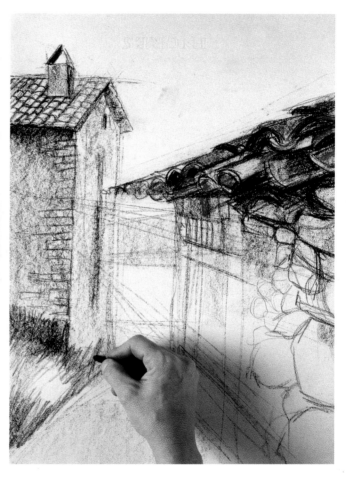

The profile of each shingle is drawn with black chalk, defining its characteristic rounded shape carefully, making sure that the idea of layering and a certain spontaneity in the arrangement are conveyed.

Combining black and sanguine chalk, we shade the shingles repeatedly and with contrast to emphasize their proximity and volume. The shape of the stones in the wall is sketched out with soft lines.

The profile of the house in the midground is drawn with the tip of the black chalk, applying very little pressure. The roof's texture is created with diagonal lines, more or less parallel, and the texture of the stone is suggested only at the corner of the building.

To sketch out the shingles we can use short diagonal lines to help us define and establish their position and angle.

The texture of the stones in the wall of the house in the mid-ground should be drawn with soft lines; they are combined with reflections and unpainted areas.

371

20.3

ENHANCING THE FOREGROUND. When an object is located very far away, it is very difficult, sometimes even impossible, to see its texture. However, with the resources used in drawing, the artist can create the feeling of depth by adding detail to the foreground and reducing it as the subject recedes.

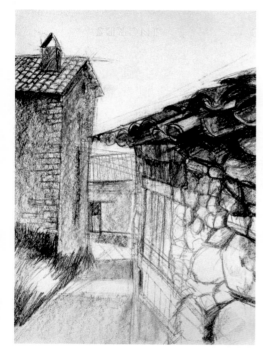

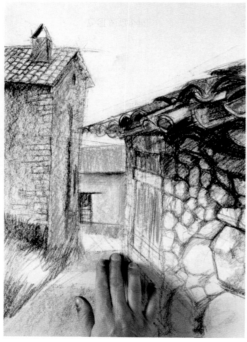

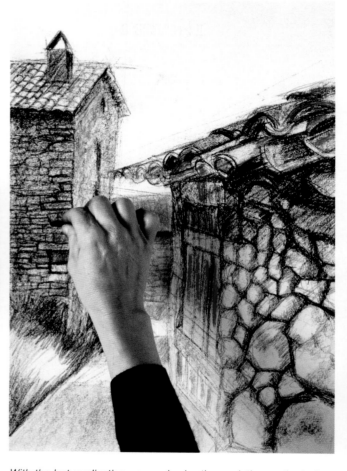

We go back to the wall in the foreground. We emphasize the shape of each stone by drawing a dark outline, which is darker on the upper part of the wall and somewhat lighter at the bottom, due to the incidence of light.

We continue defining the texture of the objects in the foreground. The wall of the house in the background is smooth, without any texture. At the same time that we draw the lines, we shade with black and sepia chalk. We blend the areas with the hand.

With the last application we emphasize the gradation on the texture that is far away. We go over the lines of the stones in the foreground again, paying special attention to their shape. We darken the façade on the second plane; here the stones look squarer and somewhat diffused.

The stones of the façade in the second building are shaded with black and sanguine chalk. Gradations are avoided to prevent them from becoming three-dimensional; they should look flat, in clear contrast with the foreground.

The final drawing shows three different treatments for each of the façades. Lack of definition plays an important role in creating depth. The greater the distance, the lighter the lines that define the texture of a surface.

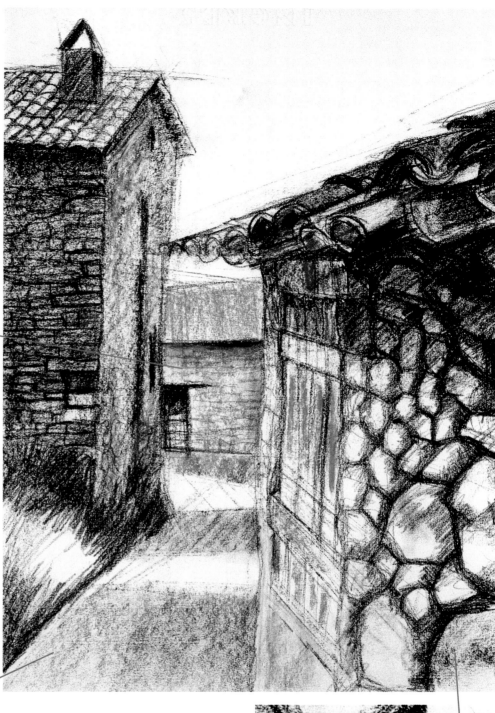

The façade in the background hardly has any texture. It is drawn simply with a few lines of sienna.

Each texture requires a different type of shading. The ground is created with flat shadows blended with the hand, while the edges are covered with gray hatching.

To emphasize the stones' effect of volume, we add soft shading effects that define their irregular surfaces.

GRADATIONS. The graduated shadows best portray the loss of color effect experienced by receding spaces. It is therefore the most commonly used method in atmospheric perspective. It enhances the three-dimensional effect when applied to any surface, since it portrays, very effectively, the changing quality of light.

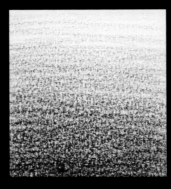 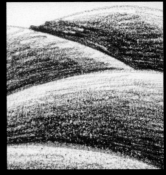

A simple gradation by itself explains the effect of losing color saturation that the landscape experiences with atmospheric perspective.

Gradations can be applied over each plane to enhance volume and to give the terrain a more rounded look.

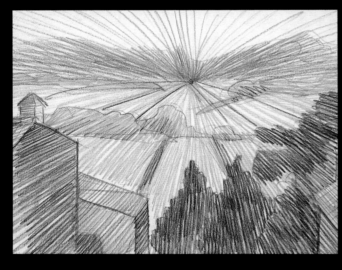

RADIAL LINES. When we use cross-hatching for drawing, radial lines can become very handy. These lines converge at a single point on the horizon line; this way, all the lines look as if they were drawn in a circular configuration around that point.

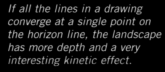

If all the lines in a drawing converge at a single point on the horizon line, the landscape has more depth and a very interesting kinetic effect.

FOREGROUND OUT OF FOCUS. Often, with atmospheric perspective, we try very hard to show detail in the foreground of the painting, even when that is not the most important thing. There is no logical explanation for it, because if the area we want to focus on is in the center of the piece, the grass below our feet or a branch that cuts through the surface is not important.

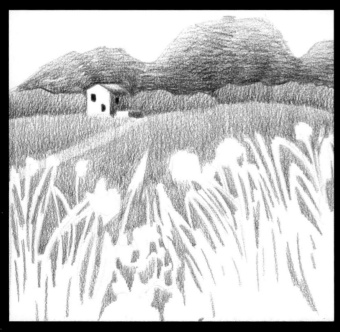

If the drawing's center of attention is in the middle ground, the foreground can be left out of focus and unfinished.

A branch drawn out of focus, without details, that springs out in the foreground can enhance the effect of depth.

GRADATIONS, LINES, SOFT FOCUS, AND TRANSPARENCIES. There are several ways to ensure the continuity of the space and to make it coherent, for example, the use of gradations or radial hatching in perspective, as well as other approaches that help break down the physical quality of an object, such as drawing an element out of focus to create an imaginary space, or using transparencies. Let us look at how these resources can be used.

DEPTH AND TRANSPARENCY. A special case for overlapping elements is through transparencies. Here, the occlusion is only partial since the layered objects can still be seen. The light of the transparent area creates an imaginary space that differentiates the foreground from the background, enhancing the effect of depth through overlaying. The sun rays, the mist, the filters, the haze... are physically transparent.

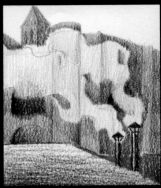

The transparency creates an overlapping effect that helps differentiate planes and distance.

A transparency is achieved when a surface lets sufficient light through for the element below to be visible.

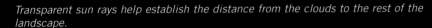
Transparent sun rays help establish the distance from the clouds to the rest of the landscape.

THE CONTRIBUTION OF TRANSPARENCIES IN LINEAR PERSPECTIVE. Transparencies are very helpful in linear perspective, especially in urban scenes. In this case, drawing transparent cubes and rectangles helps represent dual surfaces at once, as well as differentiating the front from the back.

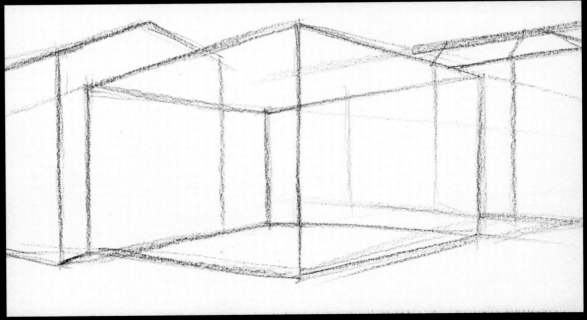

Drawing urban elements as if they were transparent geometric shapes helps understand the subject.

We use a series of lines to block in the cloister and the placement and sizes of the arches. There is also another indicator of depth: the shadows, which are darker in the foreground and lighter gray in the background.

Shading is another important factor that gives the work a feeling of depth. It is a good idea to work with a 4B pencil or mechanical pencil. The background is shaded softly and lightly.

To draw the arches in the foreground, the width of each one of them is established with the texture gradient technique. Then, we project a diagonal from the upper part of the first line, which crosses the second one through the middle, and it is projected across the previous vanishing line. We draw a new perpendicular line from this point.

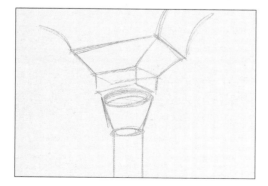

The easiest way to resolve the capitals is by combining different simple geometric shapes, as if it were a series of stained glass pieces that fit together.

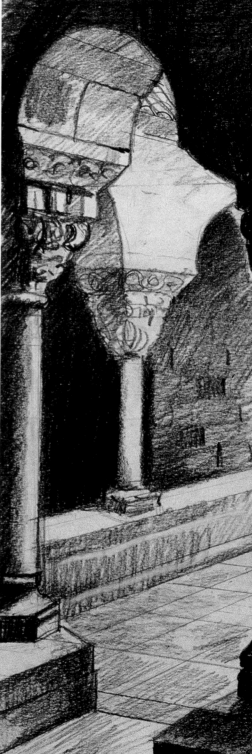

When a model presents some degree of architectural complexity, it is necessary to break down the space into very simple shapes. To begin with, it is a good idea to draw the vanishing lines of the walls in the cloister with a two-point perspective: the first one on the paper, and the second one, very far away, outside of the surface of the drawing.

PERSPECTIVE OF A CLOISTER. A cloister full of architectural features and elements may look like a daunting task for an artist. However, knowing how to break down the space from the beginning makes the process very easy and very pleasant.

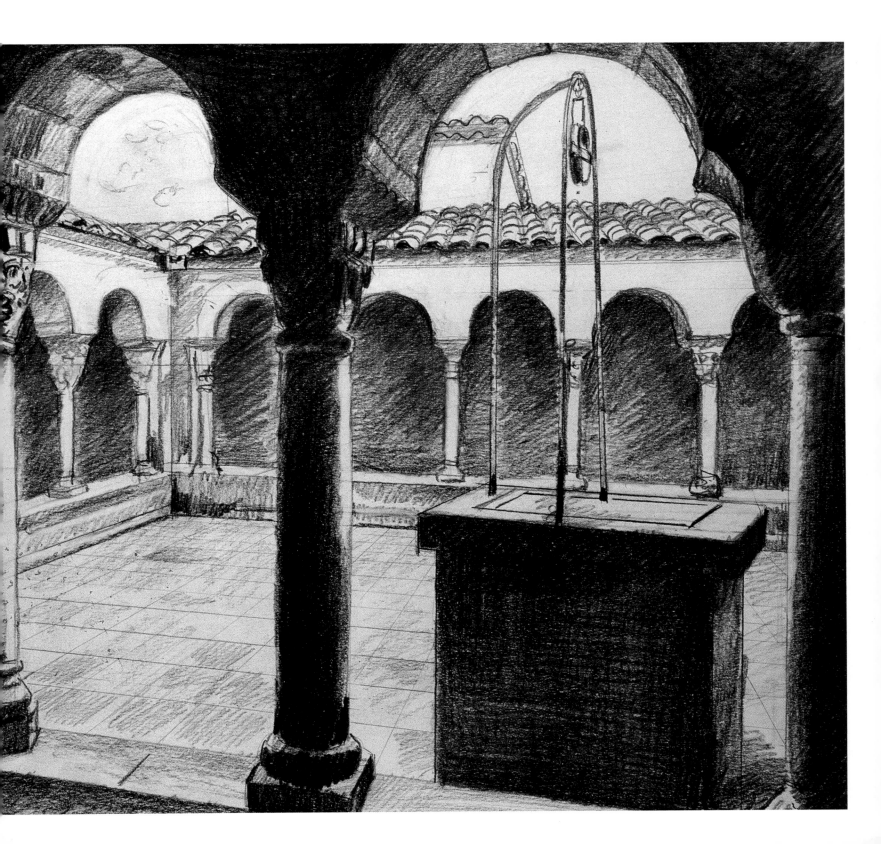

THE *COULISSE* EFFECT. The term is a French word that makes a reference to a theater's stage set. It consists of representing each plane with a solid color that becomes lighter as it recedes. When the *coulisse* effect is used to represent depth in a landscape, it is important for the progression of values to be decreasing and orderly; this way, all the forms that belong to the area in the background are seen as if they were a continuous backdrop.

In a landscape with a coulisse effect, each plane is treated with a uniform color that lightens as it recedes.

ELEVATION IN PERSPECTIVE. To draw this, we create a floor that is divided into regular squares, drawn in perspective. Beginning with the grid, we project the objects in perspective. This approach is very useful for drawing interiors with their furnishings.

We draw a tiled floor. The grid in perspective helps us project the volumes.

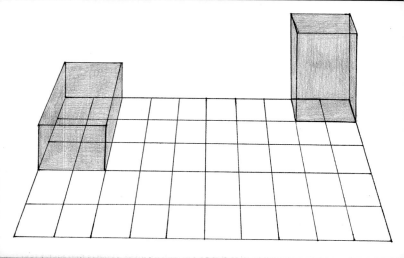

Using the grid as reference, we project the rectangular geometric shapes.

SCENIC PERSPECTIVE. Theatrical perspective is often compared to an auditorium or a stage set, complete with an onstage area and a backdrop. Perspective resources are drawn from elevation techniques, from creating depth with stage sets, from angling the floor, among other techniques. The goal is to create the optical illusion that the limited stage is a landscape with unlimited depth.

ASCENDING FLOORS. Often the artist wishes to create a greater feeling of depth than is physically possible. If a stage designer builds a regular space, with horizontal floors and rectangular walls, the viewer arrives at specific conclusions. If, on the other hand, the floor gradually goes up toward the back, the ceiling descends and the trapezoidal walls converge. A physical slope combined with perspective slopes results in a projection.

If an interior has a regular shape, with the corners meeting at right angles, the effect of depth is limited.

The perception of depth in a stage or a room is increased by placing the ceiling and the floor at an angle to force the perspective.

DIVERGENT PERSPECTIVE. Converging perspective conceals the sidewalls; diverging perspective reveals them. It reveals the sides of a cube, and in doing so gives it more volume. The visual advantages of this procedure are so obvious that modern artists (Fauvists, Cubists, and Futurists, among others) used this method to represent façades, buildings, and still life.

An example of a geometric shape in converging perspective.

The same geometric body in diverging perspective.

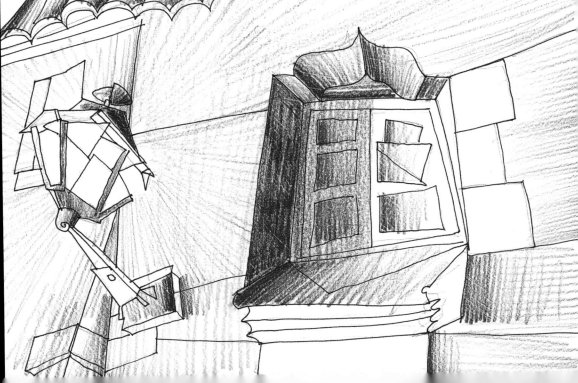

Diverging perspective has always been a source of inspiration for Cubist artists.

A / B / C / D / E
F / G / H / I / J / K
L / M / N / O / P
Q / R / S / T / U
V / W / X / Y / Z

Glossary

GLOSSARY

A

ACADEMIC. Drawing that follows norms considered to be classic. A correctly proportioned drawing that faithfully reproduces the model.

ATMOSPHERE. The air from the foreground to the background of a composition, which becomes successive layers of fog, through the greater contrast in the foreground and the lesser amount of color and definition in the background. This is visible in landscapes and seascapes, especially when the light source is in the background.

B

BLENDING STICK. A cylinder made of paper, used for graying and grading lines and colored areas of graphite, charcoal, sanguine, and other dry art media.

BLENDING. An effect created by rubbing the surface of a drawing to reduce the contrast between the edges and lines. This can be done with any part of the hand, or with blending sticks, a cotton rag, a fan brush, etc.

BLOCKING. A drawing technique based on shading with areas of uniform, solid color. This technique is very commonly used when drawing with India ink.

BLOCKING-IN. This is a process that consists of drawing simple lines on the surface of the paper to create a layout, a first approximation of the subject.

C

CAST SHADOW. A shadow projected by the model on nearby surfaces (floors, walls, grass, etc.).

CHALK. Sticks made of pigment and agglutinate (binder) that are similar to hard pastels. The name comes from a white calcareous stone. They are generally white, black, ochre, sanguine, and sepia.

CHIAROSCURO. This is the distribution of light and shadows that creates the greatest contrast between the illuminated and dark areas of the drawing. It makes the visible areas, colors, and forms stand out despite being wrapped in the most intense shadows.

COMPOSITION. A method for creating the most balanced and harmonious arrangement of the diverse elements that make up a work of art. In other words, composing is selecting the best possible combination of harmony and balance for a drawing or painting.

COMPRESSED CHARCOAL. This is a cylindrical or square stick that is made by binding charcoal powder with a little clay and glue. Its line is darker and denser than that of a conventional charcoal stick.

CONTRAST. Describes the opposition between two different tonal sensations.

CROSS-HATCHING. This is a drawing technique where the tonal effects are created by overlaying parallel lines at different angles.

D

DRAPERY. A recurring subject in still life drawings that consists of studies of the shadows created in the folds and wrinkles of fabric.

E

ERASING. This is a drawing technique where an eraser is used to create light areas in dark ones, and for making highlights and tonal gradations.

F

FIXATIVE. A liquid that is used on drawings to fix the different powdered materials on the surface of the paper, thus keeping part of the work from coming off of the support. It is sold in liquid and aerosol forms and is sprayed directly on the works of art we wish to preserve.

FRAMING. An imaginary form, generally rectangular, that encompasses the artist's view of the model to create an attractive composition.

G

GLAZE. A layer of transparent color painted over another color to intensify or modify it.

GRADATION. Reducing the value of a tone, which gradually moves from a dark sensation to a lighter one, without creating a brusque transition between them.

GRAPHITE. This is a carbon mineral with a compact texture, black color, and metallic luster that is used for making pencils.

GRID. Used for transferring a drawing with a screen that is placed over the original drawing. A similar screen made to scale is placed over the paper, and the drawing is constructed square-by-square.

H

HATCHING. This screen of drawn lines is used to simulate a color with texture.

HIGHLIGHT. Created with a line or dab of color that stands out against a dark background. Highlights are applied in a drawing to represent reflections or direct impacts of the light source on the represented object.

HORIZON LINE. In perspective, this refers to the line marking the height of the horizon. The vanishing point, where the receding diagonal lines that identify the outline of an object meet, is on the horizon line.

I

INTENSITY. Refers to the strength of a color.

L

LAYOUT. A preliminary drawing that captures the basic structure of the objects using simple geometric figures that reference the exterior forms of the model (cubes, rectangles, prisms…); this can also be called blocking-in.

LINE DRAWING. A drawing made only with lines and lacking any color or shading. The result is a model where only the outlines of the essential shapes of the subject can be seen.

LINE SHADING. This method of tonal shading uses crisscrossing lines.

M

MODELING. Despite its use as a term in sculpture, this is also used in drawing and painting to describe the application of shading using various tones with the goal of creating the illusion of three dimensions.

N

NEGATIVE SHAPES. These are the spaces that exist between the models in a drawing, and that frequently show us what is happening in the background.

P

PENUMBRA. A zone of intermediate tone between an area of light and one of shadow, either its own or projected.

PERSPECTIVE. This refers to the art that graphically represents the effects of distance in respect to appearance, shape, and color. We can distinguish between linear perspective, which represents the third dimension (or depth) using lines and shapes, and atmospheric perspective, which represents depth with colors, tones, and contrast.

PIGMENT. Mineral or synthetic powder that is the base for the manufacture of any paint. In drawing it is often used for shading, by impregnating a cotton ball with the color and rubbing the paper with it.

PROPORTION. The harmonic relationship of measures, that together represent the different parts of a model or objects in a composition.

Q

QUICK SKETCH. A fast drawing whose goal is to capture the essence of an image in a spontaneous and simple representation.

R

REFLECTION. An effect created by the contrast between a white space and the more or less dark areas around it.

S

SANGUINE. A reddish pigment used for making pencils and sticks for drawing.

SEPIA. Also known as bistre, this is a brown pigment used for making ink and hard pastels.

SFUMATTO. An Italian term for the technique based on blending the outlines of the model in a drawing or a painting.

SHADE. This occurs in an area on a drawn object that lacks light.

SILHOUETTE. This is a lighting effect that is created when the light source is behind the model that is being drawn.

SKETCH. The first phase in executing a drawing, from which a later definitive work can result. It is done with a few lines, just enough to situate the essential elements of the drawing.

SUPPORT. A base material used for painting or drawing, such as a wooden board, a canvas, a sheet of paper, etc.

SYMMETRY. This is a type of composition in which the elements of the picture are repeated on both sides of a central axis.

T

TEXTURE. Refers to a visual and tactile quality that can be represented on the surface of a drawing. It can be smooth, sandy, rough, cracked, etc.

TONAL VALUE. Assigning gradations of light or darkness to represent a color. When we assign a tone to a determined area on the representation of a model, we are using the tonal value system, where each different tone has its own value.

TONE. A term from music that is applied to painting to refer to the strength and relief of all parts of the work of art with respect to the color and luminosity. Different tones are achieved with charcoal or chalk by applying more or less pressure on the stick.

V

VANISHING POINT. The only point on the horizon where all parallel lines that go in any direction will converge.

VINE CHARCOAL. A carbonized twig or vine that is used for drawing.

VOLUME. In drawing, the three-dimensional effect in the representation of a model in a two-dimensional space.

W

WASH. A drawing and painting technique that consists of painting with a color diluted in water. The most common practice is to mix watercolor, sepia, or India ink with water

WASHING. This refers to the application of an ink or watercolor wash that is very diluted with water, which makes the color very transparent.